The Collected Writings of Robert Motherwell

The Collected Writings of Robert Motherwell

Edited by Stephanie Terenzio

New York

Oxford University Press

Oxford

Oxford University Press

Oxford New York Toronto
Delhi Bombay Calcutta Madras Karachi
Kuala Lumpur Singapore Hong Kong Tokyo
Nairobi Dar es Salaam Cape Town
Melbourne Auckland Madrid

and associated companies in
Berlin Ibadan

Copyright © 1992 by Stephanie Terenzio

First published in 1992 by Oxford University Press, Inc.,
200 Madison Avenue, New York, New York 10016

First issued as an Oxford University Press paperback, 1994

Oxford is a registered trademark of Oxford University Press

Library of Congress Cataloging-in-Publication Data
Motherwell, Robert.
[Selections. 1992]
The collected writings of Robert Motherwell
edited by Stephanie Terenzio.
p. cm. Includes bibliographical references.
ISBN 0-19-507700-8
ISBN 0-19-509047-0 (pbk.)
1. Motherwell, Robert—Philosophy.
2. Art.
3. Art, Modern—20th century.
I. Terenzio, Stephanie.
II. Title.
ND237.M852A35 1992
709'.04—dc20
92-13639

1 2 3 4 5 6 7 8 9 10

Printed in the United States of America

PREFACE

This book brings together a representative selection of Robert Motherwell's writings about art, dating from 1941 to 1988. It contains over sixteen essays, a number of pieces from exhibition catalogs, more than a dozen public lectures and talks, and all the artist's vanguard editorial work. The last comprises his introductions to several volumes of the pioneering series The Documents of Modern Art, which he began directing and editing in 1944; it also includes his contribution to *possibilities 1* (1947/1948), the first magazine devoted to modern art and culture in the United States, and to *Modern Artists in America,* a book designed to bring balanced attention to modern art in the conservative climate that prevailed in 1951.

Edited portions of four of many interviews conducted with Motherwell have been selected to develop a fuller portrait of this complex artist (who, in addition to writing, editing, and lecturing, also taught) and to present ideas he did not express elsewhere. A few of his letters are included, most from recent years and many responding to questions about his early painting milieu.

Several of these selections have never before been published. Of those that were, their original appearance was most often in publications that are now out of print or difficult to obtain. This volume thus not only brings together Motherwell's writings for the first time, but also makes available a number of important texts that until now have been circulated largely in photocopies or have been reprinted only in excerpted versions.

That Motherwell's writings have not been collected earlier may be surprising to some readers, given the influence he exerted on his times and his importance among theorists of abstract art. Ironically, it is the artist himself who resisted such a book. Over the years, he often told me that he would have been better off if he had not written a single

word about art, and considered it (in a characteristic hyperbole to ensure emphasis) the *tragedy* of his life that he had written as much as he did. This, I think, is because the broad cultural dimension he brought to his early essays and editorial work caused him painful alienation from many fellow artists in bohemian Manhattan, a milieu that in general was critical of an artist with intellectual or extra-painterly pursuits. The attitude was characterized in a comment later related to him by a colleague about his appearance on the New York art scene in the early 1940s: "We artists were getting along just fine until Motherwell came along with a sense of history."

Motherwell's hesitation to publish his literary work in collected form may in part have been because he felt that his writings—from the early 1940s, in particular—were too partisan. Even acknowledging the hostile climate they were meant to ameliorate, these essays proselytized for modern art to a degree with which his mature personality, conspicuously passive in regard to politics (but not to modernism or the human condition), may have been somewhat uncomfortable. Against these early texts, the writing he in later years felt most natural to him was that which he produced for his book on dada in 1951. It is there, where *having no axe to grind,* he could be *detached and scholarly.* Unquestionably, his preface and introduction to *The Dada Painters and Poets,* as well as his concept and execution of the book itself, are a supreme achievement. Yet I must argue for further dimensions to this literary talent. Motherwell's colorful tribute in an essay to Joan Miró and his poignant recollections of Mark Rothko, David Smith, and Pierre Chareau, as examples included in this volume, are writings only an artist could have produced.

My feeling is that Motherwell's reluctance to have his writings published in part concerns the integrity of the initial experience. As universal as his essays and lectures are in their message, they reflect a keen awareness of the particular audience they were meant for, with no apparent thought to their independent literary merit. The full intent of his original presentation, always in response to a specific request, must have become distorted for him when he thought of it projected into such an arbitrary context. And, too, there had never been a consistent program to his literary work: almost everything he wrote was solicited; every lecture, the result of an invitation. Since certain of these writings and talks took weeks to produce, while others were completed just before the deadline (at times while he was drinking heavily), they could not but appear markedly different in tone. Motherwell, ever sensitive to nuances, must have realized that through compilation the ad hoc, *ad hominem,* nature of the individual selection would become evident and the emphases and repetitions more pronounced. And so they do.

No doubt, Motherwell would have wanted to edit much of his writing. Notwithstanding his inherent historical perspective, he existed vi-

tally in the present, where a new "take" on a subject was frequently cause for his reframing of the entire picture. This will to change was neither arbitrary nor quixotic, but a basic characteristic of his total creative process: it could be evidenced in his painting as well as in his day-to-day affairs. If many of his pictures were not already in the public domain, he probably would have repainted them. His imagination was primed to remain flexible, allowing inconsistency in order to gain richer and more subtle expression. His constancy to his early found belief in modernism permitted him such freedom, and his experience, forever new, became grist for that universal mill. Contrary to the creative impulse he took with him when he died in the summer of 1991, and with few editorial interferences of my own (in most cases noted), his writings are presented with little alteration.

Essentially, Motherwell's reluctance to this publication must have arisen from his judgment that the initial purpose of his writings was fulfilled—that his primary role in the public arena had been played out. For instance, The Documents of Modern Art, a series of seminal texts he selected, edited, and had translated into English when they were otherwise inaccessible to American readers, has long since become part of our basic artistic language. Thousands of young artists and students were weaned on these very works, as others were on Motherwell's own writings, lectures, and teaching—in addition to, and along with, his painting. The fortunate (and unfortunate) truth is that Motherwell's literary and editorial work, which helped illuminate the nature of modernism and was instrumental in dislodging a deep-rooted provincialism in American culture, has been seamlessly appropriated by subsequent generations. So successful was he in his effort that it is nearly impossible to extricate from history the difference he has made.

Still, on the strength of their internal logic, their humanistic and universal vision, their artistic integrity and historical accuracy, and (particularly in the later pieces) their poetic resonance, Motherwell's writings stand on their own—perhaps for all time. Their intelligence and coherence and passion make a forceful argument against any reservations the artist himself may have had against their publication in this volume. For those young readers who come to these writings new, as well as for those who may have read some of them in their original context, the thoughts and feelings they evoke will, as they do for this reader, surprise some nearly extinguished spark that may still be taken for the human spirit.

Coventry, Conn. S. T.
February 1992

EDITOR'S NOTE

It was less consistency than clarity that determined the minor changes I have made in some of Motherwell's writings from the way they first appeared in print. In essentials, fidelity to the original printed text has been maintained. In no instance has the wording or context been altered other than by noted omissions. These omissions take the form of ellipses within editorial brackets [. . .], to distinguish them from Motherwell's frequent use of ellipses, intervals that became an important part of his style.

Since the writings included in this book span almost half a century, during which time attitudes toward spelling, punctuation, capitalization, and other style conventions have evolved (and, at that, were subject to the preferences of different editors and house rules), the writings are presented with a uniformity in these regards. For example, the names of artistic movements such as abstract expressionism, surrealism, and dadaism, which may have originally appeared both capitalized and not (at times within the same published writing), are now consistently lower case. Hyphenated words (many in the artistic terminology of the 1940s), no longer taking that form, have been up-dated. Foreign words that have since been adopted into English are no longer in their original italics, a decision that may better accommodate Motherwell's frequent use of emphases (therefore italics) in his writings and the many quotations from him that I have put into italics.

It is assumed that the copies left in Motherwell's files were of letters actually sent. Motherwell rarely, if ever, made spelling mistakes, whereas he occasionally did not correct typographical errors in his dictated letters, probably because, as he often said, he could not properly focus on the typewritten page. Spelling errors that occur in his letters have been changed without note.

Where Motherwell's paragraphing was critical to what he was saying, it has remained as he would have wished it. He had indicated to

me that before they were republished he would want to put some of the earlier writings back in the form in which he had given them to editors, with distinct intervals between thoughts, an underscoring of the verbal collage he felt most accurately presented his ideas. Now, it can only be assumed what these changes would have been. In general, I consider the minor alterations referred to earlier those that the editor Motherwell would have made.

ACKNOWLEDGMENTS

Apart from Robert Motherwell, who was the cause and inspiration of it all, Jack Flam (whose own sense of artistic purpose and generosity of spirit evoke the essential memory of Motherwell) must be credited with initiating this project and helping to bring it into being. I wish to publicly thank him for his continuing assistance and advice and for his permission, as literary adviser to the Dedalus Foundation, to reprint from Motherwell's written oeuvre.

The preliminary work that Robert Hobbs did in collecting many of Motherwell's writings was a helpful beginning for me.

I am indebted to Joan Banach, as are all of us who have worked with Motherwell over the last decade of his life (and who now work with his foundation), for her thoughts and her implementation of miriad requests, not only with knowledge and thoroughness but with graciousness and discretion.

I enjoyed the enthusiastic assistance I received from my research assistants during this project: Charles Anderson, who dug deep at the very beginning; Karl Henzy, who continued the work in mid-course; and Serena Enger, who took it into home stretch. I acknowledge with gratitude the financial aid these three young scholars received from the Research Foundation at The University of Connecticut and the implementation of my research grant by Cookie Roy at the university's William Benton Museum of Art.

At the University of Connecticut's Homer Babbidge Library, I want to thank Robert Vrecenak of the Inter-Library Loan Service (and staff at reciprocating libraries), Thomas Jacoby and Tim Parker of the Art and Design Library, Richard Schimmelpfeng of Special Collections, and Barbara Lott and others in the Reference Department for considerable assistance over several years of work. In this connection, I wish to express my appreciation to Elaine D. Trehub, college history librarian at Mt. Holyoke College, South Hadley, Massachusetts, for use of

special material, and to Ellen O'Donnell and Judith Rothschild for providing information on Forum 49.

For consent to reprint material from their publications or archives, I am grateful to *The American Scholar;* Archives of American Art, The Smithsonian Institution; The Arion Press; *Art and Antiques; Art in America; Art International; Art Journal; Art News; Arts and Architecture;* Harvard University Press; John Gruen; The Metropolitan Museum of Art; The Museum of Modern Art; National Gallery of Art; The Phillips Collection; Otis Parsons School of Art and Design; *Partisan Review;* Provincetown Art Association and Museum; Smith College Museum of Art; The Trustees of St. Paul's School, Concord, New Hampshire; Viking Press; Whitney Museum of American Art; and Yale University Art Gallery.

My thanks to the photographers whose photos I have used in this book, particularly Renate Ponsold, who has dedicatedly, since they first met in 1971, recorded Motherwell over the years and continues to provide us with rare and permanent glimpses into her late husband's public and private life.

I wish to thank my dear friends Thomas Kane and Leonard Peters, who, in addition to reading and commenting on parts of the manuscript and encouraging me all along, introduced me to John Wright, now my invaluable literary agent, who, in turn, introduced me to Oxford University Press, where the manuscript received an enthusiastic response from its editors, particularly Joyce Berry. I am indebted to Irene Pavitt for the expert and sensitive care she gave my manuscript. Motherwell loved all stages in the production of a fine book, and it would have given him pleasure to see his writings take public form with such discrimination and with what he valued even more—personal attention.

In a writer's mental geometry, there are a few persons who provide points of reference—individuals who, after the writer's own sense of rightness, become a subliminal audience during the course of the work and thereby help keep it on course. Jack Davis, friend, eminent scholar, and teacher, with the esteem he has held for Motherwell's work and his anticipation of this book, as well as his comments on aspects of the manuscript, helped me in this way. My husband, Anthony Terenzio, to whom (along with the memory of Motherwell) I dedicate this book, is ever present in this dynamic, less as a relation than as a resolute artist, and thereby ever a true measure.

I want to thank my daughter, Lisa, for her varied assistance, particularly during the final phases of this project, and for her constant encouragement. In this last (and primary) regard, I want to thank the doctors, nurses, and staff of Hartford Hospital's Hemodialysis Unit.

CONTENTS

CHRONOLOGY

Emphasis is on events pertinent to this volume and on Motherwell's literary and public activity in general rather than on his painting and exhibiting. The artist's yearly diaries, starting with relative consistency after 1960, except for a few missing years, have provided much of the information from that year to 1991. A listing of his writings and editorial work can be found in the Bibliography. Entries followed by [★] indicate texts included in this volume. Events during a given year are not necessarily listed in chronological order.

1915
Born Robert Burns Motherwell III of Irish and Scottish heritage, 24 January, in Aberdeen, Washington.

1926–1932
After several moves, (the family) settles permanently in San Francisco. Receives fellowship to Otis Art Institute, Los Angeles. Spends year in San Francisco high school. Attends Moran Preparatory School, Atascadero, California. Summers (frequently, until 1940) at Westport, on the coast near Aberdeen.

1932–1937
Studies painting briefly at California School of Fine Arts, San Francisco. Attends Stanford University, Palo Alto, California. Travels with father and sister in Europe. Receives A.B. from Stanford.

1937
Enters Graduate School of Arts and Sciences (enrolling in Department of Philosophy), Harvard University, Cambridge, Massachusetts; urged by his professors to continue work on Delacroix for his degree.

1938–1939
Travels in Europe, mainly in France to work on Delacroix's *Journals*. Summer: attends University of Grenoble. Fall: takes studio in Paris (to following July); studies briefly at Académie Julien; begins painting; ex-

hibits at Raymond Duncan Gallery, Paris. Translates Paul Signac's *D'Eugène Delacroix au Neo-Impressionisme*. Stops briefly in England before returning to United States.

1939–1940
Teaches art, University of Oregon, Eugene.

1940
Fall: moves to New York City; enters Department of Art History and Archaeology, Columbia University; studies with Meyer Schapiro. Takes apartment at Rhinelander Gardens, West Eleventh Street, in Greenwich Village. Works in private classes and as studio assistant with surrealist artist Kurt Seligmann; (for several years remains closely affiliated with surrealists, many of whom he meets through Seligmann). Meets other exiled European artists.

1941
Early spring: introduced to Chilean-born surrealist painter Roberto Sebastian Antonio Matta Echaurren. Travels with Matta to Mexico; meets Mexican actress María Emilia Ferreira y Moyers aboard ship. Summer: makes first automatic drawings in Taxco. Fall: moves to Coyoacán near surrealist artist Wolfgang Paalen; works on translation of essay by Paalen for first issue of *DYN*. Returns to New York just before Second World War is declared; takes apartment on Perry Street, in Greenwich Village. Classified 4F by local draft board. Abandons academic studies; dedicates himself to painting. Writes to William Carlos Williams [★] about new surrealist magazine, *VVV*.

1942
Begins making notes for book intended for artists (never realized). Impressed by Mondrian's paintings on exhibit; writes "Notes on Mondrian and Chirico" [★] for *VVV*. For brief period works with André Breton and Max Ernst on *VVV*. Through Matta, meets American artists Joseph Cornell and William Baziotes; close friendship develops with Baziotes. Summer: first visit to Cape Cod, Massachusetts; marries María Ferreira y Moyers in Provincetown. Included in exhibition "First Papers of Surrealism," Whitelaw-Reid mansion, New York. Through Baziotes, introduced to several American artists; meets with some of them and Matta in discussions of art; experiments in automatic writing.

1943
At this time, is living on West Eighth Street, in Greenwich Village. Begins working at Atelier 17 making etchings and engravings. Spring: exhibits in "Spring Salon" at Art of This Century [ATC], New York. Exhibits first collages at ATC in international collage exhibit. Summer: Mexican trip aborted because of father's impending death; leaves for San Francisco; returns to New York; rents cottage in Hampton area (Long Island his summer and eventually year-round locale until end of decade). Writes "Painters' Objects" [★] for *Partisan Review*, published early following year.

1944
Invited by George Wittenborn and Heinz Schultz [W/S] to be editor of Documents of Modern Art [D.M.A.] (until 1951 produces first ten num-

bers in series). First museum purchase: *Pancho Villa, Dead and Alive* (Museum of Modern Art [MoMA], New York). Summer: in Amagansett, Long Island; meets and develops friendship with French architect Pierre Chareau; produces paintings for first U.S. solo exhibition at ATC (October–November). Presents "The Modern Painter's World" [*] at Mount Holyoke College, South Hadley, Massachusetts. Writes two book reviews for *New Republic,* one on Henry Moore and the other on book by Alexander Calder.

1945

Signs contract with Samuel Kootz Gallery, New York (exhibits there until 1955). Travels to Florida with Baziotes (to paint in *Mediterranean light*). Summer: teaches month-long session at Black Mountain College, Black Mountain, North Carolina. Receives commission to illustrate Marianne Moore's translation of La Fontaine's *Fables* (project canceled, but sketches remain). Meets Mark Rothko (friendship continues until Rothko's death in 1970); through Rothko, eventually meets Herbert Ferber, Adolph Gottlieb, Barnett Newman, and Bradley Walker Tomlin, artists who become his second milieu after Baziotes and the surrealists.

1946

Writes "Beyond the Aesthetic" [*] for *Deisgn.* Summer: in Hampton, Long Island, area. Shows several works in "Fourteen Americans" at MoMA; writes for exhibition catalog [*]. Construction on new studio under way. With Harold Rosenberg and others, work on magazine *possibilities* in progress. Winter: remains on Long Island.

1947

Exhibits with Kootz Gallery artists at Galerie Maeght, Paris; writes for catalog of Kootz Gallery exhibition of his work [*]. Spring: moves into Quonset house and studio, Jericho Lane, East Hampton, Long Island, designed for him by Chareau (lives there to fall of 1948 and briefly later). Signs Editorial Preface (with Rosenberg) to *possibilities* [*], published by W/S that winter.

1948

Summer: visited by Rothko and Clyfford Still on Long Island; discuss new art school. Writes introductions to books on Max Ernst [*] and Hans Arp [*] in D.M.A. series. Makes drawing that later inspires *Elegy* paintings. Fall: leaves East Hampton for New York; lives at 323 Fourteenth Street. Founds school, Subjects of the Artist, with Baziotes, David Hare, and Rothko; joined later by Newman. Writes "A Tour of the Sublime" [*] for *Tiger's Eye.*

1949

Introduces several artists to lectures at Subjects of the Artist on Friday evenings. Writes introductions to books by Daniel-Henry Kahnweiler [*] and Guillaume Apollinaire [*] in D.M.A. series. Presents "A Personal Expression" [*] in New York; (eventually gives other lectures in MoMA's educational programs). May: Subjects of the Artist closes. Summer: boards with Dr. William Helmuth family in East Hampton, Long Island. Presents "Reflections on Painting Now" [*] in Forum 49 in Provincetown. Fall: in Nevada; obtains divorce from María Ferreira y Moyers; meets Betty Little; writes introduction to book by Marcel Ray-

mond [*] in D.M.A. series. Boards with Chareau in New York. Takes studio/loft at 61 Fourth Avenue, in Greenwich Village; shares space for a while with Tomlin; opens Robert Motherwell School of Fine Art.

1950

Writes "Black or White" [*] for Kootz Gallery exhibition catalog. Meets David Smith soon after he writes catalog preface for the sculptor's Willard Gallery exhibition (the two remain close friends until Smith's death in 1965). Moderates closed session of Studio 35. Signs protest letter with other "Irascibles" to Metropolitan Museum of Art, New York. Marries Betty Little on Long Island. Summer: in Quonset house and studio, East Hampton. Writes introduction to book by Georges Duthuit [*] in D.M.A. series. Fall: rents house in East Islip, Long Island (through spring of following year). Fall: attends first of several College Art Association [CAA] meetings; presents "The New York School" [*]. Dismissed by W/S from position on D.M.A.

1951

Writes preface to Perls Gallery, Los Angeles, exhibition catalog [*]. Receives first mural commission. Begins teaching at Hunter College, City University of New York (active there until 1959). Presents "What Abstract Art Means to Me" [*] at symposium at MoMA. Presents "The Rise and Continuity of Abstract Art" [*] at seminar at Harvard University. Completes and signs introduction to *The Dada Painters and Poets* in East Islip. Moves to New York; takes apartment at 122 East Eighty-second Street. Completes and signs preface to *The Dada Painters and Poets* [*]. Summer: second one-month teaching residency at Black Mountain College. *Modern Artists in America* [*] published by W/S. Introduces Max Ernst at the Artists' Club. Lectures at Philadelphia Museum of Art.

1952

Lectures at CAA, New York, and at Washington University, St. Louis; gives graduate seminar at Oberlin College, Oberlin, Ohio; participates in panel discussion in Woodstock, New York.

1953

Daughter Jeannie born. Purchases brownstone house, 173 East Ninety-fourth Street, New York (lives there for next seventeen years). Writes on Joseph Cornell. Designs tapestry for Springfield, Massachusetts, synagogue.

1954

Presents "Symbolism" [*], public lecture at Hunter College. Writes "The Painter and the Audience" [*] for *Perspectives USA*. Summer: teaches at Colorado Springs Fine Arts Center; meets artist Emerson Woelffer. Guest of Federal Republic of Germany in exchange program.

1955

Included in exhibition "The New Decade: Thirty-five American Painters and Sculptors," Whitney Museum of American Art, New York; writes "A Painting Must Make Human Contact" [*] for catalog. Daughter Lise born. Included in MoMA's exhibition "Modern Art in the United States" (exhibition tours European cities).

1956

Summer: in Provincetown (returns there for most summers for remainder of his life; in general highly productive painting periods). Addresses convocation at Trinity College, Hartford, Connecticut.

1957

Separated and divorced from Betty Little. Writes on Tomlin [*]. Sidney Janis Gallery, New York, becomes exclusive dealer (exhibits there regularly until 1962). Buys summer house in Provincetown. Meets Helen Frankenthaler.

1958

Spring: marries Frankenthaler. Takes sabbatical leave from Hunter College. Summer: travels and paints in Spain and mainly in Saint-Jean-de-Luz, France. Included in MoMA's "The New American Painting" (exhibition tours European cities).

1959

Writes "The Significance of Miró" [*] for *Art News*. Summer: in Falmouth, Massachusetts. First retrospective exhibition, Bennington College, Bennington, Vermont. Fall: delivers paper [*] at Association for the Advancement of Psychoanalysis, New York. Resigns from Hunter College.

1960

Summer: paints in Alassio, Italy. Interviewed for BBC by David Sylvester. Participates in panel discussions at Philadelphia Museum School of Art and at New York University.

1961

Travels to London and Paris. Summer: in Provincetown; rents studio at Days Lumberyard (also for the following summer.) Retrospective exhibition in São Paulo, Brazil. Rents former pool hall at Eighty-sixth Street and Third Avenue as studio. Writes "What Should a Museum Be?" [*] for *Art in America*. Signs statement (with others) "In Support of French Intellectuals," in reaction to Algerian war.

1962

Lectures and conducts workshops at Emily Lowe Art Gallery, Coral Gables, Florida. Travels to Pasadena, California, for lecture in conjunction with retrospective exhibition. Summer: in Provincetown; rents studio at Days Lumberyard; begins negotiations for purchase of house at 631 Commercial Street, which he eventually buys, renovates, and refers to as Sea Barn (lives and paints there for remaining summers of his life). Attends funeral for Franz Kline in New York; writes "Homage to Franz Kline" [*]. Appointed visiting critic at University of Pennsylvania, Philadelphia. Visits Smith College, Northampton, Massachusetts, regarding exhibition following spring; conversation at lunch recorded [*].

1963

Becomes art consultant for *Partisan Review*. Forced to leave studio on Eighty-sixth Street; takes Rothko's studio on Third Avenue in East Seventies. Travels to Smith College for exhibition opening and lecture. Included with fourteen other contemporary painters in CBS television broadcast. Joins Marlborough-Gerson Gallery, New York and Rome (remains affiliated through 1972). Summer: in Provincetown. Fall: presents

"A Process of Painting" [★] at symposim sponsored by American Academy of Psychotherapists, New York. Travels to Paris, Venice, and London.

1964

Winter: spends two weeks in Caribbean (for next several years he and Frankenthaler take brief vacations during winter into warmer regions). Travels to London for Frankenthaler exhibition opening; visits Henry Moore; travels in France: Sainte-Maxime-sur-Mer, Saint-Tropez, Nice, and Paris. Summer: in Provincetown. Visits David Smith at Bolton Landing, New York, with family; Smith spends time in Provincetown (with future summer visiting exchanges). Travels to Washington, D.C., to discuss Phillips Gallery exhibition for following year. Invited as visiting critic, Columbia University's Graduate Program in the Arts (through 1965). During course of year lectures in Baltimore; participates in seminars at New York University and in Detroit. Subject of filmed interview by Bryan Robertson for WNET (public television).

1965

Considerable time during year spent on upcoming retrospective exhibition at MoMA. Interviewed by Robertson in addenda to previous interview [★]. Writes on David Smith. Makes *Lyric Suite* drawings inspired by music of Alban Berg. Smith dies in driving accident. Summer: makes "grand tour" of Europe with family (Frankenthaler and his two daughters): travels to Paris and Venice; sails to Trieste; to Rijeka, Split, and Dubrovnik; and to Athens and the Greek islands. Major retrospective at MoMA, curated by Frank O'Hara; writes letter to O'Hara [★] published in catalog. Signs several protests organized by the artistic and intellectual community against Vietnam War. During course of year lectures at several academic institutions, including Yale University, New Haven, Connecticut; Bennington College; and Harvard University. Participates in panel discussions at MoMA and at Solomon R. Guggenheim Museum, New York. Appointed a director, CAA; appointed educational advisor, John Simon Guggenheim Foundation, New York (with reappointments into the mid-1980s).

1966

Travels to France and then to Venice for opening of Biennale (his work and Frankenthaler's, with a few others, representing United States); travels to Bologna, Ferrara, San Remo, and Saint-Tropez. Late summer: in Provincetown. Executes mural commission for John F. Kennedy Federal Office Building, Boston.

1967

Interviewed by art historian Sidney Simon [★]. Travels to Washington, D.C., for symposium sponsored by the Smithsonian Institution. Summer: in Provincetown. Commissioned by MoMA to illustrate deluxe edition of Rimbaud's poems (project not realized). Rents studio at 414 East Seventy-fifth Street, New York. Contributes drawing to MoMA's book honoring recently deceased O'Hara. During year, lectures at University of Bridgeport, Bridgeport, Connecticut (appointed Albert Dorne Professor of Drawing at university preceding year); Carpenter Center, Harvard University; and Yale University Summer School, Norfolk, Connecticut. Also lectures and holds seminars at Bennington College.

1968

Elected advisory editor of the *American Scholar*. Becomes general editor of Documents of 20th-Century Art (Viking Press) (beginning this year and for some time after meets frequently with Arthur Cohen, managing editor, and with publisher to produce sixteen titles through 1980). Appointed adviser to the Bliss International Study Center, MoMA (beginning of series of appointments over the years to art-related organizations). 24 April–4 May: in Mexico for opening of retrospective exhibition; vacations in Acapulco. Summer: in Provincetown; Rothko rents nearby. Donates works to campaigns against Vietnam War. Lectures and participates in seminars at several institutions throughout year, including Chicago Art Institute; Southern Massachusetts Technological Institute, North Dartmouth; and Fine Arts Work Center [FAWC], Provincetown.

1969

January–February: revises translation of Marcel Duchamp book for Documents of 20th-Century Art aboard *Raffello* in Caribbean. March: views his exhibition at Virginia Museum of Fine Arts, Richmond; judges regional exhibition in Richmond. Appointed special adviser, National Council on the Arts, Washington, D.C. Lectures at Bard College, Annandale-on-Hudson, New York. May: travels to Paris and then to London for opening of Frankenthaler exhibition. October: travels to Switzerland to participate in symposium celebrating Heidegger on his eightieth birthday. Finds country home in Connecticut. November: lectures in Toledo, Ohio. Writes Addenda to MoMA *Lyric Suite* Questionnaire [*]. Interviewed by Arthur Cohen. Executes work for International Rescue Committee.

1970

Gives up studio on Seventy-fifth Street; acquires carriage house at 909 North Street, Greenwich, Connecticut; begins renovations (addition of studios and alterations continue until his death). Delivers "On the Humanism of Abstraction" [*] at St. Paul's School, Concord, New Hampshire. February and March: works on print project in London. Rothko commits suicide. Appears before subcommittee of U.S. Congress, Washington, D.C. [*]. Presents "The Universal Language of Children's Art, and Modernism" [*] at Conference on International Exchange in the Arts, New York. Summer: in Provincetown; writes "Thoughts on Drawing" [*] for Drawing Society exhibition catalog. Travels to Toronto for gallery exhibition of his work. Protests Vietnam War by refusing to contribute to federally sponsored exhibition. Participates in Art Workers' Coalition at MoMA. Spends considerable time during year making prints at Universal Limited Art Editions, West Islip, Long Island. During course of year, participates in panel discussions and delivers lectures at various institutions, including Metropolitan Museum of Art; Yale University; Detroit Institute of Arts; Corcoran Gallery of Art, Washington, D.C.; High Museum, Atlanta; Art Gallery of Toronto; and University of Toronto. Writes eulogy for Rothko [*], delivered in January 1971 in New York.

1971

Spends time between New York and long weekends in Greenwich. Interviewed by John Gruen on David Smith [*] for book published in

1972. Begins sessions with Blackwood Productions for documentary film on him; shown in United States in 1972. May: moves permanently to Connecticut; divorced from Frankenthaler. With daughter Jeannie travels to London to sign prints; drives from Stuttgart to Saint Gall, Switzerland, for exhibition opening and printmaking sessions; travels in France to Annecy and Juan-les-Pins. First two volumes of Documents of 20th-Century Art series published; writes introduction to book on Duchamp [★]. Writes introduction to *The Journal of Eugène Delacroix*. Summer: in Provincetown. Fall: meets German-born photographer Renate Ponsold. During course of year, lectures and participates in seminars at a number of institutions, including FAWC; Yale University; College of the City of New York; Hunter College; and Joselyn Art Museum, Omaha, Nebraska. Appointed counselor, Smithsonian Institution. Appointed distinguished professor at Hunter College (1971–1972); delivers several public lectures there. Begins interviews for Archives of American Art (completed in 1974).

1972

Travels through France to Switzerland; makes prints at Saint Gall. Signs *A la pintura,* a *livre de peintre* based on poems by Rafael Alberti; writes "The Book's Beginning" [★], an account of its genesis. Filmed by BBC in Greenwich studio. Knoedler Contemporary Art, New York, London, and Zurich, becomes exclusive painting dealer (remains with gallery for remainder of his life). Visits dying mother in San Francisco. Donates work to Spanish Refugee Aid. Marries Renate Ponsold in Wellfleet, Massachusetts. Travels to London; Munster, Germany; and Saint Gall for print signing. During course of year, participates in seminars and delivers numerous lectures at institutions, including Princeton University, Princeton, New Jersey; Boston Museum of Fine Arts; Guggenheim Museum; Museum of Fine Arts, Houston; and Walker Art Center, Minneapolis. Appointed advisor on art, Columbia University. Documentary film on *A la pintura* produced by Blackwood Productions; also included in film for New Yorker Films with thirteen other New York artists.

1973

March: works at Gemini Workshop, Los Angeles (returns there to complete work in fall). Installs etching press (lithography press added later) in Greenwich studio and continues to make prints there for the next eighteen years. June–July: is hospitalized. Remainder of summer: in Provincetown. During course of year, delivers lectures and participates in panel discussions at institutions, including Institute of Fine Arts, New York; CAA conference, New York; Los Angeles County Museum of Art; Wadsworth Atheneum, Hartford, Connecticut; and Yale University. First of numerous honorary degrees conferred on him by academic institutions over the next several years. Included in Blackwood Productions documentary film on the New York School.

1974

February–June: conducts seminar at State University of New York, Purchase; participates in panel discussions at Massachusetts Institute of Technology, Cambridge, Massachusetts, and at National Institute of Arts and Letters, New York; and lectures at University of South Carolina, Columbia. Interviewed by Otis Art Institute for catalog [★] of exhibition

later in year. June: emergency hospitalization. Summer: in Provincetown. September–October: at Mt. Sinai Hospital, New York, undergoes major surgery requiring several operations (remains on heart drug therapy and monitoring for remainder of life). Publisher George Wittenborn dies. Contributes to "Chile Emergency Exhibition." Participates in print panel discussion at MoMA.

1975

Retrospective opens at Museum of Modern Art, Mexico City. Receives three painting commissions, including one to be adapted for Mouton-Rothschild wine-bottle label. Spends considerable time during year with others working on his monograph, published by Abrams in 1977. During course of year, lectures at University of Bridgeport; New School for Social Research, New York; Baltimore Museum of Art; and Yale University; and participates in panel discussion at Bard College. Travels to Washington State College, Pullman, for symposium on prints and lecture. Subject of lengthy videotaping for Albright-Knox Gallery, Buffalo, New York.

1976

February: in Key West; conducts seminars and delivers lecture at Florida International University, Miami. Travels to Texas for gallery opening of his work. Summer: in Provincetown. September: travels to Düsseldorf via London for opening of retrospective exhibition; travels to Paris. November: travels to Stockholm for opening of retrospective exhibition. Begins studies for mural commissioned by National Gallery of Art, Washington, D.C. During course of year, lectures at Carnegie Institute, Pittsburgh; Swarthmore College, Swarthmore, Pennsylvania; FAWC; and Chicago Art Institute; participates in print panel discussion at Rhode Island School of Design, Providence; and is subject of filmed interview by Robert Hughes for BBC.

1977

March: travels to Vienna for opening of retrospective exhibition. June: travels to Paris for opening of retrospective exhibition; participates in symposium. Subject of French National Television documentary. October: travels to Edinburgh for retrospective exhibition at Royal Scottish Academy. Appointed visiting artist, Harvard University (through 1978). During course of year, speaks at Graphic Arts Council of New York; publicly interviewed and videotaped at New School for Social Research.

1978

Travels to London for retrospective exhibition at Royal Academy of Arts; conducts seminar; visits Henry Moore sculpture studios. Travels to Paris to receive medal (first of several honors from foreign governments). Completes mural for National Gallery. Delivers talk at Harvard University; participates in seminar at Tufts University, Medford, Massachusetts. Summer: in Provincetown; filmed by French television; writes "Provincetown and Days Lumberyard: A Memoir" [*], on experiences in Provincetown. Participates in panel discussion on Matisse at MoMA.

1979

Retrospective exhibition, University of Connecticut, Storrs; lectures to public and to students [*]. Delivers commencement address, Boston Mu-

seum School. Writes "The International World of Modernist Art: 1945–1960" [★] for *Art Journal,* published in 1980. Travels to Cologne, Germany, for gallery exhibition opening. Appears in documentary for WETA (public television) in conjunction with opening of East Building of National Gallery of Art, where his mural is installed. During course of year, delivers award speeches for Erick Hawkins and I. M. Pei.

1980

Delivers commencement address, Rhode Island School of Design. Lectures to print collectors at MoMA. Travels to Spain for retrospective exhibitions in Barcelona and Madrid; subject of CBS television documentary film on Madrid show. Summer: in Provincetown; addresses James Joyce symposium. Retrospective exhibition of prints opens at MoMA (exhibition travels throughout United States). Documents of 20th-Century Art moves to G. K. Hall in Boston (as series editors, he and Jack D. Flam produce several titles during next ten years, including second edition of *The Dada Painters and Poets*).

1981

Delivers "In Memoriam: Anthony Smith" [★] in New York. Appointed visiting professor of art (1981–1982) and participates in colloquium and seminar at Brown University, Providence, Rhode Island.

1982

Second edition of monograph published by Abrams. Rewrites foreword to book by William Seitz [★]. Delivers "Remarks" [★] at Yale University Art Gallery's 150th Anniversary. Travels to Munich for lecture and inauguration of Motherwell Gallery, Bavarian State Museum of Modern Art. Interviewed by Robert Enright for Canadian radio.

1983

Awarded honor from Pennsylvania Academy, Philadelphia (during next several years is recipient of numerous honorary doctorates and other awards, most requiring an acceptance speech). Travels to view installation and again to opening of retrospective exhibition at Albright-Knox Art Gallery (exhibition travels throughout United States). Presents "Kafka's Visual Recoil: A Note" [★] at Cooper Union, New York. Delivers the eulogy "A Collage for Nathan Halper in Nine Parts" [★] in Provincetown. Completes work on *El Negro,* a *livre d'artiste* based on poem by Rafael Alberti. During year, addresses the National Arts Club, New York, and lectures at Yale University.

1984

Summer: in Provincetown. Travels to Walker Art Institute, Minneapolis, for exhibition opening and public dialogue. Retrospective exhibition opens at Guggenheim Museum; is subject of *New York Times Magazine* article. Writes "Animating Rhythm" [★], a brief piece on Jackson Pollock, for *Art and Antiques.*

1985

Presented by Ponsold with *Festschrift* for seventieth birthday, with contributions by writers, painters, and friends. Travels to Paris and then to Madrid for artists' reception given by King Juan Carlos of Spain. Summer: in Provincetown; Fritz Bultman dies. Over course of year, lectures (many related to awards) at various institutions, including Ninety-second

Street YMHA, New York; Brown University; New School for Social Research; Hunter College; and MacDowell Colony, Peterborough, New Hampshire.

1986
Presents "On Not Becoming an Academic" [★] at panel discussion at Harvard University. Participates in symposium at Spanish Institute, New York. Recipient of gold medal (accepted by Ponsold in Madrid) from Juan Carlos. General health begins to decline.

1987
Participates in panel discussion, "Aspects of Modernism," at Boston Athenaeum. Talks at Century Club, New York. Inducted into American Academy of Arts and Letters, New York. Begins work on documentary film for PBS with Catherine Tatge of International Cultural Programming. Participates in discussion with Arthur Danto at Aldrich Museum, Ridgefield, Connecticut. Introduces Octavio Paz [★] at Ninety-second Street YMHA.

1988
Schedules of physical therapy, which were intermittent in previous years, now become routine. Completes *livre d'artiste* based on three poems by Octavio Paz. Summer: in Provincetown; interviewed on tape by David Hayman [★] on James Joyce; ongoing work on Tatge film; speaks at FAWC. Completes and signs *Ulysses,* a *livre d'artiste* of the novel by Joyce. Participates in dialogue with Dore Ashton at Cooper Union on Joyce's *Ulysses,* comparing art and literature.

1989
Speaks at Norman Zinberg memorial service, Cambridge, Massachusetts. Participates in dialogue with Jack Flam at Guggenheim Museum. Travels to Washington, D.C., for presidential award. French documentary television film broadcast. Summer: in Provincetown; speaks at celebration of Stanley Kunitz's eighty-fourth birthday. Delivers thoughts on the artist in "Rothko Symposium" at Yale University. Waddington Graphics, London (having become his print dealer), publishes catalog including the illustrated books *Ulysses* and *Octavio Paz Suite* as well as the suite of prints inspired by poetry of T. S. Eliot, *The Hollow Men.*

1990
[Handwriting in diaries has become feeble.] Physical therapy continues along with more drug therapy for additional medical problems. Enters Greenwich Hospital after suffering stroke. Recuperates and enjoys an intense period of painting into 1991.

1991
Tatge film broadcast on public television. Summer: in Provincetown; dies 16 July. Retrospective exhibition shown in Mexico City and in Fort Worth.

The Collected Writings of Robert Motherwell

INTRODUCTION

I hung Baziotes's show with him at Peggy's in 1944. After it was up and we had stood in silence looking at it for a while, I noticed he had turned white. When he was anxiety-ridden, a white mucous would form around his lips—his throat must have become very dry with the emotion. Suddenly, he looked at me and said, "You're the one I trust; if you tell me the show is no good, I'll take it right down and cancel it." At that moment I had no idea whether it was good or not—it seemed so far out; but I reassured him that it was—there was nothing else I could do . . . You see, at the opposite side of the coin of the abstract expressionists' ambition and of our not giving a damn, was also not knowing whether our pictures were even pictures, let alone whether they were any good . . .

It was an extraordinary convergence of elements and events that led Robert Motherwell to his life's work. What he achieved in his painting—and, consequently, in his writing, editing, lecturing, and teaching—was lastingly fired by a decision that was as much the result of circumstance and chance as of talent and choice. Why he soon after also chose to write and otherwise express himself publicly—or, more accurately, why he acceded to a role thrust on him—is bound up with that moment when he accepted his destiny as a painter. Focus on this single frame from his early artistic biography affords a better understanding of the character and spirit of his pictorial imagination—and thereby the attendant and integral component of his literary work.

It is not idle supposition to think that if Motherwell had not followed through on advice (confirming his own intimation) to leave the West Coast for New York in 1940, his life would have taken a dramatically different course. He would have become another kind of painter—if, indeed, he had become a painter at all. Accordingly, he might never have written or spoken on the subject of art. Such conjecture takes into

account his early and enduring love of art, which began as a preference for drawing over other activities and won him a scholarship to the Otis Art Institute when he was eleven years old. It embraces his intense interest in aesthetics, the creative process, and modern art and literature while he was an undergraduate student at Stanford University and a graduate student at Harvard. And it acknowledges the first tentative paintings he exhibited at the Raymond Duncan Gallery in Paris in 1939. Nevertheless, the decided artistic bent of his formative years, while expressed through considerable talent and a keen intellect, was to remain peripheral—until it and related disciplines were brought to focus, coherently and pertinently. Then—without diminishing the anguish of periods of depression and doubt—there was no stopping the creative flow.

At some point before the end of 1941, when he was twenty-seven years old, Motherwell chose not to resume his academic studies at Columbia University, where he had enrolled the preceding fall, but to commit himself totally to painting. He made the decision, or, one might say, he accepted his calling, eschewing the worldly success that his family had expected of him. For a young man who was responsible and serious by nature, this could not have been easy. He would have to forgo the advantages of his upper-middle-class upbringing and the significant investment of his family's money and his own time in an academic education aimed toward a traditional career. Throw in the economic and emotional instability of the lingering Depression—remembering the meager existence an artist was destined to suffer at any time—and one must look to a deep-felt reason for this life-altering choice.

Motherwell's decision to be a painter coincided with his meeting Roberto Matta and his introduction by the Chilean-born surrealist to the process of psychic automatism, and there can be no doubt that this surrealist technique for inciting the imagination was the catalyst for many influences converging to strengthen the young man's resolve. Still, it is the bare fact of the decision itself (confirmed by a lifelong constancy to it) which reveals that in the act of painting Motherwell had tapped something deeper, truer, and more compelling than anything he had previously known. In existential terms, one could say that through his newly found medium, he had realized himself at the center of his own being, indivisible in purpose.

When Motherwell arrived in New York City in the fall of 1940, he had come equipped with a sense of history and culture, an optimism, and a critical acuity honed by philosophical argument. This humanistic dimension and his verbal skills at first alienated him from Depression-sobered American artists, many of them suspicious of qualities they perceived as extra-artistic. As much a foreigner to Greenwich Village Bohemia as were the émigré artists escaping the war then raging in Europe, he was by luck introduced to and embraced by the gregarious,

highly cultivated, iconoclastic surrealists, who confirmed many of his own broad cultural inclinations. Prizing the state of youth among their hierarchies, this close-knit group of displaced artists and writers, most of them at least a generation older than he was, welcomed the young American as their guide into daily matters of New York City life and into their many artistic enterprises. Eventfully, he soon became fast friends with their shining star and heir apparent, Matta, who electrified his imagination with new ideas about painting.

Unencumbered by the baggage of studio training and predisposed to philosophical concepts of abstraction, Motherwell was spiritually free to accept Matta's teaching. He began painting not from objects in the physical world, but—accepting psychic automatism as the point of departure for his work—from an unexplored state of being. As he came to objectify his personal experience and develop a theory of painting, he recognized the technique of free association as more than a tool for the surrealist sensibility: it was a way in which modern art (already an intense love and primary focus) could be broadened without betraying its base. Not a mere style or an aesthetic, here was a philosophically and psychologically valid means by which the artist could be wholly individual. Much as Jung had built himself a tower of stone, an actual edifice by which he could safely lower himself into the abyss of the unconscious, so could the modern artist, through the means of psychic automatism and with his medium as physical touchstone, plumb the core of the individual psyche. There, where Jung had discovered the collective unconscious, the artist would find universal archetypes—fresh, raw, and irreverent. It was up to Motherwell to translate Matta's po-etically expressed ideas into a cogent artistic theory that plastically ex-tended psychic automatism beyond the limits of the surrealists' more literary application. And it was just this message that he brought to other American painters when he was soon introduced into that milieu by the artist William Baziotes.

In the new art American artists began to develop in the early 1940s, the aspect that most exhilarated Motherwell was its freedom from dogma and the burdensome past. Above all, it was its *sense of nowness, of each moment focused and real, outside the reach of the past and the future, an immersion in nowness.* Paradoxically, it was exactly the freedom to work outside tradition, without known criteria, that produced the anxiety he and other avant-garde artists were to suffer. On the one hand, anxiety vitalized their art; on the other, it could (and eventually would) destroy some of them personally. To be sure, uncertainty was a given component of the original artist's struggle. One had only to imagine Picasso's and Braque's doubts during their hermetic experiments of 1908 to 1914. Now, the exploration had an even more subjective dimension. Each day, in order to create this art, art itself had to be rejected. The product was as unexpected and as strange to the maker as it was to be

for the viewer. No matter how convinced the artist was of his inspiration, he could never be certain that what he had made was ultimately vivid enough to equal the complexity and radiance of great art of the past.

In general, Motherwell's writing, editing, and lecturing became a way for him to share his insights about modern art with a public he recognized as alienated not only from art but from its own spiritual base. The simple imperative of his writing, however, particularly that of the early 1940s to the mid-1950s, arose from a need to intellectually test and reconcile *firstly for himself* an art that had violently broken with the past—an utterly subjective and individual art he had intuitively trusted and banked his life on—with previous art in the modernist tradition.

To make any pattern out of it at all, let alone a faultless one, an uncontradictory one, or profound one—simply to have a viable working pattern is an extraordinary accomplishment when you see how ignorantly and innocently we all walk into this.

Along with imparting to Motherwell the theory of psychic automatism, Matta had been his artistic mentor and tipster, mapping out for him the terrain of modern art and pointing out dead ends and avenues of possibility. Matta showed him that with an informed overview or artistic cartography the artist could avoid repetition and lost time, test subjective responses, and recharge his creative energies. Solidly educated in the humanities, Motherwell knew the value of ideas in generating a vital intellectual climate, a spirit by which to capture and support the imagination—the starting point of any creative endeavor. After all, in a relevant example for him, was it not the French symbolist poets who created the atmosphere in which cubism had been born? To him, however, whatever it offered in opportunity, American culture was fundamentally provincial. It was as indifferent to native artistic pursuits as it was hostile to much of modern art. If knowledge of the essential thoughts and achievements of one's time was critical to the artistic enterprise, the artist had to look to where the authentic and enduring expressions of the modern sensibility had had their origins at the beginning of the century. He would have to look to Europe—notably, France.

Through his early introduction to French painting and literature, Motherwell had been captured by the spirit of modernism, an expression of reality with which he passionately identified. For him, modernism was the culture of modern industrial civilization—one without precedent in character. He was determined to investigate it, learn it, and, if possible, add to it. Because Cézanne, Matisse, Baudelaire, Gide, Proust, Valéry, and the French symbolist poets had been among his first (and lasting) attachments, he assumed for a time that modernism

was inherently and exclusively French. His notions about leaving New York for Paris faded as he came to realize that modernism was an international phenomenon—including within its ranks such voices as Joyce, Eliot, Lorca, and Rilke—and that the French contribution was only one glorious manifestation of a more general reflection of contemporary reality. Also, several seemingly modest yet ultimately far-reaching developments, some involving him directly in their dynamics, may have persuaded him that a vital cultural climate could exist in his own back yard.

Beginning in 1943, Motherwell and other American avant-garde artists were given solo exhibits in New York City at Peggy Guggenheim's cosmopolitan museum/gallery, Art of This Century, their work shown in tandem with her first-rate collection of modern European painting. A year after Motherwell's own exhibit there in 1944, he began an affiliation with a new gallery directed by Samuel Kootz, who aggressively promoted the work of young American modern artists, eventually exhibiting it alongside modern European art. While Motherwell's dedication to modernism remained unshakable throughout his life, his early thoughts of expatriatism subsided in direct proportion to these signals of a potentially enlightened artistic climate. It was one he himself was to be instrumental in fostering, not only with his painting, but through his writing, lecturing, teaching, and, particularly, editing.

The struggle of each new generation of "modern" painters is to make the "modern" world felt, to capture the youngest generation, who are humanity's hope. This struggle takes place, especially where English is spoken, in a culture dominated by words.

In the next fortuitous encounter of his early New York experience, Motherwell was invited by booksellers George Wittenborn and Heinz Schultz to take part in a new publishing venture. The pioneering, decade-long project was the systematic publication of writings by outstanding figures in modern art and literature, most never before translated into English. As a young artist, recent student, avid reader, and inveterate bookstore browser, Motherwell appeared typical to Wittenborn and Schultz of the audience they hoped to reach with their books. Probably late in 1943, when he was not yet thirty years old, Motherwell was appointed to direct and edit the series that came to be called The Documents of Modern Art.

With freedom to choose those subjects that most interested him, Motherwell could fulfill his immediate editorial mission simply by sharing his insights and enthusiasms. On this personal level, he approached the work as a kind of hobby. He viewed the project as a programmed self-education into modern art, with opportunity to supply missing territory on its map—a natural resolution of his broader cultural interests—and as a repayment of the debt he felt he owed the

surrealists for their generosity to him. Extrapolating from his own experience, he knew that American painters—the majority of whom were monolingual—were getting information about the ideas and theoretical premises of modern art from secondary sources, primarily from journalists, who tended to distort or misinterpret it. An example of such misunderstanding for him was the work of the modern artist Piet Mondrian, which was erroneously being viewed by Americans through the ideology of Russian constructivism. Except for a handful of artist-devotees who had come under Mondrian's influence in the 1930s, the original ideas from which Mondrian's painting derived were generally unknown before 1945, the year in which *Plastic Art and Pure Plastic Art* was presented in the Documents series.

Whatever Motherwell's personal preferences, however, it was his scholastic objectivity that gave the series its enduring value. With discernment, he chose titles representing less his own taste than what he accepted as *authentic expressions within the modern tradition.* He exercised this distinction most notably with the writings of Max Ernst; although feeling little personal affinity with Ernst's painting, he produced *Max Ernst: Beyond Painting and Other Writings by the Artist and His Friends* in 1948, thereby acknowledging the German-born surrealist artist's important role in the development of modernism.

Among the publications Motherwell used as models for his project were the Everyman Library and the Harvard Classics, series whose titles had been selected for their lasting value. (Writings deemed more timely or ephemeral were published by Wittenborn and Schultz in the series Problems of Contemporary Art for which Motherwell also served as director and editor.) The Documents of Modern Art were aimed mainly at young artists and students not only in the United States, but in all the English-speaking countries to which the publishers periodically mailed their fliers. Notes, prefaces, and, beginning in the late 1940s, definitive bibliographies by Bernard Karpel were provided for each title in the series. The paperback format—still a novelty at the time—allowed the books to be priced as inexpensively as possible. The use of the term *documents* underscored the first-hand nature of the material—*writings restricted to artists or their friends and associates;* the designation *modern* referred to *international art,* which expressed *the insights and aspiration of cultivated men everywhere* and was *our most advanced expression.* The philosophy and aims of the series were succinctly presented by Motherwell on the back cover of the first title in the series (Appendix A); adherence to this credo (with only minor periodic modifications in its wording) remained surprisingly constant throughout the years.

It must be underscored that translated texts on art were rare when the series began in 1944. Even six years later, when Georges Duthuit's *The Fauvist Painters* appeared, it was (amazingly!) the only book in English devoted to this major twentieth-century art movement—then

already over forty years old. The impact of the series was considerable and long-lived, although initially underground. Throughout the decade, inquiries for particular titles or for the entire series arrived at Wittenborn's with some frequency—many coming from artists (one such, for example, in June 1946 from Ben Nicholson in England, asking about future titles).

For the first volume, Guillaume Apollinaire's *The Cubist Painters: Aesthetic Meditations 1913,* and for the next ten titles, Motherwell served as director of the project, selecting and editing many of the texts, scrutinizing the translations, and writing prefaces, introductions, or preliminary (or prefatory) notes for most. (Nearly all these writings are included in this volume.) His last publication for the original series, issued in 1951, was *The Dada Painters and Poets,* an anthology he compiled and edited, and for which he wrote the comprehensive preface and introduction. The Documents of 20th-Century Art, a second series of publications with intentions similar to those of the first but under other imprints, began in the early 1970s. It continued under Motherwell's direction until his death in 1991, with more than three dozen titles having appeared in the combined series to that date.

Yet I do not regret my innocence in supposing that an artist might be something of a scholar and a gentleman.

Motherwell had begun making notes for a book on art soon after his return from Mexico in late 1941. Intended to help the young artist avoid the dead ends and unproductive avenues of inquiry he felt had wasted his own time, he planned that his writing would lead the reader directly to the modern aesthetic (Matta's teaching had left its mark). His first essay, "Notes on Mondrian and Chirico," followed by "Painters' Objects," both of which were inspired by exhibitions, were initially planned as documentary segments for this book. Although the project was never realized, Motherwell's ambition was more effectively and meaningfully transformed into his work on the Documents series. There he could bring his reader to the immediate source and, better yet, do it with little narrative intervention. In accord with Mallarmé's pronouncement that the intention of a work of art is to represent not the thing but the effect of the thing, the artist's ideas would now speak for themselves. With the exception of desultory, fragmentary pieces, essentially personal notations of recurring thoughts made concrete, Motherwell's need to write voluntarily on art never again surfaced.

Motherwell's piece on Mondrian, however, had been more than just a review. It was also the base on which his own theory of abstract art was to build. In evaluating the Dutch artist's work for his first published writing, he abruptly and against his will experienced an about

face, from an initial disappointment with the paintings into what became a lifelong admiration for Mondrian's total achievement. Not only did the work feed directly into his repertoire of images and have a significant influence on his painting, but in Mondrian's essays he found a true philosophical mind formulating ideas that would begin to shape his own artistic thinking and reappear in his own writings for decades.

With his second essay, "Painters' Objects," Motherwell introduced the next element in his developing theory—surrealism's psychic automatism. In subsequent essays and in lectures he gave throughout the 1940s, he was to explore the territory marked off by these *feminine and masculine extremes:* surrealism's liberating method of psychic automatism at the one limit, and its antidote, Mondrian's exacting theory of neo-plasticism, at the other. With Picasso, Matisse, and Miró as ever-present signposts, he had now completed the major configuration of his painting and theoretical hierarchy.

In "Painters' Objects," Motherwell elaborated on his ideas about abstraction, now the central issue of his theory and the major theme of his writings. For him, a nonobjective painting was fundamentally different from other works of art, from abstract art in general, in that it was itself an object in the world and did not simply replicate that world. Describing objects in art was tedious and dull; the artist had advanced too far for such an outmoded system. Nonobjective painting had made its essential point, but the self-imposed limits of internalized equations no longer seemed imperative. Modern reality now demanded an art with expressive content. The surrealists had extended the issue into the social sphere, calling for a revolution of consciousness, one that would free the imagination from the constraints of rational thought and allow the full expression of human nature and reality. In an alien and conventional milieu, however, their tactics appeared naive and their devices (apart from automatism) unworkable. Mondrian had posited abstraction as an absolute value. Plastic art was progressive, and abstraction was the language of modern man. Yet even Mondrian had shifted emphasis in his New York paintings and had *entered the world.*

In "The Modern Painter's World," a lecture delivered in the summer of 1944, Motherwell politically expanded the argument of abstraction and suggested that the artist's alienation from the great historic classes of society had already limited his art from full public expression. With what would the artist, as a spiritual agent in a property-loving world, identify himself, Motherwell had asked. The surrealists' position of social interaction was untenable when social values were so debased. The painter's only options were to turn to himself and either express his own personality or objectify his ego through formalism. Motherwell concluded that until there was a radical revolution in the values of society, a highly formal art would continue.

Soon after this, Motherwell spoke of symbolic transformation, a process involving relation, in which abstraction, contrary to the errors

made by many artists, was not an end in itself but was incidental to the process. It was necessary for painting to have a subject. A work of art, by definition, must be aesthetic, Motherwell acknowledged in his essay "Beyond the Aesthetic." Yet the sensuous aspect of a work of art was not its chief end; the medium was the means through which the infinite background of feeling was condensed and projected into an object of perception. As with the developments in his painting during the 1940s, where he had come to realize all the basic pictorial ideas on which he would elaborate for decades, so in this period would he put forth in his writings the main components of his theory of abstract art. Within these perimeters and by indirection rather than formulation of an ideology or a manifesto, he proceeded to identify the underlying premises of modern art and illuminate its continuing achievements. By extension, he was to define the art emerging within his own milieu.

It was not long after his first essays appeared that Motherwell's reputation as an intellectual, and as one of few artists who was able and willing to publicly articulate the nature of the new art, began to materialize. "In one capacity or another [his] influence . . . , as partisan analyst and spokesman and as editor of the documents published by Wittenborn and Schultz, was everywhere," William Seitz was to put it later in his brilliant thesis of 1955, "Abstract Expressionist Painting in America," which was published in 1983.[1]

First in literary circles, where Motherwell was asked to write for periodicals such as the *Partisan Review* and the *New Republic,* his coherent prose style could be understood even if the art it discussed was not. Requests for him to lecture followed—from museums, universities, and various art organizations, all searching for an explanation for the artistic phenomenon occurring around them. Unlike some of his artist peers, who, with awkward public personae generally treated their audience with contempt, Motherwell for the most part patiently tried to explain what he and others were doing. He knew that if the artist refused such an invitation, the vacuum would be filled by "professionals" who distorted historical fact. His background and education had engendered in him an acute sense of social responsibility. In one respect, this made it natural for him to extend himself publicly through writing, editing, teaching, and speaking; in another, since consent meant time away from his work, it plagued him with ambivalence. *What a disagreeable subject!* was how he would begin his essay "The Painter and the Audience."

By the early 1950s, when Motherwell's reputation prompted his appointment to the art department at Hunter College in New York City, he had become—partly by default—the primary artist-spokesman for "abstract expressionism," as the new art had come to be called. After this art gained some public understanding and, during the following decade, slowly tucked itself into history, events eventually released him from his role as explicator. Yet the requests for his writing and lectur-

ing (and for exhibitions of his work) continued and even intensified. Where once he had been at the center of the artistic avant-garde, he was now the venerable elder statesman of modern art. During the last decades of his life, he returned to earlier themes—the nature of abstraction, modernism, and (the subject that occupied him most) the creative process itself. He concentrated on explaining his work habits in the detail he felt only the artist could supply. Rather than looking outward for generalizations, he turned inward to concrete examples of how a work of art, *his work,* came into being.

I have written hundreds of thousands of words during my life, though I loathe the act of writing, its lack of physicality and sensuality . . .

Nearly everything Motherwell wrote was solicited. All his lectures were the result of invitations. His editing of books on modern art and literature had come about through an original request. In all these situations, he contributed his knowledge in the way in which he was uniquely suited. The consistency of his total literary and public effort rested more in his emphasis on certain underlying values than in the systematic progression of ideas; his commitment to the modernist aesthetic remained inviolable. His influence was as broad and general as his individual contributions were concrete and specific. His public role developed as the result of his devotion to modern painting; it was the consequence of the fortuitous and inexorable place in which he found himself in its development. As much by chance as by talent, he was projected centrally into the cultural events of his age—events that he, in turn, engaged and meaningfully shaped. Throughout history there have been a handful of artists who have occupied as crucial and as causal a position in their own time.

Although a superb writer, Motherwell often expressed his distaste for the act of writing. This is because his fundamental being resided in his pictorial imagination. If, in essence, his paintings can be described as soundings on his *voyage on unknown seas,* his writings could metaphorically be seen as the fragments he cast off along the way—the "throwaways" of his life's journey. This does not diminish the quality or the significance of his literary work, but should point up the nature and totality of his creative process and the hierarchy of its components. He has been labeled an "intellectual painter." This is an erroneous confusion of the disciplined, objective reflection on creativity and existence that underscored his writing with the somewhat primitively direct way in which he made a painting. It can be said of certain artists that their hearts rest with the works they struggled over most. For Motherwell, these works were his pictures. They were carved into existence. His writing, although he resisted it, spilled straight from a coherent and cultivated mind. It was, however, always produced at the service of

his painting. While he focused on the canvas, he wrote—as if with his left hand—some of the best and most persuasive texts we have about art. ■

Note

1. William C. Seitz, *Abstract Expressionist Painting in America* (Cambridge, Mass.: Harvard University Press, for the National Gallery of Art, 1983), p. 163.

ONE 1941–1949

Letter to William Carlos Williams 3 December 1941

Robert Motherwell was introduced to the surrealist technique of psychic automatism by Roberto Matta during the summer of 1941, when he and the Chilean artist were in Taxco. Motherwell's decision to give up his academic studies at Columbia University and devote himself fully to painting appears to have coincided with his first probings into automatic drawing, suggesting that the process had liberated in him something authentic and inspired. Most important to him (and to the genesis of abstract expressionism), the technique of automatism and its results were one, integral to the medium, expressing directly and concretely the imaginative impulse. Psychic automatism, to a greater or lesser degree, remained a consistent component of Motherwell's creative process until his death in July 1991.

Motherwell returned to New York City from his six-month stay in Mexico and began to paint in earnest. He resumed his friendships among the surrealist group, self-exiled in the United States during the Second World War and recently joined by two of its most illustrious figures, André Breton and Max Ernst. With Breton and Ernst, he soon found himself engaged in the earliest—however short-lived—of his editorial undertakings,[1] the first wholly surrealist magazine published since the demise of the Paris-based *Minotaure*.

Motherwell wrote to William Carlos Williams[2] before the appearance in June 1942 of the initial issue of *VVV*,[3] as the magazine was to be called. In his attempt to persuade the American poet to become a collaborator in the new venture, Motherwell, as one of the designated editors of the magazine-to-be, began by introducing himself, thus providing us with a useful biography to that date. With youthful enthusiasm, he then offered Williams his definition of surrealism, acknowl-

15

edging his own initial differences with surrealist philosophy, but declaring affinities with certain aspects of it. Documenting Motherwell's early commitment to the surrealist technique of psychic automatism as a basis for his painting, this letter also reveals, as do many of the artist's subsequent writings, a transcendence of personal experience toward the structuring of a more universal creative theory. ■

Dear Mr. Williams:

I would rather see you in person, but since that at the moment seems impossible, I must write you in behalf of the new surrealist venture, the magazine to be called " ."[4] I am writing you because, of the three editors already chosen, Breton, Calas,[5] and myself, I am the young American (as Calas is the young European); and perhaps, as an American, I can guess most accurately the kind of thing you must want to—and certainly are entitled to know. Moreover, the surrealist vocabulary demands a certain translation, a translation a European I think would find difficult to make—rather more on cultural than on linguistic grounds. It also happens that I had a hand in proposing you (though I do not know you), which is a further reason that I—rather than one of the others—should write you.

The proposal is that a neutral person, a business man, say, should appear as the editor, with an editorial board consisting of Breton and Calas (for European culture, youth, and maturity), and yourself and myself (for America). The staff would be completed by a managing editor for the details of business. The collaborators on the graphic side are Max Ernst, Tanguy, F. Léger, Kurt Seligmann, André Masson, Matta, Onslow-Ford, myself, and others; and the magazine is to be financed largely by one hundred subscriptions to an album of original works by these artists.[6] Ordinary subscriptions will probably be three dollars for four numbers. The proposal is for a collective, nonprofit journal.

The question of written material makes it necessary to say a word about myself; and the word is probably appropriate anyhow, as the unknown among the collaborators. I am a Californian who graduated from Stanford in philosophy (instrumentalism) in 1936; I worked a bit there with Yvor Winters, though he doubtless does not remember me. I then was in the graduate school of philosophy at Harvard; and the late D. W. Prall and Arthur O. Lovejoy of Johns Hopkins (who was at Harvard in 1937–8) sent me abroad to finish a book on Delacroix[7] which I had written. In Paris I took up again my first love, painting, and exhibited there in 1939.[8] At the beginning of the war I returned here to assist Prall at Harvard, but took a lectureship in painting at the University of Oregon instead because I wanted to look at rural America, and because the job offered me a transition from philosophy to painting as a profession. The contract was for one year, and when it

expired Prall was dead, and Harvard no longer interested me, and so I came to New York to study with Meyer Schapiro, and take my Ph.D. in archaeology instead. Through him I came into contact with the surrealists—against whom I had many philosophical prejudices—but they seemed to understand empirically the solution—or perhaps better, *a* solution to those problems of how to free the imagination in concrete terms, which are so baffling to an American. Until then, in short, I had been an observer, like a character in James, but with the advantage of having logical and plastic weapons with which to test my observations. Now I have taken a partisan stand, in the creative sense that the surrealist automatism is the basis of my painting, and in the theoretical sense that I find myself intellectually in accord with them. (The philosophical objections I once held against them no longer seem very relevant, nor a better epistemological statement of their position very important.)

Now it so happens that among our collaborators there are an extraordinary number of first-rate painters, and further, painting, like music, does not need much translation from one land to another. But literature, I think, does, and moreover the European writers who can collaborate are few. I have given my (rather inexpert) opinion that there is very little imaginative writing, in either poetry or prose, in this country: you and Stevens[9] are the only ones I know whom I can read. I do think, however, that there is a great deal of good philosophy, psychology, criticism, and science of interest to a magazine which takes as its function the stimulation of imagination and the preservation of the dignity and value of personal feelings; and I have taken as my natural task the finding of such material. Our hope has been that, if you are too busy to very actively collaborate, you could at least give us advice and rough orientation in regard to imaginative material in this country: you are in a position to know it well, and your judgment is obviously to be trusted. So the proposition is, roughly, that Breton and Calas handle the European end of the international collaboration, and you and I the American, with you representing poetry and prose, and I science and painting. Your collaboration can be extremely active, if you have the time, or, if not, limited to giving me occasional advice. The use of your name in any case is of such obvious aid to us that it needs no comment.

As for the meaning of surrealism—i.e., with *what* as opposed to with *whom* you are asked to collaborate—the question is not easy to answer, and I think must in part be answered by just who is collaborating. A short answer, as I understand the matter, would run like this: a. stimulation of the imagination—in the sense of enriching sensuous life by insisting on ignored aspects of reality, the invention of new objects of perception within reality, etc.; b. the preservation of the dignity and value of personal feelings—a response to the felt need (in a world increasingly able to deal with physical nature, and potentially, with so-

cial relations) of insisting that the only possible end of science and of a good society, the *felt-content* of the organism's experiencing, must not be annihilated or be held in contempt because it is not scientifically or sociologically useful. Hence the importance of the artist, etc.; c. revolutionism—not so much in the sense of dwelling on the material difficulties and means (though this is implied), but revolution in the sense of increased *consciousness,* of consciousness of the *possibilities* inherent in *experiencing.* Emphasis therefore is on novelty, invention, the disturbing, the strange—the power of feeling to move the organism; d. the dialectic—not so much in the Hegelian sense as constituting the metaphysical nature of reality, or in the Marxist sense as the economic nature of society, but in the sense of a weapon for interpreting and synthesizing reality, as when Breton asks for a union between normal consciousness and the unconscious. In the sense that these four propositions are meant, I find it difficult to suppose that any creative mind would find it easy to reject them. The concrete result of the "programme" will be, I think, a magazine with a plastic quality (in both the illustrative material and in the magazine itself being treated as an object of sensuous perception) and with a poetic quality (in dynamiting the imagination) unknown in this country. Magazines like the *Partisan Review,* the *Kenyon Review,* the *Southern Review,* and so on, seem to be rather fine critically (for all of their various limitations), but to me shockingly weak just where the surrealists are strongest.

This is the best I can do on such short notice: we are extremely anxious to communicate with you at once, and I too, am pressed for time. I should be more than pleased to talk over anything with you, and if your practice[10] is as demanding of your time as I suspect, I should be glad to spend a whole day waiting about, and talking between calls. Or whatever else is feasible. I can be reached by telephone via Matta.

Notes

1. Motherwell was released from his editorial duties by Breton when the founder of surrealism realized that the young artist did not have the requisite financial connections. Motherwell suggested Lionel Abel as a replacement for himself, and, indeed, Abel did work on the first issue (conversation with the artist, 25 January 1984). The editors listed on the final masthead for the first issue, however, were David Hare, André Breton, Max Ernst, and Marcel Duchamp.

2. According to Robert C. Hobbs, the letter was dated 3 December 1941, indicating that it was written shortly after Motherwell's return from Mexico ("Motherwell's Concern with Death in Painting: An Investigation of His Elegies to the Spanish Republic, Including an Examination of His Philosophical and Methodological Considerations" [Ph.D. diss., University of North Carolina, 1975], p. 53).

3. Commonly referred to as "Triple *V,*" the magazine's name was intended to fulfill one of the surrealists' fantasies—the addition of a twenty-seventh letter, *their* letter, to the alphabet. Breton, in naming his new magazine, had used the French *W* (double *V*) to create the new surrealist letter. Motherwell pointed out to Breton

that if indeed his intention were accurately translated into English—the language of the new publication—the pun should instead be on the *U*, from which the English *W* is derived; the magazine thus should be called "Triple *U*." The correction caused Breton some annoyance (conversation with the artist, 25 January 1984).

4. Motherwell eventually met with Williams to discuss the matter further. Although the poet did not join the editorial board of *VVV*, he did contribute a poem to the first issue.

5. Nicholas Calas, born and educated in Greece, had come to the United States in 1940.

6. Financially supported by Bernard Reis, a sponsor of the surrealists, a portfolio of prints was issued, to which Motherwell contributed fifty hand-drawn works rather than prints.

7. The notes that Motherwell wrote for the Delacroix book, as well as his translation of Paul Signac's *D'Eugène Delacroix au néo-impressionisme*, both accomplished while he was in Paris, were *torpedoed at sea in the early days of World War II*, according to the artist's introduction to *The Journal of Eugène Delacroix* (New York: Viking Press, 1972).

8. Motherwell showed about a dozen paintings at the Raymond Duncan Gallery in Paris.

9. Wallace Stevens.

10. William Carlos Williams (1883–1963) was also a pediatrician.

"Notes on Mondrian and Chirico" June 1942

The first evidence of the significant influence that Piet Mondrian was to have on Motherwell can be seen in paintings he made soon after his return from Mexico, most notably *Spanish Picture With Window* (1941). At the time, few works by Mondrian could be seen in the United States, and it is most likely that Motherwell had discovered those in the Gallatin Collection, then housed at New York University in Greenwich Village. Early in 1942, he saw the first two exhibitions in New York City of Mondrian's paintings: a solo show at the Valentine Gallery, and "Masters of Modern Art," works from Helena Rubenstein's collection, at the New Art Center. These exhibitions inspired this review, which Motherwell wrote for the inaugural issue of *VVV*.[1]

Motherwell was twenty-seven when he first wrote on Mondrian, and he had been painting full-time for less than a year. Having spent most of his life in academia, his natural approach to the subject reflected his scholarly training. Measuring Mondrian's results against the hypothesis he had presented in his essay "Pure Plastic Art," published for the "Masters of Modern Art" exhibition, Motherwell reluctantly concluded that Mondrian had failed on his own terms. Yet the paintings nagged at him, and he returned to them a second time. Ultimately, he suspended his analytic judgment to permit his felt response to emerge, his writing revealing an actual transformation in his sensibility.

A couple of years later, while Motherwell was editing Mondrian's *Plastic Art and Pure Plastic Art* for the Documents of Modern Art series,[2] the artist's total vision became clear to him. Now—with surre-

alism's psychic automatism at the subjective extreme; with Matisse, Picasso, and Miró as signposts; and with Mondrian in place—he had completed the major configuration of his painting hierarchy. Somewhat modified later by his own abstract expressionist colleagues, who tended to have begun with more or less the same heroes, it is one to which he would remain constant for the next forty-nine years. ■

1. The Art of Abstraction: Piet Mondrian*

It is not worth while suffering so much if he is not to go far.

Jean Hélion

The most exact, and at the same time comprehensive description of science's work is that it has consisted of the formulation of relations and abstract relational structures. In the most exact sense, therefore, Mondrian's work† can be called scientific, since it consists of just the formulation of color relations, and more important, spatial relations arising from a division of space. The scientific analogy is further confirmed by the fact that Mondrian clearly employs a hypothesis about the nature of reality, of which his work is an attempt at experimental confirmation. His hypothesis holds that it is possible to fulfill the artist's function, which is the expression of the felt quality of reality, with concrete color-spaces which contain no reference to the external world, either through representation or through the more condensed and ambiguous meanings of the image. After this preliminary statement, important things to say about Mondrian are these: 1. For many years he has indomitably and tenaciously maintained the freedom of the artist, both in permitting his work to be less subject to the pressures of the outside world than any other twentieth-century painter of comparable consequence, and in freeing every artist, if he liked, of any felt necessity for representation or the image. 2. Moreover, as Meyer Schapiro had remarked of modern art in general, Mondrian's work has the value of a *demonstration*.[3] He brought abstract art into being at a moment when its nature was the object of much speculation, based on the unsatisfactory data of trying to view representational art of the past abstractly. His work has the value, like that of the experimental scientist, *whether it is successful or not,* of showing us with permanent objectivity

*The following notes are excerpts from a work on the direction of modern painting which I have in preparation. They are by no means in the final form I intend, but since it may be some time before I can again set my hand to them, I am presenting them as they are, in the hope that they may be of interest to at least a few persons. My preoccupation with the *direction* of painting accounts for the particular emphasis the notes have: they are taken from an article which was originally meant to be a chronicle of the season's exhibitions, hence their reference to the recent exhibits of Mondrian and Chirico; and though they appear without the other reviews, which would have given them more points of reference and comparison, perhaps they are able to stand alone.[4]

†Valentine Gallery.

what lies in a certain direction. 3. But in seizing the laboratory freedom of the scientist, Mondrian has fallen into the natural trap—loss of contact with historical reality; or, more concretely, loss of the sense of the most insistent needs (and thus of the most insistent values) of a given time and place. He has spent his life in the creation of a clinical art in a time when men were ravenous for the *human;* he created a rational art when art was the only place where most men could find an irrational, sensual release from the common-sense rationalism and disciplines of their economic lives. 4. Furthermore, and this is painful to say, Mondrian's experiment is a failure in its own terms. His terms were, remember, that it is possible to express the felt quality of reality (reality being just what we are aware of) in nonreferential spatio-color structures. The premise cannot be proved false a priori, for we know that color and space are able to communicate feeling, as when, to take banal instances, a green room is felt as more cool and peaceful than an orange one; or as when certain activity is felt more appropriate in a small room than in a large one. But it is possible to say a posteriori that Mondrian failed, with his restricted means, to express enough of the felt quality to deeply interest us. The aesthetic grounds of his failure are plain:★ a bare abstraction, like the simple wooden cross of the church triumphant, is *too* bare, insufficiently concrete and specific to determine a complete mental-feeling state in the observer. Nor does the perfectly valid proposition $2 \times 2 = 4$ in itself interest anyone long. Neither the abstract aesthetic presentation nor the bare mathematical proposition are complex enough *even to suggest* the complexities of that reality with which we are overwhelmed. No one denies that the artist's function involves giving form (i.e., intelligibility, a form being just what is intelligible to us) to that complexity; but after a certain degree of abstraction the form becomes simpleminded, no matter how perfect. No one can meet hostile reality with the simple proposition that $2 + 2 = 4$. The proposition is true, but it is not enough. Yet it must be insisted that it is still not a priori demonstrable that mere spatio-color relations cannot express the full felt quality of reality, as pitch relations in music of course do.

Later on, viewing the exhibition of "The Masters of Abstract Art" at Mme Rubinstein's establishment, one wonders if this judgment of Mondrian is not too harsh. Even after one has admitted the purity and integrity of his intention, perhaps one has not admitted enough. His actual accomplishment is extraordinary too. With one or two exceptions, the best artists in the exhibition are not abstract artists, in the common and strict sense of the term. But besides Mondrian, there are many strictly abstract painters; and beside him they seem dark and

★The late Bosanquet has fully treated the point in one of his aesthetical essays—the devastating one on Croce, if I remember rightly.

confused. He alone among the completely abstract painters holds his own with the other great painters there. Despite his lack of the image reenforcing his meanings, despite the simplicity of his hypothesis, despite the dehumanized treatment of his pictures (as though they had been made with a mechanical tool), despite the arbitrariness of his self-imposed limitations, despite all this and more, a definite and specific and concrete poetry breaks through his bars, a poetry of constructiveness, of freshness, of tenacity, of indomitability, and, above all, of an implacable honesty, an honesty so thoroughgoing in its refusal to shock, to seduce, to surprise, to counterfeit, that in spite of one's self, one thinks of Seurat and Cézanne. Beside Mondrian the other abstractionists seem dull and grey.

Notes

1. The section on Chirico has been omitted.
2. Motherwell's preface to Piet Mondrian's *Plastic Art and Pure Plastic Art, 1937, and Other Essays, 1941–1943*, Documents of Modern Art, no. 2 (New York: Wittenborn, Schultz, 1945, 1947) is not included in this volume, as it presents only biographical and bibliographical facts about Mondrian.
3. Meyer Schapiro, "Nature of Abstract Art," *Marxist Quarterly* 1 (January–March 1937): 77.
4. Among fragments of Motherwell's early writings (ca. 1942) is what appears to be the first draft of the preface to his intended book on modern art, in which he outlined his rationale for the work in progress. It begins:

A question which may be properly asked, and which indeed ought to be asked of any new book in a world so swamped with them as this, is how did it come to be made, what felt necessity lies behind it? In the present circumstance, the answer is quite simple: a few years ago as a young artist in an English-speaking country, preoccupied [unintelligible] *with l'art moderne, a book such as this, had it existed,* [would have] *opened up with some adequacy that marvelous terrain which I desired to explore, which it took, under favorable circumstances, time, expense, and energy to otherwise find, and much of which was wasted. This book indicates with what the modern artist must begin—not where he will end . . .* (Motherwell archives, Dedalus Foundation, Bedford Hills, N.Y.; hereafter cited in the notes as Motherwell archives)

"Painters' Objects" January 1944

During 1943, Motherwell published nothing. The year, however, was intense and eventful in terms of the development of his painting. In the spring, Peggy Guggenheim mounted at her museum/gallery, Art of This Century, the first exhibition in the United States devoted to collage, including works by modern European masters and several young Americans. Prompted by her invitation to show in the exhibit, Motherwell experimented with his first collages and found for himself a medium of lifelong interest. The discovery fired his pictorial imagination, and he created a series of probing works. Later in 1943, roughly two years after he had committed himself to painting, he produced a collage of considerable originality, *Pancho Villa,*

Dead and Alive. At about this time, his writing began to show a growing preference for projecting his ideas through verbal collage.

When "Painters' Objects" was published in 1944,[1] Motherwell's reputation in literary circles as an intellectual and an articulate artist was already established. Solicited by the editors of the influential periodical *Partisan Review,* then dedicated to Marxism and modernism, his second essay continued his study, begun in "Notes on Mondrian and Chirico," into the nature of abstraction by using current exhibitions of works by Piet Mondrian, Alexander Calder, and Jackson Pollock as points of departure. Citing Mondrian's new work, *Broadway Boogie-Woogie* (1942–1943), he acknowledged the Dutch artist's shift to an expressive content, a confirmation of his own evolution toward an art more referential to the physical world. The prophetic and much-quoted last two paragraphs of what might be considered Motherwell's first mature essay champion the work of Pollock. ■

> The study of the beautiful is a duel in which the artist cries
> out in terror before he is vanquished. Baudelaire

We know there is something odd, we might almost say *unnatural,* about the conception of *abstract* art . . . We have accepted its existence almost without reflection on how strange, and indeed frightening it is, that *l'art moderne,* in coming so far, had arrived *here.*

This disturbing sense of oddness is not confined to laymen. Braque, Miró, and Picasso have each, with surprising anger, attacked the idea of a wholly abstract art. Yet we might have expected Braque and Picasso, after their cubist discoveries, and Miró and Picasso, after their use of surrealist automatism, to evince a certain sympathy with the abstract search. But no. Picasso replies that to search means nothing in painting: *To find is the thing.*

Is there, then, some difference between what we have always called abstract art, and that extreme form of it, named nonobjective art, which is a difference in kind, and not, as we have supposed, merely in degree? For painting plainly has always been a species of abstraction: the painter has selected from the world he knows, a world which is not entirely the same in each epoch, the forms and relations which interested him, and then employed them as he pleased. Past art has had the external world for the painter's model, however variously that world has been conceived. The art of Picasso has differed in the degree of abstraction, but not in the kind of abstraction, from the art of the Renaissance tradition of which he is the bitter finale.

But, in the twentieth century—as a result of certain conclusions, whether valid or not, drawn from the suppressed premises of cubism—we find an extraordinary phenomenon: by many artists the external world is totally rejected as the painter's model.

More particularly, those painters who are usually named nonobjective, have replaced that model with arbitrary aesthetic elements of the simplest kind. These elements (and their relations) constitute a part of the external world: they in no wise image it. In this, nonobjective art differs fundamentally, differs epistemologically, one might say, from other modes of art . . .

Still, it is not easy to rid oneself of the "objects" of the external world.

Much of the power of Mondrian's austere and naked *Compositions* derives from the "objects" of the external world, *just to the extent that we are aware that they are not present.* One of the arguments, but not the only argument by any means, which may be deduced from the nonobjective painters' works, might be phrased thus: *Look! It is not difficult to abandon that dull and tedious system of describing the "objects" of the world for expressive purposes. We are too intelligent and advanced for so primitive a system. Besides, now we know all about the appearance of the world's "objects," the human body, the perspective of space, the manner in which light falls upon trees. To discover those things was the historical task of the Renaissance. We are much more interested in the structure of reality, or—if you object to the philosophical implication, you English-speaking people with your conventional notion that art is principally a question of beauty—what interests us is the structure of painting, not the appearance of the "objects" of the external world. An empty canvas is more to the point, in being itself, an "object," and not merely an awkward image of "real objects"; and is, moreover, as Kandinsky says,* far lovelier than certain pictures. *The problem is more nearly how not to lessen the original virginal loveliness of the canvas . . .*

From this direction the oddness of nonobjective art is evident. It is an art of negation, a protest against naturalistic descriptiveness as the most adequate vehicle of expression for the modern mind. This protest has not gone unheeded. No major painter of the present is primarily descriptive in his means; and, among the interesting younger painters, none is descriptive at all, so far as we know. The occasional exceptions to this tendency occur against the painter's will, as in those passages where he has not yet found adequate nondescriptive means, or where, with other ends in view, he may still involuntarily, and by chance, seem to refer to the external world.

Indeed at present, at this very moment, when nonobjective painters have made their point, we are able to feel much less strongly than earlier in the century the historical necessity of the rigid self-imposed limitations of abstract art. We are impelled instead to remark with Wallace Stevens:

> Say even that this complete simplicity
> Stripped one of all one's torments, concealed
> The evilly compounded, vital I
> And made it fresh in a world of white,
> A world of clear water, brilliant-edged,

Still one would want more, one would need more,
More than a world of white and snowy scents.[2]

It may be that the great Mondrian himself now feels such wants and needs. Certainly his recent painting, *Broadway Boogie-Woogie* (Museum of Modern Art, New Acquisitions) represents a marked shift on his part from an intent of simple purification to one of expressiveness . . .

Now in his old age, and in a foreign country, Mondrian has assembled all his remarkable resources for purely expressive ends. In *Broadway Boogie-Woogie* the simple elements of his hitherto analytical art have been transformed.★ The former severe black bands are fractured into segments of color so intense in contrast that they jump, so short in segment that they become a staccato rhythm against the larger rhythms of the main structure; there are heavier, and by virtue of size (since all the colors are pure) even more intense rests; and all the while the large white background, the eternal World, reinforces the concrete and fugitive drama. For the first time a subject is present, not by virtue of its absence, but actually present, though its appearance is torn away, and only the structure bared. The Modern City! Precise, rectangular, squared, whether seen from above, below, or on the side; bright lights and sterilized life; Broadway, whites and blacks; and boogie-woogie, the underground music of the at once resigned and rebellious, the betrayed . . . Mondrian has left his white paradise, and entered the world . . .

As a result of the poverty of modern life, we are confronted with the circumstance that art is more interesting than life. *Experience is bound to utility,* as André Breton says, *and guarded by common-sense.* The pleasurable "things" of other times for the most part no longer exist, and those which do no longer suffice. With what our epoch meant to replace the wonderful things of the past—the late afternoon encounters, the leisurely repasts, the discriminations of taste, the graces of manners, and the gratuitous cultivation of minds—what we might have invented, perhaps we shall never know. We have been made too busy with *tasks.*

At what other time could the juxtaposition of a bright square on a white ground have seemed so portentous!

★The intrinsic value of this new picture cannot concern us here. Though it has been sometimes judged a near failure,[3] we regard it as the most important work by Mondrian with which we are acquainted. The value, however, of a nonobjective painting, like that of a piece of "pure" music, cannot be proven. "Proof" rests only on persuasion; and in our time we are persuaded by demonstration. But the qualitative greatness of specific sensuous relations, which constitute the content of nonobjective art, *cannot be demonstrated*—as one can demonstrate, and apart from strictly formal qualities, the symbolic richness of the early Chirico, for instance. For the layman there is no "circumstantial evidence" in nonobjective art. This does not mean that value judgments on nonobjective art are arbitrary. We merely remark that they cannot be proven; and add that it is difficult to see how anyone, save certain painters, can even discriminate the content of such works, not to speak of valuing them.

The surrealists alone among modern artists refused to shift the problem to the plane of art. Ideally speaking, superrealism became a system for enhancing everyday life. True, the surrealists were always saying that "poetry should be made by all"; but they did not mean precisely what we have always meant by poetry. If they had been successful, we might not have needed "poetry" at all. Still, their various devices for finding pleasure—spiritual games, private explorations, public provocations, sensory objects, and all the rest—were *artificial* enough abroad before the war. In the hard and conventional English-speaking world the devices simply could not work. Here it was the surrealists who were transformed. And it may be that their pioneer and therefore often naive effort to enhance the life of the modern mind will be forgotten.

But in any case, it is not unimportant, this thing Alexander Calder has done, in making objects of pleasure worthy of adults (Museum of Modern Art, Calder Retrospective). Granted, most of us must see them in museums or galleries, and that destroys half the fun. Still, there they are! The playthings of a prince for us all . . .

It was Mondrian's influence which first led Calder from his earlier pleasantries and toys for children to these marvelous objects for the adult mind: "I was very much moved by Mondrian's studio, large, beautiful, and irregular as it was, with the walls painted white, and divided by black lines and rectangles of bright color, like his paintings . . . and I thought at the time how fine it would be if everything there MOVED; though Mondrian himself did not approve of this idea at all." Later it came to be Miró's shapes among those of abstract artists which Calder liked best. But the essential conditions of his art remained the same: a fruitful union—his native American ingenuity (a preference for tools, rather than the brush), leading in turn to a fresh discovery (an art of motion), coupled with the advances of European art (abstract forms) and European thought (the surrealist understanding of the desirability of the object of pleasure). The consequence of this union is that Calder's native American gifts become interesting to general culture.

There is something splendid about the form of motion, or, more exactly, motion *formed,* and it is with this that Calder has enchanted us.

Certain individuals represent a young generation's artistic chances. There are never many such individuals in a single field, such as painting—perhaps a hundred to begin with. The hazards inherent in man's many relations with reality are so great—there is disease and premature death; hunger and alcoholism and frustration; the historical moment may turn wrong for painters: it most often does; the young artist may betray himself, consciously or not, or may be betrayed—the hazards are so great that not more than five out of a whole young generation are able

to develop to the end. And for the most part it is the painting of mature men which is best.

The importance of the one-man show of young Jackson Pollock (Art of This Century) lies just in this, that he represents one of the younger generation's chances. There are not three other young Americans of whom this could be said. In his exhibit Pollock reveals extraordinary gifts: his color sense is remarkably fine, never exploited beyond its proper role; and his sense of surface is equally good. His principal problem is to discover what his true *subject* is. And since painting is his thought's medium, the resolution must grow out of the process of his painting itself.

Notes

1. "Painters' Objects," erroneously following "The Modern Painter's World" in Motherwell's bibliographies, should precede it, since the issue of *Partisan Review* in which it appeared (as part of the periodical's "Art Chronicle") was published in January rather than at the end of the year, as has been assumed.

2. Wallace Stevens, "The Poems of Our Climate," in *Parts of a World* (New York: Knopf, 1942), pp. 8–9.

3. Most likely this was a direct reference to Clement Greenberg's opinion of the painting ("Mondrian's 'New York Boogie-Woogie,' " *Nation,* 9 October 1943, p. 41). Since Greenberg began his review by evoking "the harmony of the original white canvas," to which Motherwell made reference in his rhetorical argument, this essay might, among other things, have been a rebuttal of the art critic's somewhat limited appraisal of Mondrian. Greenberg later changed his mind about Mondrian's stature.

"The Modern Painter's World" 10 August 1944

Through his association with the surrealists, Motherwell was invited to the "Pontigny en Amérique" programs at Mount Holyoke College in South Hadley, Massachusetts, in August 1944.[1] The *entretiens* for that year addressed "L'Art et la crise" and were divided into four week-long sessions. It was to the third—held on 10 August, entitled "Arts Plastique," and headed by André Masson—that Motherwell contributed.[2]

Motherwell's talk, "The Place of the Spiritual in a World of Property," was published later that year in *DYN* under its present title, "The Modern Painter's World." This modification reflects the artist's uneasiness with the essay's emphasis. Even compared with other writings of his formative years, its dense texture and overtly political bias make it somewhat of an anomaly within his written oeuvre.[3] The prestigious occasion had made him self-conscious, and his idealism, his romance with both the French and the American bohemian traditions, and his eagerness to make the "French connection" had prevailed. But, more immediately, Lionel Abel,[4] a literary colleague, had suggested that his original idea (a philosophical treatise on the nature of abstrac-

tion) might be too academic and esoteric for the audience and had persuaded him to choose a topic more relevant to the immediate social crisis.[5] What emerged as more natural to him was his indirect presentation through a verbal collage—a construction that would become his literary "style." ■

I must apologize for my subject, which is that of the relation of the painter to a middle-class world. This is not the most interesting relation by which to grasp our art. More interesting are the technical problems involved by the evolution of artistic structure. More fundamental is the individual problem, the capacity of an artist to absorb the shocks of reality, whether coming from the internal or external world, and to reassert himself in the face of such shocks, as when a dog shakes off water after emerging from the sea. The twentieth century has been one of tremendous crises in the external world, yet, artistically speaking, it has been predominantly a classic age. In such epochs it is architecture, not painting or poetry or music, which leads. Only modern architecture, among the great creations of twentieth-century art, is accepted quite naturally by everyone. Both surrealist and "nonfigurative" painting, with which I am concerned in this lecture, are the feminine and masculine extremes of what, when we think of the post-impressionists, the fauves, the cubists, and the art which stems, in conception, from them, has been a classic age.

Great art is never extreme . . .

Criticism moves in a false direction, as does art, when it aspires to be a social science. The role of the individual is too great. If this were not so, we might all well despair. The modern states that we have seen so far have all been enemies of the artist; those states which follow may be, too.

[. . .]

The function of the artist is to express reality as *felt*. In saying this, we must remember that ideas modify feelings. The anti-intellectualism of English and American artists has led them to the error of not perceiving the connection between the feeling of modern forms and modern ideas. By feeling is meant the response of the "body-and-mind" *as a whole* to the events of reality. It is the whole man who feels in artistic experience as when we say with Plato: "The man has a pain in his finger" (*The Republic,* 462 D), and not, "The finger has a pain." I have taken this example from Bosanquet, who goes on to say: "When a 'body-and-mind' is, as a whole, in any experience, that is the chief feature . . . of what we mean by feeling. Think of him as he sings, or loves, or fights. When he is as one, I believe it is always through feeling . . ." (*Three Lectures on Aesthetic*).

The function of the *modern* artist is by definition the felt expression

of modern reality. This implies that reality changes to some degree. This implication is the realization that history is "real," or, to reverse the proposition, that reality has a historical character. Perhaps Hegel was the first fully to feel this. With Marx this notion is coupled with the feeling of how *material* reality is . . . It is because reality has a historical character that we feel the need for new art. The past has bequeathed us great works of art; if they were wholly satisfying, we should not need new ones. From this past art, we accept what persists qua eternally valuable, as when we reject the specific religious values of Egyptian or Christian art, and accept with gratitude their form. Other values in this past art we do not want. To say this is to recognize that works of art are by nature pluralistic: they contain more than one *class* of values. It is the eternal values that we accept in past art. By eternal values are meant those which, humanly speaking, persist in reality in any space-time, like those of aesthetic form, or the confronting of death.

Not all values are eternal. Some values are historical—if you like, *social,* as when now artists especially value personal liberty because they do not find positive liberties in the concrete character of the modern state. It is the values of our own epoch which we cannot find in past art. This is the origin of our desire for new art. In our case, for *modern art* . . .

The term "modern" covers the last hundred years, more or less. Perhaps it was Eugène Delacroix who was the first modern artist. But the popular association with the phrase "modern art," like that of medieval art, is stronger than its historical denotation. The popular association with medieval art is religiousness. The popular association with modern art is its *remoteness* from the symbols and values of the majority of men. There is a break in modern times between artists and other men without historical precedent in depth and generality. Both sides are wounded by the break. There is even hate at times, though we all have a thirst for love.

The remoteness of modern art is not merely a question of language, of the increasing "abstractness" of modern art. Abstractness, it is true, exists, as the result of a long, specialized internal development in modern artistic structure. But the crisis is the modern artist's rejection, almost *in toto,* of the values of the bourgeois world. In this world modern artists form a kind of *spiritual underground.*

[. . .]

The social condition of the modern world which gives every experience its form is the spiritual breakdown which followed the collapse of religion. This condition has led to the isolation of the artist from the rest of society. The modern artist's social history is that of a spiritual being in a property-loving world.

No synthesized view of reality has replaced religion. Science is not

a view, but a method. The consequence is that the modern artist tends to become the last active spiritual being in the great world. It is true that each artist has his own religion. It is true that artists are constantly excommunicating each other. It is true that artists are not always pure, that some times they are concerned with their public standing or their material circumstance. Yet for all that it is the artists who guard the spiritual in the modern world.

[. . .]

In the spiritual underground the modern artist tends to be reduced to a single subject, his ego . . . This situation tells us where to expect the successes and failures of modern art. If the artist's conception, from temperament and conditioning, of freedom is highly individualistic, his egoism then takes a romantic form. Hence the surrealists' love at first sight for the romantic period, for disoriented and *minor* artists: individualism limits *size*. If the artist, on the contrary, resents the limitations of such subjectivism, he tries to objectify his ego. In the modern world, the way open to the objectivization of the ego is through form. This is the tendency of what we call, not quite accurately, abstract art. Romanticism and formalism both are responses to the modern world, a rejection, or at least a reduction, of modern social values. Hence the relative failure of Picasso's public mural at the Spanish Republic's pavilion in the Paris Exposition, *The Bombing of Guernica.* Hence Picasso's great successes, given his great personal gifts, with the formal and emotional inventions in cubism, the papier collé, and even in many of the preliminary drawings for *Guernica:* here it is a question of Picasso's own genius. In the public mural, it is a question of his solidarity with other men. Picasso is cut off from the great social classes, by the decadence of the middle class and the indifference of the working class, by his own spirituality in a property-ridden world. *Guernica* is therefore a tour de force. It expresses Picasso's indignation, as an individual, at public events. In this it is akin to Goya's *Los Desastres de la Guerra.* The smaller format of etchings, or even of easel paintings is more appropriate. We see this in the greater effective horror of Picasso's *Girl with Cock.* The mural form, by virtue of its size and public character, must speak for a whole society, or at the very least, a whole class. *Guernica* hangs in an uneasy equilibrium between now disappearing social values, i.e., moral indignation at the character of modern life— what Mondrian called the *tragic,* as opposed to the eternal and the formal, the aesthetics of the papier collé.

We admire Picasso for having created *Guernica.* We are moved by its intent. Yet how accurately, though intuitively, art measures the contradictions of life. Here a contradiction exists. So long as the artist does not belong, in the most concrete sense, to one of the great historical classes of humanity, so long he cannot realize a social expression in all its public fullness. Which is to say, an expression for, and not

against. The artist is greatest in affirmation. This isolation spiritually cripples the artist, and sometimes gives him, at present, a certain resemblance to Dostoyevsky's Idiot.

The history of Picasso, from one point of view, is that of his effort not to be limited to the strictly aesthetic, not to strip his art bare of a full social content, and contemplate her merely under the eternal aspect of beauty. He would not so impoverish himself. It is an aesthetician's error to suppose that the artist's principal concern is beauty, any more than the philosopher's principal concern is truth. Both are technical problems, which the artist and the philosopher must solve, but they do not represent the end in view. To express the felt nature of reality is the artist's principal concern. Picasso *wills* therefore the retention of social values, at any cost, just as Masson strives with a kind of desperation, like Delacroix, to raise modern painting out of the petty relations of modern life to the level of our great humanist past. But since Picasso, no more than any artist, can accept the values of a middle-class world, he must, in retaining them, treat them with a savage mockery, like Joyce. Here somewhere is the ground of Picasso's otherwise unparalleled parody of the history of art.

It was the late Piet Mondrian who accepted the impoverishment of his art involved by the rejection of social values. He was perhaps less opposed to ordinary life than indifferent to its drama. It was the eternal, the "universal," in his terminology, which preoccupied him: he had an affinity with oriental saints, with, say, Mallarmé. Since the aesthetic is the main quality of the eternal in art, it may be that this is why Mondrian's work, along with certain aspects of automatism, was the first technical advance in twentieth-century painting since the greatest of our discoveries, the papier collé. It was Mondrian who accepted most simply that debased social values provide no social content.

History has its own ironies. It is now Mondrian, who dealt with the "eternal," who dates the most. To underestimate the capacity of the individual to transcend the social, is to deny the possibility of art now.

[. . .]

The surrealists had the laudable aim of bringing the spiritual to everyone. But in a period as demoralized as our own, this could lead only to the demoralization of art. In the greatest painting, the painter communes with himself. Painting is his thought's medium. Others are able to participate in this communion to the degree that they are spiritual. But for the painter to communicate with all, *in their own terms,* is for him to take on their character, not his own.

Painting is a medium in which the mind can actualize itself; it is a medium of thought. Thus painting, like music, tends to become its own content.

The medium of painting is color and space: drawing is essentially a

division of space. Painting is therefore the mind realizing itself in color and space. The greatest adventures, especially in a brutal and *policed* period, take place in the mind.

Painting is a reality, among realities, which has been felt and formed.

It is the pattern of choices made, from the realm of possible choices, which gives a painting its form.

The content of painting is our response to the painting's qualitative character, as made apprehendable [*sic*] by its form. This content is the feeling "body-and-mind." The "body-and-mind," in turn, is an event in reality, the interplay of a sentient being and the external world. The "body-and-mind" being the interaction of the animal self and the external world, is just reality itself. It is for this reason that the "mind," in realizing itself in one of its mediums, expresses the nature of reality as felt.

[. . .]

Spinoza reminds us that the thing most important to man is man. Hence the poverty of the modern painter's experience. We long to embrace one another, and instead our relations are false. It is after the French Revolution and the triumph of the bourgeoisie that the human figure disappears from painting, and the rise of landscape begins. With Cézanne landscape itself comes to an end, and from him to the cubists the emphasis is changed: the subject becomes "neutral." Now certain painters wish to be called nonfigurative . . .

[. . .]

Empty of all save fugitive relations with other men, there are increased demands on the individual's own ego for the content of experience. We say that the individual withdraws into himself. Rather, he must draw from himself. If the external world does not provide experience's content, the ego must. The ego can draw from itself in two ways: the ego can be the subject of its own expression, in which case the painter's personality is the principal meaning expressed; otherwise the ego can socialize itself—i.e., become mature and objectified—through formalization.

In terms of Freud's fictions, the ego is the synthesis of the "superego" and the "id." The superego represents the external world: the father, the family, society, in short, authority. The id represents the inner world: our basic animal drives. In the situation in which the ego rebels against the authority of the external world, but still retains an aspect of that world which is eternal, the aesthetic, the superego is the effect of society; in the present case those values have been reduced to that of form. Form, like the influence of society in the usual superego, comes from the outside, the world. It is in this sense that formalization represents a socialization of the ego. In rejecting the values of middle-class society, as a historical event, the aesthetic and other eternal values like chance, love, and logic are what remain.

It is the nature of such art to value above all the eternal, the "pure," the "objective." Thus Mondrian used to speak of the "universal." Thus the notion of "pure form" among the nonfigurative painters, and Valéry's idea of the "pure self." Thus the modern sculptor's admiration for the purity of materials. Thus Arp's violent attacks on romantic painters' egoism; and the general admiration of abstract painters for an art without a self . . . The desire for the universal is that for one of its forms, the aesthetic; the desire for purity is the rejection of contemporary social values for the aesthetic; the desire for objectivity is that for the socialization of the ego through the aesthetic. Lissitsky's white square on a white ground contains the magic of the aesthetic position in its most implacable form.

The power of this position must not be underestimated. It has produced some of the greatest creations of modern art. But the fundamental criticism of the purely formalist position is how it reduces the individual's ego, how much he must renounce. No wonder there is such insistence among formalists on perfection. Such limited material is capable of perfection, and with perfection it must replace so much else.

The surrealist position is far more contradictory. They have been the most radical, romantic defenders of the individual ego. Yet part of their programme involves its destruction. Where the abstractionists would reduce the content of the superego to the aesthetic, not even the aesthetic has value for the surrealists. It serves merely as a weapon of the middle class. Authority from the external world is rejected altogether. This is the dada strand in the fabric of surrealism. With the content of the superego gone, the surrealists are driven to the animal drives of the id. From hence the surrealists' admiration for men who have shattered the social content of the superego, for Lautréamont and the Marquis de Sade, for children and the insane. This is the sadistic strand. It is from this direction that surrealism tends to become predominantly sexual. Yet it is plainly impossible for cultivated men to live on the plane of animal drives. It is therefore a pseudo-solution to the problem posed by the decadence of the middle class.

A second major tendency of surrealism is to renounce the conscious ego altogether, to abandon the social and the biological, the superego and the id. One retreats into the unconscious. The paradox is that the retreat into the unconscious is in a sense the desire to maintain a "pure ego." Everything in the conscious world is held to be contaminating, as when the hero in search of the fabulous princess, in the Celtic fairy tale, *must never permit himself to be touched,* whether by a leaf, an insect, or anything from the external world, as he flies through the forests on his magic horse. If he were touched by the world, his quest would immediately come to a disastrous end. Even when the hero arrives at the princess's castle, he must jump from his flying horse through a window without touching the windowframe. He does in the end reach

the princess, and after resting with her seven days and nights, wherein she never opens her eyes, she gives birth to a young god. The surrealist conception of the journey into the unconscious is of some such hero's task. Automatism is the dark forest through which the path runs. The fundamental criticism of automatism is that the unconscious cannot be *directed,* that it presents none of the possible choices which, when taken, constitute any expression's form. To give oneself over completely to the unconscious is to become a slave. But here it must be asserted at once that plastic automatism though perhaps not verbal automatism—as employed by modern masters, like Masson, Miró, and Picasso—is actually very little a question of the unconscious. It is much more a plastic weapon with which to invent new forms. As such it is one of the twentieth century's greatest formal inventions . . . Still, the impulse towards the unconscious contradicts to a degree that towards the id. Hence a content partly consciously sexual, partly automatic, in many of the surrealist painters.

Self-annihilation is of course undesirable. We are neither merely biological organisms nor automatons. Thus the third tendency of the surrealists, contradictory to the other two: the destruction of the free ego's enemy, the middle class. Here is the rapport between surrealism and the politics of the left. But here the surrealists have been blocked by the inertness of the working class.

Because of its internal contradictions, and its impracticality in the external world, the surrealist position has been subject to a certain instability. What we love best in the surrealist artists is not their programme. The strength of Duchamp and Ernst has been their dada disrespect for traditional uses of the painter's medium, with its accompanying technical innovations. The strength of Arp, Masson, Miró, and Picasso lies in the great humanity of their formalism. Dali long ago became reactionary: art has its traitors, too.

The argument of this lecture is that the materialism of the middle class and the inertness of the working class leave the modern artist without any vital connection to society, save that of the *opposition;* and that modern artists have had, from the broadest point, to replace other social values with the strictly aesthetic. Even where the surrealists have succeeded, it has been on technical grounds. This formalism has led to an intolerable weakening of the artist's ego; but so long as modern society is dominated by the love of property—and it will be, so long as property is the only source of freedom—the artist has no alternative to formalism. He strengthens his formalism with his other advantages, his increased knowledge of history and modern science, his connections with the eternal, the aesthetic, his relations with the folk (e.g., Picasso and Miró), and, finally his very opposition to middle-class society gives him a certain strength. Until there is a radical revolution in the values of modern society, we may look for a highly formal art to

continue. We can be grateful for its extraordinary technical discoveries, which have raised modern art, plastically speaking, to a level unreached since the earlier Renaissance. When a revolution in values will take place, no one at present can tell. The technical problems which stand before us I must speak of some other time.

Notes

1. These sessions were modeled after the "Décades," programs held earlier in the century at the Cistercian abbey of Pontigny, which had become a mecca for scholars and prominent figures of French letters, André Gide and Paul Valéry among them. The events in the United States were hosted by the Mount Holyoke French department and co-sponsored by the college and the Ecole Libre des Hautes Etudes, the Franco-Belgian university-in-exile attached to the New School for Social Research in New York.

2. Other participants were Robert Goldwater, Stanley William Hayter, Jean Hélion, José Luis Sert, and Ossip Zadkine, with Jean Wahl (former editor of the *Nouvelle revue française*) serving as one of the vice presidents of the program committee.

3. Rather than exclude this inordinately long and atypical essay in its entirety, those sections that do not further the development of Motherwell's artistic theories have been omitted.

4. Lionel Abel had just translated Apollinaire's *The Cubist Painters: Aesthetic Meditations 1913*, Documents of Modern Art, no. 1 (New York: Wittenborn, 1944).

5. Conversation with the artist, 17 May 1984. Among various drafts for Motherwell's early writings is one that may have been first thoughts for this essay and that more accurately touches on his "politics" at the time. It begins:

I am as anxious as anyone to keep to the business at hand, the relation of the concept of the modern to painting, and in doing so, to avoid both philosophy and politics. I hope then I will not be misunderstood when I remark something of crucial importance, something which might be taken for philosophy, and almost certainly will be for politics. What I wish to remark is this: Every consequential contribution to l'art moderne has been made by revolutionary minds . . . and by revolutionary minds only. I cannot pause to enumerate the answers to the conventional objections to this proposition, to the objection that, for instance, Cézanne was a conservative in politics and a Catholic in religion; it is too obvious that the revolutionary character of Cézanne's mind appears first in how he interests us most here, in his painting; it is equally obvious that many a political revolutionary, so far as we restrict ourselves even within broad limits to our subject, has no interest for us here at all . . . (Motherwell archives)

"Beyond the Aesthetic" April 1946

The mid-1940s were exceptionally creative years for Motherwell, for his literary work as well as for his painting. After his article for the *Partisan Review,* he wrote a review of a book by Alexander Calder[1] and a review of a book about Henry Moore,[2] both for the *New Republic.* He began what was to be nearly a decade of work as the director and editor of the Documents of Modern Art series, writing introductions to the first two titles of this pioneering series: *The Cubist Painters: Aesthetic Meditations 1913* by Apollinaire and

Plastic Art and Pure Plastic Art by Mondrian. During the summer of 1944 at Amagansett on Long Island, he composed his complex "Pontigny en Amérique" lecture and painted most of the works for his first U.S. one-man exhibition, which was held at Art of This Century in the fall. Early the next year, he signed a contract with the newly established Kootz Gallery in New York City, which, in exchange for an annual stipend, demanded from him a high quota of work. That summer, he was invited by Josef Albers to teach for a month at Black Mountain College in North Carolina, his growing reputation as a notable avant-garde painter—at least among the initiated—having preceded him at the experimental school.

In 1946, Motherwell was invited to write an essay for an issue of *Design* magazine to be devoted to Black Mountain College. His contribution, "Beyond the Aesthetic," rather than addressing his teaching experience of the previous summer, made public his continuing internal dialogue with the creative process. ■

For the goal which lies beyond the strictly aesthetic the French artists say the "unknown" or the "new," after Baudelaire and Rimbaud; Mondrian used to say "true reality." "Structure" or "gestalt" may be more accurate: reality has no degrees, nor is there a "super" one *(surréalisme)*. Still, terminology is unimportant. Structures are found in the interaction of the body-mind and the external world; and the body-mind is active and aggressive in finding them. As Picasso says, there is no use looking at random: "to find is the thing."

The aesthetic is the sine qua non for art: if a work is not aesthetic, it is not art by definition. But in this stage of the creative process, the strictly aesthetic—which is the sensuous aspect of the world—ceases to be the chief end in view. The function of the aesthetic instead becomes that of a medium, a means for getting at the infinite background of feeling in order to condense it into an object of perception. We feel through the senses, and everyone knows that the content of art is feeling; it is the creation of an object for sensing that is the artist's task; and it is the qualities of this object that constitute its felt content. Feelings are just how things feel to us; in the old-fashioned sense of these words, feelings are neither "objective" nor "subjective," but both, since all "objects" or "things" are the result of an interaction between the body-mind and the external world. "Body-mind" and "external world" are themselves sharp concepts only for the purposes of critical discourse, and from the standpoint of a stone are perhaps valid but certainly unimportant distinctions. It is natural to rearrange or invent in order to bring about states of feeling that we like, just as a new tenant refurnishes a house.

The passions are a kind of thirst, inexorable and intense, for certain feelings or felt states. To find or invent "objects" (which are, more strictly speaking, relational structures) whose felt quality satisfies the passions—that for me is the activity of the artist, an activity which does not cease even in sleep. No wonder the artist is constantly placing and displacing, relating and rupturing relations: his task is to find a complex of qualities whose feeling is just right—veering toward the unknown and chaos, yet ordered and related in order to be apprehended.

The activity of the artist makes him less socially conditioned and more human. It is then that he is disposed to revolution. Society stands against anarchy; the artist stands for the human against society; society therefore treats him as an anarchist. Society's logic is faulty, but its intimation of an enemy is not. Still, the social conflict with society is an incidental obstacle in the artist's path.

It is Cézanne's feeling that determined the form of his pictorial structure. It is his pictorial structure that gives off his feeling. If all his pictorial structures were to disappear from the world, so would a certain feeling.

The sensation of physically operating on the world is very strong in the medium of the papier collé or collage, in which various kinds of paper are pasted to the canvas. One cuts and chooses and shifts and pastes, and sometimes tears off and begins again. In any case, shaping and arranging such a relational structure obliterates the need, and often the awareness of representation. Without reference to likenesses, it possesses feeling because all the decisions in regard to it are ultimately made on the grounds of feeling.

Feelings must have a medium in order to function at all; in the same way, thought must have symbols. It is the medium, or the specific configuration of the medium that we call a work of art that brings feeling into being, just as do responses to the objects of the external world. Apart from the struggle to endure—as Spinoza says, substance is no stronger than its existence—the changes that we desire in the world, public or private, are in the interests of feeling. The medium of painting is such changing and ordering on an ideal plane, ideal in that the medium is more tractable, subtle, and capable of emphasis (abstraction is a kind of emphasis) than everyday life.

Drama moves us: conflict is an inherent pattern in reality. Harmony moves us too: faced as we are with ever imminent disorder, it is a powerful ideal. Van Gogh's drama and Seurat's silent harmony were born in the same country and epoch; but they do not contradict one another; they refer to different patterns among those which constitute reality. In them the projection of the human has become so desocial-

ized as to take on the aspect of the "unknown." Yet what seems more familiar when we confront it?

The "pure" red of which certain abstractionists speak does not exist, no matter how one shifts its physical contexts. Any red is rooted in blood, glass, wine, hunters' caps, and a thousand other concrete phenomena. Otherwise we should have no feeling toward red or its relations, and it would be useless as an artistic element.

But the most common error among the wholehearted abstractionists nowadays is to mistake the medium for an end in itself, instead of a means.

On the other hand, the surrealists erred in supposing that one can do without a medium, that in attacking the medium one does not destroy just one's means for getting into the unknown. Color and space relations constitute such a means because from them can be made structures which exhibit the various patterns of reality.

Like the cubists before them, the abstractionists felt a beautiful thing in perceiving how the medium can, of its own accord, carry one into the unknown, that is, to the discovery of new structures. What an inspiration the medium is! Colors on the palette or mixed in jars on the floor, assorted papers, or a canvas of a certain concrete space—no matter what, the painting mind is put into motion, probing, finding, completing. The internal relations of the medium lead to so many possibilities that it is hard to see how anyone intelligent and persistent enough can fail to find his own style.

Like Rimbaud before them, the surrealists abandoned the aesthetic altogether; it takes a certain courage to leave poetry for Africa. They revealed their insight as essentially moral in never forgetting for a moment that most living is a process of conforming to an established order which is inhuman in its drives and consequences. Their hatred sustained them through all the humiliating situations in which the modern artist finds himself, and led them to perceptions beyond the reach of more passive souls. For them true "poetry" was freedom from mechanical social responses. No wonder they loved the work of children and the insane—if not the creatures themselves.

In the end one must agree with Rilke when he says that with "nothing can one touch a work of art so little as with critical words: they always come down to more or less happy misunderstandings." It was Marcel Duchamp who was critical, when he drew a moustache on the *Mona Lisa*. And so was Mondrian when he dreamt of the dissolution of painting, sculpture, and architecture into a transcendent ensemble.

Notes

1. Robert Motherwell, "Calder's 'Three Young Rats,'" *New Republic*, 25 December 1944, pp. 874, 876. Generally omitted from Motherwell's bibliographies,

probably because it is not indexed in the *Readers' Guide to Periodical Literature,* this essay is the artist's first book review. The initial paragraph of the piece, which the editors had wanted to drop (conversation with the artist, 11 January 1984), reflects Motherwell's general thoughts about politics more accurately than, for instance, his "Pontigny" lecture of the same year:

There is this to say apropos the advanced art of our time: that the critical problems of direction and of quality are not kept distinct. Because a given work has originated in the most "modern" milieu, it is supposed to be valuable ipso facto, just as we sometimes assume unthinkingly that because so-and-so is a radical in his politics, he must be a humanist as a man. Otherwise art and politics were only specialized games. But in practice, we can judge nothing but a man's politics from his politics. In the same manner, the point is now so evident that Renaissance modes of expression are obsolete, so little courage and insight are needed to assert it, that novelty is no longer, as it once was, an adequate test of the livingness of a work.

2. Robert Motherwell, "Henry Moore," *New Republic,* 22 October 1945, p. 538.

Statement in *Fourteen Americans* 1946

■ "Fourteen Americans," an exhibition held in the fall of 1946 at the Museum of Modern Art in New York, was the third in curator Dorothy Miller's prestigious series of group shows of works by American artists; in particular, it signaled the museum's future commitment to avant-garde American art. Motherwell esteemed MoMA above all other museums, primarily because of the great permanent collection of modern art amassed by its director, Alfred Barr, Jr.; and, indeed, his inclusion in the exhibition was a milestone in his early career. He showed thirteen works—paintings, drawings, and collages—all installed in one room, in what amounted to a mini one-man exhibit. Along with the thirteen other artists included in the show,[1] he wrote a statement for the exhibition catalog, which illustrated six of his paintings, including two already owned by the museum.[2] ■

There are so many things that ought to be said about modern painting, about its structure, its relation to the self, its social conditioning, that a single idea is bound to seem fragmentary and misleading. It is for this reason that artists often remain silent, disliking words; but it is false to think that modern artists do not know what they are doing. Among other ends, modern art is related to the ideal of internationalism.

In the art schools they say that one ought to learn anatomy, and then "forget" it, in the sense no doubt that for Mozart the sonata form became as much a part of the functioning of his body-mind as his personal talent. Medical anatomy is irrelevant to the ends of modern art; but there are some things that must be known as well as anatomy has been in the past, so that in the process of working in terms of feeling they need not be consciously thought. One is to know that art

is not national, that to be merely an American or a French artist is to be nothing; to fail to overcome one's initial environment is never to reach the human. Still, we cannot become international by willing it, or by following a foreign pattern. This state of mind arises instead from following the nature of true reality, by taking things for what they are, whether native or foreign. It is part of what Plato meant by *techne,* that is, mobilizing one's means in relation to an insight into the structure of reality. With such insight, nationalities become accidental appearances; and no rendering of the appearance of reality can move us like a revelation of its structure. Thus when we say that one of the ideals of modern art has been internationalism, it is not meant in the sense of a slogan, of a super-chauvinism, but as a natural consequence of dealing with reality on a certain level.

Notes

1. David Aronson, Ben L. Culwell, Arshile Gorky, David Hare, Loren Mac-Iver, Isamu Noguchi, I. Rice Pereira, Alton Pickens, C. S. Price, Theodore J. Roszak, Honoré Sharrer, Saul Steinberg, and Mark Tobey.
2. *Pancho Villa, Dead and Alive* (1943) and *In Beige with Sand* (1945).

Letter to Samuel Kootz 21 January 1947

When Samuel Kootz opened his gallery on Madison Avenue in 1945, he was one of the first art dealers in New York City after Peggy Guggenheim to concentrate on young American modernists. He periodically added new artists to his roster, but it appears that his emphasis was on William Baziotes, Adolph Gottlieb, David Hare, Hans Hofmann, Ibram Lassaw, and Motherwell. After the Second World War, his successful personal and business relationship with Picasso won him the artist's exclusive U.S. dealership. By the late 1940s, Kootz was cleverly juxtaposing works by his American group with paintings by such European modernists as Picasso, Léger, Miró, Dubuffet, and Vlaminck.

Early in 1947, an exhibition featuring Kootz's group of artists[1] was sent to the Galerie Maeght in Paris under the patronage of the United States Information Service. A good deal was riding on the show, since "Introduction à la Peinture Moderne Américaine" was the first exposure of the new American painting in Europe.[2] Although Motherwell fared better than some of the other artists who had been included, in general the exhibit was panned by French critics. Disappointment over this poor reception had been part of a contentious conversation between Motherwell and Kootz at the gallery. This and other issues that the artist and his dealer had discussed prompted correspondence from Motherwell when he returned to Long Island.

Motherwell had been living year-round in East Hampton for over two years and was now anticipating his move to the Quonset house

and studio that the French architect Pierre Chareau had designed for him. The building project had been stressful for him, in both execution and cost, but his painting activity remained intense and prolific as he prepared for his one-man exhibit at Kootz in April. His literary work in 1947 was to include the second edition of Mondrian's *Plastic Art and Pure Plastic Art* for the Documents of Modern Art and the publication in the late winter of *possibilities*,[3] the magazine of modern art and culture that had preoccupied him since 1946.

Kootz was critical of Motherwell's editing activity and had expressed this during their discussion at the gallery. It seems that Kootz's concern had less to do with Motherwell's painting output than with negative perceptions about a painter who was also a writer.[4] In a letter to Kootz, dated 21 January, Motherwell challenged the dealer on the question of his editing, his ace in the hole being the paintings he was soon to deliver to the gallery, works that in fact were to impress Kootz.[5] Considering his growing dislike of Kootz and his alienation from Pollock, Motherwell's appraisal of the dealer's efforts on behalf of young American moderns and of Pollock's painting are noteworthy.[6] ■

Dear Sam:

I would be glad if you would ask Jane to send me a list of what I have already turned in for 1946; I want to meet my quota, but naturally I would rather not give you any of my own things unless necessary. I will bring the final delivery for 1946 in on the fifth or sixth of February; the size of many of them will certainly make up for any little ones I have given you already; I think it is the best group I have ever had for you; and when you see it, we can discuss the future.

As far as our conversation about me the other day is concerned, if there *is* any problem, it is simply whether you still have faith in me or not: I have in myself, and I do pretty well toward meeting my quota, which is a steep one for a qualitative painter,[7] so there is no problem for me. My editing is my hobby, a way of dealing with minds that interest me, in the same way that Baziotes likes to talk with people in bars, and I don't see why that should bother you. If I were by nature a painter who would really rather edit, I would be a much better editor and a much worse painter than I am in fact. If my work received little response in Paris, that shouldn't shake you: it was inevitable, since they have always hated a truly abstract art, and the air is filled with the conflict between the communists and the Catholics, and my work stands for a greater impassivity and individualism (though this latter they both would like to deny) than either will, or perhaps could admit. But words don't change feelings, and after you see my new work is the time to discuss what is going to happen.

I am glad you got Picasso, and hope you will pull many more such coups, because it will put you in a much more stable position; but

apart from money, the important thing you've done is back a young movement in painting—and that movement will only be important to the degree that we try to advance beyond the great Parisian painters (who are bound to be against such an effort when they confront it, even though they accept the principle of reaction), and at the same time try to approach the Parisian painters' depth of feeling and painting quality; and I hope you will always try to help such young people, even if one day you should be persuaded that I am not one of them. For that reason, though I don't get along especially well with him, I would like to see you take on Pollock, particularly if his new show, which I haven't seen, marks a progress.

Notes

1. William Baziotes, Romare Bearden, Byron Browne, Adolph Gottlieb, Carl Holty, and Motherwell.

2. For the accompanying catalog, Harold Rosenberg wrote an introduction, later that year reprinted as "Introduction to Six American Artists," in *possibilities 1: An Occasional Review,* Problems of Contemporary Art, no. 4 (New York: Wittenborn, Schultz, 1947), p. 75.

3. The periodical's title had no initial capitalization, underscoring the publication's universality and openness, and a device that was something of a literary vogue at the time.

4. The art critic Thomas Hess later confirmed this about Kootz in his writings.

5. On 21 March 1947, after Motherwell's work arrived at the gallery, Kootz wrote to the artist: "I opened up your paintings today and I'm bowled over at the advances you've made this year. Something like this is heartening and makes me feel the gallery is worth doing" (Motherwell archives).

6. According to Motherwell, Lee Krasner had made him *persona non grata* with Pollock (conversations with the artist, 1983–1986).

7. According to Motherwell's contract with Kootz, the artist's annual quota of work owed the gallery was not only steep, but excessively rigid in terms of size and medium (Motherwell archives).

Statement in *Motherwell* 1947

As noted earlier, Motherwell had signed a contract with the Kootz Gallery in New York City in early 1945. He was given his first one-man show there in the following year, and, except for a year's interruption when the gallery temporarily closed to the general public, he remained affiliated with Kootz until early 1955. In April 1947, he showed sixteen works in a solo exhibition entitled "Motherwell" and wrote a statement for the unpaginated catalog. ■

I begin a painting with a series of mistakes. The painting comes out of the correction of mistakes by feeling. I begin with shapes and colors which are not related internally nor to the external world; I work with-

out images. Ultimate unifications come about through modulation of the surface by innumerable trials and errors. The final picture is the process arrested at the moment when what I was looking for flashes into view. My pictures have layers of mistakes buried in them—an X-ray would disclose crimes—layers of consciousness, of willing. They are a succession of humiliations resulting from the realization that only in a state of quickened subjectivity—of freedom from conscious notions, and with what I always suppose to be secondary or accidental colors and shapes—do I find the unknown, which nevertheless I recognize when I come upon it, for which I am always searching.

The absolute which lies in the background of all my activities of relating seems to retreat as I get on its track; yet the relative cannot exist without some point of support. However, the closer one gets to the absolute, the more mercilessly all the weaknesses of my work are revealed.

For me the medium of oil painting resists, more strongly than others, content cut off from external relations. It continually threatens, because of its motility and subtlety, to complicate a work beyond the simplicity inherent in a high order of abstraction. I attribute my increasing devotion to oil lately, as against the constructionalism of collage, to a greater involvement in the human world. A shift in one's human situation entails a shift in one's technique and subject matter.

Letter to Christian Zervos 13 June 1947

In addition to the Documents of Modern Art, George Wittenborn and Heinz Schultz published another series for which Motherwell served as director and editor. Problems of Contemporary Art, designated as somewhat more ephemeral than the Documents of Modern Art, was *planned as an open forum for twentieth-century artists, scholars, and writers, the word "art" being taken in the broadest sense. A medium for exchanging work and ideas, it* [was] *to be controversial in nature.* Conceived as a periodical, *possibilities 1* appeared in approximately two thousand copies during the winter of 1947/1948 as the fourth title in this series.

In the nearly two years the magazine was in preparation, Motherwell attempted to expand its concentration solely on art (as Wittenborn had wanted) to include other aspects of modern culture. Hoping to *make a magazine which* [was] *international in character,* he used publications such as *Verve* and the pioneering, Paris-based *Transition* as two of several models. As general editor, he selected Harold Rosenberg as co-editor for literature, John Cage for music, and Pierre Chareau for architecture, serving as art editor of the magazine himself.[1]

Writing from East Hampton to Christian Zervos in France on 13

June 1947 for permission to use Joan Miró's poems in *possibilities,* Motherwell explained his new venture to the editor of the preeminent art magazine *Cahiers d'art.* (Miró's poems were replaced by an interview with the Spanish artist.) ■

Dear Mr. Zervos:

Some of us artists are beginning a small review in order to combat the indifference to, and reaction against, modern art in the United States; and when I spoke to Miró about printing an American translation of his poems in the last number of *Cahiers d'art,* he said that he was in accord; and so I should like to ask you if, as the original publisher of Miró's poems, we might have your permission also. We are trying as hard as possible to make a magazine which is international in character, and in a moment in which the entire world is becoming chauvinistic, the task is not easy. [. . .]

With my best wishes and admiration for your work.

Note

1. In selecting a name for the new magazine, Rosenberg had first suggested "Problems of Contemporary Art: Transformations," with no subtitle, or one Motherwell evidently preferred, "Notebook of Painters and Writing." It was Rosenberg who chose the magazine's final name and suggested as a model the format of *Commentary,* a periodical for which he had written. On the printed letterhead for this correspondence to Zervos, which lists the magazine's four editors, Motherwell had crossed out the title "Transformations" and replaced it with "possibilities" (Motherwell archives).

Editorial Preface to *possibilities 1* Winter 1947/1948

In the mid- to late 1940s, when work on *possibilities* was in progress, Motherwell and Harold Rosenberg (who spent extended summers and long weekends in the East Hampton, Long Island, area) were close associates. They were also the prime movers behind the publication. Apart from their general intellectual *bull sessions,* primarily about avant-garde art and French literature, they exchanged ideas and correspondence about the production of the new magazine, and in September 1947 they co-signed the Editorial Preface to it.

For his part as literary editor of the magazine, Rosenberg wrote a play, "The Stages: A Geography of Human Action," for publication in it. He also solicited articles from Lionel Abel and Paul Goodman, among others, and, hoping "to spring new guys," from Andrea Caffi and Lino Novás Calvo, neither of whom had published in the United States.[1] His "Introduction to Six American Artists," the English version of his introduction to the catalog accompanying Kootz's Paris ex-

hibit earlier in the year, was included. Motherwell received manuscripts from Jean Arp, William Baziotes (who also included a favorite text by Paul Valéry), William Stanley Hayter, Jackson Pollock, Mark Rothko, and David Smith;[2] an interview of Miró by Francis Lee; and the essay "En Avant Dada," by Charles R. Hulbeck, anticipating the inclusion of this article in the anthology *The Dada Painters and Poets,* on which Motherwell was already working.[3] John Cage supplied what was essentially biographical and bibliographical material on contemporary music, and Pierre Chareau contributed modestly on architecture. Published in the winter of 1947/1948, *possibilities 1* was the first magazine in the United States devoted exclusively to modern art and culture. For a number of reasons, including George Wittenborn's dislike of Rosenberg, the "occasional publication" was discontinued. The second issue was to have set the first into balance and strengthen the international character that Motherwell had originally wanted.[4]

The Editorial Preface to *possibilities* is essentially an artistic credo. If it is compared with other of Motherwell's writings of the period, it would appear that he had settled for himself the question of commitment to the artistic versus the political act, still an issue here, suggesting that the thrust of the writing is Rosenberg's. Motherwell's discarded drafts for the preface reveal that he had intended quite a different approach, which he must have relinquished to Rosenberg's persuasion. Using as his epigraph a quote from Nietzsche—"The strong man is the one who can wait"—Motherwell began one of these drafts with: *The problem of the artist is to wait until reality speaks to him. [. . .] To do nothing until a work, an image, a clear structure begins to unfold its meaning.*[5] The first three sentences of the published piece are most probably his alone. Although Motherwell's actual writing for the publication is modest, his conception for it and his effort in its realization are noteworthy among his literary accomplishments. ■

This is a magazine of artists and writers who "practice" in their work their own experience without seeking to transcend it in academic, group or political formulas.

Such practice implies the belief that through conversion of energy something valid may come out, whatever situation one is forced to begin with.

This question of what will emerge is left open. One functions in an attitude of expectancy. As Juan Gris said: you are lost the instant you know what the result will be.

Naturally the deadly political situation exerts an enormous pressure.

The temptation is to conclude that organized social thinking is "more serious" than the act that sets free in contemporary experience forms which that experience has made possible.

One who yields to this temptation makes a choice among various theories of manipulating the known elements of the so-called objective state of affairs. Once the political choice has been made, art and literature ought of course to be given up.

Whoever genuinely believes he knows how to save humanity from catastrophe has a job before him which is certainly not a part-time one.

Political commitment in our times means logically—no art, no literature. A great many people, however, find it possible to hang around in the space between art and political action.

If one is to continue to paint or write as the political trap seems to close upon him he must perhaps have the extremest faith in sheer possibility.

In his extremism he shows that he has recognized how drastic the political presence is.

Notes

1. Harold Rosenberg to Robert Motherwell, 10 February 1947 (Motherwell archives).
2. Invited by Motherwell to contribute, Pollock sent a statement (which was later extensively quoted) in which he described his process of tacking an unstretched canvas to the wall or floor: "On the floor, I am more at ease. I feel nearer, more a part of the painting, since this way I can walk around it, work from the four sides and literally be *in* the painting. [. . .] When I am *in* my painting, I'm not aware of what I'm doing. It is only after a sort of 'get acquainted' period that I see what I have been about" ("My Painting," in *possibilities 1: An Occasional Review,* Problems of Contemporary Art, no. 4 [New York: Wittenborn, Schultz, 1947], p. 79).
Rothko, feeling uncertain about what he had submitted to the magazine, requested that Motherwell make whatever changes he felt necessary. In editing the essay, Motherwell altered the sequence of paragraphs, much to Rothko's displeasure. Rothko nevertheless granted permission for its publication (Motherwell archives). Although in recent years Motherwell acknowledged that he still felt that the alteration had made Rothko's piece more effective, he expressed his *presumption in Frenchifying it"* (conversation with the artist, 24 August 1985).
Judging from a copy of an undated letter written by Motherwell to Baziotes, in which he apologized for omissions in the material Baziotes had submitted, Motherwell's editing caused additional criticism (Motherwell archives).
After he received a copy of *possibilities* late in 1947, David Smith wrote to Motherwell (the two artists had not as yet met): "I was pleased to see the Picassos [the magazine contained scores of illustrations]. While I naturally admire him still, I think there is a lot to be said for our American painters. And we need it more. I liked the balance, and I hope the magazine becomes the most important in all American aesthetics" (Motherwell archives).
3. Robert Motherwell, ed., *The Dada Painters and Poets: An Anthology,* Documents of Modern Art, no. 8 (New York: Wittenborn, Schultz, 1951).

4. Conversations with the artist, 1983–1986.

5. The draft is at the Motherwell archives.

Prefatory Note to *Max Ernst: Beyond Painting*
and Other Writings by the Artist and His Friends 1948

The selection of *Max Ernst: Beyond Painting and Other Writings by the Artist and His Friends* for the Documents of Modern Art series had been Motherwell's idea. His Prefatory Note to the book was signed and dated *June, 1948.*

Motherwell and Ernst had met in New York after Motherwell's return from Mexico, most likely in early 1942 in their association with the first issue of the surrealist periodical *VVV.* During preparation of the Wittenborn and Schultz publication in 1947, Ernst was living in Arizona, and communication from him regarding production of his book continued through a lively correspondence with Motherwell.[1] In 1952, several years after *Max Ernst* appeared, Motherwell introduced the artist in "An Evening with Max Ernst" at the Artists' Club in New York.[2]

Motherwell's preface to this volume reveals his aesthetic stretch to include Ernst in his artistic pantheon. Ernst's painting was focused in the literary and pictorial arena in which surrealism had best projected itself; however, it reflected a deeper tradition in European culture, embracing art and literature in a totality that appealed to Motherwell. Also, with Jean Arp, Ernst had actively collaborated in the Cologne dada movement and had organized the first dada exhibition there in 1919. For Motherwell, Ernst's writings, painting, and background were a natural bridge for his own immediate interest in surrealism and his questions about its origins in dada. The Ernst book, along with Arp's *On My Way: Poetry and Essays 1912–1947,*[3] were steps to the realization of *The Dada Painters and Poets,* which was already in progress. ∎

The struggle of most modern painters takes place in their studios, their structural devices are plastic means for reproducing dramas that happen within the self. Their assault upon society is by indirection, through contrasting the subjectively real with the conventional. In contrast, Max Ernst is among the few consequential modern painters whose concern is directly with the external world, with the world of social events and institutions—the Church, political repression, erotic enslavement. His work is filled with ironies and cruelties, sarcasms and satires. For example, his *Natural History* is an act of revolt projected from the level of poetry against the rational approach to nature as we find it in science books. It is a poetic act. And one specifically surrealist.

I for one am not in the least disturbed by the fact that modes of expression that mean much to me . . . minimization of the role of

objects, tactility, flatness, abstract plasticity . . . are ignored or even undermined by Ernst's painting. His subject matter is contemporary history, for him man is essentially a historical creature; Ernst has to employ images, objects, all the paraphernalia of the external world; he warns, criticizes, jeers, prophesies, lays bare suppressed fantasies. His vision is that "nothing is in order," that the order out there has nothing to do with a truly human order, that we are victims of history. His art depends on the sense of a vicious past.

To the American mind nothing could be more alien than such a contest with the past. Such images as a black mass, a bloody nun, an invader from the east cannot arouse deep feelings in most of us. Time gives objects and images their qualities of love and hate; generations of connotations, associations, sense experiences are what make the past. But for better or worse, most Americans have no sensation of being either elevated or smothered by the past; most of us (or our ancestors) came here in order to cease to deal with the past. Consciously abandoning the past is the essentially American creative act; we painters here remain indifferent to the objects surrounding us. Our emotional interest is not in the external world, but in creating a world of our own, and it is precisely those artists here who are not "conscious" who behave as if America had a usable past.

It is from this reasoning that we can account for the fact that objectless painting, that is, various modes of abstraction, appeals more to most modern American painters than surrealism. But the American experience is a small part of the story of modern art which, with its variety, its contradictions and dilemmas, its heroic monsters and monstrous victims, is a reflection of the general human situation in our time. Human reality appears in it as constituted of bitter and relentless struggles over each person's image of the world . . . struggles located largely on unconscious and symbolic planes of action. What absorbs me in the history of modern art is the ingenuity and inventiveness, the wit and subtlety, the implacability and force with which each modern painter has carried out his assaults upon the conventional world.

Like every consequential modern painter, Max Ernst has enforced his own madness on the world, which has to submit, since madness that moves and creates is a liberation, in contrast to the sterile madness of people tied to conventions . . .

These reflections support my spontaneous interest in the universe of Max Ernst. They do not account for my personal affection for him during the five or six years I have known him, the natural affection of a younger painter who has been treated in a friendly, generous, fraternal way by a mature painter and personality whose freedom in action, gesture, and speech makes his company always lively and liberating. But even one not acquainted with him, and committed, as I am, to quite another vision in painting, would inevitably be brought, some

time or other, to contemplate his message. His work represents the assault of his poetics on the conventional, including many of the conventions of modern plasticity.

Notes

1. The correspondence is at the Motherwell archives.
2. Also called "The Club" or the "Eighth Street Club," located at 39 East Eighth Street, in Greenwich Village, the Artists' Club was organized in 1949 by a group of artists headed by Philip Pavia and limited its membership to artists, with Friday evenings open to guests. Motherwell, dissatisfied with the club's lack of structure, free-for-all atmosphere, and politics, stopped attending soon after he introduced Ernst.
3. Jean (Hans) Arp, *On My Way: Poetry and Essays 1912–1947*, Documents of Modern Art, no. 6, trans. Ralph Manheim (New York: Wittenborn, Schultz, 1948).

Prefatory Note to Jean (Hans) Arp, *On My Way: Poetry and Essays 1912–1947* 1948

Early in 1949 and a few months after Motherwell had completed work on a book of Jean Arp's writings for the Documents of Modern Art series, he invited the artist to speak at a Friday-evening session of the school that he and three other artists had opened in the autumn of 1948.

Subjects of the Artist, advertised in the *New York Times* on 12 September 1948 as "a new kind of art school," was organized by Motherwell, with William Baziotes, David Hare, and Mark Rothko, and opened at 35 East Eighth Street on 11 October. The idea of bringing together in a teaching group both young artists and more seasoned ones in a city milieu had been Clyfford Still's, although teaching commitments in California precluded his participation.[1] Barnett Newman joined the group after the Christmas break primarily to administrate, and it was probably he who gave the school its name. For personal reasons, Rothko and Hare left the school before it closed in May 1949.

A printed prospectus stated that the school was for anyone who wished "to reach beyond conventional modes of expression." Students were to be viewed as collaborators with the artists "in the investigation of the artistic process, its modern conditions, possibilities, and extreme nature, through discussions and practice" (Appendix B). Classes were conducted four evenings a week, with Friday-evening sessions for special invited speakers, such as Arp.[2]

As an artist, poet, writer, theorist, and active participant in the dada movement, Jean (Hans) Arp had made a strong impression on Motherwell, dating back to when he was a student at Stanford University.[3] Motherwell had personally selected Arp's writings for publication in the Documents of Modern Art, and, as general editor of the Documents of 20th-Century Art, he produced another book on the artist's writings, *Arp on Arp: Poems, Essays, Memories.*[4]

While on his only visit to the United States, in early 1949, Arp resumed his friendships with old-time European dadaists and participated in the decision to publish a new manifesto in Motherwell's *Dada Painters and Poets,* then in progress. He gave Motherwell several suggestions for the book and, in addition to contributing existing writings and a number of illustrations, wrote "Dada Was Not a Farce" especially for it.

Arp's *On My Way: Poetry and Essays 1912–1947* was published in late 1948. In his Prefatory Note to the volume, written on Long Island and dated *24 August 1948,* Motherwell diverged from his more scholarly approach to one more poetic, perhaps responding to prevailing perceptions of him as an editor rather than a creator. Using unlined drawing paper, a practice he continued over the years, Motherwell printed his first draft, which remains one of the few examples not written in longhand. The second draft was written in the script that identifies most of the artist's handwriting. ■

Shadowy figure in a low, modern doorway; marble white, precisely carved biomorphic eggs; light blue and white jigsaw puzzles, cleanly painted like fishermen's buoys or toy boats; full of satires ("man is a pot the handles of which fell out of his own holes"); loving "nature but not its substitute," representation; a modern man who hates for art or the world to wear the costumes of the past, a man who loathes the intrusion of the social world.

The "world of memory and dreams is the real world"; there Arp would live as a private citizen, but thought of the social world arouses his rage; his invective equalled only by that of his friend Max Ernst and of Picasso and Wyndham Lewis among modernist artists; his words explode at the workings of modern society, costumed fraud; he cannot bear that the "daily black joke" exists beside the "real world"; the dadaist in him is aroused, and he writes true poetry, spontaneous and unforced, without desire to "be" a poet.

The emotion in his sculpture is prolonged; it is carved from hard stones; rage never enters his plastic work. Even the torn papers in his collages "arranged according to the laws of chance" which might, to the innocent, seem angry rebellion against traditional art are serene, an effort to find a natural order, like that of leaves fallen on the ground (an order like any other when perceived as such, and relaxed and uninsistent). He finds correspondences for the volumes and rhythms of the surface of the human body, quiet and living, in bed, in the studio, and on the bank of the river, wherever it moves slowly or rests stationary.

Imagine coming upon one of Arp's sculptures of "stone formed by human hand" in midst of a wood. Few artists in modern times enhance nature, perhaps only Arp. Brancusi's outdoor works are monumental

stone tables and columns on the scale of the elements, settings for a modern Oedipus or Lear; Alberto Giacometti's recent figures are pervaded with anguish, the "I" seen from distance, untouched, a stranger in the world of nature and man. Arp is a true pastoral artist ("my reliefs and sculptures fit naturally in nature"); his scale derives from adjusting the human body to its surroundings, garden or field; his process is slow and even as nature's, carving that has the effect of water run over human stones ("the empty spaces in the marble nests . . . were fragrant as flowers"). No wonder predatory man nauseates him! His love is permanent.

The sky is August blue. Green skins dangle from the wild cherry trees. Its hair scorched, the ground drowses. If an Arp sculpture were present, it too would sleep in the sun ("I work until enough of my life has flowed into its body").

Notes

1. Still and Rothko had visited Motherwell in East Hampton during the summer of 1948 to discuss Still's plans for a school.

2. Among other speakers in 1949, all introduced by Motherwell, were Joseph Cornell, who showed his unique collection of films on 21 January; John Cage, who performed on 28 January; Dr. Charles R. Hulbeck, who presented "Dada Days" on 4 February; and Harry Holtzman, who delivered "Every Man His Own Hero" on 1 April.

3. Motherwell had come upon an issue of *Transition* (no. 14 [Fall 1932]), illustrating a mural that Arp had executed in 1926 for the Aubette building in Strasbourg. Pictured in black and white, the painting (later destroyed) had apparently extended the length of an entire wall, presenting a series of silhouetted and overlapping forms that, because of Arp's treatment, gave the image a monumental scale. No doubt Arp's work remained in Motherwell's subconscious, years later emerging into the making of his *Elegies to the Spanish Republic* (beginning in 1948).

4. Jean Arp, *Arp on Arp: Poems, Essays, Memories,* Documents of 20th-Century Art, ed. Marcel Jean (New York: Viking Press, 1972).

"A Tour of the Sublime" 15 December 1948

The fall of 1948 was a difficult and decisive time for Motherwell. For personal reasons, he left East Hampton and moved back to New York City,[1] and although he returned to Long Island for short durations during the next two years, the ultimate break was to be final.

For both Motherwell's painting and his literary work, the period in the Hampton area had been one of the most intensely productive of his career. During these five years, he had found almost all his basic painting ideas—the colors, themes, forms, and attitudes he would expand and elaborate on for decades. On Long Island, he had nurtured his earlier "discoveries" of automatism and collage, and had executed such individual works of note as *The Homely Protestant* (1948) and the seminal drawing for what would become his *Elegy* series. He had painted

pictures for his first one-man exhibit at Art of This Century, for annual solo shows at the Kootz Gallery (as well as to honor his yearly quota there), and for an exhibition at the Museum of Modern Art, all in New York City. He had lectured, taught at Black Mountain College, written and published essays, produced a magazine devoted to modern art and culture, and directed the publication of eight titles in the Documents of Modern Art, having written introductions for four of them, with subsequent titles (including *The Dada Painters and Poets*) already in progress.

After his return to New York City in the fall of 1948, and before the year ended, Motherwell wrote "A Tour of the Sublime" (originally called "Against the Sublime") for the sixth number of *Tiger's Eye*. The essay had been solicited for the magazine's forum, "Ides of Art," focusing on "What Is Sublime in Art?" to which Barnett Newman also contributed.[2] ■

The Sublime I take to be the emphasis of a possible felt quality in aesthetic experience, the exalted, the noble, the lofty, "the echo of a great mind," as the treatise formerly ascribed to Longinus phrases it.

The history of modern art can be conceived of as a military campaign, as a civil war that has lasted more than a hundred years—if movements of the spirit can be dated—since Baudelaire first requested a painting that was to be specifically *modern* in subject and style. Perhaps the first dent in the lines of traditional conceptions was made by the English landscapists and by Courbet, but the major engagement begins, earlier means being now obsolete, with Manet and the impressionists who, whatever their subjective radiance and rhythms, represent objectively the rise of modern realism (in the sense of everyday subjects), that is, the decisive attack on the Sublime . . . The story is interesting if the essence of their goal is taken to be a passionate desire to get rid of what is dead in human experience, to get rid of concepts, whether aesthetic or metaphysical or ethical or social, that, being garbed in the costumes of the past, get in the way of their enjoyment. As though they had the sensation, while enjoying nudes in the open air, that someone was likely to move a dark Baroque décor into the background, altering the felt quality of their experience. No wonder they wanted to bury the past permanently. I pass over how remarkable it seems to some of us that small groups of men should have had, for a century or more, as one of their ideals getting rid of what is dead in human experience.

A true history of modern art will take account of its innumerable concrete rejections. True, it is more difficult to think under the aspect of negations, or to contend with what is not stated. But this does not justify the history of an indirect process being written under the category of the direct. I do not see how the works of a Mondrian or Duchamp can be described apart from a description of what they refused

to do. Indeed, a painter's most difficult and far-reaching decisions re-
volve around his rejections.

Suppose that we assume that, despite defaults and confusions, mod-
ern art succeeded in ridding us of the costumes of the past, of kings
and queens and the glory of conquerors and politicos and mountains,
rhetoric and the grand, that it became, though "understood" only by
a minority, a people's art, a peculiarly modern humanism, that its tac-
tics in relation to the general human situation were those of gentle,
strong, and humane men defending their values with intelligence and
ingenuity against the property-loving world. One ought not oversim-
plify: if humane men would doubtless agree with the character in Dos-
toyevsky who holds that no gain, social or military, can be equated
against the life of a single child, nevertheless I take a murderer by
profession like "Monsieur Verdoux" to fall under the heading of the
gentle, strong, and humane, that is to say, it does not astonish me that
the effort to be gentle and humane involves one in murder. Indeed,
without trying to present a paradox, but simply in an effort to be
phenomenologically exact, and speaking apart from times of war, one
might say that it is only the most inhuman professions in modern so-
ciety that permit the agent to behave nicely in everyday life and to
regard the world with a merry and well-glassed eye.

When living Ulysses meets in Hades the shade of Ajax, from whom
he had won the armor and set on the course that led to Ajax's death,
Ulysses expresses his regret; but Ajax "did not answer, but went his
way on into Erebus with the other wraiths of those dead and gone."
One has not the right from one's anguish to bring to the surface an-
other's anguish. This must be the meaning of the first century A.D.
treatise on the Sublime when it says: "The silence of Ajax in *The Wraiths*
is inexpressibly great." Otherwise it can only mean how terrible is
being dead.

Perhaps—I say perhaps because I do not know how to reflect, except
by opening my mind like a glass-bottomed boat so that I can watch
what is swimming below—painting becomes Sublime when the artist
transcends his personal anguish, when he projects in the midst of a
shrieking world an expression of living and its end that is silent and
ordered. That is opposed to expressionism. So is the beauty and per-
fection of the school of Paris. Like the latter, all of us must reject the
Sublime in the social sense, in its association with institutional author-
ity, regardless of one's relation to beauty as an ideal. In the metaphys-
ical sense, it cannot be a question of intent, one experiences the Sub-
lime or not, according to one's fate and character.

Notes

1. Hoping to avoid the breakup of his six-year marriage to María Emilia Fer-
reira y Moyers, who felt isolated in the country, Motherwell made the decision to
move.

2. Other contributors to this forum were Nicholas Calas, Kurt Seligmann, and John Stephan.

As different as they were in projection, Motherwell's and Newman's pieces were surprisingly similar in content. Both artists set their subject into historical and philosophical perspective, tracing the concept of the sublime from its identification with ideal beauty, as fostered by the Greeks, to the modern artist's extrication of beauty as a necessary requisite to or product of expression. Commenting on this a few years ago, Motherwell said: *When all these things were published, Barney, who was not a generous man, embraced me, saying, "You're the one who's right." I remember it vividly since it was so unlike him. Today, I'd say his piece is better* (conversation with the artist, 19 May 1985).

Preliminary Notice to Daniel-Henry Kahnweiler, *The Rise of Cubism* 1949

■ *The Rise of Cubism* was the first English translation of Daniel-Henry Kahnweiler's *Der Weg zum Kubismus* (1915), written just after major advances in the movement had occurred but not published until 1920. Kahnweiler's association and close friendship with many of the cubist artists, particularly Picasso and Braque, had provided the art dealer an unparalleled vantage point in his advocacy and documentation of this heroic period in modern art. Kahnweiler's book had been suggested by Motherwell as a title for the Documents of Modern Art and appeared in that series in 1949. For the volume, he supplied a Preliminary Notice, written in New York City and dated *February 22, 1949.*

For Motherwell, the years between 1910 and 1912, when Braque and Picasso reached *cubism's highest flights,* were the most vital in the development of modern art. When he visited the exhibition devoted to the cubist work of these two artists at the Museum of Modern Art in 1989, Motherwell spent the afternoon viewing the paintings and collages made in those years. ■

Cubism began as an analysis of the nature of the aesthetic. The present little book is an account of the cubists' experiments by a man who was their friend and advocate, as well as a dealer in their works, a man who has reflected on their achievement all his life. Kahnweiler formulates their problem in the beginning of this book in the sentence that reads, *"representation and structure conflict."* Written as early as 1915, this book is the story of the solution that they worked toward; when it came to be seen, it broke the back, if only temporarily, of centuries of naturalistic representation. Since then the struggle to be free from nature has passed into other hands, and will pass in turn to still others— as long as modern society remains what it is, and man's insight into it and himself increases, the distance between the objects in the world and an enlightened mind will lengthen. In accord with its analytical intent, cubism started in a mood of objectivity. From this derives its

famous "purity," from its indifference to the demands of the "I" before an objective problem. This morality has been inherited by many abstract artists and architects; it is in direct opposition to expressionism, which asserts the dominance of the "I" above everything. Part of the beauty inherent in the cubist enterprise lies in that for a time their minds were questioning and open about the forms of painting, though they scarcely transformed at all its subject matter. Doubtless they seized upon Cézanne too quickly, but they were eager to act, and he provided one of the few precedents for a reconsideration of modern painting. They also listened to poets who had been influenced by Mallarmé and the symbolists, notably Guillaume Apollinaire; they talked, probably in a purely intuitive way, of modern science; and all the time in their studios they were struggling with the absolutes of painting. But from their free bohemian life they had already rid their minds of history, middle-class society, religion. Essential steps. Nevertheless the cubists' painting world was filled with objects—nudes, trees, houses, still life. Sometime in 1909 or 1910 Picasso took "the great step," as Kahnweiler puts it, and pierced the "skin" of objects, reducing them and the world in which they existed to what we would now call subjective process. With this step cubism snapped traditional naturalism. Working with great intelligence, stubbornness, and objectivity, they stumbled over the leading insight of the twentieth century, all thought and feeling is relative to man, he does not reflect the world but invents it. Man is his own invention; every artist's problem is to invent himself. How stupid from this point of view to pass one's time copying nature or history. And what an invention is Mozart! Through analysis and work of great objectivity, Braque and Picasso were led directly to the subjective—I am speaking of the brief period when their insight did not waver—to the problem of inventing themselves. It is in a much deeper sense than Manolo[1] guessed when he made his crude joke that Picasso's family would not have recognized him at the Barcelona station if he had descended as a cubist portrait. Cubism invented Picasso as much as he invented cubism; it revealed himself to himself, as painting does to every true painter; of course it made him unintelligible to others. In looking back now, one is not certain how completely the cubists possessed their insight. It is shocking to read in this book of their fears of being unintelligible, of their confusing the sudden appearance of their subjectivity with the appearances of the external world, as though one would look like the other; it is shocking too that they were afraid that the work might be merely decorative—a mistaken image Kahnweiler still has of Mondrian and other nonfigurative painters. But we must remember in what a sea of confusions everyone begins, even genius, and for that matter often ends; everyone's life has to be spent in transcending his initial inheritances. In the sense that he has been chosen in modern times by the artist as his special enemy, a middle-class person is one who is what he has learned from conventions. Around 1910-12,

in cubism's highest flights, what is striking is not the material structure that Kahnweiler and most abstract artists like to speak of, but a sensitive calligraphy that sweeps up internal and external worlds into a oneness in which reality consists not of opposing essences of matter and spirit, representation and structure, but of relations, process. During these years cubism approached ecstasy. Presently it lost its intuition of the mysterious, and they returned to Western construction, like carpenters or masons. Corot, Courbet, and the impressionists made the subject matter of modern art secular. The cubists accepted from them landscape and still life, and from the academic tradition the nude. These subjects the cubists mildly transformed into their own intimate objects, bare rooms in place of the outdoors, glasses, playing cards, labels, newspapers, musical instruments in place of fruit, and, one supposes, their own girls in place of the model in a public studio. But the intrinsic conflict between subjectivity and the objects of the world, between structure and representation, as Kahnweiler puts it, led them slowly to abandon natural appearances as much as they could in the interests of art; this process constituted their dramatic conflict, which they resolved long enough to liberate everyone after them, and then abandoned, for they refused to give up their studio subjects. Tender and lyrical, perhaps for the moment unable to stand expressionist distortion, the cubists came to invent a new sign language with which to refer to their familiar objects in the studio, signs whose meaning was arbitrary, invented, and by definition, like other symbolic structures: words or relational logic or the language of deaf-mutes. Cubism was filled with the optimistic desire to be modern that Apollinaire expressed; but when cubism returned later to its pleasure-giving objects, it became filled with nostalgia, with a sense of their certain decay. When the cubists painted still life they may have intended, as one says in French, *nature morte* . . . I say these things as all of us artists like to speak, not as history, but as evocative of what I have seen and guessed; nothing of interest can be spoken of save by indirection. This was just cubism's insight. For several years the cubists painted as if no truth is true that is not subtle.

Note

1. Manuel Martínez Hugué Manolo (1872–1945), Spanish sculptor and a friend of Picasso.

"A Personal Expression" 19 March 1949

Soon after he presented his lecture "A Personal Expression" in 1949, Motherwell wrote a note of clarification to it:

The following lecture, delivered under the auspices of the Seventh Annual Conference of the Committee on Art Education sponsored by the

Museum of Modern Art, New York City, was delivered on the afternoon of
19 March 1949 in the auditorium of the Central High School of Needle
Trades, New York City. The lecture was written all through the night be-
fore; there is scarcely a sentence in it whose formulation seems to me suffi-
ciently exact. The present version is slightly revised; the substance is the same.

It seems clear that Motherwell later reviewed his lecture notes, proba-
bly written in a state of extreme frustration, and felt uncomfortable
with their intensity. Even in the present version, there is nowhere among
his writings an occasion when he so sharply expressed his annoyance
with prevailing attitudes about his activity as an editor and a teacher
and with the label "intellectual" pejoratively applied to him. The prej-
udice, which may seem unfathomable outside the context of the period
(that is, *the belief that an artist must be a feeling imbecile or probably is not
an artist*), had haunted Motherwell throughout much of his early ca-
reer. As he stated in this lecture, his resistance to public speaking and
to writing was overridden, here and elsewhere, by a sense of intellec-
tual responsibility—that he might less mislead the audience in describ-
ing the new art than would others who were eager to fill the vacuum.
"A Personal Expression" remains one of the most passionate state-
ments of his artistic credo.

Entitled "The Artist's Point of View," the ninth session of the con-
ference series was moderated by Ruth Reeves, with Balcomb Greene
and Ben Shahn as the other artist contributors. The occasion marked
the first public disagreement between Shahn and Motherwell on the
nature and purpose of painting. The verbal altercation that followed
their presentations may in part account for some of the intensity re-
maining in Motherwell's revision. ■

First, I want to apologize for speaking here today. I—no more than
any artist—believe in these forums, either that they are very pleasura-
ble to participate in or that they can accomplish very much. I ought to
be painting in my studio, where the dramas that interest me take place.
I expect to leave here frustrated and tired, too excited to feel at peace.
I do not even know why I was chosen to speak, I knew no one con-
cerned in this affair and if, as I have heard, the theme of these confer-
ences is "Art and the Unity of Mankind," I have no ideas on the sub-
ject: it does not move my imagination. Besides, I believe that the artist's
problems are the same as every man's. Sometimes artists are more con-
scious of these problems—though certainly not everyone who calls
himself an artist is—and plainly from certain points of view someone
other than the artist is more competent to speak . . . I accepted the
invitation today for tactical reasons, from a sense of intellectual respon-
sibility. When the artist refuses to speak at these forums on art, they
are generally taken over by professional "horners in." I hope, though

I may not succeed, that I will mislead you less. Yet on the level that art interests me, only the poet has an adequate rhetoric.

I suppose that I was asked to speak to you here today because I am sometimes taken for an "intellectual" among the artists. If you do not mind, I will take this for my subject. I feel pretentious in speaking of anything but my own experience.

I doubt if very many people regard my painting as predominantly intellectual. I should guess that when it moves anyone it is because of its moral struggle. For the rest, when I look at my painting as detachedly as I can, it appears to me as warm, sensual, silent, and felt, all qualities related to its internal morality. Aesthetic decisions in the process of painting are not primarily aesthetic in origin but moral, and nowadays largely negative. One might say today that the morality of a picture is unusually dependent on what the artist refused to accept in it as bearable. Modern pictures—"abstract" ones, that is—tend to be the residues of a moral process.

But such pictures are also assertions of positive values, conscious or not, presentational structures (in the language of modern logic) there to be felt. In my own work, for instance, sometimes there is humor, a kind of *blague* as a critic recently wrote, with different ranges of reference—technical, social, and perhaps even metaphysical—I am not sure. Sometimes my essential loneliness creeps into the work, or anguish. But I try to suppress these qualities. It is more seemly to keep one's suffering to oneself. I resent it when I see that I was unable, on occasion, to muffle the shriek that lies deep in nearly everyone. My main effort is to come into harmony with myself, to paint as I breathe or move, or dream, to make works that are as natural in their execution, as inevitable in their ultimate form as a stone or a wall. To realize such an ideal is a lifelong task.

I take neither my subjects nor the modes of painting them from the world of intellectuals. I have been mainly a lyrical artist, a "poet," if you like, with occasional dramatic or satirical overtones. I loathe every form of ideology: politics, religion, aesthetics, domestic relations. I am interested in persons who are independent moral agents. Most "intellectuals" I have seen were quite properly labeled by a friend of mine, Harold Rosenberg,[1] the poet, as "a herd of independent minds." But I also dislike painters who talk as though they were carpenters or some other kind of craftsman, who speak as though art is not a question of inspiration—of something in you that rises as simply, beautifully, and unpredictably as the flight of a bird.

I think I have been accused of being an "intellectual" on other grounds than my painting. I have been extremely active, but perhaps psychologically it is incidental that the actions have been in relation to art. My father was an active man, a banker, who wanted me to enter a profession, medicine or law. I resisted, though I knew he was con-

cerned with my welfare, because I wanted to be a painter. At the same time, I had no means to resist, because I wanted only to be a "modern" painter. In those days, fifteen years ago, I was greatly taken as I still am by the work of Henri Matisse, and I knew no "modern" painters nor how to begin. It was only eight years ago, when I was twenty-six, that Professor Meyer Schapiro kindly introduced me to the Parisian surrealists, who were beginning their exodus to New York; they treated me tolerantly and I was able to begin to paint.

In the years between the ages of seventeen and twenty-six, under an unspoken agreement with my father, I studied philosophy in various universities and travelled, here and abroad. I had begun my studies with literature and art, but even in those days I quickly understood that they cannot be taught academically. I chose philosophy instead. The Greeks and the early Christians, the continental Renaissance philosophers and the British empiricists, and moderns such as Charles Sanders Pierce and Alfred North Whitehead, who was still living in Cambridge when I was at Harvard, became my constant companions and ingrained in me a humanism that remains a basic element in my feelings. Otherwise I think these studies had little effect on my attitudes toward painting; modern French poetry was more decisive, except in incidental points; for instance, the possibility that if you understand modern relational logic, the structural basis of Mondrian's painting may be more easily described. Still, the thing to do with a Mondrian is to feel it, as we all know. Plainly philosophy itself is not a proper subject for painting—not even Raphael could manage it.

Perhaps the chief advantage of a liberal arts university education is learning to express oneself readily in language. From the outside world, I learned the importance of this as a weapon; and I would be untruthful if I say that I regret, on the whole, having been armed. The struggle of each new generation of "modern" painters is to make the "modern" world felt, to capture the youngest generation, who are always humanity's hope. This struggle takes place, especially where English is spoken, in a culture dominated by words. Everything is done through the word: the man who writes about the artist gains position and livelihood; the artist himself is treated, as the case may be, as gentle or unmanageable, but in any case as not knowing what he is doing, as inarticulate in words, as if they were the same thing! I cannot help believing that *what the art situation in America needs most is to get art away from the universities and museums back into the hands of painters and poets,* as has been the situation for the past century in France.

In the past four years I have been able, thanks to the good faith and courage of my publishers, Messrs. Wittenborn and Schultz, to edit for younger people books by artists or their intimate friends—by Guillaume Apollinaire, Piet Mondrian, Lazló Moholy-Nagy, Louis H. Sullivan, Wassily Kandinsky, Max Ernst, Hans Arp, and Daniel-Henry

Kahnweiler. We now have in press a large dada anthology, with contributions by Marcel Duchamp, André Breton, Tristan Tzara, Francis Picabia, Kurt Schwitters, Paul Eluard, Max Ernst, Hugo Ball, and many other dada poets and painters, as well as a survey of modern French poetry, Marcel Raymond's *From Baudelaire to Surrealism:* I believe the role of poets in making the atmosphere of ideas in which the *école de Paris* worked is underestimated here. Ultimately I should like to see in print in good English translations every major document in relation to modern art—fauvism, cubism, de Stijl, expressionism, futurism, dada, surrealism, constructivism, and the other movements and principal individuals, here and abroad, in twentieth-century art. If I may exaggerate for emphasis, the purpose of this publishing activity is obvious, to render unnecessary the reading of secondary writings about contemporary art.

Artists have their faults in writing of their art. They are often ignorant of, or indifferent to other contemporary expressions. They stack history as much as they can, often in a shocking manner. There are several scholars here in New York, such as Mr. Barr or Professor Schapiro,[2] whose knowledge of the history of twentieth-century art beggars that of any artist in its objectivity and detail and in its scholarly responsibility. This and more ought to be admitted. Yet there is some sense—one that I cannot adequately formulate—in which the statements of artists themselves constitute the literature that is most inspiring to others, and especially younger artists, as though dreams related were a more direct route to another's mind than an analysis of behavior; and it is young artists and poets, not scholars or historians, whose wants I have had in mind in editing the Documents of Modern Art series. One never knows for certain what another's needs are, but I cannot believe it has helped American artists in the recent past to have been in general so provincial. Certainly my own ignorance hindered me.

If I may move on to another controversial point, which also ought to be more adequately supported, but which at least I can offer as an opinion, it seems to me that there is no important museum collection or large annual exhibition of contemporary art in America—it is here that one sees the influence of the official and scholar—that is anything but a deformed exhibition, in its omissions and emphases, of what is living in our art—if I may distinguish between art and what passes for art. Some day, when we are all dead, the truth will be known; as Apollinaire said, "do not tell me there are today various other schools of painting in whose images humanity will be able to recognize itself. All the art works of an epoch end by resembling the most energetic, the most expressive, and the most typical works of a period . . . Who would dare to say that the dolls that were sold at bargain counters, around 1880, were shaped by a sentiment akin to what Renoir felt

when he painted his portraits? No one perceived the relationship then. But this only means that Renoir's art was sufficiently energetic to take hold of our senses, even though . . . his conception seemed absurd and foolish."

In America the chief sources of obsolete standards in relation to living art have been the university and museum; this would not be important if their influence were inconsequential, but it is important and constantly spreading in a country in which everything becomes subject to "education." Yet precisely what is "modern" in art is its assault on what is dead in immediate experience, and an affirmation of what is alive. Perhaps the university and museum ought to be taken over by artists! Or at least restricted to situations in art at least thirty years old. Perhaps then we artists could breathe. We are fed up of being bullied in terms that belong to other times and places. One might say as a joke that it is the artist, not the historian, who takes time seriously. Just as one might say that it is the abstract artist who is making the effort to recover the concrete experience. The work of nearly every painter "picturing" (in the old-fashioned sense) is filled with despair and a sense of decay, with death. The art that interests me asserts man's moral courage, intellectual daring, radiant sensuality; perhaps this "abstract" art understands death better . . .

It is not often that one finds in the academic world a scholar with the imagination to penetrate a world of absolutes lying beyond the struggle to survive materially, no matter how socially modified at base. Plainly abstract art is concomitant with a certain condition of society— a world in which there are few usable precedents or props, which is its own invention, and not without desperation. Art is a form of action, a drama, a process. It is the dramatic gesture itself in modern times, not a religious content, that accounts for art's hold on the minds of men. One enters the studio as one would an arena. One's entire character is revealed in the action, one's style, as we say, which differs from individual to individual, and from tradition to tradition. Of course, everyone undergoes risks just by living. From one point of view, the artist's function is to give each risk its proper style. In this sense everyone should be an artist.

Discussions of the artist's social responsibility are gratuitous, no matter how abstract his work. He lives in the same social relations as everyone else, and responds according to his character. The abstractness of modern art has to do with how much an enlightened mind rejects of the contemporary social order. It also has to do with an effort to find a more adequate expression of subjective experience than what one sees in the street, or on the table.

With four other abstract artists, William Baziotes, David Hare, Barney Newman, and Mark Rothko, I have formed a little school of art at 35 East Eighth Street. Clyfford Still, who wanted to join us, was unable

to find a means of living in New York City. The way to learn to paint—to begin one's orientation, I mean—is to hang around artists. We have made a place where young people can do so. We regard courses in art as they are generally taught as devices for concealing oneself from oneself. We talk to the students as we do to one another, trying to break down ignorance and clichés, encouraging each individual to find his own expression of his inner life. This kind of teaching must be done by artists. No one else "reads" plastic expressions quickly or subtly enough.

Still, in a basic sense art cannot be taught, and we do not try to. Yet paradoxically it can be learned—in the beginning from other artists, and then from oneself. We have tried to provide a congenial atmosphere for novices before they enter the arena. They are mostly on their own, but on occasion we are able to give them courage. I believe that they enjoy being around us. They know that we love them because they love art, that we sympathize with their struggle, which is identical with our own. There is little more one can do for young people.

On Friday evenings we invite other artists to talk about whatever they like—among them have been Adolph Gottlieb, Willem de Kooning, Hans Arp, Ad Reinhardt, Fritz Glarner, John Cage, the composer, and Richard Hulsenbeck, one of the founders of dada. There is always a general discussion afterward. These meetings are open to the public.

I suppose it is these various activities that have given me the name of being an "intellectual." Perhaps they make me so indeed. But I resent the invidious implications of the word in American society, the belief that an artist must be a feeling imbecile or probably is not an artist. I have no desire to act, and particularly to be known, as an editor or teacher. I am also aware of my inadequacies in relation to these activities. I resent the external disciplines that they involve, and above all the loss of time from my own painting process. I am anxious to return to it, perhaps altogether. Yet I do not regret my innocence in supposing that an artist might be something of a scholar and a gentleman. The Chinese have thought it necessary.

Now I must beg your pardon for how elementary and simple my discourse has been. It is because I have been speaking of my relations to the external world. My inner world is more complicated, and consequently difficult to express. That is why I invented my art. In this sense art is a necessity, a natural outgrowth of man's life.

Notes

1. Harold Rosenberg was not yet the prominent art and cultural critic he was to become. In recent years, Motherwell often spoke of his numerous discussions on art and literature with Rosenberg during the late 1940s, where he had used French symbolist poetry (which Rosenberg knew well and loved) for comparison with abstract expressionism, and he considered their talks an influential factor in

Rosenberg's later focus on art criticism rather than poetry (conversations with the artist, 1983–1986).

2. Alfred H. Barr, Jr., director of the Museum of Modern Art, and art historian Meyer Schapiro.

Preliminary Notice to Guillaume Apollinaire, *The Cubist Painters: Aesthetic Meditations 1913* 1949

Published in the Documents of Modern Art, initially in 1944, Guillaume Apollinaire's contemporaneous account of the cubist painters had been translated into English by Lionel Abel and had appeared as the first number in the series. It had been suggested by Heinz Schultz, but Motherwell had been in total accord with the choice. And it was no accident that a text on cubism—the decisive adventure into modernism—would be the first publication Motherwell would edit and support. Also, and this obviously pleased him, *The Cubist Painters: Aesthetic Meditations 1913* not only was authentic documentation of a heroic moment in modern painting, but was written by a poet working within cubist concepts. Apollinaire's friendship with the artists afforded him an insider's view into their day-to-day progress, and his observations, in turn, provided an objectivity by which they could argue their intuitive insights. Viewed in light of this special relationship and of Motherwell's own role as a painter and theorist in the genesis of what was to be called "abstract expressionism," it is plain that Apollinaire's text would have been filled with interest for the young artist.[1]

For the first edition of *The Cubist Painters,* Motherwell had written what was essentially a factual preface, with twenty-four footnotes and subject headings he felt would aid the reader.[2] Presented here is his Preliminary Notice to the 1949 edition of the text, written in New York City and dated *March 29, 1949.*[3] ■

Some speak as if all cubism had been a mode of showing an object from four sides. Apollinaire saw more deeply: "The canvas should present that essential unity which alone can elicit ecstasy." He understood that the unity of a work depends on its internal relations, and consequently why the cubists were led to deny the claims of representation in favor of structure. His own sense of poetical structure had been liberated by reading Mallarmé, especially perhaps by *A Throw of Dice*—published in 1897, the year before Apollinaire arrived in Paris at the age of eighteen—a subtle, intricate, inexhaustible poem, in which words tumble down the page typographically as though thrown in a game of dice. The cubists' adventure was understood by Apollinaire; he moved among them as an equal—experimental, "modern," lyrical—animated by feelings identical with their own: "O inventive joy, there are men

who see with these eyes!" Whatever its faults,[4] *The Cubist Painters* still breathes, nearly forty years later, with the immediacy of life. But Apollinaire's enthusiasm was not blind; he saw cubism's inner structure with great clarity for his time; he wrote his book after discussions with the painters; and many of his generalizations hold true, not only of cubism, but of the various modes of "abstract" painting that keep appearing again and again, in "waves," as a scholar has recently noted.[5] Apollinaire was able to say, for instance, that cubism was "the art of painting new structures borrowed not from the reality of sight *(réalité de vision),* but from the reality of insight *(réalité de connaissance)."* He adds, "All men have a sense of this interior reality." Another passage finds him speaking of "a pure art," "a structure which is self-evident," anticipating an aesthetic notion of A. N. Whitehead's. Certainly *The Cubist Painters* might have been more perfect, perhaps as beautiful as Apollinaire's own poetry, if he seemingly had not been in a hurry to record the moment, before it had passed. Yet only a year after its publication, the First World War began, and the cubist group broke up. Apollinaire himself, though of foreign birth, joined the French army; he was perhaps the only poet, apart from the futurists, to look upon the war as an adventure. He was wounded in the head, necessitating an operation, and he died a year or so later, during the influenza epidemic, on the evening of the Armistice, 1918, at the age of thirty-eight, thinking, it is said, that the crowds in the streets of Paris shouting "A bas Guillaume" ("Down with William," meaning the German kaiser) were referring to himself. Some years earlier, he had been imprisoned for several days by the police, falsely accused of stealing the *Mona Lisa* from the Louvre. Afterwards he wrote a piece about the episode for a Paris newspaper, a tone of naive simplicity covering his anguish, that reminds one of writings by Erik Satie, the composer. But he revealed that when the heavy door of the prison closed behind him it was like death. He loved life, and had always felt free; it is for this reason that he was the natural writer for the cubists. One can only marvel at the instinct of Parisian painters to keep their art in the hands of poets.

Notes

1. As general editor of the Documents of 20th-Century Art, Motherwell also produced Guillaume Apollinaire, *Apollinaire on Art: Essays and Reviews 1902–1918,* ed. LeRoy C. Breuning (New York: Viking Press, 1971).

2. The preface had been signed *RM.* According to Motherwell, European readers violently objected to his interpretations, and the headings were eliminated in the second edition (conversations with the artist, 1983–1986).

3. Motherwell's comments in this edition read:

In typography and illustrative matter the present edition is greatly changed from the edition of 1944, the first volume to appear in this series. The translation by Lionel Abel of Apollinaire's poetic text remains unaltered, but a long, characteristic poem by Apollinaire and a detailed bibliography have been added; the small, documentary illustrations of cubist

works of the original edition have been replaced by larger illustrations having to do with Apollinaire himself.

4. Motherwell considered the book somewhat jumbled, the best parts being passages picked up directly from the artists' conversations and not, in his opinion, wholly understood by the author (conversations with the artist, 1983–1986).

5. Probably the art historian Meyer Schapiro.

"Reflections on Painting Now" 11 August 1949

Motherwell gave the lecture "Reflections on Painting Now" on 11 August 1949 in Provincetown, Massachusetts, at a symposium entitled "French Art vrs. U.S. Art Today." His presentation was part of weekly sessions organized during the summer by a group of avant-garde artists and referred to as "Forum 49." Although several modern artists lived or summered in "P'town," they were still a relative minority in the art colony; and the exhibit of art they installed at Gallery 200 on Commercial Street, where the programs took place, was as controversial as the symposium itself. To some extent, Forum 49 and its exhibition had been designed to both provoke and enlighten the community.

Invited for his individual reputation and as a representative of the vital Long Island contingent of modern artists, Motherwell made the trip to Cape Cod with Willem de Kooning. His invitation to speak may have come through Weldon Kees, a prime mover in the sessions, who had written on his work. Or he may have been asked by Adolph Gottlieb, a fellow artist at the Kootz Gallery, who had organized events for 11 August.[1] Although all the sessions of Forum 49 embraced modernist ideas and elicited controversy, the discussions following the presentations on this particular evening were especially heated. Arguments polarized into a denigration of Parisian art or an allegiance to it, with the opposition promoting an advanced but isolated American art and supporters fearing a return to a prewar provincialism. Motherwell's talk was carefully structured—to be distinguished from lectures he delivered spontaneously or wrote the evening before their presentation. Avoiding the trap implicit in the symposium's title, he instead focused on the universality of all advanced art. His nautical references were not only metaphors for the creative process, but a literary nod to Provincetown itself, the fishing village to which he would return almost every summer beginning in the early 1950s. ◼

> Keep your weather eye open, and sing out every time.
> Melville, *Moby Dick*, XXXV

Philosophers often talk about the so-called "subject–object" relationship; for many of them including Descartes, Locke, and Hume, this relationship is the basic pattern of experience. The "subject" is the

knower, in their terminology, as when someone is perceiving a picture; the "object" is the thing known, in this example, the picture. One sometimes has the illusion that the relationship works in reverse, "In this state of illusion," as Novalis[2] says, "it is less the subject who perceives the object than conversely, the objects which come to perceive themselves in the subject." So a painter, in working a canvas, sensing it all over, watching it shift and change and slowly emerge from its flat void, mere extension, may have the illusion that the picture is not being painted by him, but rather is painting him, that he who is supposed to be the subject has become the object, that the picture knows him better than he knows it.[3] It is this phenomenon that lay at the back of my mind when, in my preface to Kahnweiler's book on *The Rise of Cubism,* I remarked that it was less Picasso who invented cubism than cubism that invented Picasso. Painting itself told him what to do, so to speak, and in so doing, gave him his identity. It is when he attempts, on occasion, to force painting to his will that for me he has least power . . . At this point I should like to remark that these experiences are neither French nor American in origin, but universal among sensitive painters.

What is meant by an object is something that has a certain form; it is by virtue of its form that we recognize it as an object. An object becomes an object if form is perceived by the subject—abstract painting is difficult only for those who will not comprehend that it comprises objects that differ from what they are accustomed to call objects; once this notion is accepted, it is as easy to discriminate among them as it is to discriminate a Louis XV chair from one by Mies van der Rohe. The whole universe—external and internal—constitutes potential objects. Abstract painting, in choosing a new class of objects, enriched human experience. This enhancement is neither French nor American, but international.

The concept of creativity introduces strongly the notion that the subject–object relationship is active, that the subject seeks out, finds, invents—none of these verbs is precise—its objects of feeling from the potentialities of the universe. An example: we form in the mind's eye constellations from the starry heavens. A constellation is recognized by its form, its pattern, its gestalt; but this form is projected on to it by the subject; Orion is there, it is also man's invention. From this point of view, form is subjective, unified feeling; it is simultaneously the unity of an object. The stars have had different constellations for different cultures; indeed, one of the minor tasks of the modern mind might be a new mythology of the heavens—the surrealists had the same kind of enterprise in mind when they collectively designed a new set of cards, with kings and knaves replaced by modern poets and political heroes . . . The relations among the monads of the universe are active; it is this activity that I am denoting by the term creativity; creativity,

in the most modern conceptions as in the most ancient, denotes what makes the world move. Whitehead describes it beautifully: "Creativity is the throbbing emotion of the past hurling itself into a new transcendental fact. It is the flying dart, of which Lucretius speaks, hurled beyond the bounds of knowledge." This is not a specifically French or American experience, but inherent in the universe's structure.

One becomes a painter when existing painted objects do not wholly satisfy one's subjective unity of feeling, the sense of one's own identity. Any modern painter's work is a criticism of the whole culture of painting from the standpoint of his own identity. As we become more and more individualized historically, as the community begins to disintegrate, every painter feels more and more the necessity to reinvent painting. One supposes that an ancient Egyptian felt no such necessity; his identity was that of the community; his identity was exhausted by tradition; his personal satisfaction was in his fineness: in an old manuscript, an Egyptian painter, applying for a position in the service of a noble, brags of the fineness of his proportioning. One might say that we artists of the School of New York[4] are a collection of co-existing separate pasts. So are the individuals who constitute the School of Paris. These two handfuls of individuals are closer to each other in their essential acts than either is to the herd of individuals who constitute his national culture, French or American.

A painter "succeeds" in his intent when he invents an object that corresponds to the subject, his self, that is; consequently in a wider sense than is usually meant, all modern painting is self-expression. From this point of view, the distinction that Kahnweiler makes, in his beautiful book on Juan Gris, between "classical" artists who place "the unity of the work above the expression of their emotion" and "romantic" artists who "sacrifice form in their need to express themselves," is silly. Any work of art, even a "bad" one, is a self-expression; its qualities depend on the qualities of the self who made it. An unbalanced, incomplete self makes an ill-proportioned, fragmentary work. One might say that a work of art is the tension between an artist's aspirations and his limitations. Rimbaud, in revealing his most intimate obsessions, his desperate efforts to break out of the iron ring of reality in *A Season in Hell,* projects them with such intense rhythm that the poem arouses in us that unity of feeling that we call "classical." As though a shriek had a prolonged, complicated, clear internal structure.

There are selves who unify their expressions by their subjective force; it is only with the intensity of such subjectivity that one even sees the world of objects; these selves' background of reference tends to become infinite, or, as Mondrian used to say, universal. Such selves have existed in French painting for a long time; now they are beginning to appear in America, in clusters. This fact fills me with excitement, not

because I am American, but because it is extremely moving to see anyone anywhere rise to a certain level of consciousness.

The conditions under which an artist exists in America are nearly unbearable; but so they are everywhere in modern times. Sunday last I had lunch in a fisherman's inn in Montauk overlooking Gardiner's bay with Wilfredo Lam, the Cuban and Parisian painter, who is half-Chinese, half-Negro; he has difficulty in remaining in this country because of the Oriental quota; I know he is humiliated on occasion in New York, for example, in certain restaurants. He kept speaking to me of his admiration of America, asking me what American painters thought of this and that, and I answered as best I could; but a refrain that ran through his questions is less easy to answer, whether artists were always so "unwanted." I replied that I supposed that artists were more wanted in the past when they spoke for a whole community, that they became less wanted as their expressions became individual and separate; but since I had never had the sensation of belonging to a community, it was difficult for me to imagine being wanted. This is not wholly true; we modern artists constitute a community of sorts; part of what keeps me going, part of my mystique is to work for this placeless community. Lam and I parted advising each other to keep working; it is the only advice one painter ever gives another. It is not always easy to keep working; sometimes one's feelings rise up in one wild surge of indefinable emotion, which Mallarmé, quietly writing in his study, beaten senseless each day by the absolutes of poetry, indicated in the famous lyric whose last line reads "Listen, O my heart, to the sailor's song!" But then one remembers the line of Walt Whitman's that André Gide likes so much, "O days of the future I believe in you—I isolate myself for your sake."

Until the structure of modern society is radically altered, these will continue to be the conditions under which modern artists create. No one now creates with joy; on the contrary, with anguish; but there are a few selves that are willing to pay; it is this payment, wherever one lives, that one really undertakes in choosing to become an artist. The rest one endures, in France or America. In so doing, one discovers who one is, or, more exactly, invents oneself. If no one did this, we would scarcely imagine of what a man is capable.

Notes

1. Gottlieb both moderated and spoke. Other participants, along with Motherwell, were Stuart Preston, art critic of the *New York Times;* Karl Knaths, artist; Paul Mocsanyi, art critic of *United Press;* and Frederick Wight, education director of the Boston Museum of Contemporary Art.

2. Pseudonym of Baron Friedrich Leopold von Hardenberg (1770–1801), German lyric poet.

3. This section was reprinted, along with a brief statement by Marianne Moore,

in the brochure for "Robert Motherwell Collages, 1943–49," an exhibition held at the Kootz Gallery in New York later in the year.

4. This appears to be Motherwell's first use of the designation "School of New York" or the "New York School," both of which subsequently were adopted in critical literature as alternatives for "abstract expressionism," a name coined at about the same time.

Preliminary Notice to Marcel Raymond, *From Baudelaire to Surrealism* 1949

André Breton, who considered Marcel Raymond's *De Baudelaire au surréalisme* a superb work, had pointed it out to Motherwell, who, in turn, suggested to Wittenborn and Schultz that the French text be translated for the Documents of Modern Art.[1] *From Baudelaire to Surrealism*, translated by "G.M." and with an introduction by Harold Rosenberg, appeared in late 1949 or early 1950.[2] Motherwell had written the Preliminary Notice in Virginia City, Nevada, during his brief stay there in October.[3]

In his notice, Motherwell defended his selection of the text, partly against his publishers, who were unhappy with the book's literary rather than visual-art emphasis.[4] His choice of the subject was a continuation of his self-education into the ideas of modernism—Baudelaire heading a lineage in which surrealism would signify its last progressive development at the time. His first draft was written in longhand on drawing paper. The final draft, with few corrections, was dated *16–21 October 1949*. As in his Prefatory Note to Arp's *On My Way*, Motherwell addressed his immediate surroundings—here, in an unusually lyric paragraph, rare among his writings for this series. ■

> Old Lady: Do you call this painting?
>
> Webster, *Duchess of Malfi*, II,1

> The arts aspire, if not to complement one another, at least to lend one another new energies. Baudelaire

A weakness of modernist painting nowadays, especially prevalent in the "constructivist" tradition, is inherent in taking over or inventing "abstract" forms insufficiently rooted in the concrete, in the world of feeling where art originates, and of which modern French poetry is an expression. Modernist painting has not evolved merely in relation to the internal structure of painting; it's not only legitimate, but necessary to include, among the documents of modern art, reference to French poetry from Baudelaire to surrealism. Cubism, for instance, could not have developed so quickly, surely, and identically for Picasso and Braque without Cézanne's surface as a model; but Kahnweiler is certainly correct in his assertion, in his remarkable book on *Juan Gris* (N.Y.,

1947), that the poet Mallarmé was responsible for the atmosphere in which cubism became possible. I am glad to have permission to add, as an appendix to the present volume, Kahnweiler's separate essay on Mallarmé and painting, with its general account of a direct relation.

Still, the fundamental relation between modernist painting and French poetry is indirect, pervasive, and not wholly recoverable now; but it is extraordinary how, in countries that speak other tongues, the implications of the fact that French is the language of the School of Paris are so often passed over. And do not tell me that Parisian painters have not read or conversed with poets.

True painters disdain "literature" in painting. It is an error to disdain literature itself. Plainly, painting's structure is sufficiently expressive of feelings, of feelings far more subtle and "true" to our being than those representing or reinforcing anecdotes; but true poetry is no more anecdotal than painting. Both have sought in modern times to recover the primitive, magical, and bold force of their mediums and to bring it into relation to the complexities of modern felt attitudes and knowledge; no modernist painter can read in this marvelous book of some of the ideals of French poets without a sharp sense of recognition.

Perhaps the "plasticity" that we painters so admire is no less than the poetry of visual relations.

The miners' graveyard. Beyond, the town's ruins, burnt sienna, pink, yellow ochre—arid and clear in the distance, as the hill towns of Italy. Here silent monuments of the past rest, in white October sun, wind sweeping from the Sierra Nevada mountains. Crystal light! Vertical personages gaping, a broken grave. Here, too, in the midst of gold and silver, there were yearnings for the *word,* but what confusions! Jenny Lind, the Great Patti, Mark Twain, General Tom Thumb, *Uncle Tom's Cabin* companies. As with French poets, desire for the sensuous "new." Dragged up the mountains from California in eight-span wagons, wood, to construct French baroque mansions. Glass chandeliers from Vienna. But the desert air is white, Mallarmé's swan.

Notes

1. Conversations with the artist, 1983–1986.

2. The book bears a printed copyright date of 1949, but it may not actually have been issued until 1950 (the date that Wittenborn and Schultz give it in their listings), hence the confusion in some of Motherwell's bibliographies.

3. Motherwell had stayed in Virginia City in order to obtain a divorce from his wife, María.

4. Conversations with the artist, 1983–1986.

1950-1959

"Black or White" 1950

▪ Motherwell's personal discovery of the expressive power of black and white paint pigments, when they are used as colors rather than as tonal gradations, came in early 1949 when he found a drawing he had made in the previous year. Intended for the second and aborted issue of *possibilities,* and limited to only black ink by the dictates of the reproductive process, the work was to have illustrated "The Bird for Every Bird," a poem by Harold Rosenberg. Motherwell's image so boldly engaged the white ground with opaque black oval and vertical masses that, when isolated from its intended use, it impressed on him the possibility of a forceful new language. The discovery unleashed for him a lifelong preoccupation with certain themes in black and white—most notably, works he was to entitle *Spanish Elegy* (1948–1991).

In early 1950, the exhibition "Black or White: Paintings by European and American Artists" was held at the Kootz Gallery in New York City. The work of fourteen artists, nine Americans (Motherwell showed the painting *Granada* [1949]) and five Europeans, was included.[1] Motherwell's preface for the exhibition catalog, dated *10 Feb. 1950,* follows. ▪

> Are we to mark this day with a white or a black stone?
> *Don Quixote,* II,ii,10

There is so much to be seen in a work of art, so much to say if one is concrete and accurate, that it is a relief to deal on occasion with a simple relation.

Yet not even *it,* no more than any other relation in art, is *so* simple.

The chemistry of the pigments is interesting: ivory black, like bone black, is made from charred bones or horns, carbon black is the result of burnt gas, and the most common whites—apart from cold, slimy zinc oxide and recent bright titanium dioxide—are made from lead, and are extremely poisonous on contact with the body. Being soot, black is light and fluffy, weighing a twelfth of the average pigment; it needs much oil to become a painter's paste, and dries slowly. Sometimes I wonder, laying in a great black stripe on a canvas, what animal's bones (or horns) are making the furrows of my picture. A captain on the Yukon River painted the snow black in the path of his ships for twenty-nine miles; the black strip melted three weeks in advance of spring, and he was able to reach clear water. Black does not reflect, but absorbs all light; that is its essential nature; while that of white is to reflect all light: dictionaries define it as snow's color, and one thinks of the black slit glasses used when skiing. For the rest, there is a chapter in *Moby Dick* that evokes white's qualities as no painter could, except in his medium.

Indeed, it is our medium that rescues us painters. "The black grows deeper and deeper, darker and darker before me. It menaces me like a black gullet. I can bear it no longer. It is monstrous. It is unfathomable.

"As the thought comes to me to exorcise and transform this black with a white drawing, it has already become a surface. Now I have lost all fear, and begin to draw on the black surface" (Arp). Only love—for painting, in this instance—is able to cover the fearful void. A fresh white canvas is a void, as is the poet's sheet of blank white paper.

But look for yourselves. I want to get back to my white-washed studio. If the *amounts* of black or white are right, they will have condensed into quality, into feeling.

Note

1. Also included were William Baziotes, Georges Braque, Fritz Bultman, Willem de Kooning, Jean Dubuffet, Adolph Gottlieb, Hans Hofmann, Welden Kees, Joan Miró, Piet Mondrian, Pablo Picasso, Mark Tobey, and Bradley Walker Tomlin.

Preface to Georges Duthuit, *The Fauvist Painters* 1950

Les Fauves, in its *Cahiers d'art* version, had come to Motherwell's attention in the late 1940s. Finding the text *very beautiful,* he approached Georges Duthuit, its author, with the idea of publishing an English translation in the Documents of Modern Art. *The Fauvist Painters,* translated by Ralph Manheim, appeared in 1950—the second book in English (the other published in the same year) to address a major art movement then nearly forty-five years old.[1]

Motherwell wrote his preface to the volume in East Hampton on *14 July 1950*. In what might best be termed a prose poem and a tribute to Matisse himself, he extracted from French painting those elements Matisse had built on when, arriving at an independent analogous structure, he liberated color from its description of nature. Using the advances of modernism as signposts, Motherwell continued with his own exploration and study into abstraction. Rather than repeat trial-and-error methods, by which the artist slowly abstracted his subject from external objects, he sought to distill from the history of modernism factors by which the artist could extrapolate a more direct path toward essential and enduring form. Along with Matisse, who represented a key position in his painting hierarchy, Motherwell would attempt in his own painting "to reach that state of condensation of sensation," where the picture could later be recognized as "a work of [the] mind." ∎

Henri Matisse at home; relentless daily routine, like that of Renoir, whom "they" could keep from working only once in forty years. Henri Matisse in the studio; relating colors, interpretive gift constantly transforming, "luxury, calm, voluptuousness."

A painter's pigments are duller than light, forcing a series of substitutions, the brightest pigment becoming the equivalent of the brightest light, analogous structures. "Light cannot be reproduced, but must be represented by something else, color. I was very pleased with myself when I found this out" (Cézanne).

Unlike light when mixed, the painter's pigments, when physically mixed, become dulled, greyer. Thus the tendency of the impressionists, loving summer, to use colors "pure," as they come out of the tubes, in such small areas of extension that, standing an adequate distance from a picture, separate strokes of color are combined into a single color by one's eyes, red and blue becoming an optical violet. Still, "substance" is lost. Matisse said to Duthuit of a Seurat, "It's like print." Matisse enlarged Seurat's little *touche* to great areas of color; everyone quotes the remark of his teacher, Gustave Moreau, that Matisse's gift would be to simplify. But last year, pointing to a color reproduction of one of his own works, with large areas of green and black, Matisse subtly said, "Can't you see the red that this harmony physically evokes?" And a moment later, with malice, "Fauvism is when there's red in it."

His criticism of impressionism is in his article just after the fauve period, *Notes of a Painter* (1908):* "The impressionist painters, Monet,

*Quotations that follow are from this article, unless marked to the contrary; the quotations are from the translation by Margaret Scolari in Alfred H. Barr, Jr.'s *Henri Matisse*, New

Sisley especially, had delicate, vibrating sensations; as a result their canvases are all alike. The word 'impressionism' perfectly characterizes their intentions, for they register fleeting impressions. The term, however, cannot be used with reference to more recent painters who avoid the first impression and regard it as deceptive. A rapid rendering of a landscape represents only one moment of its appearance. I prefer, by insisting on its essentials, to discover its more enduring character and content, even at the risk of sacrificing some of its pleasing qualities."

It is said the immediate influences were the drawing of Manet and the color structure of Cézanne; perhaps there is the inspiration of van Gogh, too, all made by Matisse more decorative, bizarre, flat, Mediterranean, sexual, as by an Arab in France.

"I should love to look at Africa . . . What I want to find out is the effect of a more intense blue in the sky. Fromentin and Gêrome find the southern landscape colorless, and lots of people see it that way. But, my God, if you take some sand in your hands and look at it closely, or study even water and air that way, they will all seem colorless. *There's no blue without yellow and orange*" (van Gogh, 1888).

The patches of color on the canvas tend to become out of gear with one another as more colors are added during the process of painting: "every brush stroke diminishes the importance of the preceding one." Revisions, increases of amount are necessary to recover the original structure. "To do this I must organize my ideas; the relation between the hues must be so established that they will sustain one another."

Large amounts of black, say, can make the existing hues on the canvas more brilliant, as the disappearing white of the canvas was once brilliant in relation to them; but too easy, perhaps. Begin a corrected version, on a fresh canvas, just to guard freshness of surface.

With black added, the colors may still need intensification; if they are the intensest pigments, it can only be done physically by enlarging their extension: "In order that the first dot may maintain its value I must enlarge it as I proceed."

Begin a third version, so that the canvas will not be "dirtied" with reworked colors. (No wonder Dufy has a horror of correcting his first impressions.) A green floor may have to become redder: "I am forced to transpose until finally my picture may seem completely changed when, after successive modifications, the red has succeeded the green as the dominant color."

One really speaks, in speaking of fauvism, of Henri Matisse, of the stage in his development that first revealed his uniqueness and identity and influenced other painters, momentarily or permanently, but with-

York, 1931, a new edition of which is now in preparation. I have changed the word "tone" when it appears in the translation to "hue" since it is color, not degrees of grey, that is being referred to, and the word "sentiment" to the more idiomatic "feeling."

out the depth of his grasp of logical form. Matisse's subsequent history has been one of deepening his first fauve discoveries about color, of strengthening their structural relations in the light of his own criticism of fauvism: "Charm, lightness, crispness—all these are passing sensations. I have a canvas on which the colors are still fresh and I begin to work on it again. The colors will probably grow heavier—the freshness of the original hues will give way to a greater solidity, an improvement to my mind, but less seductive to the eye . . . I want to reach that state of condensation of sensations which constitutes a picture. Perhaps I might be satisfied momentarily with a work finished at one sitting but I would soon get bored looking at it; therefore, I prefer to continue working on it so that later I may recognize it as a work of my mind." Matisse in 1949 insisted on the continuity of his later work with that of the fauve period: "Is fauvism dead? Can you recognize in a man of completed education and proper behavior the provincial young man who once sallied forth in quest of his 'climate'? And yet it is the same man who lives and acts today; his aspirations have changed, but they spring from the same source."

Fauvism represents that aspect of Henri Matisse's work in which he began to separate color as a self-determining relational structure from its use in describing the objects in the external world, and consequently to move toward abstraction: "It is not the fault of abstraction that few people can really think abstractly, any more than it is the fault of mathematics that not many people are good mathematicians," a modern logician tells us, adding that correct abstraction is one of our most powerful, necessary, and efficacious modes of thought. It is a form of emphasis, as A. N. Whitehead said, of expressing what one wants to without being involved in everything else: ". . . superfluous details would, in the mind of the beholder, encroach upon the essential elements" (Matisse, 1908). Duthuit admits that he often cannot recall the subjects in Matisse's pictures; but the content is always clear. Matisse named it in one of his fauve masterpieces, *The Joy of Living* 1906–07 (Barnes Foundation).

An aspect of modern painting is to stubbornly maintain pictorial logic: "A 'logical picture' differs from an ordinary picture in that it need not look the least bit like its object. The relation to the object is not that of a *copy,* but of *analogy* . . . Two things that have the same logical form are *analogous.* The value of analogy is that a thing which has a certain logical form may be *represented* by another which has the same structure," our modern logician tells us. The analogy of a picture by Matisse is with the world as felt joyfully: "I cannot copy nature in a servile way . . ."

Note

1. Duthuit, against Motherwell's counsel and much to his disappointment, insisted on a revised version of the writing; in the process, the original text, which

Motherwell felt was both condensed and revealing, became for him relatively inflated and subjective (conversations with the artist, 1983–1986).

1950–1959 "The New York School" 27 October 1950

Motherwell's attendance at the College Art Association (CAA) meetings in the fall of 1950 predated by a few months his affiliation with Hunter College in New York. These two events mark the beginning of nearly a decade of increased public activity for him, coinciding with demanding domestic obligations.[1] The energy he had applied to the Documents of Modern Art was redirected to his students at Hunter, where at the beginning of 1951 he began nearly ten years of teaching in the art department's graduate program.

During the next several years, Motherwell also executed public murals, lectured, judged exhibitions, served on several occasions as visiting artist and critic at academic institutions, participated on panels and in seminars, and took an active part in the CAA (for a time serving as a director). In most cases he was responding to the demands on his growing reputation as the most articulate artist-spokesman of modern art. The period beginning with his first contributions to the CAA in 1950 and continuing for several years coincided with a relative diminution in his painting and writing output.[2]

The Mid-Western Conference of the CAA met in late October at the University of Louisville in Kentucky. On 27 October, after a series of papers addressing the topic "Appraisals of Contemporary Art," Motherwell delivered "The New York School." It was the second time he had used the title to designate the loose circle of artists recently referred to as "abstract expressionists,"[3] and his first public defense of their art before so large a group with vested interest in the subject. He reviewed and edited his spontaneous remarks on 10 December 1950. ■

I should like to speak briefly of the generation of abstract artists in this country who came into prominence between 1940 and 1950 and who, for the most part, though there are three or four exceptions, are now between thirty-five and forty—that is to say, born between 1905 and 1915. For convenience's sake I shall call the group of artists to which I am referring "The School of New York." To identify the School more specifically, though others could be named, I can cite as characteristic examples among the sculptors: Louise Bourgeois, Mary Callery, Herbert Ferber, David Hare, Seymour Lipton, Theodore Roszak, and David Smith; and among the painters: William Baziotes, the late Arshile Gorky, Adolph Gottlieb, Hans Hofmann, Willem de Kooning, Jackson Pollock, Ad Reinhardt, Mark Rothko, Bradley Walker Tomlin, and, if it is not immodest to say so, myself.

The School of New York has been bitterly attacked in many quar-

ters, most recently in the columns of the *Richmond Times-Dispatch* apropos the exhibition arranged by James Johnson Sweeney,[4] and on other occasions greatly praised; but it seems to me that its work has never been regarded analytically or with any knowledge of its history. In these moments I can only throw out a few clues in regard to a movement whose value cannot yet be determined, but whose authenticity is indubitable. I shall make an obstinate effort to be impersonal and analytical, though I am a member of the School of New York, and other members of it are among my closest friends.

My intention is to be as concrete as I am able. I am not interested in a philosophy of what is present in all art, that is to say, in that branch of philosophy called aesthetics; my interest is in what is individual and unique in each artist. But this would carry me beyond reasonable limits. Consequently I will confine myself to the School of New York as a whole, though in fact it is a collection of extreme individuals. I must, however, make one generalization: I believe the School of New York, like the other schools in what is vulgarly called "modernistic" art, has as its background of thought those fragments of theory, which, taken as a whole, we call the symbolist aesthetic in French poetry, whose formulation reached a climax in France in the decade 1885–95, though it extends into our own time in the persons of a number of poets of many occidental countries, among them Valéry, Yeats, Joyce, Rilke, Lorca, Apollinaire, Eliot, and Cummings. (In the remarks that follow I'm greatly indebted to a book that recently appeared in Oxford, *The Symbolist Aesthetic in France,* by Dr. A. G. Lehmann, as well as to a book that I recently had the privilege to edit in English, Professor Marcel Raymond's *From Baudelaire to Surrealism.*) This is a proposition I cannot now demonstrate; but if it is true it represents a truth of which I am sure many members of the School of New York are unaware. All I can say on this point is that many of us—though all of us are abstract artists—were in contact with the Parisian surrealists, many of whom were in New York during the late World War. I mean only to remind you that modern art (of which the School of New York is possibly a part) has a history.

In this paper I will try to define the School of New York, although for the moment I can only hover over my subject like an aviator with a low ceiling before a field he knows well but, knowing it through the coordination of his body-mind, hesitates before describing it in words. It is easier to say some of the things the School of New York is not. Its painting is not interested in giving information, propaganda, description, or anything that might be called (to use words loosely) of practical use—in contrast with those nonobjective painters mostly influenced by Mondrian, Kandinsky, or the Bauhaus. The School of New York is not intellectual, but intensely emotional, though its members include the most cultivated among the American artists that I know of—to choose emotion rather than intellection can be an intellectual

position. Its extreme tendency might be described, in the words of a critic summarizing the notion of Paul Valéry's, as an "activity of bodily gesture serving to sharpen consciousness."

It is evident that such a position is of little interest to a rote social critic, whether Marxist, existentialist, or Catholic. But I think that the art of the School of New York, like a great deal of modern art that is called "art for art's sake," has social implications. These might be summarized under the general notion of protest—of protest of what goes on, of protest against the suppression of feeling, above all of protest to the falsifications of personal concrete experience. In many respects a negative position, to be sure, but not without its pathos or a kind of dumb, obstinate rebellion at how the world is presently organized.

A dangerous tendency of such artists, in rejecting as legitimate content much of what moves and involves everyday men, is solipsism—the idea that what is most real is what one finds to be most real in one's own mind. This makes the School an ostensibly easy prey to social criticism, whether from Marxists or from the editors of *Life* and *Time*.[5] Still, the position becomes interesting when one ignores the solipsistic danger and realizes that it is willingly run by these artists in an effort to be more true to the concrete experience, to the subtleties and complexities of the modern mind. What I find more reprehensible is a certain lack of compassion and trust in the general run of men. Artists know more about their medium than anyone . . . but not necessarily more about anything else.

It is true that artists sometimes have further pretensions, but most of us are aware of our limitations. Thus being neither purveyors of knowledge—public, discursive knowledge, that is—nor of a prevailing ideology—magical, religious, social, or political—the principle interest of most artists is the language of art. Indeed, one might say that modern painting, and particularly its more abstract manifestations, differs from all other art in this: its subject matter is just art itself—what art is, and what it is not. The work of every modern artist is a criticism of all other art, past and present. That is its taking off place. The protest that many of the School of New York artists recently signed against the monster exhibition of American art soon to be held at the Metropolitan Museum of Art in New York did not revolve around the question of an exhibition of modern American art but rather about who in fact was considered a modern American artist.[6]

One criticizes past and present art in an effort to find out what art is. One might say that the School of New York tries to find out what art is precisely through the process of making art. That is to say, one discovers, so to speak, rather than imposes a picture. What constitutes the discovery is the discovery of one's own feeling, which none of us would dare to propose before the act of painting itself. From this you can see the reckless enterprise in which I am now engaged in speaking

of our art rather than in making it. It is only through the process of making that I really know—if you will excuse me a sloppy idiom—what I feel about the world. The content of any art is just the world as felt.

In defining the nature of the medium as a central preoccupation of modern art in general and of the School of New York in particular, I realize how vulnerable what I say can appear to the historian. That is to say, to the person who takes history seriously. I should like to interject that I believe all art to be historical, that there is no such thing as an eternal art that transcends a specific historical period; on the contrary, there is only the art of various periods. The historian is therefore under an obligation to be as subtle as the artist. The modern emphasis on the language of art (and its consequent contempt for artists who are not sensitive to the unique properties of this language, whether they be social realists, portrait painters, folklore painters, or describers of any sort) is not merely a matter of internal relations, of the so-called inherent properties of a medium. It is instead a sustained, systematic, stubborn, sensitive, and sensible effort to find an exact formulation of attitude toward the world as concretely experienced. The interest in the language of art is quite simply an interest in the tool that can lead one to being honest, which used without great care leads one inevitably to the lie, the cliché, the standardized, and to all one thinks one thinks and feels rather than to what one actually does.

Here I must interject an example. A year or so ago I had what amounted to a public duel with the leading Communist modern artist in America in a forum held under the auspices of the Museum of Modern Art in New York.[7] He, of course, insisted that my art had no content, that it was decorative and good to taste, like a wedding cake. I remarked that of course every art has a content, only that the content of some art is more subtle. My hostility against him was not that he was a Communist, but that his art contains no feeling for real humanity and its capacity for self-realization. Instead his art seems to me to be cold, empty, mechanical, and alienated from the world. [. . .]

The art of the School of New York is, among many things, a protest against dogmatic intellectualism in any form. We know what we believe by how we paint. Our criterion of when a canvas is finished is not how beautiful it is, but how true it is to our experience as felt. The autonomy that modern art claims is not to be irresponsible or to be above the struggle, but to maintain fidelity to one's own experience, whether or not it offends the powers that be or would be.

The rejection by the School of New York of prevailing ideologies—or its refusal to accept conventional positions as representative of man's real needs, basic wants, and desires—tends to lead to a position of anti-intellectualism, more particularly to a distrust of conscious concept. Only through a medium as subtle as art—without preconceived ideas

about its nature—can one formulate one's true attitudes to reality that, before the act of painting, were unknown to oneself.

Consequently, there is an opposition to conventional composition, to anything that smacks of dogmatic certainty of what art or, for that matter, anything else is. It is this unconventionality of formal organization that leads the unlearned as well as the philistine to the notion that we modern artists do not know how to paint. What is omitted is that we know very well how to paint, but without traditional modes of expression, which in the Occident means the Renaissance tradition. It is interesting that the rejection of the lies and falsifications of modern Christian, feudal aristocratic, and bourgeois society, of the property-loving world that the Renaissance tradition expressed, has led us, like many other modern artists, to affinities with the art of other cultures: Egypt and the ancient Mediterranean, Africa, the South Seas, and above all the Orient. Still, the energy, substantiality, sexuality, and heaviness of Occidental art persists in our work.

To many people our work gives the appearance of disorder. We want order, but an order that is true—one that is more exact and more adequate to the experience. Indeed, if you ask what strikes me as most moving about the School of New York—and now I speak not of myself but of my colleagues—I should say it is not that of reducing painting to what we really feel, to a rejection of nearly everything that seems to interest nearly everyone, to a protest against what goes on and the art that supports it, it is not these rejections that so much impress me—though they are true to the nature of our extreme individualism and iconoclasm. What impresses me is the radiance and subtlety with which this attitude of protest is expressed. The radiance means ideas on the part of persons of intelligence, sensibility, and passion. Fidelity to what occurs between oneself and the canvas, no matter how unexpected, becomes central. The specific appearance of these canvases depends not only on what the painters do, but on what they refuse to do. The major decisions in the process of painting are made on the grounds of truth, not taste. Conventional painting is a lie—not an imposture, but the product of a man who is a living lie, who cannot help himself, since he does not know it.

That painting and sculpture are not skills that can be taught in reference to preestablished criteria, whether academic or *modern,* but a process, whose content is *found,* subtle, and deeply felt; that no true artist ends with the style that he expected to have when he began, anymore than anyone's life unrolls in the particular manner that one expected when young; that it is only by giving oneself up completely to the painting medium that one finds oneself and one's own style; that it is only someone who himself is engaged in this process that is likely to be able to "read" the truest works of a period when they first appear—such is the experience of the School of New York.

One must not be discouraged if these works are not easily read at

first sight, and there is no use in being outraged. For a hundred years modern painters, stubbornly and in the face of incessant hostility, have moved, step by step, leaving superb monuments by the wayside, towards an art of arrangement whose expressiveness depends less and less upon its elements imitating the objects of the external world. Such a project can be criticized philosophically, that is to say abstractly; it can be accounted for historically and socially, as a new secular mystique; but no one can doubt its energy and vitality, and consequently how inspiring the values that have led to its creation have proved themselves to be. We have to trust painters, trust that constructiveness of mind and healthy sensibility, which only needs a proper subject matter (which is to say a radical alteration in the nature of existing society) to inspire men anywhere who can accurately perceive the language of paint. What the lesson of the School of New York in particular and of modern art in general really means—and I'm doing my best to resist the temptation to become rhetorical—is subjectivism and its sensibility, its abstract structural sense rather than its descriptiveness in the external world, its devotion to a language of painting rather than to prevailing visions of man. In our world art tends to be more inspiring than any other activity. We artists can only be inspired by what indeed does inspire us. One can only guess, if there were something more deeply and humanly inspiring, at what we might be, what all mankind might be capable of.

Notes

1. During the first five years of his marriage to Betty Little, Motherwell became the father of two girls—Jeannie, born in 1953, and Lise, born in 1955—in addition to Little's daughter from her previous marriage.

2. Although Motherwell went into a painting slump in the early 1950s, he produced several notable works, among them *Elegy to the Spanish Republic No. 34* (1953–1954), now at the Albright-Knox Art Gallery, Buffalo, New York; a number of works he called "Wall Paintings" (1952–1954) and "Je t'aime" (1955–1957); and the unique oil *Jour la maison* (1957).

3. Motherwell had referred to *The School of New York* in his lecture at Forum 49 in Provincetown, Massachusetts, on 11 August 1949.

4. Sweeney delivered the opening lecture, "American Painting 1950," setting the perimeters for the sessions, and had organized the exhibition of the panelists' work at the J. P. Speed Museum in Louisville.

5. Beginning in early 1950, both magazines had begun publishing what were essentially disparaging articles and reviews in their questioning of the new art.

6. This letter, signed by eighteen artists and ten sculptors, which earned them the enduring title "the irrascibles," was a protest against the general attitude of the Metropolitan Museum jury ("notoriously hostile" toward advanced art) toward the upcoming exhibition of contemporary American art.

7. Motherwell was referring to his lecture "A Personal Expression," delivered on 19 March 1949. The artist was the American painter Ben Shahn (1898–1969).

Motherwell wrote the preface to the unpaginated pamphlet accompanying the exhibition "Seventeen Modern American Painters," in East Islip, Long Island, on *1 January, 1951*.[1] Although he had used the designation "The School of New York" (the preface has since been referred to by this title) or "The New York School" in two earlier lectures,[2] this was the first published use of the title subsequently adopted in critical literature as an alternative name for "abstract expressionism," the term coined a few years earlier. In his preface, Motherwell more succinctly presented ideas he had set forth in his lecture before the College Art Association the previous fall, in fact, and in a practice not uncommon for him, lifting almost two paragraphs from it verbatim.

The exhibition, held at the Frank Perls Gallery in Beverly Hills, was later installed at the Santa Barbara Museum of Art, for which the pamphlet was reprinted in one thousand copies. Artists whose work was included were William Baziotes, Willem de Kooning, Lee Gatch, Adolph Gottlieb, Morris Graves, Hans Hofmann, Roberto Matta, Jackson Pollock, Richard Pousette-Dart, Ad Reinhardt, Mark Rothko, Theodoros Stamos, Hedda Sterne, Clyfford Still, Mark Tobey, Bradley Walker Tomlin, and Motherwell. Too controversial for its uninitiated audience, the Beverly Hills showing elicited a fair amount of negative criticism, anticipated by Perls when he made an anxious telephone appeal to Motherwell for an "explanation" of the work.[3]

Also raising criticism was Motherwell's preface to the pamphlet, which rankled some of his peers. Writing to Perls after the exhibit opened, Clyfford Still (reportedly with Bradley Walker Tomlin and Mark Rothko) accused Motherwell of a presumption in serving as spokesman for artists whose work they claimed he had selected without their permission.[4] In fact, the exhibit had been picked by Perls himself.[5]

Some time later, Motherwell became aware of the controversy and wrote a four-page paper, never made public, in which he defended his position:

My preface to "The School of New York" had among its chief emphases where this art differs, as best I could say it, from modern art in general and from a certain tradition in abstract art in particular—though all are hopelessly intertwined. The other emphasis was on the fact that many modern pictures are not—as is often assumed by non-painters—made by traditional methods: hence my emphasis on "automatism" and impulsiveness, both of which play a relatively small role in my own work. [. . .] I believe that the School of New York, like surrealism, is less an aesthetic style (look at the differences between Miró and Delvaux, between Arp and Max Ernst, between Giacometti and Dali, for instance) than a state of mind, which overlaps at places,

though always with individual differences, and a mode of life, which overlaps at certain places, again with individual differences . . .[6] ■

Every intelligent painter carries the whole culture of modern painting in his head. It is his real subject, of which anything he paints is both a homage and a critique, and anything he says a gloss. It is the visual expression of the modern mind, subtle, right, and sensual; who lacks the culture of modern painting is without a great human experience, new, adventurous, and pure with the intensity of mystical experience, but secular in background. Odilon Redon wrote, in 1898, that his works *"inspire* and are not meant to be defined. They determine nothing. They place us, as does music, in the ambiguous realm of the undetermined. They are a kind of metaphor . . ."

The recent "School of New York"—a term not geographical but denoting a direction—is an aspect of the culture of modern painting. The works of its artists are "abstract," but not necessarily "nonobjective." They are always lyrical, often anguished, brutal, austere, and "unfinished," in comparison with our young contemporaries of Paris; spontaneity and a lack of self-consciousness is emphasized; the pictures stare back as one stares at them; the process of painting them is conceived of as an adventure, without preconceived ideas on the part of persons of intelligence, sensibility, and passion. Fidelity to what occurs between oneself and the canvas, no matter how unexpected, becomes central. The specific appearance of these canvases depends not only on what the painters do, but on what they refuse to do. The major decisions in the process of painting are on the grounds of truth, not taste.

That painting and sculpture are not skills that can be taught in reference to preestablished criteria, whether academic or *modern,* but a process, whose content is *found,* subtle, and deeply felt; that no true artist ends with the style that he expected to have when he began, anymore than anyone's life unrolls in the particular manner that one expected when young; that it is only by giving oneself up completely to the painting medium that one finds oneself and one's own style; that it is only someone who himself is engaged in this process who is likely to be able to "read" the truest works of a period when they first appear—such is the experience of the School of New York.

One must not be discouraged if these works are not easily read at first sight, and there is no use in being outraged. For a hundred years modern painters, stubbornly and in the face of incessant hostility, have moved, step by step, leaving superb monuments by the wayside, towards an art of arrangement whose expressiveness depends less and less upon its elements imitating the objects of the external world. Such a project can be criticized philosophically, that is to say, abstractly; it

can be accounted for historically and socially, as a new secular mystique; but no one can doubt its energy and vitality, and consequently its inspiration and reality. We have to trust painters, trust that, in any given moment in the history of painting, they are doing what has to be done. The layman is greatly mistaken in his universal and unconscious assumption that a painter is simply a man with greater skill who does what the layman would do if he were a painter. One must live with and love the art of painting all one's life before its essential problem, in any given period, even begins to appear. In modern times the problem has been to project an experience, rich, deeply felt, and pure, without using the objects and paraphernalia, the anecdotes and propaganda of a discredited social world. The means left for the painter are those inherent in his medium, its structure, rhythm, color, and spatial interval.

With these few means, abstracted from the complex of relations that constitute the external world, modern painters have succeeded in their task, to create a painting that is rich, felt, and pure. The courage, inventiveness, and faith of such painters ought to be evident, even to those for whom experience of the painting itself is not yet real.

Notes

1. Motherwell had moved to East Islip in the fall of 1950.

2. Motherwell had referred to the School of New York in "Reflections on Painting Now," delivered on 11 August 1949, and entitled his paper given at the meeting of the College Art Association in October 1950, "The New York School."

3. Motherwell was related to Frank Perls through his stepsister's marriage to the dealer. (The artist's mother had remarried a few years after his father's death in 1943.) Before the exhibit opened, Motherwell received an urgent call from Perls requesting an introduction to the art (conversation with the artist, 11 January 1984).

4. See John R. O'Neill, ed., *Clyfford Still* (New York: Metropolitan Museum of Art, 1979), pp. 191–92.

5. Just before his Los Angeles exhibit, Perls selected many works for it from the "4th Annual Exhibition of Contemporary Painting," held at the California Palace of the Legion of Honor in San Francisco.

6. The paper is at the Motherwell archives.

"What Abstract Art Means to Me" 5 February 1951

"What Abstract Art Means to Me" was Motherwell's contribution to a symposium organized by the Junior Council of the Museum of Modern Art. Held at the museum on 5 February 1951, the event had been scheduled in conjunction with the exhibition "Abstract Painting and Sculpture in America." Allotted ten minutes each and charged with addressing the subject of abstract art through their individual beliefs, the symposium participants (in order of their appearance) were George L. K. Morris, Willem de Kooning, Alexander Calder, Fritz Glarner, Motherwell, and Stuart Davis. Andrew Rit-

chie, director of the museum's painting and sculpture department, had organized the exhibit (in which Motherwell was represented by the oil *Western Air* [1946–1947]) and moderated the session. The papers were published in the spring issue of the museum's *Bulletin*.[1]

Motherwell, comfortable with a subject to which he had devoted over a decade of thought and with an enlightened audience, summoned his ideas with poetic ease. His and de Kooning's comments in particular, each highly individual and considerably different from each other, remain among the milestones of early abstract expressionist literature. ◼

The emergence of abstract art is one sign that there are still men able to assert feeling in the world. Men who know how to respect and follow their inner feelings, no matter how irrational or absurd they may first appear. From their perspective, it is the social world that tends to appear irrational and absurd. It is sometimes forgotten how much wit there is in certain works of abstract art. There is a certain point in undergoing anguish where one encounters the comic—I think of Miró, of the late Paul Klee, of Charlie Chaplin, of what healthy and human values their wit displays . . .

I find it sympathetic that Parisian painters have taken over the word "poetry," in speaking of what they value in painting. But in the English-speaking world there is an implication of "literary content," if one speaks of a painting as having "real poetry." Yet the alternative word, "aesthetic," does not satisfy me. It calls up in my mind those dull classrooms and books when I was a student of philosophy and the nature of the aesthetic was a course given in the philosophy department of every university. I think now that there is no such thing as *the* "aesthetic," no more than there is any such thing as "art," that each period and place has its own art and its aesthetic—which are specific applications of a more general set of human values, with emphases and rejections corresponding to the basic needs and desires of a particular place and time. I think that abstract art is uniquely modern—not in the sense that word is sometimes used, to mean that our art has "progressed" over the art of the past—though abstract art may indeed represent an emergent level of evolution—but in the sense that abstract art represents the particular acceptances and rejections of men living under the conditions of modern times. If I were asked to generalize about this condition as it has been manifest in poets, painters, and composers during the last century and a half, I should say that it is a fundamentally romantic response to modern life—rebellious, individualistic, unconventional, sensitive, irritable. I should say that this attitude arose from a feeling of being ill at ease in the universe, so to speak—the collapse of religion, of the old close-knit community and family may have something to do with the origins of the feeling. I do not know.

But whatever the source of this sense of being unwedded to the universe, I think that one's art is just one's effort to wed oneself to the universe, to unify oneself through union. Sometimes I have an imaginary picture in mind of the poet Mallarmé in his study late at night—changing, blotting, transferring, transforming each word and its relations with such care—and I think that the sustained energy for that travail must have come from the secret knowledge that each word was a link in the chain that he was forging to bind himself to the universe; and so with other poets, composers, and painters . . . If this suggestion is true, then modern art has a different face from the art of the past because it has a somewhat different function for the artist in our time. I suppose that the art of far more ancient and "simple" artists expressed something quite different, a feeling of *already* being at one with the world . . .

One of the most striking aspects of abstract art's appearance is her nakedness, an art stripped bare. How many rejections on the part of her artists! Whole worlds—the world of objects, the world of power and propaganda, the world of anecdotes, the world of fetishes and ancestor worship. One might almost legitimately receive the impression that abstract artists don't like anything but the act of painting . . .

What new kind of *mystique* is this, one might ask. For make no mistake, abstract art is a form of mysticism.

Still, this is not to describe the situation very subtly. To leave out consideration of what is being put into the painting, I mean. One might truthfully say that abstract art is stripped bare of other things in order to intensify it, its rhythms, spatial intervals, and color structure. Abstraction is a process of emphasis, and emphasis vivifies life, as A. N. Whitehead said.

Nothing as drastic an innovation as abstract art could have come into existence, save as the consequence of a most profound, relentless, unquenchable need.

The need is for felt experience—intense, immediate, direct, subtle, unified, warm, vivid, rhythmic.

Everything that might dilute the experience is stripped away. The origin of abstraction in art is that of any mode of thought. Abstract art is a true mysticism—I dislike the word—or rather a series of mysticisms that grew up in the historical circumstance that all mysticisms do, from a primary sense of gulf, an abyss, a void between one's lonely self and the world. Abstract art is an effort to close the void that modern men feel. Its abstraction is its emphasis.

Perhaps I have tried to be clear about things that are not so very clear, and have not been clear about what is clear, namely, that I love painting the way one loves the body of woman, that if painting must have an intellectual and social background, it is only to enhance and make

more rich an essentially warm, simple, radiant act, for which everyone has a need . . .

Note

1. The evening had aroused considerable public interest and brought requests for publication of the papers that had been delivered. The version of Motherwell's comments published in the museum's *Bulletin,* and presented here, was illustrated by his oil *Personage* (1943) and varied somewhat from an article of the same title, purportedly his complete text, that appeared in *Art Digest* 25, no. 10 (15 February 51): 12, 27–28. A few months later, a Parisian monthly magazine of modern art devoted an issue to "La Peinture abstraite aux U.S.A." (*Art d'aujourd'hui* 2, no. 4 [June 1951]) and included French translations of all the papers, except that of the sculptor Calder.

"The Rise and Continuity of Abstract Art" 12 April 1951

On 12 April 1951, Motherwell delivered a lecture at Harvard University as part of a symposium on modern art arranged by the Fogg Museum's director, John Coolidge. Other participants in the event were the art historian Oliver W. Larkin, who spoke on "Modern Art and a Continuing Modern Art," and the artist Ben Shahn, who presented "An Unorthodox View: Some Relationships of Art to Social Philosophy."

In his original and extended presentation, Motherwell divided his talk into ten sections, adding a prelude and a conclusion. With each section, he projected slides of works by the artists on whom he focused, which remained on the screen while he spoke. This technique was one he was using at the time in his classes at Hunter College in New York, and fittingly a portion of his talk addressed his teaching methods and philosophy.

The following portion from "The Rise and Continuity of Abstract Art" is essentially the conclusion of his lecture at Harvard and the version that appeared later in *Arts and Architecture.* ■

I have placed emphasis on the modern artist's existence as a solitary individual. I would be misleading however if I left the impression that this solitariness is caused solely by his desire, whether conscious or unconscious, to remain aloof from the world surrounding him, as when the Chinese artist argued that the best place for a studio is on a mountain top—that is, that withdrawal from the world is a necessary condition of contemplation. Only psychological analysis of each modern artist as an individual could adequately demonstrate how far his solitude is brought about by his own character in the sense that, whenever we encounter an aloof individual, artist or not, we suspect that his isolation derives in part, from his own secret desires.

Still, if we assume the hypothesis—a false one, I am sure, whose

fruitfulness is not affected by its falseness—that every modern artist wants to come into intimate contact with the world—that is, with other human beings—as an artist, then it is immediately apparent that the general ignorance of plastic culture as a whole among other human beings—laymen of course, but most intellectuals too, often even critics and museum directors—is such that a modern artist often has difficulty in being granted some of the simplest things that he is, intelligent, accomplished, cultivated—since hardly anyone but his confreres can "read" his work and consequently his basic characteristics. Perhaps it is for this reason that in modern times artists have written and spoken in public so much and issued manifestoes by the dozens.

It is true that modern art has a unique amount of experimentation in it, and that perhaps only people very close to these experiments can at once "read" them. But it is true too that much of the so-called "un-intelligibility" of modern art is a result of the enormous extension in modern times of the background of art, a background which was for everyone until a century or so ago, and still is for most people, the realism of Greece and Rome and the Renaissance and modern modes of illustration. If I may give an example from my own experience, which I am certain is that of every advanced artist who earns his living by teaching, my students come to me—all themselves teachers of art, by the way—with their chief experience in painting from the model as it has been taught in academic institutions from the time of Delacroix and Ingres down to our own day in, say, the Art Students League of New York or the Chicago Art Institute. This narrow background—self-evidently narrow, when one compares it with the totality of world art, which is now available to everyone, less, as André Malraux points out, because of the ease and speed of modern travel than because of the enormous diffusion of reproductions—leads the students to believe at first sight that I propose to teach them radically experimental techniques (even the idea of experiment seems radical to them), "wild" and irrational beyond belief (one sees very well even now how inevitable it was that such terms as "fauve" and "dada" should come to be accepted, with malice by the public and humor by the artists), tolerated at first only by the authority of my position as the teacher of the class. One of my pleasures, and one of the students' is, when the day comes, more rapidly than one expects in a studio class, less rapidly in a lecture course, that students can "read" a Mondrian or a Miró or a cubist collage as feelingly as they already could a Vermeer or a Chardin or a Goya; an equally great pleasure on my part, and one unexpected on the students' part, is that they can also "'read" with equal ease an Italian primitive, a Cretan clay figure, a Byzantine mosaic, a New Hebrides mask. It is interesting that once this range of perception is added to their previous appreciation of the various modes of realism in painting, I cannot persuade them to return—though they always are at liberty to—to the live model. They say that it gets in the way of their

real conceptions. As indeed I believe it does. Some of my academic colleagues tend to be shocked at my students' works, as though I were destroying the students' respect for the past and its traditions! But I think that the students know that their work has so "modern" an aspect in part at least because it has so broader a background of traditional culture, that past can only be recovered genuinely through the needs of the present. Otherwise it remains a series of alien monuments to be forgotten as soon as they walk out into the street. But Piero della Francesca and Uccello are real to them in a sense that they were not to nineteenth-century students; and these modern students realize that what happened was that modern art intervened, that Seurat, Cézanne, and the cubist collage helped us recover Piero and Uccello. In this sense, modern art is universalizing and humanizing.

There is a danger to this great augmentation of our plastic repertoire, the danger of a sort of universal eclecticism. To be cultivated and to be creative are not the same thing, though each vivifies the other. But the answer has already been implied. The recovery of the past through present needs teaches us what is relevant. That is, the immediate demands of one's subject matter determine what is living in past cultures. But the subject matter of modern art is another topic.

The emphasis here is that much of the seeming radicality of the appearance of modern art derives from its greatly enlarged frame of reference, a frame still missing from the minds of most observers.

Preface to *The Dada Painters and Poets: An Anthology* 1951

In that dada, like surrealism, represented a development in the modernist tradition, the subject had intensely engaged Motherwell for over a decade before his book on dada was published. His interest in the long-defunct movement had dated back to his fraternity with the surrealists, beginning in 1940, when his questions regarding their artistic origin met with evocations of dada.

When *The Dada Painters and Poets: An Anthology* appeared in 1951 in the Documents of Modern Art series,[1] it was the first anthology of dada literature in English, and it remains the most comprehensive compilation in any language.[2] Its publication, a virtual resurrection of the First World War nihilistic movement, was noted in the United States particularly by what came to be known as the "New York School of poets" and then by artists of the pop art movement, whose aesthetic was influenced by it.

The book's unorthodox history includes the unusual compilation of its text, which was set into type in batches and, complete with illustrations, put aside for months as each section was "discovered" (many with the help of Bernard Karpel, then chief librarian at the Museum of Modern Art in New York). Complicating and delaying publication

was an eleventh-hour squabble among old-time dadaists over a manifesto written especially for the edition, requiring diplomacy and pragmatic solutions from Motherwell. As a whole, the method of production was undoubtedly unprofitable, and this volume and others in the series—which Motherwell in recent years characterized as *labors of love unimaginable in the publishing industry today*[3]—were realized through a rare combination of perspicacity and what can only be called naiveté shared by the two publishers and their young editor.

Motherwell wrote his introduction to the book in the winter of 1951 in East Islip, Long Island,[4] and his preface in New York City on 14 June of the same year. The unique physical method by which he actually wrote these pieces offers an unparalleled insight into the totality of his creative process. The sustained introduction necessary to fill in links missing from the text loomed as a tedious chore to him, even though, after the six years he had spent with his subject, he was more than familiar with it. Since he had always felt that typewriter paper and type were unsympathetic as materials, he began the writing on large pieces of stiff, expensive drawing paper, a solution he had employed for at least two other of his introductions. With the introduction, however, each idea occupied a separate sheet. In a discussion regarding his method, Motherwell stated:

My creative and critical sense are all bound up and dependent upon seeing everything at once. I basically have a spatial and not a temporal sense. Therefore, my inspiration—which may sound absurd—was to pin these sheets upon the forty-foot wall of my painting studio, and then to begin moving them around like a collage. It was only then that I began to hit it exactly because, although I couldn't read them from a distance, I could remember the particular passages from the way they looked. In this manner, I could keep everything in my mind—what I said, what I hadn't said—and rearrange the sequence and order until it all came to life.[5]

Regrettably, as this book remains one of Motherwell's supreme literary efforts, these two lengthy writings cannot be included in their entirety, but are available in the second edition.[6] Presented here is a significant portion of the preface. ■

[. . .]

Since the series called the Documents of Modern Art is primarily devoted to visual art, this anthology began simply with the purpose of publishing a complete translation of Georges Hugnet's *The Dada Spirit in Painting*—an abbreviated version of which appeared in Alfred H. Barr, Jr.'s *Fantastic Art, Dada, Surrealism*—with the addition of a few related texts. But in editing the book my conviction grew, reinforced by past experiences as a young artist among the Parisian surrealists, that, as with surrealism, without an adequate grasp of the value-

judgments of dada as evidenced in its literature, the image of dada that emerges from consideration of its plastic works alone is distorted and incomplete. It was then decided to include the principal histories of dada from a literary viewpoint, the *History of Dada* by Georges Ribemont-Dessaignes, a French view, and *En Avant Dada: A History of Dadaism* by Richard Huelsenbeck, a German view. I believe the latter work to be one of the most extraordinary expressions, not only of dada, but of the avant-garde mind in the strictest and narrowest sense; and I am grateful to the translator of many of the texts in this volume, Mr. Ralph Manheim, for having resurrected it from the small and now difficult-to-find brochure published in Germany at the end of the First World War.

From such major additions to the original project, it was a natural desire to try to make the anthology really complete. I began to ask the dadas in New York, as I would find them by chance browsing in Messrs. Wittenborn and Schultz's bookstore, which is devoted to books on the fine arts, to make suggestions towards having the anthology as complete and fair as possible.

During the six years in which the anthology was in the making, in came dadas, sometimes to browse, sometimes because they knew the anthology was being prepared, champing at the bit, like old war horses— among them, Arp, André Breton, Marcel Duchamp, Max Ernst, Richard Huelsenbeck, Man Ray (whom I never met), and Hans Richter, as well as others who had known the dadas in Germany, Josef Albers, Frederick Kiesler, Moholy-Nagy, and Mies van der Rohe.

Arp, Duchamp, Ernst, Huelsenbeck, and Richter examined the dummy of the book on various occasions, though its final character is my responsibility. Duchamp suggested the pre-dada section, maintaining that dada did not arrive in Zurich as a "bolt out of the blue," so to speak, but had been "in the air" a long time before. Max Ernst suggested asking Tristan Tzara in Paris to write an introduction to the anthology; and Huelsenbeck proposed that the dadas now in America sign a new (1949) dada manifesto, written by himself, to bring the anthology to an end, [. . .] Richter kept underlining the slight done to the German-speaking side of dada by French historians. And Tzara, whose antagonism to Huelsenbeck's 1949 manifesto created an impasse, introduced by implication the question of the U.S.S.R. Indeed, I believe that the present view of dada as a historical movement held by each of the dadas is in every case somewhat colored by his present sympathy for or antagonism to the U.S.S.R. It is interesting that Huelsenbeck who—to judge by his writings of the period—was one of the strongest spokesmen for the politics of the left in the dada days so long ago, who accused Tzara of trying to make a French literary movement out of dada, has been for a long time a bitter opponent of the U.S.S.R. and a practicing psycho-analyst on Central Park West; and Tzara is now a Russian sympathizer living on the Left Bank of Paris.

Dada was indeed the first systematic attempt to use the means of *l'art moderne* in relation to political issues—a magazine edited by Baargeld and Max Ernst, was sold among the workers of Cologne. This tendency was one of dada's principal bequests to surrealism, which was founded by one-time dadas; and like surrealism, dada tended to be hostile towards abstract art. Yet now, a generation later, the works of dada appear more at home alongside abstract works than they do beside surrealist ones. There is even a gallery in New York now, Rose Fried's, that shows only dada and "nonobjective" works. In one of his last letters, the late Piet Mondrian wrote (to James Johnson Sweeney): "I think the destructive element is too much neglected in art." Both dada and strictly nonobjective art are trying to get rid of everything in the past, in the interests of a new reality.

There is another, and I believe stronger line in modern art, say, from Matisse to Picasso to Miró, that had its destructive side only in order to recover for art human values that existed in art before and will again, but to which conventional and "official" art remain insensitive. It is one thing to hold that many of humanity's values have vanished from or have been vulgarized by contemporary art, as Cézanne believed; it is another thing to believe that the history of humanity has been a collective fraud—as when Picabia nailed a stuffed monkey to a board and called it *Still Life: Portrait of Cézanne*.

A hundred years ago Leconte de Lisle wrote what could have been a dada slogan, "I hate my epoch." But the problem now, as then, is to change the epoch, not to pass through it uninvolved, like Duchamp's *Young Man on a Train*.

[. . .]

It remains now to say what this anthology is, and what it is not. It is primarily an accumulation of raw material for students, the largest, so far as I know, under the covers of one book; there has been no effort at correlation, nor to deal with the numerous contradictions—I might add that the bibliographer and myself are not indebted, on the whole, to the dadas for accurate dates or reliable information about anyone but himself, that in every case this attitude has been justified as "being dada," with a shrug—though Duchamp alone claims still to be dada. In the same spirit, I have been less discreet in the Introduction than normally. Secondly, though there is some effort in this anthology to indicate dada's literary ramifications, the volume is primarily concerned with visual works. Thus it must be remembered, in using the book, that dada, like surrealism, was probably more the work of poets than painters, however inspiring the cubist revolution in painting may have been to both, and that, like surrealism, dada's permanent effects have been on contemporary French literature, not on modern painting—though there is a real dada strain in the minds of the New York School of abstract painters that has emerged in the last decade, painters, many of whom were influenced by the presence of the Parisian

surrealists in New York during the Second World War. Thirdly, for various reasons—economic, editorial, and the limits of space—it has not been possible to make the anthology wholly complete, or always properly proportioned. But I think it would be unjust, in view of what it does present, to criticize the book seriously in regard to these details. I believe that it does succeed in its main objective, that it is not possible to read this book without a clearer image of dada forming in one's mind.

Notes

1. By this time, Motherwell had been dismissed from his work as the editor of the series due to a bizarre set of circumstances. Both George Wittenborn and Heinz Schultz and their wives believed in astrology and had hired a well-known astrologer to read into all their futures. With the publishers' grave regrets and to Motherwell's astonishment, he was asked to leave the publishing firm when it was predicted that seven years of bad luck would befall him (conversations with the artist, 1983–1986). Motherwell did not consent to a later request from Wittenborn to rejoin the firm in another venture (Motherwell archives).

2. Most notable of the critical attention the book received was "The Dada Movement," *Times Literary Supplement,* 23 October 1953, pp. 669–71. This was the first review of an American book on modern art as the subject of the publication's leading and front-page article.

3. Conversations with the artist, 1983–1986.

4. In the spring of 1951, Motherwell and his second wife, Betty Little, left East Islip, Long Island, where they had been living since the fall of 1950, to live in Manhattan.

5. Conversations with the artist, 1983–1986.

6. Robert Motherwell, ed., *The Dada Painters and Poets: An Anthology,* Documents of 20th-Century Art (Boston: Hall, 1981), pp. xvi–xliii.

A Statement and an Introduction to the Illustrations in *Modern Artists in America: First Series* 1951

Modern Artists in America: First Series was published by Wittenborn and Schultz in 1951. Intended as a biennial, the book was a systematic and detailed documentation of events occurring in American modern art during the two years preceding its appearance.[1] Handwritten end papers announced that the publication was "not concerned with all contemporary art, but only with what is specifically modern." It was designed "to convey *the sense of modern art as it happened,*" with "excerpts from magazines, catalogs and pamphlets compressed into a calendar which illustrate[d] the social attitudes affecting the position of the practicing artist."

Motherwell had conceived the idea for *Modern Artists,* designed its cover, and directed the project to completion. In some respects, it was a realization of the "chronicle" he had envisioned when he reviewed the Mondrian and Chirico exhibits for the periodical *VVV* in 1942. Now, his more concerted effort was to present modern art in a balanced perspective with the dominating conservative art.

The essential text of *Modern Artists* was the transcribed and edited

proceedings of the final and closed sessions at Studio 35.[2] Including only advanced artists, these now-historic three-day discussions, held on 21–23 April 1950, were moderated, respectively, by Richard Lippold, Alfred H. Barr, Jr., and Motherwell, and the transcript was edited to half its length by Robert Goodnough for publication in the following year. Also included was "The Western Round Table of Modern Art," edited by Douglas MacAgy, with Marcel Duchamp, Robert Goldwater, Darius Milhaud, Arnold Schoenberg, Mark Tobey, and Frank Lloyd Wright among the participants in the San Francisco seminars.[3]

Although Motherwell's actual written contribution to *Modern Artists* was a collaboration, the venture as a totality must be included among his literary accomplishments. The statement appears over his name, along with those of Ad Reinhardt, associate editor, and Bernard Karpel, documentary editor; and the introduction to more than fifty pages of illustrations, written in the fall of 1951, bears his name along with Reinhardt's. ■

A Statement

Today the extent and degree of modern art in America is unprecedented. From East to West numerous galleries and museums, colleges, and art schools, private and regional demonstrations display their mounting interest in original plastic efforts. One can say that by 1950, modern art in the United States has reached a point of sustained achievement worthy of a detached and democratic treatment.

It is true that very recently great attention has been paid to abstract art in exhibitions and publications. Yet, on the whole, this solicitude has been characterized by an erratic concern, full of prejudice, and confused by misunderstanding. In the light of its actual history, the more radical innovations and variations of modern American art rarely obtain recognition based on real accomplishment and in terms of its specific problem: the reality of the work of art.

This biennial is the first of a continuing series which promises to come to grips with that central situation. Through works and documents of its own making, the scope and nature of that struggle will be self-revealed. By impartial documentation of the event as it happens, the society in which the artist exists responsibly and the world of imagery and design in which he must exist creatively, stands manifest. This is the program of *Modern Artists in America*.

Introduction to the Illustrations

The collecting of these illustrations was begun by us in 1949, at the start of the Fifty-seventh Street[4] exhibition season; and they are in the main restricted to 1949–50. Despite our plans for an annual covering of each exhibiting season, it turned out not to be possible—for tech-

nical, as well as more personal reasons—to publish a modern annual within the year. The completed records were somewhat enlarged towards a biennial—a more practical method for us of reporting the modern aspect of art in America.

Since then the scene continues to change, with the modern aspect better, if haphazardly reported. Thus though this volume bears the mark of its date in a few respects, it is of value for its orderly documentation and completeness. And since what is continually needed is a systematic and sympathetic treatment of our chosen area, avant-garde art in America, we intend to document similarly the seasons of 1950–51 and 1951–52 in the second series of *Modern Artists in America,* in which other artists will appear in turn. Had it been our intention to reproduce only those artists by whose work we are especially moved, they would have been fewer, and the proportions different; had our intention been wholly critical and analytical, concentrated on the problems of modern art in America, rather than documentary, the emphasis likewise would have shifted—even so, there is perhaps too much of the nonfigurative. Still, this is where "the pressure of reality," in Wallace Stevens's phrase, has led the majority of our most imaginative and fertile artists: "It is not that there is a new imagination but that there is a new reality." To this might be added his preceding remarks: "It is one of the peculiarities of the imagination that it is always at the end of an era. What happens is that it is always attaching itself to a new reality, and adhering to it." It is this new reality, as it appears, that we want to document.

Selection of contemporary works of art, whether for exhibition or reproduction, is neither easy nor simple. And though it may be thankless, if not worse, in this instance, it has seemed to be an essential step—regardless of personal vanities or professional pique. Plainly an honest attempt to picture the modern aspect of painting and sculpture on Fifty-seventh Street can gain from the stress of limitation and elimination, since two or three national magazines report all exhibitions. We are concerned with the modern aspect. It *is* odd that this effort to bring some order into the situation should come not from critics or scholars, but from practicing artists; still, this may have its good side.

Notes

1. The second series, which was never realized, was scheduled to appear in the spring of 1953. Proposed contents were "Texts by Artists and Their Friends: A National Survey"; "Conferences and Symposia on Art in the United States"; a "Photographic Report" of paintings and sculpture of 1951 and 1952 from New York to San Francisco; "Art Films"; "Collections of Abstract Art," presented by Katherine Dreier's Société Anonyme; "Museum Acquisitions of Modern Works"; "Art in the World of Events: A Calendar of Texts from Critics and the Press"; "Publications, 1951–1952"; and "The Idea of the Avant-Garde in America."

In February 1958, about eight years after Motherwell had discontinued his work with George Wittenborn, the publisher wrote to him regarding the organization

of a foundation to publish the Documents of 20th-Century Art. Among proposed titles, the publishing program was to include *Modern Artists on Art II,* to be followed by updated volumes (Motherwell archives).

2. Studio 35 was established at 35 East Eighth Street after Subjects of the Artist closed at those premises in the spring of 1949. Friday-night discussions were modeled after those at Subjects, with artists invited to lecture in order to broaden the experience of students. (Motherwell, who introduced many of the speakers at both schools, also moderated a number of evening sessions at both.) The closed three-day sessions at Studio 35 were scheduled only for artists in order to avoid repetition and to permit unencumbered discussion.

Among the participants were Alfred H. Barr, Jr., William Baziotes, Janice Biala, Louise Bourgeois, James Brooks, Willem de Kooning, Jimmy Ernst, Herbert Ferber, Adolph Gottlieb, Peter Grippe, David Hare, Hans Hofmann, Weldon Kees, Ibram Lassaw, Norman Lewis, Richard Lippold, Seymour Lipton, Motherwell, Barnett Newman, Richard Pousette-Dart, Ad Reinhardt, Ralph Rosenborg, David Smith, Theodoros Stamos, Hedda Sterne, and Bradley Walker Tomlin.

3. Motherwell credited Bernard Karpel with finding and including these talks (conversations with the artist, 1983–1986).

4. At the time, most art galleries exhibiting modern art were clustered there, mainly near Madison Avenue.

Final Page of Letter to Unknown Party *Early 1952*

Among the several enterprising exhibitions through which Samuel Kootz explored ways to introduce and sell the work of his group of artists to the public was one he mounted in 1950. For "The Muralist and the Modern Architect," William Baziotes, Adolph Gottlieb, David Hare, Hans Hofmann, and Motherwell executed and displayed works designed with projected buildings of distinguished architects in mind. Motherwell's sketch for a mural for the Architects' Collaborative by Walter Gropius was never realized as a project, but a mural commission from the architect Percival Goodman did arrive for him the following year. For the synagogue of the Congregation B'nai Israel in Millburn, New Jersey, he executed a 9- by 12-foot mural, his first commissioned public work. The project proved to be a gratifying collaborative experience and, in terms of his studio painting, opened up for him the potential in works of large scale.

In a letter presumably written and sent in early 1952 to an unidentified correspondent, Motherwell made reference to working on the synagogue commission. Only the final page of the letter is extant. It appears that the subject under discussion in the preceding page (or pages) was public versus private activity. This prompted Motherwell to remarks about his synagogue work, his teaching at Hunter College, and his upcoming seminar for 15–24 April at Oberlin College in Ohio. More revealingly, it gave occasion for expression of his most personal thoughts on what painting was for him. ∎

[. . .] my own way—I dislike the insecurity; there is nothing bohemian in my makeup. I have had to struggle too hard against mental

chaos for there to be not a great need of order in my personal life. And I hate too the separation from the world that leads us to become more and more abstract and "pure" in our expressive means. I loved working with the Rabbi on the synagogue, though I hadn't time or proper working conditions to realize what I am really capable of. But I can't pretend that the separation does not exist when it does, and those people who were confused by my accepting the commission when I am neither Jewish nor religious in that sense don't see that it was neither for money nor fame, but from a desire to work with other people—as one human being to another—in short, to enlarge not merely aesthetically but humanly my experience, which otherwise is pretty much limited to maintaining the right to paint in the manner I regard proper for myself, and to regard criticisms of it as vitiated by the critic's lack of involvement in the present.

Thus, from the standpoint of a de Kooning, Hofmann, or Rothko, certainly from my own, I believe what becomes false in a realist or a social realist, say a Wyeth or a Shahn, is not merely an aesthetic difference, or an intolerance or blindness on our part, [but] their belief and assertion, like Dali before them, that the public really loves art; and they are really involved with the public—instead of with the artist's love for art. I think that is why there is no joy or radiance in their work, whereas in de Kooning's most anguished and even loathsome images (on occasion), there is invariably a joy in the medium of painting itself, which is the real love of his life, as it is with the rest of us.

Well, the more clear I try to become, the more I get mixed up. All I am trying to say is that I am in favor of any opportunity that will help me realize and make actual my ethic (which is my identity as a man), to act with love in regard to art; but that it is never easy—or perhaps I am not clear enough or strong enough in relations to institutions. At Hunter I am at present a part-time lecturer, though I believe they are trying to make me an associate professor, since I teach more than halftime at halftime pay; and I am going to teach for ten days at Oberlin this spring on some foundation previously occupied by Panofsky and by Morey—to my stupefaction, as you can imagine! A complication for me in going away is that at Hunter my substitute's pay is deducted, though in Oberlin they are paying me a great deal, because of the foundation. I wish they asked me to paint a wall for the money instead of teaching; I could do it on paper, and they could throw it away at the end. Instead I'll write one of my speeches—which really aren't very good, outside of a certain sincerity and candor—and throw it away at the end.

But I've taken too much of your time. We can talk when you come . . .

1950–1959

■ Appointed part-time lecturer in the graduate teacher-education program at Hunter College in New York, Motherwell assumed his teaching duties during the spring semester of 1951.[1] His appointment was the result of a call from Edna Wells Luetz, chairman of the college's art department, to the Museum of Modern Art during her search for "a modern artist, and one who is articulate."[2] Two years later, in a speedy vote of confidence, Motherwell was made assistant professor. He was given tenure in 1954,[3] and became associate professor in 1957.[4] With a sabbatical leave and two personal leaves of absence during the period, he taught happily at Hunter until his resignation in 1960. During the decade of his affiliation with the college, he recommended the appointments of several avant-garde artists to the staff, and played a part in turning the art department into one of the most esteemed in the country. He returned to Hunter as distinguished professor for the 1971/1972 academic year.

On 24 February 1954, Motherwell delivered a public lecture at Hunter entitled "Symbolism," in a program addressing that subject. Preceding him on the agenda was William B. Kimmel, professor of music at the college. ■

I

One is rarely handed a subject more difficult to speak on than "symbolism" in art—it supposes that all the processes of the artist's mind are adequately known, *known* by himself, and that these can be translated into ordinary discursive English. I think none of these assumptions is true, which doesn't mean they are altogether false; but if they were true, there would be more agreement. The French mathematician Poincaré said, "Thought is only a flash between two long nights." Artists work by these flashes of thought, which are symbolic in character; it is not possible to think without symbols. But the symbolic thought is *in* the work, so to speak, and not *about* it; otherwise you would be thinking a symbolizing of a symbolizing, not merely symbolizing. I do not think it is possible to do both at once. At least I have never had a thought about painting while painting, but only afterwards. In this sense one can only think *in* painting while holding a brush before a canvas, and this symbolization I trust much more than the thinking that I do *about* painting all day long. And I think that most artists tend to trust the canvas much more than the words about it. One is much more apt to find agreement among artists about the worth of a specific canvas than about any of the reasons advocated for its having value. Yet surely the value of a work derives ultimately from the adequacy of its symbolization, and from what it symbolizes; and these things ought to be clear to anyone able to apprehend a modern work of art at all. In a sense they are, but seldom in a sense that can

be said. As Whitehead wrote, we suffer from a "deficiency of language. We can see the variations of meaning, although we cannot verbalize them in any decisive, handy manner. Thus we cannot weave into a train of thought what we can apprehend in flashes . . . For this reason, conventional English is twin sister to barren thought. Plato has recourse to myth." And so is the instinct of every artist to have recourse to image, metaphor, and when there were living ones, myth. Yet in an academic situation, that is to say, a primarily discursive situation, if one speaks poetically one has the feeling of somehow defrauding the audience, of keeping suspended in mystery what is somehow supposed to be made clear. But in "the study of ideas," as Whitehead said in another book, "it is necessary to remember that insistence on hard-headed clarity issues from sentimental feelings, as it were a mist, cloaking the perplexities of fact. Insistence on clarity at all costs is based on sheer superstition as to the mode in which intelligence functions." Clarity is bought at the price of incompleteness. For my part, I have always assumed that the essential nature of intelligence's functioning is the grasp of relations. Many of the relations that a painter grasps are nonverbal. Indeed, one of the worst things that a painter can say about a painting is that it is a "literary" painting, which of course is just the painting that people who have words as their medium tend to like, an unbridgeable abyss between the painter and the non-painter. Yet the relations in painting *are* essentially wordless. I suppose that it is for this reason that André Malraux ultimately called his book on the psychology of the visual arts, *The Voices of Silence*.

II

Still, there are some things that can be said about a work of art—I say *a* work of art because I no longer believe that it is useful to talk about art in general, but only about specific works in specific times and places. The most common implied criticism of Picasso, which I find ridiculous, is that he is not Michelangelo; moreover, if Michelangelo were alive now, his work would be akin to Picasso's . . . In the same way, I would rather talk about specific cases of symbolization than about symbolization in general. Professor Kimmel's distinctions between symbolism as having to do with internal relations and symbolism as having to do with external relations seem to me so just and skillfully put that it is hard for me to imagine anyone fundamentally disagreeing. But this does not quench my thirst for specific examples. Ordinarily I would give some, but this would take not minutes; so that it seems to me the thing to do is to give a summary of the kind of thing that I would discuss if there were time. The interest is to relate the internal and external references in a work or a series of works by the same man—that is, to deal with its symbolic character inside and out. To the degree that you are emphasizing the internal relations, you speak

as an artist, with an artist's empathy for structure; to the degree that you speak of the external relations, you speak as an art historian. This might seem funny, but every artist has to be his own art historian because, in becoming an artist, you begin with art not nature. Nature is not a form of art, but a possible subject . . . It doesn't matter where you begin the analysis because none of the processes of symbolization that these systems of relations involve has logical or temporal priority over another—especially in a period like ours in which most works are not commissioned, that is, when there is not something *first* given from the outside. For the same reason it doesn't matter where you end. What does matter is to be complete and to be sufficiently subtle. The ancient Chinese painters, who did all the writing about art in China and almost gave the word to the wordless, used to say that no truth is true that is not subtle. I mean the same thing when I say that the criterion of truth for me is adequacy; truth is not a property of reality—reality just is what it is, whatever it is, just as yellow is yellow, and neither true nor false. Truth is a property of symbolizations of reality, not reality itself. Truth exists for men alone, because men alone symbolize. From this point of view, works of art are true or false (as well as beautiful or ugly, and good or evil), as with propositions and mathematical formulae. This point of view enforces upon you the obligation to be very accurate in ascertaining what a work of art is really symbolizing. There is nothing more accurate than a work of art itself, or less accurate than most of its criticisms.

III

The late Piet Mondrian's painting can be naively described as strictly horizontal and vertical black bands on white ground—with occasional squares of the three primary colors; yet Mondrian himself denied that the bands were bands or the squares squares, or that the color was restricted. "I don't see any squares or rectangles in my work," he used to say, though there was nothing but horizontals and verticals at ninety degree angles. What he meant—though his remark was taken as one of those crazy painter's jokes—was that the canvas was a continuum of space, sheer extension, energized by *rhythm,* which for him was the *élan vital.* Even as an old man here in America he was mad about boogie-woogie, and used to dance with our wives in some dive or other. For him there was no division between an object and the space surrounding it, all were spatial, configurations of space, so to speak; and consequently he found Renaissance pictures, which are conceived of as personages on a stage, as "primitive" as the nineteenth century regarded savage art to be. There were no lines or squares in his pictures because both were extension, black extension and white extension, lying side by side, as the spaces of reality lie side by side. The color was not restricted, even though he used only red, yellow, and

blue, because the three primary colors "include" all colors, since all colors can be made from them. As an aside, I might say that I think this seeming restriction also saved him from what Kierkegaard a hundred years ago called the despair of the aesthetic, the fact that when you are allowed to use any color, any shape, any series of relations, the possibilities are so innumerable, the possibility of ultimate decision so arbitrary and tedious, that a kind of anguish overcomes you that, say, the medieval painter, who *had* to paint the Virgin's mantle blue, did not dream of. It was also Kierkegaard, that severe Protestant theologian, who pointed out that only Mozart could deal convincingly with the Don Juan legend, that only Mozart's music, of all the voices we know, speaks so seductively that no one could resist it.

Mondrain, that man whose work was so often called empty, formalistic, abstract, cold, and mathematical, regarded his work as symbolizing the ultimate nature of reality as he conceived of it; indeed, to the stupefaction of the ignorant, he called his work "the New Realism," using the word as St. Thomas Aquinas did, as an adjective for reality, not as an adjective for the photographic. He spent months in his old age writing in foreign languages. Hating conflict and loving harmony, he was politically an internationalist as he was metaphysically a universalist, and it was part of his ethic to write and speak only the language of the country in which he happened to be living. He spent months writing down his vision of reality, and upstairs in the art department, when we come to him in some of my courses, we spend hours correlating what he was symbolizing from reality with the symbolic structure of his work. I think at this stage the students begin to grasp that every work of art symbolizes an infinite background of thought, overt or unconsciously assumed.

Then we speak of Mondrian under the aspect of the ethical. I draw up a table of what he regarded as good and evil, inducted from his paintings and his writings and conversation. As I have said, for him harmony was good, and conflict evil. The origin of all evil for him in a sense was the individual, the particular, the limited, the given in space and time, the impure, and so on, which he lumped together under the category of the tragic. For him it was tragic that we are all given individuals, living in a given space and time, subject to the accidents of birth, background, and language. He would never paint a still life or a landscape because they were bound to be Dutch or Japanese or French or African, and he wanted to deal only with the universal. All this extended to his studio. Everything was black or white or the three primary colors, and everything squared at right angles. With his passion for music, it distressed him that the turntable of his gramophone had to be round for the records. Because he liked to dance so much, we asked him why he had never married, and he replied that he would have liked to, but he was never able. Later on, after his death, when I was editing the book of his writings in English, a mu-

seum director[5] who was writing a book about him told me that Mondrian had lived in Paris for a decade on about five dollars a month. No wonder he regarded man's lot as tragic! When all this is established in detail, I think some of the students begin to see that all his aesthetic decisions were ethical in origin, according to his conception of good and evil, and some of them feel very deeply when I quote his remark, "If we cannot free ourselves, we can free our vision."

They also begin to see how vulgarized is his influence on the General Electric refrigerator, the packaging of Chanel No. 5, or the ads for Orhbach's, to mention three of a thousand objects. One of the problems of modern industrial society is that there is no folk art, so that the only place industrial designers and commercial artists can steal from is our best painters. But they always misunderstand them, turning the ethical into "taste," which is never creative. In short, I think the students have at least an intimation of how Mondrian's art symbolizes his vision of reality as inexorably, passionately, and austerely as the ethical propositions of another inhabitant of Amsterdam flow from his vision. I mean Spinoza.

IV

At this point, I had meant to speak similarly of Picasso's mural, *Guernica*. Upstairs I have dozens of slides of its preliminary drawings, subsidiary works, and so on, as well as seven stages of the work on the mural itself, all of which needless to say are correlated with its content, the Spanish Civil War. But since time is so short, I would rather pick up a passage from a piece I wrote recently implying more generally than I could say in relation to Mondrian how a work of art can symbolize the ethical.

The context is this. The Ford Foundation publishes a cultural quarterly called *Perspectives USA,* which is distributed in Europe in four languages as well as English. Recently they asked four artists, a novelist, Saul Bellow, a poet, Robinson Jeffers, a composer, Roger Sessions, and a painter, myself, to write briefly about the relations of our various media with the audience. I pointed out that in the case of the modern painter there is no such thing as the audience, but instead a series of audiences, of which the most accurate in judgment is other painters. Then follow roughly museum people and critics, then private collectors, then university teachers and scholars, then celebrity hunters, then newspapers, and finally the public with vested interests, and so on. It seemed to me then necessary to explain that painters are more accurate in their judgment, not only because of our working intimacy with the medium, but because of a different attitude; everyone else's is strictly aesthetic, and usually a past aesthetic at that, which is not exactly what is involved.

V

Modern painting is sometimes called "painters' painting." It is not so commonly observed how painters tend to judge each other—I think primarily ethically, and then aesthetically, the aesthetic judgment flowing from the ethical background. I do not mean to say that painters systematically think this way; it simply seems to be what happens when painters look at other painters' new work. Kierkegaard, who was not interested in painting, was very aware of the active role of the ethical. In his analysis of existence in quite another context, he wrote, "If anything in the world can teach a man to venture, it is the ethical, which teaches to venture everything for nothing, to risk everything, and also therefore to renounce the flattery of the world-historical . . . a daring venture is surely not merely a high-sounding phrase, or a bold ejaculation, but a toilsome labor; a daring venture is not a tumultuous shriek, however reckless, but a quiet consecration which makes sure of nothing beforehand, but risks everything . . . dare, dare to become nothing at all, to become a particular individual, of whom God requires all, without your being relieved of the necessity of being enthusiastic: Behold, that is the venture!" Now if venturesomeness were valued in painters by painters, as it is in the specifically modern milieu, it is evident that certain aesthetics, academic ones, for example, *for which you can prepare and consequently do not really risk anything,* are automatically ruled out. It is from this point of view that we can understand Picasso when he says, "Academic training in beauty is a sham . . . It is not what the artist *does* that counts, but what he *is:* Cézanne never would have interested me a bit if he had lived and thought" like an academic painter, "even if the apple that he painted had been ten times as beautiful. What forces our interest is Cézanne's anxiety—that's Cézanne's lesson. The torments of van Gogh—that is the actual drama of the man. The rest is a sham."

Venturesomeness is only one of the ethical values respected by modern painters. When all the ethical values are taken together, they represent the background of thought for the strictly aesthetic. Every aesthetic decision is ultimately ethical in origin. It is unawareness of this background of thought that is the audience's chief problem. It is a matter of consciousness.

My emphasis is that adequate symbolization depends on adequate consciousness. Anyone who does not "understand" a given work of art is deficient in consciousness in that area of the symbolic process.

Notes

1. Letters of recommendation for Motherwell's appointment came from Alfred H. Barr, Jr., and Ad Reinhardt, then assistant professor in Hunter's design department.

2. Conversation with the artist, 21 October 1984.

3. Letters of recommendation for Motherwell's promotion came from James Johnson Sweeney, Philip Guston, René d'Harnoncourt, and Lloyd Goodrich.

4. In one of his periodic evaluations at Hunter, Motherwell was acknowledged as "an excellent teacher." The department chairman's general report in the spring of 1956 noted that Motherwell's students were "enthusiastic and devoted," the results of his graduate spring classes were "excellent," his seminar work was on an "exceptionally high level," and, "with his modest manner, he [was] well liked by the faculty of the department" (Motherwell archives).

5. James Johnson Sweeney.

"The Painter and the Audience" Fall 1954

The following essay, which Motherwell called "The Painter and the Audience," was solicited by the editors of *Perspectives USA,* a quarterly journal sponsored by the Ford Foundation, in early 1954. Published in the fall of that year, the piece was actually written before Motherwell delivered his lecture on symbolism at Hunter College in February, where he took many of the ideas presented here and further developed them. His reference to a ceiling or a wall as the sociable *audience* for the modern painter was probably spurred by his second commission, which he had received a year earlier, the design of a tapestry for Congregation Beth-El in Springfield, Massachusetts. The three other artists who responded to "The Creative Artist and His Audience," a symposium in which each was to address the relationship of his medium to his audience, were the novelist Saul Bellow, the poet Robinson Jeffers, and the composer Roger Sessions. ■

What a disagreeable subject!

To the degree that the modern painter's activity outside the studio is exhibiting, I suppose that he might be called an audience seeker. Painters must have begun to have exhibitions at that moment in history when commissions were no longer the custom and an audience had to be sought out—just as writers must have begun to publish when they ceased reciting to their patrons. The painters' loss caused by this change was not merely economic; it was as well a loss of collaboration with others; both losses profoundly affected the character of "modern" art. Perhaps this new situation calls for some examination, though here I feel rather ill at ease: for most painters nowadays, examination is self-examination—this is all that we are accustomed to—while the relation to the audience is a social matter. And it is our pictures, not ourselves, that live the social life and meet the public . . . It is interesting that the creations of solitary individuals should turn out to have such a gift for sociability!

When my generation of "abstract" painters began exhibiting ten years ago, we never expected a general audience, not at least one that would

make its presence obvious to us. After many years of genre painting in this country, and the great imports coming from Europe, it would have been unreasonable for us to expect one, no matter what we did; and yet an audience was there all the time, as it was for the cubists in their own time . . . Ten years ago, it seemed that we were embarked upon a solitary voyage, undertaken, I think—in regard to painting—in the belief that "the essence of life is to be found in the frustrations of the established order." We were trying to revise modern painting in relation to some of its obvious frustrations, so that painting would represent our sense of reality better. This general tendency each of us followed in his own way . . .

A modern painter may have many audiences or one or none; he paints in relation to none of them, though he longs for the audience of other modern painters; and if the modern painter should have a relation with any audience, it is because that audience has somehow found *him,* and managed to approach the center of his being, i.e., the character of his painting. Someone does find you, though it never can be, in a period like ours, everybody . . . As everyone senses, it is curious when a modern painter like Braque paints a public ceiling for the Louvre; and yet the intent on his side and that of the audience was surely that this is the way things should be . . .

For the "audience" that a modern painter *could* treat sociably is a ceiling or wall. It is a question of direct social contact. If the painter is commissioned to paint a specific wall in a specific place for a specific person, he must take into consideration the wall's needs, as well as his own, and a real marriage could come about, lessening perhaps the distance between the modern artist and the public. Yet certainly these marriages usually fail to be consummated, as I believe was true of Braque in the Louvre; collaboration is so rare that painter and public have difficulty in understanding each other; besides, in our time, painters cannot be married to institutions . . . And from the standpoint of the public, how many walls have been turned over during the past fifty years to the most celebrated and esteemed painters? So far as I know, to Matisse thrice, once by a Russian millionaire, once by an American millionaire, once by a French nunnery; to Picasso once, a temporary pavilion, for which he painted *Guernica.* Doubtless both painters have made even greater works in the studio's solitary inspiration; but still, what a triumph these four commissions represent as efforts to reach beyond that solitude! A solitude that has become traditional in modern society. Georges Seurat was born to paint walls, the large scale was inherent in his painting methods; yet no one ever asked him to; and there would not be even an easel painting of his in France, if it weren't for the bequest of an American collector.

Sometimes when I walk down Park Avenue and regard the handsome and clean-cut Lever Brothers building, which I suppose belongs to the same "family" as the tall UN skyscraper, I think to myself how

the interior walls need the sensuality and moral integrity of modern painting; but then one cannot help reflecting that what lies behind this building is not the possibility of collaboration between men on "ultimate concerns," but instead big business, that is, a popular soap, whose needs in the end will determine everything, including how its makers think about reality. It is strange when a commodity is more powerful than the men who make it.

My emphasis is the absence of direct social relations between the modern painter and his audience. One *can* understand, though it is curious to think this way, that a Picasso is regarded by speculators as a sounder investment than French government bonds; but what a peculiar responsibility or circumstance for a solitary artist. Indeed, our society, which has seemed so freedom-giving and passive in its attitudes toward the artist, really makes extraordinary demands upon him: on the one side, to be free in some vague spiritual sense, free to act only as an artist, and yet on the other side to be rigorously tested as to whether the freedom he has achieved is great enough to be more solidly dependable than a government's financial structure—as though the painter's *realistic* audience, as opposed to an audience with sentiment, were rare stamp collectors. No wonder that modern painters, in view of these curious relations to society, have taken art matters into their own hands, decided for themselves what art is, what its subjects are to be, and how they are to be treated. Art like love is an active process of growth and development, not a God-given talent; and since in modern society the audience rarely sees the actual process of art, the audience's remoteness from the act of painting has become so great that practically all writing about modern art has become explaining to the audience what the art is that the audience has got so far away from. And those whose profession is to do the explaining are more often than not mistaken. It is in this context that one has to understand the fury of Picasso's famous statement of 1935 beginning, "Everyone wants to understand art. Why not try to understand the song of a bird? One loves the night, flowers, everything around one, without trying to understand them. While with painting everyone must *understand*. If only they would realize that an artist works above all of necessity . . ." What angers Picasso is not the desire to understand, but that understanding should pose a problem, that his audience is unprepared for him. More exactly, prepared for something else.

Let us begin again. Modern art is often called a painter's painting, the assumption being that painters are the people most deeply involved with it, and in a sense the only people who can be, apart from a few aficionados and speculators. But what is not commonly observed is how modern painters themselves tend to judge modern painting, which I think might be the clue to the audience to what baffles it—still, in a verbal society, most people are "form-blind," in the sense that a few

people are tone-deaf, which increases the difficulties of true under-
standing. I believe that painters' judgments of painting are first ethical,
then aesthetic, the aesthetic judgments flowing from an ethical context.
Doubtless no painter systematically thinks this way; but it does seem
to me to be basically what happens when modern painters judge any
new manifestations of painting. Søren Kierkegaard, who did not value
painting, was nevertheless very much aware of this distinction in his
general analysis of existence. In quite another context, he wrote, "If
anything in the world can teach a man to venture, it is the ethical,
which teaches to venture everything for nothing, to risk everything,
and also therefore to renounce the flattery of the world-historical . . .
the ethical is the absolute, and in all eternity the highest value . . .

"Besides, a daring venture is surely not merely a high-sounding
phrase, or a bold ejaculation, but a toilsome labor; a daring venture is
not a tumultuous shriek, however reckless, but a quiet consecration
which makes sure of nothing beforehand, but risks everything. There-
fore says the ethical, dare to renounce everything, including this loftily
pretentious yet delusive intercourse with world–historical contempla-
tion; dare, dare to become nothing at all, to become a particular indi-
vidual, of whom God requires all, without your being relieved of
the necessity of being enthusiastic: Behold, that is the venture!" For
"only in the ethical is your eternal consciousness: Behold, that is the
reward!"

Now if venturesomeness is valued by painters, as it is by those
working in the specifically "modern" milieu, it is evident that certain
aesthetics, e.g., academic ones *for which you can prepare,* are deliberately
ruled out, not arbitrarily, but as beneath the level of the ethical. It is
in this sense that Picasso added, "Academic training in beauty is sham
. . . It is not what the artist *does* that counts, but what he *is:* Cézanne
never would have interested me a bit if he had lived and thought [like
an academic painter], even if the apple that he painted had been ten
times as beautiful. What forces our interest is Cézanne's anxiety—that's
Cézanne's lesson. The torments of van Gogh—that is the actual drama
of the man."

Venturesomeness is only one of the ethical values respected by mod-
ern painters. There are many others, integrity, sensuality, sensitivity,
knowingness, passion, dedication, sincerity, and so on, which taken
altogether represent the ethical background of judgment in relation to
any given work of modern art. Every aesthetic judgment of impor-
tance is ultimately ethical in background. It is its unawareness of this
background that is an audience's chief problem. And one has to have
an intimate acquaintance with the language of contemporary painting
to be able to see the real beauties of it; to see the ethical background is
even more difficult. It is a question of consciousness.

What is interesting in the poet Guillaume Apollinaire's relation to
cubism is not the book he wrote about cubist painting, but that in his

own poems he had the cubist consciousness, and therefore quite rightly was called a "cubist" poet.

An artist's "art" is just his consciousness, developed slowly and painstakingly with many mistakes en route. How dare they collect those ugly early van Goghs like trophies, because he happened to sign them!

Consciousness is not something that the painter's audience can be given; it must be gained, as it is by the painter, from experience. If this seems difficult, then—as Spinoza says at the end of his *Ethic*—all noble things are as difficult as they are rare.

Without ethical consciousness, a painter is only a decorator.

Without ethical consciousness, the audience is only sensual, one of aesthetes.

"A Painting Must Make Human Contact" 1955

In May 1955, the Whitney Museum of American Art in New York mounted "The New Decade: 35 American Painters and Sculptors." Curated by John I. H. Baur, the exhibition focused on the work of certain artists who had emerged during the post–Second World War decade (1945–1955) and was subsequently shown in San Francisco, Los Angeles, Colorado Springs, and St. Louis. Among the artists whose work was included were William Baziotes, James Brooks, Willem de Kooning, Herbert Ferber, Adolph Gottlieb, Franz Kline, Ibram Lassaw, Richard Lippold, Motherwell, Jackson Pollock, Richard Pousette-Dart, Ad Reinhardt, Theodore Stamos, and Bradley Walker Tomlin. For the exhibition catalog, Motherwell wrote a piece since referred to as "A Painting Must Make Human Contact." ■

I never think of my pictures as "abstract," nor do those who live with them day by day—my wife and children, for example, or the profound and indomitable old French lady[1] whose exile in New York has been enhanced by a miniature collection of them. I happen to think primarily in paint—this is the nature of a painter—just as musicians think in music. And nothing can be more concrete to a man than his own felt thought, his own thought feeling. I feel most real to myself in the studio, and resent any description of what transpires there as "abstract"—which nowadays no longer signifies "to select," but, instead, something remote from reality. From whose reality? And on what level?

If a painting does not make a human contact, it is nothing. But the audience is also responsible. I adore the old French lady because among my works she chooses those that specifically move *her*. Through pictures, our passions touch. Pictures are vehicles of passion, of all kinds and orders, not pretty luxuries like sports cars. In our society, the capacity to give and to receive passion is limited. For this reason, the act

of painting is a deep human necessity, not the production of a hand-made commodity. I respect a collector who returned one of my "abstract" pictures to the gallery, saying it was too tragic in feeling for her to be able to look at it every day. But somewhere there is a man with a tragic sense of life who loves that same picture, and I think he will find one day a way to have it. These are real human contacts, and I love painting that it can be a vehicle for human intercourse. In this solitary and apathetic society, the rituals are so often obsolete and corrupt, out of accord with what we really know and feel . . . True painting is a lot more than "picture-making." A man is neither a decoration nor an anecdote.

Note

1. Dollie Chareau, wife of the architect Pierre Chareau.

Letter to John 10 November 1956

Since Motherwell's first attendance at College Art Association meetings in 1950, several exhibits of modern American art had been mounted throughout Europe. The impact of the new painting had been significant abroad, and in the United States the gap between the avant-garde painter and his audience was beginning to narrow. Abstract expressionism had become a dominant subject in art schools and university art departments, and works were now exhibited and purchased with increasing frequency. Also aiding in the education of the public to the meaning of abstract expressionism was a more enlightened and sympathetic criticism. Reflecting this transition, the explicatory nature of Motherwell's writings on the new art was to be replaced over the next decade by an amplification of earlier thoughts on modernism and abstraction, expressed with a new dimension of authority and a resonant poetry.

Motherwell's letter, dated 10 November 1956, was in response to one from John (as yet unidentified) inviting him to upcoming meetings of the CAA. Motherwell declined the invitation to Detroit (opting for the *existential artist* in himself over the *civilized humanist*), but his regard for his correspondent inspired a collage of thoughts about the meetings. That the forty-fifth CAA conference was a joint meeting with the Society of Architectural Historians no doubt prompted his comments on Corbusier. He alluded to the alleged chasm between the artist and the art historian and the perennial debate among academics on the differences between them. Quoting an apt phrase from Kierkegaard, he regretted that he was unable to use it in making that *confrontation*. Having recently joined the Sidney Janis Gallery in New York, where he was to exhibit the following April, Motherwell, by his letter and decision not to attend the meetings, signaled his renewed focus on his painting and a tempering of public activity. ■

Dear John:

I feel greatly honored at your invitation—more than I can say—but I won't come to Detroit. I am going to have a show in April,[1] and I am as restless as a tiger for months before; and despite the intelligence and seriousness of a man like yourself, in general the CAA meetings are apt to enrage me in that mood. There is an existential artist in me and—I hope—civilized humanist, but for the moment the one has to take priority over the other. If our humanism weren't so rooted in academic institutions here, but more freewheeling, as in Paris, perhaps the conflict would not feel so sharp—but it does. I discipline myself six hours twice a week at Hunter College to be fair, tender, and learned; and then I revert. I have a little collage, *Histoire d'un Peintre,* in the Whitney Annual, and on it is written *"jour la maison, nuit la rue."* Maybe it's just a question of energy.

I give a course at Hunter [Appendix D], an "existentialist" one—that is, conceived in existences, not essences—called "The Artist and Modern Society," and a portion of it is devoted to Fathers Couturier and Régamey and the review *L'Art sacré,* and Ronchamp, which I believe to be *the* masterpiece of modern architecture.[2] I have a purely intuitive aside that may interest you: Corbusier is the greatest architect since Michelangelo; partly because both were painters—true, Corbusier is not as great a painter as Michelangelo, but *is* of the great twentieth-century movement, indeed Corbusier as painter *is* Picasso; indeed, only Picasso could "decorate" Ronchamp, but it doesn't need it, because in Ronchamp—Corbusier is Picasso as architect. How can this be? Because they both have—P. and C., that is—the two major contexts (in your sense) or perspectives of twentieth-century plastic art, modern French literature, and the plasticity (taste in a profound sense) of the Mediterranean—one could add Miró, Brancusi, Giacometti, a few others, Matisse most of the time, but Vence[3] fails because it is the Matisse of the collages, not of the *Stations of the Cross,* that is this thing. My own art in part is an obstinate and perhaps absurd effort to relate to those same two contexts. I have a relentless prejudice that modern European artists of the first line have been fed on modern French poetry as Spirit, and the Mediterranean as the Medium, as Focillon's "world of forms."[4] If so, what misunderstandings in the North, from expressionist distortion to abstract formalism:

All ancient and prehistoric art is "Mediterranean."

But you can see how the historians would annihilate my simplicities! Still, they suit me.

No teacher who has cultivated students visually can believe in creation *ex nihilo,* or anyone regarding Van Gogh or Picasso before and after Paris—and surely Van Gogh was more clearly *ex nihilo* by temperament and circumstance in the beginning than most anyone.

There is no freedom more unfree than being unrelated to contexts. I think there are two kinds of real freedom, the traditional, uncritical, inherited tribal relatedness, and the modern romantic choosing of what you are related to; the latter is more heroic and less satisfactory perhaps, though I suspect both are now.

I believe the real artistic relatedness is not "influence" the way historians tend to write about it, but Edmund Wilson's "shock of recognition,"[5] that is, seeing something you recognize and are confirmed in what you already are—though it is true also that there are Kierkegaardian "leaps," sprung by paradoxical faith.

I believe profoundly in Kierkegaard's three stages, aesthetic, ethicoreligious, and religious; that art is the first, the world of sensuous feeling, that the aesthetic can embody ethical decisions, but not reach altogether the ethical or the religious. Ronchamp is a masterpiece, but it is not Christian, there is not enough blood or moralizing; in a strange way, it must be too beautiful for the priests to take over. This morning I have just read that Jean Cocteau has been commissioned to provide the murals for the chapel of Saint-Pierre in Villefranche! And yet who would you get, a devout hack?[6]

I had an interesting telephone conversation with Pickens[7] (whom I've never met) about the CAA. The artists always agree naively but naturally on a chasm between two groups there; but it's not really, as we say, artist and historian, but as Kierkegaard says, "it is one thing to think and another *to exist in what is thought.*" If I had the genius and the occasion, I would like to make *that* confrontation. K. is also right when he says existence is (and is only) choosing, and living out the choice; he is right when he says an artist's (or aesthete's life) is boredom, passion, immediacy, despair—because it doesn't make ethical choices, but is neutral; but also is a real existence, in choosing oneself as object—think of Mozart; he is right when he says faith always involves risking "venturing out upon 70,000 fathoms of water": that real thought can only be real (or transcendent) in the absurd paradox, Mozart and Shakespeare are full of it, Donne sometimes too. —For the last two years I have been making a series of paintings with *"je t'aime"* written across them in calligraphy of the painting, sometimes tenderly, sometimes in a shriek. —I never thought much about it, but I am sure in part it is some kind of emphasis or *existing in* what is thought.

I don't know what extraordinary alchemy you exert to get me to write at such length, I never write letters (almost) and never about ideas; there is something about the naturalness and seriousness with which you take ideas that I find very moving. I remember years ago at one of those meetings you said something I never forgot in relation to modern art's humanism, that maybe it was "a matter of a new kind of humanism." Indeed it is. Through an unexpected inheritance I own

my house and studio here, and also somewhat unexpectedly I have three* beautiful small daughters, so I think my address won't change and hope that you don't forget it.

Notes

1. Most likely, his one-man exhibit at the Sidney Janis Gallery in New York.

2. French Catholic priests Fathers Pierre Marie Alain Couturier and Pie-Raymond Régamey were pioneers of the modern liturgical arts movement. At mid-century, they wrote for the review *L'Art sacré,* of which Couturier had been co-director. They espoused the utilization of fine modern art for the Catholic Church and, to this end, were responsible for the design and decoration of many churches and chapels in France by prominent twentieth-century architects and artists, whether or not they were Catholic.

The church at Ronchamp in northeastern France was designed by Le Corbusier (Charles Edouard Jeanneret) in the 1950s.

3. Motherwell is referring to Matisse's interior design and decoration of the Chapel of the Rosary in Vence in the late 1940s.

4. Henri Focillon, *The Life of Forms in Art* (New York: Wittenborn, 1948), was the first English translation of the French text of 1934.

5. Motherwell frequently used Edmund Wilson's concept-phrase, taken from *The Shock of Recognition* (New York: Doubleday, 1943), which included writings by "first-rate figures on other first-rate figures."

6. Cocteau was an iconoclast and a surrealist.

7. The American artist Alton Pickens had exhibited his work with Motherwell's in "Fourteen Americans" at the Museum of Modern Art in 1946.

Notes in John I. H. Baur, *Bradley Walker Tomlin* 1957

In the fall of 1949, about when Studio 35 was founded on the former premises of Subjects of the Artist, Motherwell opened his own school, essentially to accommodate a few students from Subjects who wanted to continue working with him.[1] The loft he had recently rented for his studio at 61 Fourth Avenue in Greenwich Village (between Ninth and Tenth Streets and over the bookstore Biblo and Tannen) also served as his classroom four afternoons a week.[2]

At about this time, Bradley Walker Tomlin was forced to leave his Manhattan studio, whereupon Motherwell offered him the use of his own studio space. Since Motherwell's routine was to paint from the evening into the early morning (his practice for the remainder of his life) and Tomlin's was to work in the morning, the arrangement suited both artists for a period of time.[3]

It had been after the death in 1945 of Tomlin's longtime associate, the painter Frank London, that Tomlin developed strong personal and artistic friendships with Adolph Gottlieb, Philip Guston, Jackson Pollock, and Motherwell. Influenced by their painting and their use of

*The third daughter was Betty Little's from a former marriage.

automatic techniques, his own work began to change, and by the late 1940s, he had found his own distinctive style.

Four years after Tomlin's death in 1953, the Whitney Museum of American Art in New York organized an exhibition of his work. Motherwell was among those invited to write "notes" for the accompanying catalog.[4] In his tribute to Tomlin, he included a recapitulation of the beginnings of abstract expressionism—both for a record he must have felt was being distorted and to acknowledge Tomlin's role in the movement.[5] ∎

He loved painters and painting. This is the essential fact about him. In everything else, he was a dandy and a dilettante, at great ease in any social circumstance. One would have thought that he was the son of an Anglican bishop or a British general, he had an air—so that it would have surprised none of us if he indeed had been, though I realize now that he was his own *construct,* from the military moustache to the Brooks Bros. scarf. The gift he gave me, one Christmas, was a volume of English critics, on T. S. Eliot. I gave him Joyce Cary's "The Horse's Mouth" in return, though at the time I was immersed in Céline. He liked me, because he regarded me as a gentleman too; but he loved me, as he did Philip Guston and Jackson Pollock, because of a wholehearted and perhaps reckless commitment on our parts—he never understood real despair—to painting, and the acceptance of the existential consequences it brings about in one's life. Guston, Pollock, and I were a generation younger, all reared in California—if there is a "California School," which I doubt, it never acknowledges the three of us—the three of us filled with a self-torment and an anxiety that was alien to Tomlin, but to which he must have deeply responded, to have loved us so much in turn. He simply ignored our wives. I have only known two painting milieus well personally, the Parisian surrealists, with whom I began painting seriously in New York in 1940, and the native movement that developed in New York that has come to be known as "abstract expressionism," but which genetically would have been more properly called "abstract surrealism"—the first exhibition quarters of the movement were Peggy Guggenheim's "Art of This Century," which otherwise was a museum of abstract and surrealist art. Mondrian and Léger were also in New York, where Mondrian was to die in 1944; but it was the influence of the European surrealists—with Joseph Cornell, David Hare, Noguchi, myself, and a little later, Gorky, as transmission agents—that acted as the catalyst for the explosion of "abstract expressionism." In my view, at least, who was there.* My emphasis is that the social attitudes of the surrealists were

*The "expressionist" part had to do with something violent in the American character, not at all with German art.

ironical, humorous, and often destructive, imbedded in a superb poetic awareness; the social attitude of the abstract expressionists despairing and sometimes self-destructive, a feeling in almost any social situation of "what am I doing here?," no less poetic in awareness; while Tomlin's social dilettantism left him comfortable and at ease everywhere. What contrast! Indeed, I believe the struggle that his lifework portrays is an effort to overcome the sense of *style* that every dilettante has with the sense of *existence* that every artist has. From this point of view, his art represents a genuine human drama, a genuine existential problem in art; if in life he was a dilettante, then in art he was involved in a heroic struggle, whether he succeeded or not; and we all in turn were moved by him—which was precisely and all that he wanted from us painters. How extraordinary that such a man had so much nerve! I think of the horde of empty faces that has come to surround and penetrate our milieu; Tomlin's face was full-formed . . .

O Bradley!

Choose any direction on the compass that you like, all roads lead to death.

Notes

1. Robert Motherwell School of Fine Art: Painting, Drawing, Theory. Sessions were held on Tuesday and Wednesday evenings and Monday through Thursday afternoons.

2. Motherwell's divorce from his first wife was made final that fall. He had spent the summer boarding with the William Helmuth family in East Hampton and was now living as a boarder at Pierre and Dollie Chareau's apartment in New York City.

3. It had been Tomlin who, on entering Motherwell's studio in 1949, convinced him not to destroy two of his paintings, *At Five in the Afternoon* (1949) and *The Voyage* (1949).

4. Other contributors were Philip Guston, Duncan Phillips, and Frederick S. Wight.

5. The intensity of Motherwell's argument suggests that he was responding to what must have been prevailing misconceptions about the origins of the movement.

"The Significance of Miró" May 1959

To Motherwell, Joan Miró early became and remained one of the major figures in twentieth-century art. He had probably seen his first original Miró paintings in the Gallatin Collection at New York University, but the profound and lasting influence on him came shortly after his return to New York from Mexico when he saw the artist's first major retrospective, held during the winter of 1941/1942 at the Museum of Modern Art. Later in the 1940s, unable to include Miró's poems in *possibilities,* he instead published an interview with the Spanish artist. At the invitation of the editors of *Art News,* and inspired by Miró's second retrospective at MoMA in the early

spring of 1959, he wrote an essay, "The Significance of Miró," that appeared before the exhibit closed. In recent years, and underscoring Motherwell's sustained admiration of Miró, he and Jack D. Flam, as general editors of the Documents of 20th-Century Art, produced *Joan Miró: Selected Writings and Interviews.*[1]

Along with his affection for many of Miró's characteristics and his esteem for the artist's work, expressed with particular clarity in this essay, Motherwell deemed Miró one of few artists who had success-fully projected surrealist principles into painting. As an aside in his essay, he compared Miró's use of psychic automatism with that of his own generation of painters. His choice of quotations from Miró point up several personal affinities he shared with the older artist—for example, the love of baseball and the comparison of love-making to the making of a work of art, the latter metaphor being one he frequently used in his own writings. In terms of style, this compelling tribute remains unique within Motherwell's written oeuvre because of its sus-tained descriptive narrative. ■

I like everything about Miró—his clear-eyed face, his modesty, his ironically-edged reticence as a person, his constant hard work, his Mediterranean sensibility, and other qualities that manifest themselves in a continually growing body of work that, for me, is the most mov-ing and beautiful now being made in Europe. A sensitive balance be-tween nature and man's works, almost lost in contemporary art, satu-rates Miró's art, so that his work, so original that hardly anyone has any conception of how original, immediately strikes us to the depths. No major artist's atavism flies across so many thousands of years (yet no artist is more modern): "My favorite schools of painting are as far back as possible—the primitives. To me the Renaissance does not have the same interest." He is his own man, liking what he likes, indifferent to the rest. He is not in competition with past masters or contempo-rary reputations, does nothing to give his work an immortal air. His advice to young artists has been: "Work hard—and then say *merde!*" It never occurs to him to terrorize the personnel of the art world, anxi-ety-ridden and insecure, as many of our contemporaries, angry and hurt, do. He believes that one's salvation is one's own responsibility, and follows his own line of grace and felt satisfaction, indifferent to others' opinions, but with his own sense of right. One might say that originality is what originates just in one's own being. He is a brave man, of dignity and modesty, passion and grace.

He has the advantage of liking his own origins . . . But he worked in France during the twenties and thirties, mainly in the surrealist mi-lieu, to which he is greatly indebted, and of which he is, among other things, a leading exponent. With the outbreak of the war in 1939, Miró as a neutral returned to the relative artistic isolation of his native Ca-

talonia, a part of Spain that is energetic, hardheaded, republican, and straight, involved in neither mysticism nor blood-ritual. He lives in a magnificent studio-house in Palma, designed for him by José Luis Sert, now of Harvard, who designed the Spanish Pavilion at the Paris World Fair in 1937 that was decorated by Miró and by Picasso's *Guernica*. There was a time in the twenties when Miró was so poor that he gave André Masson a lunch of radishes and butter and bread; it was then that he wrote a lovely piece called "I Dream of a Big Studio." Palma is the native island of his wife, to whom he is deeply devoted. "Painting or poetry is made as we make love, a total embrace, prudence thrown to the wind, nothing held back . . ." He is sixty-six, the same age as Most General Franco. I hope that Miró lives to be a hundred, in good health.

In the past two decades, Miró has increasingly devoted himself to the crafts, to the world of the artisan. His collaboration with the Spanish ceramist Artigas is well known, as are his lithographs, engravings, book illustrations, and woodcuts, printed in teamwork with master artisans in Paris. He has spoken eloquently about all this recently: "I do not dream of a paradise, but I have a profound conviction of a society better than that in which we live at this moment, and of which we are still prisoners. I have faith in a future collective culture, vast as the seas and the lands of our globe, where the sensibility of each individual will be enlarged. Studios will be re-created like those of the Middle Ages, and the students will participate fully, each bringing his own contribution. For my part, my desire always has been to work in a team, fraternally. In America, the artisan has been killed. In Europe, we must save him. I believe that he is going to revive, with force and beauty. These past years have seen, nevertheless, a reevaluation of the artisan's means of expression: ceramics, lithos, etchings . . . All these objects, less dear than a picture and often as authentic in their plastic affirmation, will get around more and more. The supply can equal the demand, understanding and growth will not be restricted to the few, but for all." We feel the melancholy shadow of Franco's gloomy, suppressed Spain over his words, as well as the human desire to escape one's solitary studio that nearly every modern painter feels on occasion. But Miró must also feel, with his incredible sensitivity to the various materials of plastic art, like his peers Matisse and Picasso before him, continual inspiration in sensing out a new material, and in finding that precise image that stands at an equal point between its own nature and his own. And who would not prefer the constant company of artisans to that international café society around art that otherwise surrounds us? When he was in America twelve years ago, making a beautiful mural for a hotel in Ohio, he answered questions about how he likes to live: "Well, here in New York I cannot live the life I want to. There are too many appointments, too many people to see, and with

so much going on I become too tired to paint. But when I am leading the life I like to in Paris, and even more in Spain, my daily schedule is very severe and strict and simple. At six a.m. I get up and have my breakfast—a few pieces of bread and some coffee—and by seven I am at work . . . until noon . . . Then lunch . . . By three I am at work again and paint without interruption until eight . . . *Merde!* I absolutely detest openings and nearly all parties. They are commercial, 'political,' and everyone talks so much. They give me the 'willies' . . . The sports! I have a passion for baseball. Especially the night games. I go to them as often as I can. Equally with baseball, I am mad about hockey—ice hockey. I went to all the games I could . . ."

Critics rarely talk about his subject matter, save for the fact that he loves the landscape of his native Catalonia. All the shores of the Mediterranean are drenched in intense, saturated color, and inhabited by various folk whose habits go back to the beginnings of recorded and painted history. From this environment come Miró's instinctively lovely colors, the bright colors of folk art—reds, ultramarine blues and cobalt, lemon yellow, purple, the burnt earth colors, sand and black. His colors are born for whitewashed plaster walls in bright sunlight. These colors are as natural to his region as to the whole Mediterranean basin, and from there beyond to the Near East, India, China, Japan, Mexico, and South America, wherever a folk still exists in the sun. But his color-structure rarely becomes a major, or a profound weapon of getting at you, as it does in Matisse, in the old Bonnard, in Rothko. Instead it is simply universally beautiful, as long as there is a sunlit folk, with "primitive" feelings.

His main two subjects are sexuality and metamorphosis, this last having to do with identity in differences, differences in identity, to which he is especially sensitive, like any great poet. As Picasso says, painting is a kind of rhyming. Miró is filled with sexuality, warm, abandoned, clean-cut, beautiful, and above all intense—his pictures breathe eroticism, but with the freedom and grace of the Indian love manuals. His greatness as a man lies in true sexual liberation and true heterosexuality; he has no guilt, no shame, no fear of sex; nothing sexual is repressed or described circumspectly—penises are as big as clubs, or as small as peanuts, teeth are hacksaw blades, fangs, bones, milk, breasts are round and big, small and pear-shaped, absent, double, quadrupled, mountainous, and lavish, hanging or flying, full or empty, vaginas exist in every size and shape in profusion, and hair!— hair is everywhere, pubic hair, underarm hair, hair on nipples, hair around the mouth, hair on the head, on the chin, in the ears, hair made of hairs that are separate, each hair waving in the wind as sensitive to touch as an insect's antenna, hairs in every hollow that grows them, hairs wanting to be caressed, erect with kisses, dancing with ecstasy. They have a life of their own, like that Divine hair God left behind in

the vomit of the whorehouse in Lautréamont. Miró's torsos are mainly simplified shapes, covered with openings and protuberances—no creatures ever had so many openings to get into, or so many organs with which to do it. It is a coupling art, an art of couples, watched over by sundry suns, moons, stars, skies, seas, and terrains, constantly varied and displaced, like the backgrounds in Herriman's old cartoons of Krazy Kat. But in Miró there are no dialogues. Simply the primeval energy of a universe in which everything is attracted to everything else, as visibly as lovers are, even if they are going to bite each other. In Picasso the erotic is usually idyllic, more rarely rape, and now lately old men looking in lascivious detachment at young nudes. In Miró there is constant interplay. Even his solitary figures are magnetized, tugged at by the background, spellbound by being bodies that move. It is a universe animated by the pull of feeling.

How Miró makes a painting is interesting. As Renaissance painters did, he proceeds by separate steps (though his process has nothing else in common with Renaissance painting, any more than does his image of reality). The whole process is pervaded throughout by an exquisite "purity," that is, by a concrete and sensitive love for his medium that never distorts the essential nature of the medium, but respects its every nuance of being, as one respects someone one loves. The nature of the medium can be distorted by a brutal or insensitive artist, just as a person's nature can be distorted by another human being. The painting medium is essentially a rhythmically animated, colored surface-plane that is invariably expressive, mainly of feelings—or their absence . . . The expression is the result of emphasis, is constituted by what is emphasized, and, more indirectly, by what is simply assumed or ignored. In "bad" painting, the emphases are essentially meaningless, i.e., not really felt, but counterfeited or aped . . . There are not many painters as sensitive to the ground of the picture at the beginning of the painting-process as Miró—Klee, the cubist collage, Cézanne watercolors, Rothko come to mind, and the Orient, with which he otherwise has no affinity. When Miró has made a beautiful, suggestive ground for himself, emotionally the picture is half done (technically a third done), whether he chooses a beautiful piece of paper (sand or rag) and just leaves it as the ground, or whether he scrubs it with color, color-patches, or a single color all-over, or color-patches and a main color both. Indeed, there is a picture in the present exhibition at the Museum of Modern Art that is simply a blue-brushed color plane, punctured in the upper left corner by a hole the roundness of a pencil, and in the lower right corner his tiny signature and the year. The picture stands. Brancusi polished his statues with the same love. Matisse did it the other way round. He made his revisions on working canvases, and then made the final version as clean and pure as Miró's paintings, but with an infinitely more subtle and varied brush—but then Matisse's

brush is the most subtle since Cézanne's, the most complicated and invariably right in its specific series of emphases. What a miracle it is! It is as though the brush could feel, breathe and sweat and touch and move about, as though sheer being contacted sheer being and fused. After the artist who did it is dead and gone, we can still see that intense moment captured on the canvas. That is the miracle for the audience. Miró's miracle is not in his brushing, but in that his surface does not end up heavy and material, like cement or tar or mayonnaise, but airy, light, clean, radiant, like the Mediterranean itself. There is air for his creatures to breathe and move about in. No wonder he loves Mozart.

To speak of Miró's second step is to be forced to introduce two words that are perhaps the most misunderstood critical terms in America, "surrealist automatism." Miró's method is profoundly and essentially surrealist, and not to understand this is to misunderstand what he is doing, and how he came upon it, and usually derives from a mistaken image of surrealism itself—which was a movement of ideas, had its greatest expression of all in literature, in French, and which produced the greatest painters and sculptors of the post-Picasso generation in Europe—Jean Arp, Max Ernst, Alberto Giacometti, and Joan Miró, as well as a masterpiece of art-literature, *The Secret Life of Salvador Dali*. Painting is a secondary line in surrealism and the dream images of Dali-Tanguy-Magritte-Delvaux, on which the popular image is based, are a secondary line of its painting, which appears in a major way in the early de Chirico. Surrealist ideas pervade some of the most alive literature in Europe today. I for my part, though this is not my subject, believe that surrealism is the mother, as certain philosophers are the father, of a major part of the attitudes in contemporary existentialist literature and art. I believe, too, that the fact of the Parisian surrealists being here in New York in the early forties had a deep effect on the rise of what is now called abstract expressionism; for example, surrealist automatism was discussed often with Jackson Pollock in the winter of 1941–42, before his first show;[2] he made surrealist automatic poems in collaboration with others that same winter—which is to take nothing from his personal force and genius. All this is a long and complicated story: but one can't help remarking how fantastic are the lies that have been built up about those days during the last nineteen years, by people who were not around then, and even worse, by some who were—in the interests of chauvinism, of originality, of being first, of, as Harold Rosenberg quotes, everyone wanting to get into the act, an act that started so simply and straight.

Miró is not merely a great artist in his own right; he is a direct link and forerunner in his automatism with the most vital painting of today. The resistance to the word "automatism" seems to come from interpreting its meaning as "unconscious," in the sense of being stone-drunk or asleep, not knowing what one is doing. The truth is that the

unconscious is inaccessible to the will by definition; that which is reached is the fluid and free "fringes of the mind" called the "pre-conscious," and consciousness constantly intervenes in the process. What is essential is not that there need not be consciousness, but that there be "no moral or aesthetic a priori" prejudices (to quote André Breton's official definition of surrealism), for obvious reasons for anyone who wants to dive into the depths of being. There are countless methods of automatism possible in literature and art—which are all generically forms of free association: James Joyce is a master of automatism—but the plastic version that dominates Miró's art (as it did Klee's, Masson's in his best moment, Pollock's and many of ours now, *even if the original automatic lines are hidden under broad color areas*) is most easily and immediately recognized by calling the method "doodling," if one understands at once that "doodling" in the hands of a Miró has no more to do with just anyone doodling on a telephone pad than the "representations" of a Dürer or a Leonardo have to do with the "representations" in a Sears catalogue.

When Miró has a satisfactory ground, he "doodles" on it with his incomparable grace and sureness, and then the picture finds its own identity and meaning in the actual act of being made, which I think is what Harold Rosenberg meant by "action-painting." Once the labyrinth of "doodling" is made, one suppresses what one doesn't want, adds and interprets as one likes, and "finishes" the picture according to one's aesthetic and ethic—Klee, Miró, Pollock and Tanguy, for example, all drew by "doodling," but it is difficult to name four artists more different in final weight and effect.

The third, last stage of interpretation and self-judgment is conscious. A dozen years ago Miró explained to J. J. Sweeney: "What is most interesting to me today is the material I am working with. It supplies the shock which suggests the form just as the cracks in the wall suggested shapes to Leonardo. For this reason I always work on several canvases at once. I start a canvas without a thought of what it may become. I put it aside after the first fire has abated. I may not look at it again for months. Then I take it out and work at it coldly like an artisan, guided strictly by rules of composition after the first shock of suggestion has cooled . . . first the suggestion, usually from the material; second, the conscious organization of these forms; and third, the compositional enrichment." But it depends on the man. Dufy also went through three equivalent stages in his working process.

Lately Miró's art has become more brutal, blacker, torn, heavier in substance, as though he had moved from the earlier comedies through *Anthony and Cleopatra* and Falstaff to *King Lear,* harsher, colder, ironic, more ultimate. There is one joke of God's that no one can escape consciousness of—death.[3]

Notes

1. *Joan Miró: Selected Writings and Interviews,* Documents of 20th-Century Art, ed. Margit Rowell (Boston: Hall, 1986).

2. This was the winter of 1942/1943. Pollock's first one-man show was at Art of This Century in the fall of 1943.

3. The final three paragraphs of this piece have been omitted, as they deal with factual information regarding then-current exhibits of Miró's work.

Lecture with Charles R. Hulbeck October 1959

German-born Richard Huelsenbeck, a medical student when he escaped to Zurich during the First World War, had been one of the founders of dada at the Cabaret Voltaire in that city in 1916. He remained a prominent figure in the movement, writing manifestoes and contributing articles on dada well into the 1930s. Huelsenbeck later became Charles R. Hulbeck, assuming this as his professional name when he began his practice as a Jungian psychoanalyst in New York.

Motherwell considered "En Avant Dada," Huelsenbeck's 1920 history of the movement from the German point of view, *a savage and rollicking attack on art as a profession* and *one of the most extraordinary expressions, not only of dada, but of the avant-garde mind.* He had published the essay in *possibilities* in 1947 and had had several other of the dadaist's writings translated for *The Dada Painters and Poets.* Expressly for the dada volume, and at first in accord with other dadaists, Huelsenbeck wrote the "Dada Manifesto 1949." Aspects of the piece caused a rebellion among the ranks, leading to an impasse in publication of Motherwell's book and ultimately causing him to publish separately the "Manifesto" and an essay by Tristan Tzara.

In October 1959, Motherwell was invited to speak at the Association for the Advancement of Psychoanalysis at the New York Academy of Medicine. Dr. Charles R. Hulbeck, the other speaker, delivered a paper entitled "Modern Art and Human Development, a Psychoanalytic Comment." The appearance of Motherwell and Hulbeck together on the same platform represented *nearly forty-five years of one strand in the fabric of modern art.* Motherwell's comments were untitled. ■

I had a very brief conversation with Dr. Hulbeck several days ago concerning what he intended to say tonight, and in the course of that conversation, he showed interest in the fact that from my personal point of view as a practicing artist, and as a person abreast of contemporary developments in art, the presence or not of objects in a painting is unimportant to me. Dr. Hulbeck asked me to remark on this particular point, and I am glad to do so. I might add that I am one of the founders of a contemporary art "movement" often called "abstract

expressionism," for which the presence of the Parisian surrealists in New York during the Second World War served as a catalytic agent; that surrealism was profoundly imbedded in dadaism, the most socially-minded of modernist art movements, growing up as it did during the First World War; and that Dr. Hulbeck, as most of you must know, was one of the founders of dadaism. So that our presence here tonight represents nearly forty-five years of one strand in the fabric of modern art. I might add that in my opinion Dr. Hulbeck's long article, "En Avant Dada," is one of the indubitable masterpieces of modern art literature, a savage and rollicking attack, among other things, on art as a profession. Who could have thought that we would meet one night in a citadel of professionalism, the New York Academy of Medicine! We all know, since Marx, that history has its comic aspects; but sometimes it is not easy to determine who are the clowns at a given moment . . .

When I say that objects in a painting or their absence are unimportant to me, I mean in the sense of unconcern. Throughout my career I have used "objects," still lifes, pregnant women, invented human figures, Mediterranean walls, birds, labels from objects that I have eaten or drunk, studio interiors with easels, printer's type, lovemaking, and so on, in my pictures. Simultaneously, I have consistently made equally numerous "abstract" works without objects, such as the series of pictures with black ovals and stripes on white grounds that have the collective title of *Elegies to the Spanish Republic,* though I have no special interest in politics. I would guess that among these works, there are an approximately equivalent number of successes and failures . . . One of the penalties of an art insisting on the values of risk and inspiration is a high percentage of failures, not all of which are seen as such before they venture into their own life in the world . . .

But I must insist that whether these works employ objects or not, their style is the same. That is, to the degree that my style is recognizable and one says, looking at a painting, "Yes, that is a Motherwell," all of these pictures are indeed Motherwells, less ambivalently than my children, who certainly are not abstractions, but on the contrary, are so real that one smiles at reality's capacity to confirm endlessly its own nature, which all of us, on one level or another, with one end in view or another, are constantly investigating—the word "experimental" does not belong to science alone. Indeed, I would think that a life that is alive is a constant experiment under conditions that one is only partly able to control. Oppression in art, as in life, is when the conclusion to be reached is predetermined, by inner or outer a priori notions of how life or art ought to be. There are lots of guidebooks, especially in Europe, to historical monuments that are beautiful. There ought to be a guidebook to the historical monuments that kill us. As Guillaume Apollinaire wrote before I was born, apropos the cubist revolution in art, you can't carry the corpse of your father around on your back

forever. I presume that one of the functions of psychoanalysis, as of modern art, is to point *that* out, that one must respond to one's own desires, wants, and felt necessities. To me, one of the most miserable annoyances of the contemporary situation is how many people who have no reason to seem to like modern art, as though it were a form of entertainment . . .

When I look at other contemporary artists' work, I do not look first to see whether the works have objects in them or not, but simply whether I am moved. It is true that I am more often moved by abstract works among those being made now—the main exception is surrealism—and I am apt to presume that the various forms of realism and naturalism are dead in painting; in any case, realism and naturalism represent very minor qualities of the world's art, both in space and time. Realism historically has always been mainly the mode for reaching the vulgar, the great lump of people . . . Still, all that is necessary—to contradict this presumption—is the emergence of a major realistic artist. I suppose that more than ninety per cent of all people who try to make art employ some form of realism, but the twentieth century has not been able to produce one major naturalistic artist, though I for one have respect for certain minor realists, such as Edward Hopper or Andrew Wyeth. But important realism has always been historically rare, the nineteenth century in Western Europe, the seventeenth century for a moment in Holland, ancient Rome, and what else?—not much more.

One might say that one is distressed by the disappearance of the object in painting in direct proportion to one's ignorance of world art, an ignorance that in this day of reproduction is unnecessary on the part of any cultivated human being. One might say that the presence or absence of objects in painting strikes an audience much more than it does artists, that it is essentially an outsider's problem. That in our society most people are so far removed from the making of art makes the audience mainly one of outsiders. This situation can be modified a bit by education, it can only really be changed by a radical alteration in the nature of society, a profound shift in what people are tempted to and allowed to do. In our society art is most integrated in persons under seven, and in patients in hospitals, and these two classes have by far the highest percentage of true artists, in my opinion.

To use a different example: When one considers whether to put *Don Giovanni* or the clarinet quintet or the last Requiem on the gramophone, I think NO ONE thinks, "Now I want to hear a story of Don Juan," or "Now I want to hear abstraction," or, "Now I want to hear the Mass." No, what is prior is that one wants to hear *Mozart!* and the choice is simply Mozart in what mode . . . Moreover, I find the clarinet quintet not at all abstract in that I know as clearly what it is "saying" as his "Don Juan." I think that psychoanalysts above all, to the measure that they are indeed sensitive, must recognize that there is no

more accurate communication than when true subject is feeling and attitudes . . .

Abstraction's original meaning is "to select from," in the Latin; though I will not say, as is so easy for defenders of abstract art, that consequently all art is abstract because all art is selected; this is simply to win a dialectical point—in the Socratic sense of dialectical. *Au contraire.* What is selected is selected on the basis of the most concrete, personal feeling. One might say, unless one has the patience to listen to an encyclopedia from beginning to end, that to the degree that one has the capacity to be abstract, that is, to select, only then has one the capacity to be concrete and individual—which seems to be the most that our society can reach in relation to what is human. To be concrete and individual *and* in harmony with society—that is the contradiction yet to be resolved in a sophisticated society . . . But that is another question.

One might say that the triumph of modern artists in our society has been the capacity to protect one's own modes of being. These modes may be well or sick or both, I do not precisely know; but you must recognize that to choose a mode of existence within modern society, and to be able to maintain it, is a considerable accomplishment. It is as though a few gifted children were able to outwit the adult world and protect their own felt necessities.

The question of objects in painting is unimportant because the real subject of painting is moral attitudes. Moral attitudes can revolve around objects, but objects are not essential to moral attitudes. Indeed, it is possible that objects tend to get in the way of moral attitudes. If this were true, then what an extraordinary stripping away of the irrelevant abstract art would represent, and what a hard core of makers and followers one would expect to find around it . . .

What really distinguishes an artist from other people—for many other people are creative—is an extraordinary sensitivity to his medium, a sensitivity so accurate and intense that I think perhaps that people who don't have it can scarcely imagine it. What is music but sounded pitches regulated in time? What is painting but a surface-plane animated by patches of color and lines made with hairs glued to sticks dipped in pots of color. And yet, these incredible simple physical elements, in the hands of sufficient sensitivity, can express what every adjective in Roget's *Thesaurus* denotes, all forty-four pages of lists of words. Painting is a specific instrument, like a string quartet, and no more than a quartet needs objects, though like a quartet, it can imitate any object if one likes, at one's discretion.

Modern art, like many other things in modern life, is a revolt against some crushing aspects of the nineteenth century. Modern art found two ways to fight: one was to get rid of false sentiments in painting, to "purify" it, which is the significance of the cubist revolution, and the abstract developments that followed it. If you substitute the word

"pure" for the word "abstract," you will be much closer to the intent involved. The other revolution on the part of modern art has been expressionism, which is an effort to be truthful about human realities at any cost—in spirit, though often not in means, dadaism and surrealism are part of the expressionist enterprise to be truthful.

In these senses, abstract expressionism is not badly named. It guards the effort to keep art pure, free from false sentiment, and it also is involved in the truth at any cost. There are other forms of abstraction that are involved in purity and the consequent beauty, but not in asserting truths; and there are forms of expressionism that are involved only in truthfulness, not purity and its beauty.

Of course all this is a historical enterprise. There is no such thing as art in general, but only the various arts of specific times and places. It obviously would not be necessary to purify the art of primitive peoples, say, the art of a village in Africa, or of Siena in the Middle Ages; nor was it even necessary to make art "truthful" except in modern times, during the last century and a half, when true art has been surrounded by and indeed almost submerged by all kinds of "art," essentially false and corrupt, from Tokyo to Moscow, from Moscow to Paris and London, from New York to San Francisco.

In this historical situation, a few artists try to protect the purity and truthfulness of art, *simply from love.* To love painting is perhaps irrational to begin with, but I suppose there is something irrational in all love, though I for one delight in it. Those of you who suppose that modern art is either essentially irrational or chaotic or childish or representing some modern form of disintegration exhibit your own cultural barbarism.

On the contrary, modern art is a specific ethical enterprise in relation to specific historical necessities. It is a conscious, mature, and ethical enterprise, on the part of men who deeply love painting, to preserve its integrity and truth. No one likes the resulting product at first acquaintance, so far are we from subtle ethical actions; but everyone who comes to love it cannot do without it; and to watch its drama historically unfold—its traitors and enemies, as well as its heroes and lovers—is a modern Iliad of absorbing interest, like all the great enterprises of mind and sensibility rooted in true ethos.

OCCASIONAL PIECES

Motherwell kept no formal written journal or diary. His date books, spanning the past four decades, contain only cryptic notations of the day and its appointments. Sporadically since the early 1940s, and as he had felt so moved, he jotted down certain pressing thoughts, essentially short epigrams, primarily for the purpose of pinning them to his studio walls. This practice, continued

throughout his life, appears to have been a way for him to make concrete certain reference points in his thinking—a means to keep the "map" of his imagination before him—and thus indirectly inspire his painting. Occasionally, he felt compelled to externalize his ideas in more complete form. These three pieces, probably all written in the 1950s, represent his most persistent themes. "Of Form and Content" was first published by Robert C. Hobbs in his 1975 dissertation, and "Expressionism" appeared in the catalog that accompanied the artist's 1976 retrospective exhibition in Düsseldorf.[1] ■

"Of Form and Content" [ca. 1950s]

These matters are not easy to be clear about if one has, in the background of one's mind, the traditional critical distinction between "form" and "content" as a valid and necessary distinction. To experience a work of art, as in making love, is to experience a human contact: and one can say equally well, the "content" is just the "form" involved, or the "form" is just the "content" involved. If we were to employ the old distinction, then the "content" of love-making is the human contact, and that the contact is made in such-and-such a way is its "form"; but it is at once evident that—in love-making—the specific human contact that is made is determined precisely by its form, that with a different form there would be a different human contact, that what the human contact is, is just the form of what is done—just as the form of what is done is determined by the human contact; that, in short, when we talk about "form" and "content" in the human contact that is making love, we are not talking about two differing things, but about the same thing, felt structure, that is, the relations among feelings as they progress in time.

"Abstract Art and the Real" [ca. 1950s]

Indeed, abstract art never would have been invented, except as the result of the most obstinate and sensitive effort to go with art's grain. Abstract art is not something, as are certain modes of surrealism—though not all—that a "literary" or "philosophical" mind would have imagined a priori. In this sense, abstract art is not invented or arbitrary at all, but *found,* found in the sensitive, passionate, and profoundly accurate—in terms of feeling—adjustments that constitute the immediate act of painting which is an effort, often clumsy and sometimes desperate, like a blind swimmer, to cover the abyss, the void that the world sometimes presents, with our love, with our sensuality and passion, our sense of commitment to a mode of expression that becomes ideal, when it does, only because it is so deeply rooted in the real. It is this sense of abstract art's reality that Mondrian must have had in mind

when he remarked on his own art, "Squares? I see no squares in my pictures," and led him, at the end of his life, to speak of his art as a "new realism."

"Expressionism" [ca. 1950]

I should like to make a distinction between feeling and emotion, one that may have no ultimate validity, but which I find useful in my efforts to think clearly about art. From this point of view, feelings are just the way things feel to one, and constitute one's oneness with the world, as when, on a warm day, one feels warm, or when one sees one's good wife, one feels good, or when one picks up an orange, it feels round. Feelings in this sense are always "objective," the felt quality of things in perception. A work of art belongs to this world of feeling; its fundamental nature is that of an "object" that is meant to be enjoyable to feel, or, more accurately, is meant to feel, and is consequently enjoyable—what Poussin was referring to when he said that painting "is for the delectation of the eye." Emotion, on the contrary, is not determined by what is immediately surrounding one, but is something already in one, what one carries around with one, as a woman carries a child in her womb, and whose state of mind is consequently as much determined by what she has within her as what she sees outside. If the emotion that one carries around within one is anguish, for instance, something outside that need not be felt as anguished, say, a casual glance from a stranger, can set off the emotion as strongly as if one were in the presence of something anguishing, say, the illness of one's child.

I think that what is meant by "expressionism," as an aesthetic term, is reference to this emotion already within one; in looking at the work of Edvard Munch, for example, one senses that his sadness is not only about the world, but within himself; or that the terror in Grünewald's Crucifixion is not only about that event, but within himself: a still life by Grünewald would also be filled with terror. I think that, when Dürer gave up painting in the last years of his life and went to Italy to find out the Italian secret of "beauty," it was not, as is often implied, a case of the artist being overcome by the intellectual, but the result of a valid judgment that there was a difference between Italian art and other contemporary art—the difference that Michelangelo referred to when he said that, "No one but Italians know how to paint," a feeling that Parisians have about themselves in modern times—and that this difference, which in the case of Italian Renaissance or contemporary Parisian painting is sometimes spoken of as a question of "beauty" or of "harmony," is the difference between an art of feeling and an art of emotion. Pure feeling is invariably harmonious, because it is, in being their felt quality, a oneness with the things of the world. Emotion is

usually around the concept of anguish or dread, and separates one from the world, because the emotion gets in the way of feeling the world—as when a dog, excited by what he hears in the distance, is unaware of the affection surrounding him, and ignores his oneness with the people around him that is just what would overcome his emotion, and put him at peace. Thus when I think of Dürer going to Italy, which was to become his grave, I think of it not as some intellectual aberration—who could say that the art of Grünewald, or of Dürer himself, is not great?—but as the desire to satisfy the deepest human need, to feel harmony between oneself and the things of the world. Being an artist, he naturally thought of his task in terms of art, as finding the secret of harmonious art, or, as he said, of "beauty"; and indeed, he was not wrong—only a man in harmony with the world can produce a harmonious art. But all his measurements and speech with Italian artists failed—he carried his anguish within him, that emotion that Italian Europe used to call "gothic," and regard as barbarous. In the last ten years of his life, when Dürer ceased to paint, in the interests of his search, the world doubtless lost some great works of art, and I can understand that connoisseurs are aghast; but from my point of view, the world gained a great man, as well as artist, a man who could give up art itself in order to reassert his deepest human need. It is an inability to grasp this that makes a Uccello more inhuman, dreaming of "sweet perspective" even in his sleep.

Note

1. Robert C. Hobbs, "Motherwell's Concern with Death in Painting: An Investigation of His Elegies to the Spanish Republic, Including an Examination of His Philosophical and Methodological Considerations" (Ph.D. diss., University of North Carolina, 1975), p. 33; "Robert Motherwell: Selected Writings," in *Robert Motherwell* (exhibition catalog) (Düsseldorf: Stadtische Kunsthalle, 1976), pp. 8–9.

THREE 1960–1969

"What Should a Museum Be?" March 1961

█ Beginning with his summer in Spain and France in 1958,[1] a trip that ended a serious creative block for him, Motherwell painted prolifically for the next several years. In addition to his annual solo shows with the Sidney Janis Gallery, with which he had recently become affiliated, his general exhibition activity greatly increased. His first retrospective was held at Bennington College in Vermont in 1959, and the second would be at the Museum of Modern Art in New York in 1965. By the end of the 1960s, he was averaging a major exhibit a month, several of them outside the United States.

During this period, he wrote very little, with scarcely an article appearing in a year's time. Most likely, his intense painting productivity accounted for some of this, releasing him from the pressure that requests and his own sense of public duty caused him, and perhaps, in turn, making refusals easier. But, too, the battle of what he had frequently likened to the Trojan War was over. In the few articles he did produce during these years, there was no longer the earlier didactic imperative—no pressing need to explain an art that was now being accepted by a growing audience. From here on, the tone of his writing would become more lyrical and its voice increasingly more comfortable. The ad hoc nature of the individual piece, a feature of almost everything he had produced, would be even more apparent.

In 1961, in response to the editors of *Art in America*, Motherwell wrote on what he felt a museum should be.[2] Unlike the approach of the majority of art museum curators, who presented their objects through exhibits with historic or encyclopedic perspective, he focused on the individual artist—on the unique nature of the creative act and the integrity of the work—presenting solutions that would illuminate these very qualities. ■

The value of an artist's testimony derives from his discipline in truthfulness to his own experience. Such experience is limited, but specific.

Foreigners often focus on what we blur from habit. The trickle of Europeans and Japanese through my New York studio (mainly persons interested in what Clement Greenberg called "American-style" painting) consistently express two judgments: profound admiration for the completeness and quality of the collections of the Museum of Modern Art in general; shocked and often angry disappointment at the Whitney Museum of American Art, *whose whole name is taken seriously.* As one museum director from the Continent said, "You go straight from your hotel to the Whitney, but in order to see *the* American art, you have to go to Ben Heller's apartment, or to the Albright Art Gallery in Buffalo; even in the Museum of Modern Art you can't see the new American art whole." As for the Guggenheim, no one seems to know what it is—its identity, I mean.

This particular failure of the Whitney is not especially hard on New Yorkers, who can see everything in private galleries; but to a visitor who does not know his way around and who is limited in time, the failure hurts. The Whitney's rationale seems to be democratic, to give a fair sampling from hundreds of artists of what is going on in America at any given moment, like the *Daily News;* but the truth is that what all the artists in any country at any given moment (even in cross-section) are painting, is depressing to view. The powers at the Whitney are certainly humanitarian, learned, and filled with good will; but unless all that is coupled with insight—i.e., perception of what is creative enough to bring about changes—the selections remain empty as an ensemble, meaningless to the individuals participating, and ultimately irresponsible to the public. My point is, should the subject matter of an art museum be history, or that which moves the eye? The effort to do both (which everyone more or less tries) invariably ends on the side of history. No one but an art historian could endure those large paintings in the Louvre by Ingres, which misunderstand everything, painting and history both.

American artists are in a unique position among artists to see the workings of a museum, because American museums are the most committed to showing living artists. Whether this is a desirable situation I am inclined to doubt, though I myself have benefited—unless the museum is devoted only to contemporary art, in which case the sanctification of history is not implied, but gambled on. The Museum of Modern Art is a great museum and the exception to the dangers that I see—because of the insight, wisdom, and magnitude of character of Alfred H. Barr, Jr. I would think that such a man in such a position would appear once in a century, and I could almost wish that his museum remain unchanged (as the Frick should have) when Barr retires. I believe in specific men, not institutions, and I do not believe (nor do

my foreign visitors) that there is his like anywhere. Still, it only takes the appearance of another man of such qualities to negate what I say . . .

Perhaps, the most remarkable experience that I have had of a museum was in the new Léger Museum in the south of France, at Biot, not because it was devoted to Léger, but because its hundreds of works by him show the whole working life of an artist of stature. There one can have the sense, the real sense, of just what Léger was, just by looking, just by looking in one place. What a joy! And a relief from the anthology museum. Most museums are conceived like a vaudeville show, a series of acts, sampling everything, *but only a sample* . . . And so one's joy with the Picasso Museum at Antibes. But less so, because there are many fewer works than those of Léger at Biot, and only from one period in Picasso's life, even though he interests me more personally than Léger.

If I had absolute control of American museums—God forbid!—my first, emergency act would be to install Charles Egan or Clement Greenberg to choose all the works to be shown at the Whitney Museum of American Art; and my second, long-range act would be to redistribute all the great artists, so that each museum, according to its importance, place, and scale would have a preponderance—preferably all—of the works in American public collections of specific artists. I would love to go to San Francisco, say, to see all the Matisses, to Cambridge for the Sassettas (if there are that many), to Chicago for the Goyas, to New York for the Rembrandts, to Merion for Renoirs, to Washington for Titians, to Philadelphia for cubism, to Boston for Greek pots; or to any small town to see all of a minor artist, say, Boudin or Marin or Guardi or Constantin Guys. And how incredibly less dull would travel be in America if, say, in Falmouth one could see all the Homer watercolors; in Cicero, Sullivan's architectural renderings; in Gettysburg, all the Mathew Bradys (instead of Charlie Weavers and Dwight Eisenhowers); in Oxford, Audubon; in Fargo, Frederic Remington; in New Orleans, Degas pastels—as one can, for example, in Colorado Springs see all the Santos statues. Just the other day, for the first time in my life I had a desire to visit Wilmington, because I learned that there is a Pre-Raphaelite collection. But as the general situation is, everywhere in America one sees the same Main Street, same Woolworths, same Coca-Cola, same chain drugstore, same movie, same motel, same fried shrimps, and the same local museum reflecting in the same lesser way the same big museum. O sameness! Bolton Landing, N.Y., is to me one of the great places in America because of David Smith's metal sculpture strewn across his acres, and in his house and studios; otherwise, it is a banal resort on Lake George, where I suppose the main place to eat is at Howard Johnson's . . .

I like museums that show a single man's work, or a series of men in depth, not because I am especially involved in a given man's identity

or glory—all men of stature are of interest, though not equally interesting to the eye. It is more that I am strongly against the existing museum tendency (like society in general) to reduce its works of art, to reduce them to *objects*. One of the most insidious enemies of art is within museums, the gentleman-connoisseur, the effete apprentice, who, though he is discriminating, *discriminates among objects*. The Metropolitan Museum is an enlarged Parke-Bernet; the National Gallery in Washington would have been matched in contents and similarly housed by Hermann Goering, had he had world enough and time. Hardly anywhere is art shown as what art is, the ecstasy of the eye, or, as Picasso says, the emotion given off by a picture so you do not notice its technique, how it was made. Is Princeton University or the New York University Institute of Fine Arts the place to learn ecstasy? When you have a retrospective at a museum, the first thing they ask you for in your biography is where you studied, as if that counts! I always remember Rothko's stories as a Jewish immigrant student at Yale, or my own misery in the Graduate School at Harvard. Are traditional New Englanders or modern German scholars, who mainly staff our museums, noted for their eye for painterly abilities or warm passions? Of course not!

Main Street is the creation of banks, supermarkets, and drugstores; museums are the creation of art historians, object-collectors, tax-deductors (what a bargain basement is the Chrysler Museum in Provincetown!), and assorted dilettantes and functionaries. No wonder museums exist apart from one's real self, impersonal, remote, everything reduced to rows of objects, whether you are an artist, art lover, student, or child. In the end, one experiences nothing of art from the history of objects. The issue is passion, whether quiet or wild. Museums distort the history of artistic passion, just as do the societies which museums reflect. For passion is only recognized by the passionate. The rest is objects, a false history of art and artists.

Notes

1. On his honeymoon with Helen Frankenthaler.
2. This editorial symposium included the sculptor Herbert Ferber and the architect Edward Durrell Stone.

"Homage to Franz Kline" 17 August 1962

Motherwell's move close to Hunter College in New York City in the early 1950s, his devotion to teaching, and his additional domestic responsibilities had physically distanced him from the Bohemian art world of lower Manhattan. His move farther uptown later in the decade and his increased painting and exhibition activity removed him once again from the art crowd centered in Greenwich Village. Consequently, he was noticeably absent from the group of

avant-garde artists, including the gregarious Franz Kline, who during these years frequented the popular Cedar Bar in downtown Manhattan.

Motherwell and Kline had first met at either of two exhibits at the Kootz Gallery in 1950, in both of which Motherwell had shown works primarily in black and white.[1] The enthusiasm Kline had expressed for these paintings came partly from his own explorations into the sole use of black and white pigments, evidenced in works he exhibited in 1950 and presaging his architectonic paintings that followed. The powerful and reductive language that Motherwell and Kline (Still and de Kooning earlier and Pollock later) had achieved by using these two opposing colors, generally utilizing a large scale, became the hallmark of the abstract expressionist movement and, in a simultaneous and independent development, characterized the work of a number of European artists at the time.

Motherwell wrote the following tribute on *August 17, 1962,* in Provincetown, Massachusetts (where Kline had also spent several summers), three months after Kline's fatal heart attack. It was intended for a catalog to accompany Kline's posthumous retrospective that year at the Gallery of Modern Art in Washington, D.C. Instead, it appeared more than fifteen years later in the catalog *Franz Kline: The Color Abstractions,* published for an exhibition held in 1979 at the Phillips Collection in Washington, D.C. ■

> You cannot explain art any more than you can learn it. Manet, whom I knew, also said: "Art is a circle, one is either inside it or outside." It is an accident of birth, and I think it would be as well to add that no one person in the circle resembles his neighbor, but at the same time they are all brothers.
>
> G. Jeanniot on Manet, 1907

No one can feel the death of Franz Kline without a wrench. We have lost part of the modern art world . . .

He and I were independently devoted (among other concepts) to the development of a contemporary "black and white" painting that has no intervening middle tones. An art of opposite weights, and absolute contrast. I viewed his version with profound respect and admiration, and often was deeply moved. He really understood that modern art can have no truck with sentiments for the past. Instead, modern art's function is to make our present existence known to each other.

Who could not be moved by his sense of push and thrust? Kline's great black bars have the tension of a taut bow, or a ready catapult. And his sense of scale, the sine qua non of good painting, is marvelously precise. His big paintings can be as good as his small ones, a rare mastery in this period concerned with the power of magnitude . . .

Franz was a born abstract painter, since he could not (so it appeared) endure the tensions of ordinary life. In a winning, boyish way, Franz seemed (at least on the surface) to try to convert most of his days into a game, or a party, filled with smiles, jokes, and good cheer. It often appeared to me that his relations as a man were based on whether you were ready to have a ball. When you were, he was funny, and shrewd, filled with comradely affection, even tenderness, which covered something much deeper and blacker, that we all respected.

It is not only someone born in a foreign land, like Gorky, who feels alienated from the world around us. Franz struck me as deeply alienated in some ways—and consequently craving affection on a broad scale. But he was not alienated from the act of painting: thus, his work's startling and moving verve, though in the background of its immediate feeling, there was always its anxious overtones. Franz projected as a person the sense of a man who was trying to save his own soul through his gift, and that he wanted to share this possible miraculous event with you. But he could not take care of himself! (It would have meant another existence.) Those few of us who knew of his true condition—not from him, but from his doctors—watched in helpless dismay the chances he took. But if he could have taken care of himself, he would not have been the enchanter we all knew, as Franz Kline, generous and heedless.

This summer, in sunlit, bustling Provincetown, which he loved as I do, I cannot tell you how I miss the sense of Franz's presence, working here . . .

Note

1. According to Motherwell, it was either at the exhibition "Black or White" or at his solo show focusing on his *Elegies, Capriccios,* and *Wall Paintings* (paintings and drawings all made in 1949 and 1950) that Kline, previously unknown to him, embraced him and expressed his excitement with the work (conversations with the artist, 1983–1986).

"Robert Motherwell: A Conversation at Lunch"
November 1962

His teaching at Hunter College during the 1950s had brought Motherwell additional associations with academia. Notable among them were his contributions to the College Art Association, a lecture at Harvard University (1951), and a seminar at Oberlin College in Ohio (1952). His retrospective exhibition in 1959 at Bennington College in Vermont heralded a decade filled with invitations to him from various academic institutions to be a visiting critic, to conduct seminars, to participate in panel discussions and symposia, and to exhibit.

Early in 1963, the Smith College Museum of Art in Northampton, Massachusetts, mounted "An Exhibition of the Work of Robert Motherwell."[1] In preparation for the exhibit, Motherwell was hosted at lunch *one day in November* 1962 by Charles Chetham, the museum's director. Their conversation was recorded in longhand notes by Margaret Paul, who, in editing them for publication, concentrated on only the artist's contribution. Among Motherwell's comments (including the memorable *an artist is someone who has an abnormal sensitivity to a medium*) was a description of his working procedures. He concluded with general thoughts on the younger artistic generation and on pop art in particular. Intending to revise the notes, but realizing that they would need considerable explanation, he allowed them to stand in their spontaneous and meandering form. They appeared in the unpaginated exhibition catalog, published by the museum at the time of the show, and became a primary source for subsequent writings on the artist. ■

About collage. For example, the labels in my collages from *Gauloises, Players:* I sometimes smoke them . . . The papers in my collages are usually things that are familiar to me, part of my life . . . Collages are a modern substitute for still life . . . Traditional still life seems funny in America, but in Europe completely natural since you see one at the end of each meal. In collage there are a lot of ready-made details, for when one wants details. My painting deals in large simplifications for the most part. Collage in contrast is a way to work with autobiographical material—which one wants sometimes . . . I do feel more joyful with collage, less austere. A form of play. Which painting, in general, is not, for me, at least . . .

In painting, I start with the canvas, but with certain conditions set. (There are certain things I won't do to a picture.) I begin somewhat by chance but then work by a logical sequence—by internal relations, in the Hegelian sense—according to strictly held values. For example, I like warm painting. Some painters will choose gray, I use yellow ochre for the middle tone. I also insist that the picture be relatively flat . . . A picture is a collaboration between artist and canvas. "Bad" painting is when an artist enforces his will without regard for the sensibilities of the canvas . . .

I work all over the canvas at a time, but in steps: the first step allover, the second step allover and so on; at the end, there is often a series of tiny steps . . . They say that Goya always "finished" his pictures by candlelight, i.e., in dim light. I understand that. Subtle minor adjustments are critical to the feeling of the picture as a whole . . . I don't always work at set hours. There are times when I *want* to work, and can't . . . the first two steps perhaps can be managed . . . One knows what one knows! But knowledge never solves a picture; it depends on

feeling. Knowledge by itself can lead one to fake feeling—which other painters instantly recognize . . . An artist is someone who has an abnormal sensitivity to a medium. The main thing is not to be dead. And nearly everyone is dead, painter or not. Only an alive person can make an alive expression. The problem of inspiration is simply to be fully alive at a given moment when working.

Generally, I use few colors: yellow ochre, vermilion, orange, cadmium green, ultramarine blue. Mainly, I use each color as simply symbolic: ochre for the earth, green for the grass, blue for the sky and sea. I guess that black and white, which I use most often, tend to be the protagonists . . . I often begin to paint on the floor. The paint often drips too much when the painting is upright. One can control the paint better when the canvas is lying down flat, and at the same time there is a less restricted view. I can walk *around* it, for example. I tend to the plane surface, and miraculously, the three-dimensional space takes care of itself. I finish the painting upright, right side up!

Physical limitations restrict us all. I would paint much larger if it wouldn't be such an enormous project to move and to store canvases. As it is, I restrict myself to a maximum of eighteen feet. I tend to be excited with either a tiny, or a very large format. It's the format, not the subject that determines a lot in the painting. I don't like to use the usual "easel-size" canvas; a different size, greater or smaller, sharpens one's sense of space. Thus, easel size has always been more "difficult" for me. (But my collages are easel size, probably because of the scale of the "found" elements.)

I don't exploit so-called "accidents" in painting. I accept them if they seem appropriate. There is no such thing as an "accident" really; it is a kind of casualness: it happened, so let it be, so to speak. One doesn't want a picture to look "made," like an automobile or a loaf of bread in waxed paper. Precision belongs to the world of machinery—which has its own forms of the beautiful. One admires Léger. But machinery created with brush and paint is ridiculous, all the same . . . I agree with Renoir, who loved everything handmade.

There are different psychological types of painters, I think. There seem to be five or six generic psychological syndromes that appear again and again in history. At any historical moment, one type may be more appropriate than another type for that particular historical project . . . At one time I had a studio for graduate students,[2] in which I set up one by one all the major experiments of the twentieth century, without letting the students know what they were repeating. Each student had a natural affinity for one or another direction . . . He felt it. Some were born abstractionists . . . Some artists who paint abstractly are not. One's natural bent is an entirely different problem from what one wants to do in a historical sense, i.e., what the culture of painting needs done to it at a given moment.

Perhaps most fertile in our epoch is a "childlike" or "primitive" syndrome, rather than a "scientific" syndrome or a "nature-loving" syndrome, say. The force, brutality, openness of children's art seems to be close to the area that's really fertile now and to which contemporary Americans certainly are most wholeheartedly committed. Matisse was too, to some extent, Picasso more so, Miró especially, and Dubuffet, of course; whereas a great painter like Bonnard was not . . . More simply, children simply love to paint "BOOM BANG." They have a real love and need to paint directly. BANG! Just like that! Don't forget that small children paint better than anybody except geniuses, just as they are appallingly truthful verbally, too . . . Now Europe is decadent. When they try to do it, it is more forced. Europeans don't feel "primitive" really. To put it another way, from a psychoanalytic point of view, maybe the freshest contemporary painting is retrogressive to a childlike level. At the same time, *it is more true to what is* than "grown-up" painting, that is, contemporary painting that pretends to originate in the Renaissance tradition of rationalism . . . But one must remember that when a grown-up is being "primitive" or "childlike," there is nevertheless a much wider background of felt thought and experience, of life and death, so that the "directness" has a weight and subtlety that a child has not . . . look at how great Miró is!

The essentially creative principle of contemporary painting I employ is what psychiatrists would call "free-association," and what the surrealists, who essentially discovered a systematic use of the principle, called "psychic automatism." And from this standpoint figure painting is impossible now, as is any painting from an a priori image standing in front of you—some abstract expressionists have never wholly understood this contradiction—i.e., between Renaissance naturalistic traditions and abstract, symbolic free-association, whereas Rothko has understood it perfectly. My own figure paintings of 1946–48 are free-association figures somewhat as a child constructs a figure, that is, conceptual . . . My *Spanish Elegies* are also free-association. Black is death, anxiety; white is life, éclat. Done in the flat, clear Mediterranean mode of sensuality, but "Spanish" because they are austere . . . Or so I suppose. Who really knows? I have been honored that various Spanish painters, Miró, Tapies, Saura, for example, have exhibited a certain interest in them . . . But they are much more than "Spain."

Immediately contemporary painting seems to be developing in the direction of pop art. Coca-Cola! There will be a tremendous excitement about what, in effect, will be the "folk art" of industrial civilization, and thus different from preceding art: i.e., the reference will not be to high art, but to certain effects of industrial society. The pop artists couldn't care less about Picasso or Rembrandt, nor mean to.

I am all in favor of pop art. For one thing, certain parasitical painters will get off (inevitably) the back of abstract expressionism . . . And

I'm glad to see young painters enjoying themselves, which the pop artists obviously are . . . And I prefer their solution, natural and un-forced, to the problem of dealing with the human figure (and with objects), to the various forced, pseudo-Renaissance and naturalistic modes of painting the figure in our time. Bravo for the young! I hope they keep their energy. Energy alone can find the new.

Notes

1. The exhibit was presented in tandem with the first Louise Lindner Eastman Memorial Lecture, delivered by Motherwell.
2. Most likely, Motherwell's teaching at Hunter College.

"A Process of Painting" 5 October 1963

Late in 1963, Motherwell was invited to participate in "The Creative Use of the Unconscious by the Artist and by the Psy-chotherapist." The two-day seminar at the Eighth Annual Conference of the American Academy of Psychotherapists was held in the Waldorf-Astoria Hotel in New York. Along with a number of analysts and psychologists, contributors included representatives from drama, architecture, dance, music, and art. Motherwell's talk, which he later referred to as "A Process of Painting," was given on 5 October and was published the following year in the *Annals of Psychotherapy*.

In his Smith College "Conversation" of the preceding year, Moth-erwell had begun to describe some of his studio work habits, thoughts on which he now elaborated. Ever deferential to a particular audience, he conjectured before this specialized group on the psychology of mak-ing art, stressing the psychic importance of familiar work space. Em-phasis on personal experience, a perspective he would utilize with growing frequency in future lectures and writings, points up his con-scious effort to project concrete and specific information—observations he recognized that only he, as the artist and maker, could offer on the evolution of a work of art and on the creative process in general. ■

> Painting is silent poetry, and poetry is painting with the gift
> of speech. Simonides

[. . .] The failure of much psychological writing about artistic activity and the unconscious is out of an inability to comprehend, in a verbally oriented culture, the depth and the intimacy of the marriage between the artist and his *medium*. A painting is not a picture of something in front of your eyes—a model, say, primarily. It is an attack on the medium which then comes to "mean" something. My impression is that a great deal is known about the unconscious, even though there is a lot more to be known, but that very little is known about creativity.

I would venture an intuition that this ignorance, in part, is owing to vastly underrating the role of the medium. Most laymen think of a painting as a representation of something in front of you as you work. Or it's something you recall or imagine; that is, painting is thought of as in a one-to-one correlation of a past experience. But it is not this at all. It is not a one-to-one relation. It is a triadic relation—composed of the artist, the subject, and the medium (the medium has a long history of its own, and important contemporary problems that every competent artist knows by heart). The subject does not pre-exist. It emerges out of the interaction between the artist and the medium. That is *why*, and only *how* a picture can be *creative*, and why its conclusions cannot be predetermined. When you have a predetermined conclusion, you have "academic" art, by definition.

My suspicion—but here I venture out of the realm of my own specific competence—my suspicion is that an artist begins as a person with an enormous capacity for love who cannot, in the beginning anyway, direct his love toward another person satisfactorily, and consequently, directs it toward a medium instead . . .

You must understand that, as far as I can see, an artistic medium is the only thing in human existence that has precisely the same range of sensed feeling as people themselves do. And it is only when you think of the medium as having the same potential as another human being, that you begin to see the nature of the artist's involvement—as it appears to himself . . .

Now, if a creative person in the arts is a person with an extraordinary capacity for love, who for whatever reason—say because of his early experience with his mother—as an example—cannot direct his love toward another person in full strength, but who nevertheless *must* love—he therefore directs his love toward the other thing in human existence as rich, sensitive, supple, and complicated as human beings themselves; that is to say toward an artistic medium, which is not an inert object, or conversely, a set of rules for composition, but a living collaboration, which not only reflects every nuance of one's being, but which, in the moments in which one is lost, comes to one's aid; not arbitrarily and capriciously (like the Greek goddesses intervening in man's fate), but seriously, accurately, concretely *with you,* as when a canvas says to you: this empty space in me needs to be pinker; or a shape says: I want to be larger and more expansive; or the format says: the conception is too large or too small for me, all out of scale; or a stripe says: gouge me more—you are too polite and elegant; or a gray says: a bit more blue—my present tone is uncomfortable and does not fit with what surrounds me.

Now if the mutual empathy between the artist and medium has been sufficiently emphasized, then I can quite briefly indicate some of the puzzling transactions that take place in my studio . . .

First of all, you have to get used to the room. And in a new studio,

this takes from four to thirty weeks. In an old one, that you have not used for a month or two, a few days. Days of hell. Consequently, one hesitates to travel. It is difficult to find a big room traveling, and it takes too long to get used to it if one does. And there is the hellish beginning again awaiting one at home. It is, of course, not just a question of *any* room, as it is for a writer. (When I write, I can write anywhere.) But in a studio, *everything that you make is related to the room in which you are working:* to the scale, to the light, to the color of the walls, to the character of the floor, the view within, the view without. Which is to say, it is a spatial and a visual world, as are the things you yourself are working on. And consequently, one has to become enormously familiar with the room, used to it—what its defects are, what its virtues are, and so on. (On the Cape where I spend the summers, I know many analysts socially; I play poker with some of them! They're always kidding us artists that we're so involved with real estate, as though somehow we're born capitalists! But it has nothing to do with the desire for possessions; in fact all artists, I think, really detest the responsibility that so many toilets, windows, roofs, etc., involve you in.) But you *cannot* work in somebody else's place or in a place that you're unfamiliar with. If my life depended upon painting a picture in this room, I could not do it properly. My work is not related to the Sert[1] Room's character. (I am not sure Sert's work here is either.)

. . . After not working for awhile—a month or two—as, for example, when you change from a summer studio to a winter studio, or have gone away for awhile, or somebody has been ill—one gets cold creatively, so to speak. One goes into the studio naked, and comes out bruised. Given the privacy of this medium, what help is there in one's memories of sex, of geography, of nature, of people, of politics, or in one's present experiences of them, for that matter? No, the issue is between you and the medium, that *empty blank rectangle* that so paralyzed Mallarmé, and of which Kandinsky rightly said, it is more beautiful empty than most finished pictures! And even the medium itself is not that simple. The medium does not exist ahistorically, for example, *sub species eternitas.* (Renaissance painters used a brick-colored canvas; their whole sense of what a picture is was different from ours.) That is to say, painting now, like everything else, is contemporary and historical—not denying the past—but in essence a silent collaboration among a score of studios between New York and Rome and Tokyo—constantly conditioning our contemporary sense of the medium.

I began twenty-two years ago with the Parisian surrealists (though I have never been a surrealist painter, because I reject their sense of what a picture is). The surrealists had a theory of creativity called "psychic automatism" and what psychoanalysts would call "free association," about what in its most common visual form in everyday life would be called "doodling." (One might say that Paul Klee was the supreme doodler, unless it was Miró.) I usually begin a picture with a "doodle,"

or with a liquid puddle like a Rorschach image (but not pressed together), or with a line and a dot, or a piece of paper dropped at random on what will be a collage. Then the struggle begins, and endures throughout in a state of anxiety that is ineffable, but obliquely recorded in the inner tensions of the finished canvas. The struggle has inexorable moral values—no nostalgia, no sentimentalism, no propaganda, no discourse, no autobiography, no violation of the canvas as a surface (since it *is* one), no clichés, no predetermined endings, no seduction, no charm, no relaxation, no mere taste, no obviousness, no coldness; or, oppositely, for me, it must have immediacy, passion or tenderness, *beingness,* as such, detachment, sheer presence as a modulation of the flat picture plane, true invention and search, light, an unexpected end, mainly warm earth colors, and black and white, a certain stalwartness . . .

I usually paint, to begin with, on the floor. (The shape of liquid puddles is more controllable!) More important, the sense of the pictorial surface as a whole is better sustained under your feet, and not fractured by three-dimensional space, as we all have a tendency to do when we're standing up—as though you are looking at an imaginary horizon. I seldom allow horizons, because of their illusionism. To preserve the integrity of the picture plane, I have to convert the horizon into a stripe . . . I often paint in series, a dozen or more versions of the same thing at once—of the same *theme* at once. One brings the weakest up to the strongest which in turn becomes the weakest which has then to be made stronger, and so ad infinitum, so that one goes beyond oneself (or sometimes below). There is no *knowing,* only faith. The alternative to faith is a black void! Sometimes that beautiful white virgin canvas that I begin with, after countless transformations, ends up nearly wholly black . . .

Art, like reality, can bring you to your knees, but I would not trade with anyone else. As Mondrian used to say: "If we cannot free ourselves from the hazards and conflicts inherent in living in space and time, we can free our vision." The artist's medium is his collaborator and his conscience in that effort in which only a few succeed.

Note

1. The Spanish architect José Luis Sert had spent time in the United States.

Interview with Bryan Robertson, Addenda 1965

Bryan Robertson was the director of the Whitechapel Art Gallery in London when Motherwell's 1965 retrospective was presented there. Robertson has written several articles on Motherwell, and he conducted a filmed interview with the artist in 1964 for WNET, New York. The following year, he met with Motherwell and,

circumscribed by the period of the late 1930s to the early 1940s, concentrated his questions on areas not covered in their first discussion.

Directed by Robertson, Motherwell addressed his philosophical training and the indirect manner in which it may have contributed to his painting, the importance of psychic automatism as a creative theory, and the influence of Mexico's popular culture on the development of his sensibility. Excerpts from this unpublished "addenda" follow. ■

[. . .]

ROBERTSON What did philosophical studies do for you as a painter? Trap the Gestalt with greater precision?

MOTHERWELL Perhaps to help me sense what kind of ideas are not relevant to painting. Often painters are involved in ideas which could be played out in some other way. For example, when Apollinaire talks about cubism and the fourth dimension, it is only possible because Apollinaire obviously misunderstood what is meant by the fourth dimension. I have seen painters involved in a mystique of scientific thought. I think painting and science have little to do with each other. Yes, it's useful to be able to discriminate among ideas, to have some professional skill in handling them. But whether this is more valuable in a painting context than in any other major human endeavor, I would doubt. Perhaps that training did help me write.

ROBERTSON Has this philosophical training experience made you more conscious, more self-conscious even, of the implications of form than you would otherwise have been?

MOTHERWELL In the sense that I have continuously been aware that in painting I am always dealing with—and never not—a relational structure. Which in turn makes "permission" to be "abstract" no problem at all. All paintings are essentially relational structures—whether figuration is present or not is not the real issue. So that I could apprehend, for example, at first sight, my first abstract art. For painters with either literary or art school backgrounds, at least in my time, to make a transition from figuration to abstraction was a threatening problem. I was able to be an abstract painter right off the bat, if I so chose. Which I did.

I understood, too, that "meaning" was the product of the relations among elements, so that I never had the then common anxiety as to whether an abstract painting had a given meaning. People who from a purist standpoint have felt that I have allowed too much "literature" at times into my painting, underestimate, in my opinion, the philosophical freedom with which it was done. Though it may psychologically have been less free, that is, more compulsive. My painting tends to become more literary in relation to how mocking it is.

There is a phrase from Whitehead that was of great help: "The higher the degree of abstraction the lower the degree of complexity."

But in the end I certainly learned more from Baudelaire and Mallarmé and Joyce than from philosophy. And even more from looking at cubism and Matisse. Remember that I haven't studied philosophy for twenty-five years now.

ROBERTSON I believe art is an act of revelation, and a work of art has no meaning outside its fact, its existence. A work of art is an act of revelation like an Old Testament character striking a rock and making water gush out. The rock is struck, the water gushes, but that is all. Other people interpret this. Is there any kind of parallel to your remark about illuminating rather than correcting, in teaching?

MOTHERWELL Yes, painting is as concrete as Moses. For example, I think of color as a thing, not as an abstraction. I do not draw shapes and then color them blue; I take a piece of blue, a large extension of blue and cut out, so to speak, from the extension of blue as much blue as I want. Color is a thing for me, and not a symbol for something else, say the sky—though associations are unavoidable, even in Mondrian.

My mind, as it feels to me, is more tentative and speculative than dogmatic and certain. I assume that other people will see the world differently. In teaching, I was always interested in illuminating, but never in converting. Or such was my illusion.

ROBERTSON What conclusions did you come to in conversations with Matta, what did you learn, as insights, from conversation with him?

MOTHERWELL Two: one negative and one positive. One was a rejection of Matta and the surrealist's stoutly held belief in anti-art. But positively, I sifted, from a great body of ideas, the following connected ideas: (a) relations among people, including art relations, tended to be an outward shell, and it was necessary in some way to fracture that shell; (b) the means was by what the surrealists called "psychic automatism" (which psychoanalysts would call "free association"); (c) that automatism always has references to meanings, unconscious among them; (d) that since I was nevertheless determined to respect the "painting" part of painting, that is to say formal order, the specific technique for me was automatic "doodling," which seemed to me to have endless possibilities.

The cubist idea of what a picture is was accepted, plastically; but the conventional subject was to be replaced by an automatically invented subject matter. My position to this day has been modified nuances, but remains essentially the same. For the first time I had an active principle for painting, specifically designed to explore unknown possibilities. A voyage to the Now, in Baudelaire's metaphor.

It should be emphasized, because of the amateurish connotations of the word doodling, that doodling can be, in the proper hands, *as high a mode of drawing as any*. By nature doodling is one of the generic artistic modes of drawing and, when elaborated, of painting in general.

The problem is *to make an abstract painting as rich as nature,* something the cubist tradition could not do.

ROBERTSON It depends on what kind of experience, what kind of conscious or unconscious realization the doodle [assumes].

MOTHERWELL Most people think of surrealism as the bizarre, the morbid, the upsetting, as a species of shock, in the sense that Sainte-Beuve said to Baudelaire: "You have created a new shudder in poetry." *But at the core of all true surrealist activity is one form or another of free association.* In the case of Dali, for example, it is the images, not the painting, that is free association. But it was clear, as in fact Masson and Miró had seen for a long time, that we could make doodles that respected all the painterly values of cubist painting.

(From this standpoint, Miró could be regarded as the godfather of modern American painting. It's interesting that Miró is the only major European artist who has continually visited New York with apprehending interest, though his style was already formed.)

You might ask then, why wasn't abstract expressionism really abstract surrealism, like Miró and Masson in those days? The answer lies in passion. The originators of abstract expressionism—Rothko, Pollock, Hofmann, Still, myself, and later on, Newman, de Kooning, and Kline—were more passionate painters than the surrealists proper. It must be this that fascinates Miró in the School of New York.

ROBERTSON Why did you have to travel to Mexico in 1941?

MOTHERWELL To be close to Matta, who had become temporarily and somewhat unwillingly, my mentor—I must have seemed stiff, Protestant, clumsy, depressed, un-socialized. He was sociable and even frivolous. I seemed joyless to him, and that one word is better than all the others. Matta was filled with enthusiasm—there was a streak of the sybarite, of Chanel, of Catholic decadence, fascinated by the idea of sin, which seemed incomprehensible to a young American. The other reason for going to Mexico was my love of the Mediterranean. The War was on, it was impossible to go to the Mediterranean, and Mexico was a substitute. Negatively speaking, I did not want to go back West for the summer. I had finally escaped my family! I was beginning to put down roots, of a fairly pliable kind, but in great anxiety, with fear and trembling.

Of course I cannot speak for Matta, but my impression was that he was uninterested in Mexican modern art and in pre-Columbian art. In those days he used to say, "North Americans have made the error of painting Indians. The thing to do is to paint as though you *were* an Indian." Matta loved Mexican *art populaire.* I remember his having made to order one of those marvelous papier-mâché bulls filled with fire crackers and pinwheels which he brought back to the U.S. and was in his New York apartment for a long while.

144

[. . .]

ROBERTSON Were you affected, in your thinking or your work, by the physical/mental character of Mexico? Poverty, death, disease, blackness, tropics, illiteracy?

MOTHERWELL Yes. I should make a preliminary comment. For some reason that I do not know, painting-wise I am often affected by places *after* I leave them. When I was in Oregon, I painted France; and as I remember, Mexico for a time became dominant in my painting after I returned to the U.S.A. It takes me a long time to absorb impressions of places. Otherwise, any place is all right so long as there is sunlight. Mexico is sunlight. I suppose what I mean by "Mediterranean" as a metaphor is "a sunlit place."

ROBERTSON Even if unaffected directly by places, didn't Mexico affect your thinking, by the individual pulse of its life, by the primitive structures of its life?

MOTHERWELL I didn't have the slightest interest in modern Mexican painting or in pre-Columbian art. But I loved the Indian market places, and I loved Mexican-Indian folk art color—magenta, bright lemon yellow, lime green, indigo, vermilion, orange, shocking pink, deep ultramarine blue, black and white, and purple, lots of purple, and nobody else uses it, (no metallic color, which I detest), beautiful intense greens. In fact Mexican folk art nowadays, in modern times, is based on German aniline dyes, which are not fast, but of an unparalleled range and intensity—quite different in range from the intense colors of Americans and Europeans—similar to Japanese and Chinese toy colors.

[. . .]

All my life I've been obsessed with death and was profoundly moved by the continual presence of sudden death in Mexico. (I've never seen a race of people so heedless of life!) The presence everywhere of death iconography: coffins, black glass-enclosed horse-drawn hearses, sigao skulls, figures of death, corpses of priests in glass cases, lurid popular wood-cuts, Posada (he is staggering the way Verdi is—the people really find their voice in a man like that), and many other things—women in black, cyprus trees in their cemeteries, burning candles, black-edged death notices and death announcements, calling cards and all of this contrasted with bright sunlight, white-garbed peasants, blue skies, orange trees, and everything you associate with life. All this seized my imagination. For years afterwards, spattered blood appeared in my pictures—red paint.

For instance, one of my most celebrated pictures, because it's in the Museum of Modern Art in New York, is called *Pancho Villa, Dead and Alive.* It's rarely observed that one half of it is a figure inside a coffin shape, covered with blood spots, and the other half is a figure with a pink penis hanging down—the penis being alive. Two portraits of Pancho Villa, one dead in the coffin, the other standing there alive!

Mexican life! At this time, I became passionately interested in the

history of the Mexican revolution. I had as a constant companion a book by Anita Brenner of contemporary photographs of the revolution called *The Wind That Swept Mexico*. And Eisenstein's movie, *Thunder Over Mexico,* for example, which I think I saw before I went to Mexico.

[. . .]

ROBERTSON What work were you doing at this time? How had it changed from work done in Mexico? Why, for example, had your formal, almost geometrical, abstract sense expanded since the work done in Mexico, if the *Little Spanish Prison* be a good example of the second New York phase?

MOTHERWELL I think I was seeing more and better abstract pictures in those months. Certainly Peggy Guggenheim's collection was one place where I was seeing good abstract pictures; it is the only gallery I've frequented a lot, and it had several excellent exhibitions. I felt the full impact of Mondrian for the first time very deeply—I realize now, much more than I think I was aware of consciously. His work gave me the sense that painting could be wholly expressive without "literature" or expressionism. But my favorite picture in the whole Guggenheim collection was the white Picasso, which she told me Max Ernst persuaded her to buy. I also loved a beautiful brown Miró.

[. . .]

What actually happened in my work was that I began pictures automatically—the automatism consisting of dabs of paint scraped across the surface of the canvas with razors or sticks or spatulas—the kind that doctors stick down your throat. Then, in my efforts to resolve the picture, a great deal of the canvas would slowly be covered over with a more formal, architectonic surface. Actually, in the portrait, *María,* done in Mexico, the primary automatism is largely covered over with a portrait with its own structure. But the portrait would have had a different figuration if it were not being worked out in relation to the primary automatism. [. . .]

My continuing struggle during the twenty odd years of my painting life has been to find an equilibrium between the automatic and the formal beauty that is the end result of an emergent process, in the sense of a dialectical evolution. [. . .]

ROBERTSON How did you interpret the term surrealism at that time?

MOTHERWELL Literally, surrealism means super-realism. I've always regarded it as unfortunate that, in English, the meaningless translation "surrealism" was taken over instead of the literal translation "super-realism," which, in the first place, if it had been taken over, would have made clear—as in fact was the case—that, as a general tendency, super-realism was the born antagonist of abstract art. And secondly, it would have been equally clear in English that super-realism means something beyond naturalism. In fact, when I edited a book

of Max Ernst's for the Documents of Modern Art, he titled the book *Beyond Painting*.

Surrealism was a mixture of many ideas, and the idea that was particularly useful to us in the early 1940s and which in the general confusion passed under the general name "surrealism" was that particular aspect that could be concretely characterized as "abstract automatism." I have been quoted as saying that abstract expressionism properly should have been called "abstract surrealism," but given the general antipathy in this country and in others to surrealist works of the order of those of Dali, Magritte, Breton, and so on, it would have been more just to suggest this term to either Coates[1] or Edward Alden Jewell, the art critic of *The Times*.

Abstract expressionism should *never* have been coined—better "abstract automatism." In those days—twenty years ago—what was regarded as "abstract" art was generally what nowadays would be called "hard-edged" abstraction. What we began to do in the early 1940s was more emotional and more violent in appearance than geometric abstraction, and in terms of the then contemporary vocabulary was therefore expressionist but more abstract than any expressionism that had been seen here in New York, and consequently was quite naturally—given the circumstances and the time—called abstract expressionism—a name that has retained general currency ever since. The abstract part we can agree on, but the expressionism was not the real father—instead it was automatic doodling.

Note

1. Robert Coates, then art critic for the *New Yorker*, coined the term "abstract expressionism."

"Letter from Robert Motherwell to Frank O'Hara
Dated August 18, 1965"

Motherwell's letter to Frank O'Hara was published in *Robert Motherwell: With Selections from the Artist's Writings*, the catalog that accompanied the artist's retrospective exhibition in 1965 at the Museum of Modern Art in New York.[1] O'Hara had curated the exhibit.

O'Hara and Motherwell had met shortly after Motherwell's marriage in 1958 to the painter Helen Frankenthaler, who counted the poet among her circle of literary and artist friends. At the time, O'Hara had published two books of his poetry and a monograph on Jackson Pollock, and was soon promoted to assistant curator of painting and sculpture exhibitions at MoMA. He and others in the group who came to be known as the "New York School of poets" had been considerably impressed by certain books in the Documents of Modern Art se-

ries and influenced particularly by Motherwell's anthology, *The Dada Poets and Painters.*

Motherwell had been offered his choice of curator for the exhibit by MoMA's director, René d'Harnoncourt, and, imagining a presentation *more like a poetry recital than a retrospective,* requested that O'Hara organize the show.[2] O'Hara had curated a retrospective of Motherwell's work for the "VI Bienal" in São Paulo and had written on the artist for the magazine *Kultur.*[3] Having just completed another article on Motherwell for *Vogue,*[4] he may have felt that he had temporarily exhausted the subject. At any rate, when the deadline for his catalog essay arrived, O'Hara developed writer's block. Motherwell, who had experienced many such an impasse in his painting and writing, sent O'Hara a battery of his random thoughts, written in a single morning, hoping that one of them might ignite a spark. Against the objection of the artist, who felt that his thoughts had been written for private purposes, O'Hara published Motherwell's letter in the exhibition catalog.[5] ■

Dear Frank:

While I think of it, would you amend (wherever it appears) the account of the School and The Club as follows: "The Friday Nights at the School led to the Friday Nights at The Club, the celebrated avantgarde artists' club of the 1950s, but other aspects of The Club grew out of another set of friendships at the old Waldorf Cafeteria in the Village."

"I told a group of philosophers to their faces: Philosophy is simply a question of form!": Valéry, *Idée Fixe,* p. 107 (1932). I quote this half-appreciatively, half-ironically.

Intelligence often manifests itself in an excellent use of language. But laymen tend not to recognize that painting is also a language. (Indeed, what makes a layman is insensitivity to a given language.) In the case of painting, this surprisingly includes many people—certain painters, curators, critics, scholars, dealers—who are "professionals." No wonder the art scene is so often confusion.

But if intelligence is essential in order to organize relations, i.e., to arrive at structural form, then the subject matter is feeling: art is not a science. Painting that does not radiate feeling is not worth looking at. The deepest—and rarest—of grown-up pleasures is true feeling.

When one is asked what painters one admires, one realizes one likes all the great ones. Who are more significant are those who invariably excite one to paint oneself: in my case, Rembrandt's drawings, Goya, Matisse, and Picasso. On the other hand, the great van Eyck or Titian never incite me to work. Another test is those of one's contemporaries

whose shows one looks forward to. These are few, but crucial. For me that has meant mostly Miró and a dozen Americans—and the possibility of anyone else anywhere.

It is a considerable achievement to have made one masterpiece in a lifetime.

An exhibition can never realize all one's desires from the world, even the most select and complete shows. Indeed, one feels how coarse and uncomprehending the world can be. But the real trauma is one's own reaction to one's work. As a great contemporary painter says: "If, after long contemplation, one feels one's life wasn't wasted, one has come out rather well."

Only painters and sculptors among artists can be exposed *in toto* in a few minutes—or seem to be.

The content has always to be expressed in modern terms: that is the basic premise. Joyce understood that perfectly.

The greater the precision of feeling, the more personal the work will be.

The more anonymous a work, the less universal, because in some paradoxical way, we understand the universal through the personal.

The dangers of recognition!

The problems of inventing a new language are staggering. But what else can one do if one needs to express one's feeling precisely?

It is the effort to respect one's feelings, one's integrity that leads to radical notions. No revolutionary was ever one for the hell of it: it is too painful a condition. But the pain is eased by its inevitability, given a real problem.

"One can never be as radical as reality itself." Lenin.

What paintings can stand up against the physical presence of nature? Few, and often least of all those who have nature as the principal subject.

Confusion always has the same cause: lack of genuine feeling.

Every picture one paints involves *not* painting others! What a choice!

Caution is the enemy of art, and everyone is more cautious than he thinks he is.

The drama of creativity is that one's resources, no matter how unusual, are inadequate.

The ultimate act is faith, the ultimate resource the preconscious: if either is suspended, the artist is impotent. This is possible any hour, any day, and it is the artist's nightmare throughout life.

149

Irony, the greatest necessity of everyday life, does not work in pictures. (Neither does pathos.)

If one has capital, and no respect for it per se, one can accomplish miraculous projects. Contrary to rumor, I never did have it.

Little pictures are for midgets or for tourists—souvenirs.

This summer in Europe . . .

What secrets are hidden in Venice!

How everybody in the Aegean slaughtered everybody! No wonder all is ruins!

Chi ama, crede: who loves, trusts.

The miracle of a good marriage is that one's qualities are enhanced and strengthened into a continuity that no one can sustain alone.

I am astonished at all the very young artists now who do not seem to reflect—as my generation did—on how expensive children are. None of us had children before forty, and most not at all.

As David Smith liked to say, "To be an artist is a luxury."

Alex Liberman likes to say, "Nothing is too good for artists."

There is something princely about even the most democratic artists.

Art is much less important than life, but what a poor life without it! This is not aestheticism, but recognition that art as much as anything—perhaps more—conveys how men feel to themselves. In this sense, even the most difficult art is meant to be shared, and does communicate.

One does not have to "understand" wholly to feel pleasure.

One can't think clearly without thinking in alternatives. Blankness is the failure of an alternative to come to mind.

It's a good thing that there is not an afterlife. What would one do with it through eternity? There's not that much capacity in the human substance.

If life were longer, one could express more. Since it isn't, stick to essentials.

Every artist needs a model. Not to paint, but as a beautiful living presence. Art that has no element of the erotic is like a life without the erotic, shrivelled.

Modern European culture castrated itself when it killed the Jews.

The power in saying no!

It's not the art in Greece that ravishes everyone: other civilizations have greater monuments—it's the pervasive nakedness!

What has the world got to tempt an artist? What is more desirable than feeling?

To feel like a man. What is better?

A man of feeling has a right to be furious.

I would fight more if I had more time.

We are saved from the word: There is more than one *can* read!

The beauty of another being's presence.

It's better to be brutal than indifferent.

An artist *cares*. That is what can be trusted.

Some children quit painting if they haven't the proper color. Picasso says, you just use another color. Who's right?

Drawing is dividing the surface plane.

Color is a question of quantity, i.e., extension in space.

But it is light that counts above everything. Not colored light, but color that gives off light—radiance!

The supreme gift, after light, is scale.

The technique of painting is the simplest of all the arts: For that reason it demands the greatest sensibility.

I love poetry and music, but I would rather see.

Somebody ought to invent an inflatable studio. Then painters would be free to travel. (The predicament of sculptors is hopeless.)

The fascination of sports figures, who must perform at a given place and time: but these are games.

What better way to spend one's life than to have, as one's primary task, the insistence on integrity of feeling? No wonder others are fascinated by artists.

We rush towards death.

Moments of joy make existence bearable: who ignores joy is immoral.

One longs to be treated by the grown-up world as one is by small children: with total trust.

One never really gets used to reality. The ultimate joke is our life of anxiety. God's small compensation is a sense of wonder.

But a sense of wonder can become a mannerism. No one is naive about everything, especially the talented.

The material things of life are mere decorations. Enough space, light, and white walls make any environment workable. Enough space and light, but not necessarily white, for that matter floods pictures with feeling.

The world cannot endure that artists' money comes from so much pleasure. Artists cannot endure that the world's money comes from so much work, and usually give extravagant tips and presents, as though our money were less "real."

I much prefer trading to selling, but not everyone who has something I need is an art lover.

The surrealist group used to demand a picture each year from its painters: the proceeds were used to support their poets. They recognized the social injustice in the fact that a great painting has more commodity value than a great poem and equalized the situation. No one objected.

Contemporary paintings would not have to sell for so much if living artists received royalties from exhibitions and reproductions.

When artists are blamed for the financial madness of the art-scene, the psychology of collectors is left out of account.

Any picture is fairly priced, if its subsequent value is greater. And the years when one made nothing.

Recognition from The Establishment is only valuable in dealing with one's relatives, and one feels a parallel ambivalence: it is at once real and empty.

When I see a newsreel from 1915, the year I was born, or a movie that takes place then, like Jeanne Moreau's "Mata Hari," I cannot believe that my life span has been from that moment until the present: I had the same perspectives throughout, while the appearance of the world changed. When I was born is another universe, and I am fifty. As though one were born in what is now a museum.

Whenever I hear talk about homosexuals, I remember that Proust's book is the greatest epic poem of the century. (Along with Joyce's *Ulysses*.)

The present vitality of American art is connected with the unparalleled depth of our democracy: it certainly did not come from cultural tradition, but from an existential context of greatly liberating forces.

New York City is a Constantinople, a great Bazaar. London is inexhaustible.

Parisian art was greatest when it was the most democratic and international city in Europe—1870–1939.

To modify one's art is to modify one's character. An artist whose work develops represents character growth, either slow and steady, like a garden, or in leaps, like Columbus's discovery of America.

The problem is to seize the glimpse.

The ethic lies in not making the glimpse presentable.

I could strangle those conservators who put glossy varnish on my pictures: what insensitivity to how their surfaces should feel.

If one paints on an enormous scale, one gets involved in all the problems of running a lumberyard.

The beauty of Europe is that sculpture is everywhere. The sculpture doesn't have to be great to function perfectly in the landscape, humanizing it.

America is what the poor people of Europe invented, given means enough and time. Europeans therefore shouldn't snub it.

The miracle of a place that one likes to go *home* to, prefers to any other. Which means to *someone*.

Homer, Shakespeare, Mozart and *l'art moderne* fill my pantheon; the rest is extra.

The only thing that I bought in Greece (1965) was a scale-model of a Homeric ship.

The adequate application of psycho-analysis to an artist is George Painter's two-volume *Marcel Proust*. The subject is ideal and the application a marvel of precision and completeness.

The world is more indebted than it seems to know to Françoise Gilot's *Life With Picasso*. It, perhaps more than any other book, should be required reading for every aspiring modern artist.

David Smith many years ago saw Ernst Kris [author of *Psycho-analytic Explorations in Art*] twice—who was already dying, and who apparently told David to endure it all, to live with it. But in the end he couldn't. Oh, David!

Every painter *au fond* is a voyeur: the question is whether he has a vision.

Painting is a totally active act.

From my writings, it would seem that I am more interested in poetry than painting, which of course is not at all true. It is that the poets have speculated much more in words about what "the modern" is.

When I used to defend "modern art" during the early struggles of abstract expressionism, I often turned to the poets for suggestions and arguments against the Philistines.

My writing does not compare, in depth or originality, with my painting. But most people are more at home with writing.

Having a retrospective is making a will.

What better definition of modern art is there than Mallarmé's ". . . the expression of the mysterious meaning of aspects of existence, through human language brought back to its essential rhythm: in this way, it endows our sojourn with authenticity, and constitutes the only spiritual task," or (1864): ". . . for I am inventing a language that must necessarily spring from a very new poetics: *to paint, not the thing, but the effect that it produces.*"

What I have never had a chance to write about (though I have sometimes lectured on it) is the changes that were brought about by the transplanting of the modern aesthetic into America: that is the real story of abstract expressionism. And part of its story is its extension of "the modern" during a decade (1940s) when European belief in the modern greatly weakened: we here had already been through those alternatives in the 1930s and had rejected them.

The interest in language so dominant in modern art is not an interest in semantics per se: it is a continual interest in making language (whatever the medium) to fit our real feelings better, and even to be able to express true feelings that had never been capable of expression before. How much more humanistic in the end is this effort on the part of solitary individuals than that of those who throw a collective ideology at one and say, that is the obvious truth, now express it! It is only authoritarian groups, whether political or religious, who can determine by pressure the *future* of their arts. To us who are freer individually, the future is a wide-open adventure of unimagined possibilities, and of hundreds of booby traps.

I regret that I have referred to the French so much in my life, because it gives the impression of something a bit precious and overcultivated. Actually, I hardly could be more American in most of my aspects, and I speak French as an oriental houseboy speaks English. Nor am I especially interested in France. My interest is in certain ideas about *modern art*. The French developed them in painting and poetry for a long time, but the man who has the strongest claim to be the father of the concept of the modern as we know it is an American, Edgar Allan Poe; and in painting at least, America has developed ideas about modern art more rigorously than any country since World War II. The other great tradition of these past two hundred years has been the English and Russian novel, followed by the movies, which I enjoyed as

much as anyone, but which by-and-large has little to do with painting—with modern painting, at least, which is symbolic and poetic, not discursive and descriptive. But the latter is always trying to infiltrate modern painting, usually under the tag of some "humanism" or another. What shit!

For me the extraordinary English artists of the nineteenth century are Dickens, Turner, and Hopkins; in America, Poe, Melville, Whitman, Ryder, and Eakins. But one has to wait until the twentieth century to talk about modern art in clusters: in this sense, in our century the enterprise is more sociable, less desperate.

I love Hopkins's insistence on particularization.

Barnett Newman for years has said that when he reads my writings, he learns what I have been reading, but when he wants to know what I am really concerned with at a given moment, he looks at my pictures. He's right.

To have the discipline to shut up, and just paint the pictures!

Notes

1. The exhibition traveled to the Stedelijk Museum, Amsterdam; Whitechapel Art Gallery, London; Palais des Beaux-Arts, Brussels; Museum Folkwang, Essen; and Museo Civico, Galleria Civica d'Arte Moderna, Turin.
2. Conversation with the artist, 20 August 1980.
3. Frank O'Hara, "Art Chronicle," *Kultur* 3, no. 9 (Spring 1963): 63.
4. Frank O'Hara, "The Grand Manner of Motherwell," *Vogue,* October 1965, pp. 206–7, 263–65.
5. Motherwell had also objected to the number of paintings in the exhibit, requesting that almost half be eliminated. O'Hara *stuck to his guns,* arguing his responsibility and commitment to the lenders. In the end, Motherwell respected O'Hara's courage in standing firm on this point and on the publication of his letter (conversation with the artist, 20 August 1980).

Interview with Sidney Simon: "Concerning the Beginnings of the New York School: 1939–1943"
January 1967

In January 1967, Motherwell was interviewed in New York City by the art historian Sidney Simon,[1] who earlier had interviewed Peter Busa and Roberto Matta in Minneapolis. Both sessions appeared under the general heading "Concerning the Beginnings of the New York School: 1939–1943" when they were published that summer in *Art International*.

The period circumscribed by the interviews had been critical to Motherwell's development as an artist, since it was during this time that he gave up his academic studies and began to paint in earnest. His fortuitous meeting with the exiled surrealists had helped to liberate his

artistic imagination and to focus his interests and talents. The principle of psychic automatism, introduced to him by Matta, later became the rallying point for a proposed manifesto, part of the coup d'état Matta had hoped would revitalize the aging surrealists. Ironically, it had been the Chilean-born surrealist who had introduced Motherwell to American avant-garde painters—first to William Baziotes. And it was Baziotes who, abetting Matta in his effort to counter the surrealists, introduced Motherwell to Jackson Pollock, Jerome Kamrowski, Peter Busa, Willem de Kooning, Hans Hofmann, and Arshile Gorky, to all of whom he was to spread the word of automatism. Motherwell's proselytizing sessions with these painters and their implication in the genesis of what was later to be referred to as abstract expressionism was at the heart of his interview with Simon, a significant portion of which follows. ■

SIMON Since these discussions are concerned with the origins of the so-called New York School, I would welcome your detailed reminiscences of the period roughly from 1939 to 1943. What, for example, were the circumstances that led to your close association with Matta in 1940?

MOTHERWELL To give some idea of what must have taken place, I will have to emphasize the fact that my background up to 1940 had little to do with painting. Until then, I had known only one obscure American artist.[2] My grown-up life had been spent in prep school and universities, involving various scholarly pursuits. It is true, on the other hand, that I drew and painted all my youth, so that I can't really say that I walked into the New York art situation visually naked, but I certainly had no professional experience at all.

SIMON Might we backtrack a bit? You were at Harvard for a time, isn't that so? When was that?

MOTHERWELL The academic year of 1937–1938. I was a graduate student in the philosophy department. That particular year, Arthur Lovejoy, who was a visiting professor, had a yearlong seminar in the History of the Idea of Romanticism. When he discovered that I was interested in painting, he assigned to me Eugène Delacroix, whose journal had just been published in translation. Both Lovejoy and my Harvard mentor, David Prall, liked what I wrote well enough to suggest that I go to Paris for a year and prepare it for publication. It was in May, 1938, that I went to France. After a short stay at the University of Grenoble to improve my French, which remained awful, I spent the rest of the time in Paris almost until the war began. There was an interlude at Oxford, in July 1939.

SIMON Had you yet decided on a career in painting?

MOTHERWELL No. Back in the States, I got a teaching job at the University of Oregon for one year, as a substitute for someone on sabbatical leave. I took the job so that I would have something to do while I was trying to make up my mind whether to continue my academic career or to become a painter—which I really longed to do, but did not know how to go about. During that year I met the composer, Arthur Berger, who advised me to go to New York and study with Meyer Schapiro at Columbia, while making up my mind. New York, he thought—and quite rightly—was much more of a center of art than the other places I had been. So I wrote to Columbia. They pointed out that I was unqualified technically to be in the graduate school of art history but were willing to take me, on probation.

SIMON Your contact with Meyer Schapiro is of course very well known.

MOTHERWELL I owe him a lot. When I came to New York I knew no one. By coincidence I lived near Schapiro.[3] I began to paint a lot. Occasionally, because I didn't know anyone else who would be interested, I used to take my pictures and show them to him—I realize now, somewhat to his annoyance. I had no conception of how busy people are in New York. One day he suggested that what I really needed was to know some other artists. He knew most. He wanted to know whom I would like to meet. If it were possible, he said, he would arrange it.

SIMON Did he influence you about becoming a painter?

MOTHERWELL He felt strongly that I should become a painter and not a scholar—not that my scholarship was inadequate—but that my real drive was obviously toward painting. He asked me what American painters I liked; and I said I didn't know of any that I really liked or wanted to meet. And then he said, what about the Parisian surrealists (who were most of them in New York in exile)?

SIMON Do you remember when exactly this conversation took place?

MOTHERWELL It must have been around Christmastime, 1940. I said that, judging from the little I had seen, I didn't like surrealist painting either. What I had in mind was the work of Dali, the more literary kind. And he said, whether you like their painting or not, they are the most lively group of artists around. (They would have been in their forties then.) They are highly literate; and, since you have an orientation toward modern French culture, it could be good for you. So I said, from that point of view, fine. After some reflection, he arranged that I study engraving with Kurt Seligmann.[4] (Seligmann spoke English very well.) He was learned, and, as we would say nowadays, "square." Although I was interested in learning engraving, the thing was really a pretext (which we both understood) to help me to enter a bit into the French milieu. After all, I couldn't just hang around . . .

SIMON What kind of an impression did the surrealists make on you? What were they like?

MOTHERWELL They were a real fraternity. Such as I have never seen before, or since, among artists. (Most of the artists I have known have as their best friends other artists, but it is a personal rather than an ideological relationship.) Surrealism was a complicated system of ideas and attitudes, having to do not only with art.

SIMON Since you found them such a close-knit group, was it hard for you to get to know them?

MOTHERWELL No. What I am trying to emphasize is their comradeship. To answer your question, through Seligmann—all the surrealists appeared in his studio at one time or another—and his reciprocal visits to various studios (taking me with him), I not only met them, but also had an important, if minor, function to perform: I was an American. Most of them had plunged straight into exile.[5] There were lots of things that puzzled them, from the most minor things like—If you couldn't get olive oil, what other kind of cooking oil would serve as well? Why do Americans do this or that or the other thing? And being an American I was in a position to be helpful, to provide other frames of reference.

SIMON I take it from what you say that they had few real contacts with Americans?

MOTHERWELL They were artistically isolated on the whole. They knew that the American artists held off, either out of jealousy or out of lack of sympathy; or perhaps feeling threatened, or merely not being interested: I don't know. But I, of course, had nothing yet about which I could feel threatened. Not yet a painter, and being imbued in French culture, and regarding them as forming a distinctive part of this culture, I had great sympathy. And so I was useful to them in some ways. I think they liked me, too.

SIMON You would have met Matta about this time?

MOTHERWELL Yes. The first surrealist I met and the only one who was close to my age was Matta. He was the most energetic, enthusiastic, poetic, charming, brilliant young artist that I've ever met. This would have been the spring of 1941. We tend to forget, in thinking about this period, that it was the end of the Depression. The war was about to begin; it had already begun in Europe. Most of the artists of my generation nearly all had been on the WPA, at $25 a week, or whatever it was. The WPA was heavily socially oriented; and those few artists who were attracted to modern art or abstract art had a rough time. None had recognition. Most were poor, depressed, with considerable feelings of hopelessness, but determined nevertheless to carry on, in their respective aspirations.

For an enthusiastic person like Matta to appear—this had an extremely important catalytic effect. (Matta and I were both "foreigners" to the New York painting scene. Matta came from a different world, while I, an American, had never been forced to endure what my colleagues had.)

SIMON Can you recall the first time you met Matta?

MOTHERWELL I can't. I would imagine it was in Seligmann's studio. (The other possibility is that I met him through the Onslow-Fords.[6] I can't remember. Gordon Onslow-Ford had something of the same relationship as I had to Matta—that is, we were both his admirers.) What I do remember is that Matta and I became friendly very quickly. By this I mean we met at least a couple of times a week, etc., during the spring of 1941. He was married at the time to an American girl. I remember that he wanted very badly to get out of America for the summer. Seligmann had another pupil in engraving, a young girl, Barbara, who was the daughter of Bernard Reis, the art collector. It was finally arranged that the Mattas and the Seligmanns, Barbara Reis and I would all go to Mexico for the summer. Then, as you will recall, in May, Paris fell to the Germans.[7] And the Seligmanns, both of whom were Swiss Jews, were worried about their relatives in Europe and so they decided they couldn't go. The Mattas, Barbara, and I got on a boat and left for Mexico.[8] On the boat was a young Mexican actress with whom I promptly fell in love, and soon after married.[9]

SIMON How important do you feel this Mexican sojourn was for your artistic development?

MOTHERWELL It was important in a special sense. In the three months of that summer of 1941, Matta gave me a ten-year education in surrealism. Through him, I met Wolfgang Paalen, a prominent surrealist, who was living in Mexico City. At the end of the summer, the Mattas and Barbara Reis returned to New York. María and I settled near Paalen till nearly Christmastime. Paalen was an intellectual, a man widely read; and it was with him that I got my postgraduate education in surrealism, so to speak.

By the time María and I returned to New York we were already married.[10] We took an apartment on Perry Street in the Village, not far from where Matta lived. One day, I recall, Matta and I went up to Columbia to see the mathematical three-dimensional objects (like very beautiful abstract sculptures) that are made by mathematicians, to show their concepts in three dimensions. In the subway, on the way back, there was a very attractive young woman, who spoke to Matta. Afterwards I asked who she was, and he said that she was the wife of a very good young American artist, Bill Baziotes. Come to think of it, he said, you ought to get to know Baziotes. He thought we would like each other. Matta had us to dinner, and we became friends on the spot.

SIMON Do you recall seeing Matta's first show in New York, at the Julien Levy Gallery? It opened in April 1940.[11] This would have been a year before you met him.

MOTHERWELL No, I don't remember seeing it. My vivid feelings about his work were always the same. I loved his pencil drawings, but I never really liked his paintings. For me they were theatrical and glossy, too illusionistic for my taste. But I do think the drawings he made in those years—in the late 1930s and 1940s—are among the most beautiful, if not *the* most beautiful work made in America at that time. And there were hundreds of them. Matta, with all his worldliness and sociability, has always been a very hard worker, enormously productive.

SIMON How do Pollock, Busa, and Kamrowski relate to the general situation that we have been discussing?

MOTHERWELL Well, here is where I have got to talk about what has always seemed to me the beginnings of what later became known as abstract expressionism. The thing that I want to establish (and I say this as a metaphor) is that Matta had an Oedipal relation to the surrealists. He was, in the time we are talking about, only about thirty years old while all of the other surrealists were in their forties. He was the loved son, the heir apparent; but he was also treated with a certain amount of suspicion, somewhat unfairly, because the last person to play his role was also Spanish-speaking—I'm referring, of course, to Salvador Dali. The surrealists at that moment hated Dali; and I think there was some suspicion that Matta might be ultimately another Dali. In any case, Matta certainly had a deep love–hate relationship with the surrealists. At one moment when the hate relationship was more dominant, he wanted to show the surrealists up, so to speak, as middle-aged, grey-haired men who weren't zeroed into contemporary reality. He realized that if he made a manifesto by himself, or even if he had a beautiful show by himself, the surrealists could say, well, he's a surrealist and he's very talented; but if there were a group who made a manifestation that was more daring and qualitatively more beautiful than the surrealists themselves, then he could succeed in his objective of showing them up.

SIMON The possibility of succeeding in this I would say must have been rather dim. Would you agree?

MOTHERWELL Of course. The thing was that there weren't a lot of good painters around; or if there were we didn't know about them; so the problem was how to go about it. Matta came to me and Baziotes with the problem. Of course, I didn't know any American artists, though by this time I had got to know most of the European artists reasonably well. Baziotes, however, had been on the WPA for many years and perhaps was still on it at that time. So Matta said to Baziotes, are there some guys on the WPA who are interested in modern art and not in all that social realist crap? Baziotes said there are

very few. He named Pollock, de Kooning, Kamrowski, and Busa. And then Matta said to me, how can we make a manifestation? And I answered that the great manifestation in America had been the Armory Show, that perhaps we should hire an armory, or a big loft or something, and show *new* work. Matta said—quite properly—if we are going to make a manifesto against the surrealists, the work has to have some group point, something more than simply personal talent. Then I said, you and I have talked for a year constantly about surrealist theories of automatism and we believe that they can be carried much further. Since the three of us have been experimenting with various forms of automatism all winter, perhaps we could explain what automatism is to the artists Baziotes has named and see if they would be interested in some kind of collaboration. I suggested that perhaps we should even rent a place, a month in advance of the show, and all go there for a month and make this manifestation on the spot.

SIMON You make it sound like a quite feasible idea after all. I would be interested to know why it never came off.

MOTHERWELL Matta was all for it then. He was very enthusiastic, full of ideas, loved to see things start; but once they started, he often lost interest or got interested in something else. So what ultimately happened was that I, as the theoretician, and Baziotes, as the friend of the artists, were sent to explain all of this to them somewhat on our own. Matta, you see, retreated from the enterprise, which nonetheless was more personal to him than to us.

SIMON But you went ahead with the project anyway?

MOTHERWELL Yes. I asked Baziotes who he thought to be the most talented of his friends. Baziotes thought probably Pollock. He gives the impression of being very tough, and he didn't know how receptive he would be to the idea. I remember that Baziotes called up Pollock and we made a date to go and spend a whole afternoon with him. I talked, I guess, for four or five hours explaining the whole surrealist thing in general and the theory of automatism in particular, which nowadays we would call a technique of free association. I showed Pollock how Klee and Masson made their things, etc. And Pollock, to my astonishment, listened intently; in fact, he invited me to come back another afternoon, which I did. This would be the winter of 1942.

SIMON Just how interested would you say Pollock was?

MOTHERWELL What I haven't said is that by this time I'd become friendly with Peggy Guggenheim (who either had or was about to marry Max Ernst[12] and was very much part of the surrealist milieu). I think a lot of Pollock's interest in me was not altogether in what I was saying, but in that I had a connection with Peggy Guggenheim. (In those days it was almost impossible for an unknown American artist to show in a first-rate modern gallery, such as Curt Valentin or Pierre

Matisse.) And it turned out, in fact, that Peggy Guggenheim was the only one who recognized—because of the milieu she was in—the value of the new artists, and showed us with style and class, to her credit. But Pollock learned something, aesthetically too. He was barely past the Mexicans and coming up to the Picasso of the 1930s.

SIMON You mentioned a second visit to Pollock.

MOTHERWELL That second visit I recall vividly. Pollock was living with Lee Krasner, who was a pupil and admirer of Hofmann, who lived only a few doors from them.[13] I think it was at Lee's behest that Pollock took me over after dinner to see Hofmann. It was the first time I had met him, and I at once realized that my being twenty-six years old—Hofmann was already in his sixties—it would be impertinent for a young apprentice artist to tell him about what painting was.[14] As it turned out, Pollock got drunk on a big jug of red wine, and we all had to carry him down four flights into the street and then up four flights to his place. It was a helluva job.

SIMON Did you see much of Pollock after that?

MOTHERWELL After several months, Pollock and I became somewhat friendly. He and his wife[15] and I and my wife and the two Baziotes used to write automatic poems together, which I kept in a book. Unfortunately, this book is now lost, given away or stolen. I greatly regret that I have never been able to recover the poems which were inserted in the book for safekeeping!

SIMON After Pollock, which artist did you contact?

MOTHERWELL I think Peter Busa was the next. In those days Busa struck me as the epitome of the Italian artisan, gentle and charming. Just married. I seem to recall that he was painting the female figure with the degree of abstraction of, let us say, Karl Hofer, or perhaps, Modigliani. After Busa, we called on Kamrowski, a depressed man who expressed an interest in our proposed project and did begin to work in these directions.

The last person to be visited—it was Pollock's initiative that took me to see him—was de Kooning. He had a loft around West Nineteenth Street. In those days de Kooning was painting figure paintings in a direction that he developed jointly with Gorky and John Graham. De Kooning was also doing abstractions in a rather loose, and to me not very interesting manner. I think at this particular time his figure paintings were not wholly resolved. He had some inability to "finish" them. I remember that there were never eyes in the sockets. There were other details that baffled him. In any case, he wasn't particularly interested in what I told him; he became interested in automatism only much later.

SIMON Does Gorky figure in this at all?

MOTHERWELL Only to the extent that about two years later, Matta, on his own, converted Gorky to the theory of automatism. Gorky in those days wouldn't pay much attention to what we said, although I spent a whole evening at Peggy Osborn's[16] house telling him all about surrealism, about which, incidentally, he knew very little. This would be the spring [of] 1942.

SIMON Would it be correct to say that an informal group of the artists you and Baziotes contacted ended up by meeting from time to time in Matta's studio in order to conduct certain experiments?

MOTHERWELL To be truthful I don't recall an awful lot about that. The meetings must have been separate. It was an awkward situation in that Matta was the guiding spirit. You have to remember that he was much more "successful," he was earning his living as an artist, he knew many famous collectors and artists very well, and he was part of the international art establishment. On the other hand, we were all loners, basically, ignored and neglected; so that he would, so to speak, flirt with us, but never abandon his other world for us. In the end, though he was the instigator of it all, the strongest relationships grew up among the American artists, because, in a way, we were left in the lurch by him, and we made our own way.

Nevertheless, my conviction is that, more than any other single thing, the introduction and acceptance of the theory of automatism brought about a different look into our painting. We worked more directly and violently, and ultimately on a much larger scale physically than the surrealists ever had. It was the germ, historically, of what later came to be called abstract expressionism.

SIMON Can you recall any of the early experiments you and the others made?

MOTHERWELL Let's see. The summer of 1941 I was in Mexico. Either the next summer or the one after, Peggy Guggenheim, who was by then married to Max Ernst, took a house for the summer in Provincetown.[17] I and several other people followed. Matta was living nearby—he had a house in Wellfleet. Several times (in going to Peggy's for dinner) Max took me into his studio. There he had hung brushes from the ceiling on a cord so that they would just touch a canvas placed on the floor beneath. They would swing like a pendulum, making a kind of labyrinth on the canvas. Of course, this anticipated Pollock's drip style, but only in a very limited sense, i.e., limited to arcs. By comparison, what Pollock achieved was totally different, totally free.

We experimented rather freely. Together we would make what the surrealists called the "Exquisite Corpse." You know what that is?

SIMON Yes, of course. The paper is folded and each one does a different part of the figure.

MOTHERWELL Right. I remember that a conflict came up between Matta and myself. As I said earlier, I greatly admired his pencil drawings which were, roughly speaking, in the same vein as Miró—very comic and very plastic. When we began to play the Exquisite Corpse, I thought Matta would use this degree of abstraction, but instead he drew comically, very realistically. As in a Barney Google cartoon there would be a nose and, very carefully, a pimple on it, a couple of hairs coming out of it—very much in the style of the present-day *Mad Magazine*. I expected that he would draw in a more inventive Klee or Miró way—more the way I tried to draw at the time. So the group drawings looked funny.

SIMON Was Pollock receptive at all to these various experiments?

MOTHERWELL I don't know. To be truthful, it always astonished me when he appeared. He said very little, and made it very clear, after the second session I had with him, that he didn't believe in group activities and would not join the proposed manifestation that we were going to have. At the same time, I think now, in retrospect, that he was much more ambitious than I realized. In those days, given my university background, I did things with a certain gratuitousness, with a love of doing things for their own sake. As an "amateur" in the English sense. Pollock had had a much more tormented, and, socially, a much more difficult life than I had. He was probably much tougher than I was, but didn't reveal this to me. He was certainly interested in getting in a functioning world. Peggy Guggenheim, rather than the surrealists, was the real center of attraction to him, I think now.

SIMON Peggy Guggenheim opened her gallery in November 1942. Exactly a year later she gave Pollock his first one-man show.

MOTHERWELL I don't remember when Peggy became aware of Pollock, Baziotes and myself among the young American artists. But I do remember that she was going to put on the first international collage show that had ever been held in America. It was going to include all the names—Schwitters, Max Ernst, Cornell, Picasso, Braque, Miró, Masson, etc. And because she was benignly and generously interested in the three of us—you see, she suggested to me that we all make some collages, and if they were any good (she reserved the right of judgment) she'd put them in the show. It was to have been the first chance for all three of us to show in a major gallery with major artists. The idea both excited and intimidated us. One day, Pollock suggested to me—Pollock in a funny way was a very shy as well as a very violent man—he suggested in a reticent way that since neither of us had ever made a collage that we try to do them together. I liked the idea and we decided to do so in his studio. (He had been painting much longer than I had, and had a much more professional set-up than mine in terms of space, light, and materials.)

 And we did make our first collages together. He, I remember, burnt

his with matches and spit on it. Generally, he worked with a violence that I had never seen before. As is well known, I took to collage like a duck to water. I showed my results to Matta, who liked them very much, but said that they are too little. "If you can do them that well little, you can do them bigger." He urged me to make some big ones. And I did. They became the core of my first show at Peggy Guggenheim's in October 1944.

[. . .]

SIMON [. . .] How much had you looked at Masson's work?

MOTHERWELL We all looked at Masson's work a lot. He was here. No one, it is true, knew him very well. To the best of my knowledge, he never learned a word of English. Also, he lived in the country, in Connecticut; the surrealists, after they had been here a couple of years, tended to move to the country. Gorky, when he was picked up by the surrealists, also moved to Connecticut. There was a regular enclave there.

SIMON Where would you have seen Masson's work?

MOTHERWELL He exhibited a lot. I can remember several one-man shows. He was a prolific, hard-working artist. Everyone would have been very aware of his work in terms of automatism, which is how his work is built. And many of us were also aware of some beautiful collages he had made much earlier—a fairly blank canvas with a few automatic lines and very often feathers or something like that pasted on—around 1927, or so.

SIMON What about Kandinsky's work?

MOTHERWELL I don't think most of us paid much attention to Kandinsky, with the exception of Gorky; but even in Gorky's case, the interest was much more technical, about edges, lines, etc., than in Kandinsky's overall conception. I think that some historical things are, in a way, invented all over again. My personal conviction is that had Kandinsky never existed, abstract expressionism would look exactly the same way.

What I am saying is that at the particular moment in American art that we are talking about, *what was needed was a creative principle*. It is never enough to learn merely from pictures. When you learn merely from pictures, the result is bound to be somewhat imitative as compared to starting off with a real principle. In this sense, the theory of automatism was the first modern theory of creating that was introduced into America early enough to allow American artists to be equally adventurous or even more adventurous than their European counterparts. It was this that put America on the artistic map, so to speak, as authentically contemporary.

SIMON In this respect Peggy Guggenheim's gallery served a very practical function.

MOTHERWELL Yes. Look at the artists who showed at Peggy's—Baziotes, Pollock, and myself—and a little later Rothko, Still, and Gottlieb, and so on. Before that time, Gorky had a large underground reputation. Also Hofmann. But very few people had seen their pictures. Around 1945 Kootz came along and offered us money to paint—very little but enough to manage on. Many of the artists of what I think of as the second wave of abstract expressionism were impressed that we were making a mark, so to speak, and decided that it was time for them to start to move. And only *then* did they begin to examine seriously the principles on which our work was based—and in the process partly distorted them. Peggy always said she would go back to Europe when the war was over, and she did.

I remember some years ago talking to Rothko about automatism. He and I became friends in the mid 1940s. I told him a lot about surrealism. He was one of the few American painters who really liked surrealist painting, went to surrealist shows, and understood very well what I was talking about. When he developed the style in the late 1940s for which he is now famous, he told me that there was always automatic drawing under those larger forms. When I talk about automatic drawing—the method we used—I don't mean doodling, something absent-minded, trivial and tiny. If we doodled—and perhaps you can say that we did—it was ultimately on the scale of the Sistine Chapel. The essential thing was to let the brush take its head and take whatever we could use from the results. And of course it was Pollock who became the most identified with this technique of working. In his dripping, one could see most clearly and nakedly the essential nature of the process.

SIMON A new sense of scale, then, I take it, you feel was an essential factor in abstract expressionism—even in the 1940s?

MOTHERWELL I think that one of the major American contributions to modern art is sheer size. There are lots of arguments as to whether it should be credited to Pollock, Still, or Rothko, even Newman. It's hard to say, probably Pollock, possibly Still . . .

SIMON Yes, what about Still in this connection?

MOTHERWELL I had never heard of Still, until he had his first show at Peggy's. Pollock had his in 1943, Baziotes and I in 1944, Rothko and Still in 1945. I must say, it is to Still's credit—his was the show, of all those early shows of ours, that was the most original. A bolt out of the blue.

SIMON In what sense?

MOTHERWELL Most of us were still working through images toward what ultimately became abstract expressionism. Baziotes, Pollock, and I all had some degree of figuration in our work, abstract as

our work was; whereas Still had none. His canvases were large ones in earth colors. I don't suppose that they would seem so large now, but they did then. They mainly had a kind of jagged streak down the center, in a way like a present-day Newman if it were much more free-handed, that is, if the line were jagged, like lightning.[18]

My belief is that Still's influence on abstract expressionism was strongest later on, in the very late 1940s when he and Rothko met in San Francisco teaching in the same school.[19] Rothko was deeply impressed with Still; and Rothko, in those days, was, in turn, very close to Newman. (I also think that they must have had some experience with expressionism, which undoubtedly contributed a certain element to abstract expressionism.)

But the developments I have been talking about—automatism particularly—came out of Paris, and not out of either German or American expressionism. I think the "expressionist" part of abstract expressionism had to do with a certain violence native to the American character; I do not think it was the result of aesthetic considerations. What, in my opinion, happened in American painting after the war had its origins in automatism that was assimilated to the particular New York situation—that is, the surrealist tone and literary qualities were dropped, and the doodle transformed into something plastic, mysterious, and sublime. No Parisian is a sublime painter, nor a monumental one, not even Miró.

Notes

1. The art historian Sidney Simon is to be distinguished from the artist of the same name, who was a friend of Motherwell's and a fellow artist with the Long Point Gallery in Provincetown, Massachusetts.

2. Lance Hart, a family friend and Motherwell's first artistic mentor, had also been instrumental in obtaining the teaching position for him at the University of Oregon in 1939.

3. Meyer Schapiro has lived in New York's Greenwich Village since 1933; during the fall of 1940, Motherwell rented an apartment at the Rhinelander Garden Apartments on West Eleventh Street.

4. The Swiss-born Kurt Seligmann (1900–1962), who had been in the United States since 1939, took on a few students each year, some as studio assistants.

5. Among the surrealists, Roberto Matta, Ives Tanguy, Salvador Dali, and Seligmann had come to the United States in 1939; William Stanley Hayter, André Masson, and Gordon Onslow-Ford, in 1940; Max Ernst and André Breton, in 1941; and Marcel Duchamp, in 1942.

6. Motherwell had met Matta at a lecture given by Onslow-Ford at the New School in New York.

7. Actually, Paris fell in mid-June 1941.

8. A passenger and mailcarrier, *The Cuban Mail,* left the Wall Street docks for Mexico at 3:00 P.M. on 21 May 1941.

9. María Emilia Ferreira y Moyers and Motherwell were married in Provincetown, Massachusetts, in the summer of 1942.

10. See note 9.

11. Motherwell did not arrive in New York City until August 1940.

12. Peggy Guggenheim and Max Ernst were married in 1942.

13. Jackson Pollock's studio was on the fifth floor at 46 East Eighth Street; Lee Krasner's studio was nearby. Hans Hofmann lived on Eighth Street, between Broadway and University Place.

14. Motherwell was twenty-seven years old in January 1942.

15. Pollock and Krasner were not married until October 1945.

16. Peggy Osborn was an American patron of the arts.

17. The summer of 1942 is correct.

18. In a "Letter to the Editor," Barnett Newman attacked Busa and Motherwell's interpretation of the events of the period (*Art International* 11, no. 7 [September 1967]). Newman's outrage, however, was reserved for Motherwell's charterization of his work. Motherwell responded in the October issue of the magazine, followed in November by another angry letter from Newman. In the January 1968 issue, Motherwell expressed his regret for the exchange.

19. California School of Fine Arts.

LETTERS TO EMERSON WOELFFER

Motherwell had accepted an invitation to teach at the Colorado Springs Fine Arts Center for part of the summer of 1954 and was given a studio in which to paint during his tenure in the Rocky Mountain resort town. Put off, as he usually was, from working in unfamiliar surroundings, he especially welcomed the friendship of Emerson Woelffer, a modern painter and resident artist at the center since 1950. Woelffer, originally from Chicago, was also a drummer and a jazz lover, owning an extensive collection of jazz records. But more to Motherwell's bibliophilic interest was Woelffer's unusual collection of avant-garde books, some of which were new even to this inveterate bookstore browser and avid reader.

Later, as a member of the board of the Pasadena Art Museum in California, Woelffer was instrumental in arranging for Motherwell's exhibition there in 1962. In 1970, Motherwell wrote the introduction to a catalog for an exhibit of Woelffer's work at the Gruenebaum Gallery in New York. A correspondence between the two artists started in 1954 and was to continue until Motherwell's death thirty-seven years later. Presented here is a letter written to Woelffer in Los Angeles from the Sea Barn (as Motherwell called his studio-home) in Provincetown, Massachusetts, dated 26 August 1968, and a second (also to Woelffer's wife, Dina), dated 12 February 1969 and written from Ninety-fourth Street in New York City.[1] In them, Motherwell commented on his editorial work for the Documents of 20th-Century Art series (his association with Viking Press in New York having just begun), on Provincetown, on Helen Frankenthaler's and his own extensive exhibition activity (he was newly affiliated with the Marlborough-Gerson Gallery in New York), and on the art scene in general. ■

Letter to Emerson Woelffer 26 August 1968

Dear Emerson,

[. . .] I was very interested in your enthusiasm for the dada–surrealist show.[2] My own impression was that it was dada and surrealism looked at through the eyes of cubism, and from that point of view Miró and Arp and Gorky stand up very well, but it seems to me a distortion of the original intent. By the way, I am reviving my Documents of Modern Art with two great publishers, Viking in New York and Thames and Hudson in London, and one of the early volumes will be Arp's complete writings, at least half of which is poetry, and it is the most beautiful writing by any standard, as free and immediate as Apollinaire, but stronger. It has taken me half a year to find a translator willing and able to make a translation very close to the original. But technical difficulties being what they are in publishing, I think it will be a year from now before the first group of books appears. I agree with you that the "heritage" part of the show was wholly inadequate. [. . .]

Helen and I are fantastically busy. She is going to have a retrospective at the Whitney Museum at the end of February, which is then going to travel in Europe under the auspices of the Museum of Modern Art, and will open in London in May. I am going to have a show at Marlborough in Rome in May, so we will certainly go abroad next spring. Before then I am going to have a small collage show at the Whitney in October, and an even smaller show with Kline at a new gallery in San Francisco, and a large show of new paintings, which are very austere, at Marlborough in New York right after New Years. The preparations and the anxiety connected with all these shows are tremendous, as you can imagine, but day by day we make a dent in all of it.

After many years of work, I finally finished here, on the edge of the water, a combined studio, house and mooring for a motor launch (that we go out on for a couple of hours whenever the weather is good). Provincetown is very beautiful from the sea. Then you can see very clearly its original character as a whaling and fishing port. The natives are largely Portuguese, so that it does not have that Yankee dryness that so much of New England does.

[. . .]

Letter to Emerson and Dina Woelffer 12 February 1969

Dear Dina and Emerson,

I was so pleased to get the photograph of the "Lapin Agile," as well as the two Arp photos.[3] —What marvelous surprises! I have often thought about both of you, wished that both your shows went well.

—Helen and I are submerged by shows. She has a retrospective opening at the Whitney here next week; then it opens in London May 6 and then we fly back for my opening here at Marlborough May 12, and then both of us will be showing all over Europe next season. And the preparations for all that are staggering, [along with a] certain emotional strain at all that exposure. Otherwise, all goes very well, though the book editing has run into a lot of hangups and goes slower than I hoped. But I do think that Duchamp, the Corbusier, the German expressionist anthology and the Hugo Ball *Flight from Time* will be ready in the fall.[4] The problem of design for a whole series of very varied works is extremely difficult, especially since the books will be relatively inexpensive. [. . .]

The art scene here seems to be changing more rapidly than I have ever seen it, with a whole generation involved in enormous, impersonal works, which I think will go on for a long time, since Americans are born object-makers and attracted to mechanical techniques. In a way, Sandy Calder prefigures it all. Or so it seems to me. We were away for a week on the "SS Raffaello," and I spent the time revising the translation of interviews with Duchamp, which is an extraordinary self-portrait, maybe the most vivid one we have by a major figure. I ended the job with great respect for him.

[. . .]

Notes

1. Both letters are in the Motherwell Papers at the Archives of American Art, New York (microfilm: 1052).
2. "Dada, Surrealism and Their Heritage," sent by the Museum of Modern Art, New York, to Los Angeles in 1968.
3. The Lapin Agile was a Parisian bistro frequented by Picasso. The Arp photos had probably been sent to Motherwell in conjunction with his future publication of *Arp on Arp: Poems, Essays, Memories* in the Documents of 20th-Century Art.
4. Pierre Cabanne, *Dialogues with Marcel Duchamp*, Documents of 20th-Century Art, trans. Ron Padgett, with an introduction by Motherwell (New York: Viking Press, 1971). If Motherwell's reference to a German expressionist anthology was to *The Blaue Reiter Almanac*, it was not published until five years later (Wassily Kandinsky and Franz Marc, eds., Documents of 20th-Century Art [New York: Viking Press, 1974]), as was Hugo Ball, *Flight Out of Time: A Dada Diary*, Documents of 20th-Century Art, ed. John Elderfield (New York: Viking Press, 1974). It appears that the Corbusier volume was never published.

"Addenda to The Museum of Modern Art
Lyric Suite Questionnaire—from Memory . . .
with Possible Chronological Slips" Fall 1969

Motherwell entitled the series of almost six hundred drawings he made on Japanese rice paper during the spring of 1965 *Lyric Suite*, named partly for a string quartet by Alban Berg, which

he had listened to repeatedly while he worked. He had been interrupted in his intense experiment with automatic drawing by news of the sudden death of his close friend David Smith, and he never returned to complete the thousand-sheet project.

In the fall of 1969, the Museum of Modern Art in New York mounted an exhibition of works selected from Motherwell's *Lyric Suite*. Concurrently, the museum's *Newsletter* published excerpts from "Addenda to The Museum of Modern Art *Lyric Suite* Questionnaire—from Memory . . . with Possible Chronological Slips," written by Motherwell in Provincetown, Massachusetts, on 8 August. Motherwell's "Addenda" were his additional thoughts to MoMA's standard questionnaire, a form sent to him after his donation to the museum of several works from *Lyric Suite*. ■

I don't remember exactly what I was painting during the winter of 1964/65—but all that winter, and in the summer of 1964, Frank O'Hara and Bryan Robertson were continually questioning me about my life work, since my 1964–65 retrospective[1] was to appear in both their museums (MoMA and Whitechapel, London) shortly; efforts were being made to get some kind of order out of my jumble of photos and written files—moreover, I felt the show should be smaller, more selective, and less verbally detailed—in short, for these and other reasons, a period of great tension, anticipatory apprehension (only painters and sculptors are subject to seeing their life work taken in in a few glances, a few seconds), much reflection on what I had been involved in, my ultimate "meaning"—my work is among the most varied of the abstract expressionists—in short, great tension and self-consciousness (this latter is awful in relation to the act of painting) . . .

Many of the questions that were asked of me at this period were about "automatism," a concept which seems to baffle (and often enrage) many people . . . I was thinking about "automatism" a lot, its general ontology, and its role (usually partial, but from the beginning, i.e., 1940)[2] in my own work . . .

As a result of these reflections and circumstances, and of dozens of others, preconscious, unconscious, and conscious—for instance, at that time the two artists I saw most frequently were of course my wife, Helen Frankenthaler, and our closest friend, David Smith, both prolific artists whose fecundity moved me more than I was aware of then, and so on, and so on. On an impulse one day in a Japanese shop in NYC, where I was buying a toy for a friend's child, I bought 10 packets of 100 sheets each of a Japanese rice paper called "Dragons & Clouds" . . .

Some weeks later—early in April, 1965, it came to me in a flash:

PAINT THE THOUSAND SHEETS WITHOUT INTERRUPTION, WITHOUT A PRIORI TRADITIONAL OR MORAL PREJUDICES OR A POSTERIORI ONES, WITHOUT

ICONOGRAPHY, AND ABOVE ALL WITHOUT REVISIONS OR ADDITIONS UPON CRITICAL REFLECTION AND JUDGMENT.★ GIVE UP ONE'S BEING TO THE ENTERPRISE AND SEE WHAT LIES WITHIN, WHATEVER IT IS. VENTURE. DON'T LOOK BACK. DO NOT TIRE. EVERYTHING IS OPEN. BRUSHES AND BLANK WHITE PAPER!

Something like that, but intuited, not thought out.

Like the first stage of a passionate affair. With paper!

So I began, in early April, 1965.

No Japanese brushes, no Japanese ink. Was already using ink and Japanese paper, so no calligraphy either. No fake Oriental work for me.

Sable watercolor brushes, Pelikan (German), Parker, and Sheaffer inks. (India ink turned out to be too leathery on rice paper.)

Anywhere from ten to fifty a day, on the floor, sweat dimming my spectacles on hot days.

Unable to control spread of ink, which varied according to heat and humidity—never knew what one would end as, until "set"; *each picture would change before my eyes after I had finished working it,* sometimes for hours—as the ink spread, like a spot of oil.† Was tempted to use blotting paper at a miraculous moment on some of them, but never did. A few spread until a square inch or two of white was all that was left of the original blank white paper.

That some of the inks bled was wholly unexpected, and did not show until the ink was nearly set, so never could exploit bleeding: couldn't see it while actually painting.

Part of the experience was like those speeded up botany films that show you months' growth in several minutes, the bud becoming a flower.

Most made in seconds, not minutes.

The rhythm of my wrist became freer and broader and unself-conscious.

The strokes were made with as much violence as possible without tearing the paper . . .

Most groups of the same color were made on the same day—can't remember the sequence, but the very first were black. Some later ones were, too.

Am still astounded with their freshness, four years later.

Was anxious that they were not complex enough. Now prefer the barest ones.

Ventured about 600.

Then one Sunday late in May, Kenneth Noland telephoned from

★I violated this last on about ten sheets, always to their detriment.

†I repeat, because of the technical process of spreading and drying after I had ended my participation, the pictures literally continued to paint themselves as the ink spread in collaboration with the paper . . .

Bennington (as we were finishing dinner in NYC) that David Smith was seriously hurt, and in the hospital at Albany. My car was delivered from the garage immediately, and I drove Helen at ninety miles an hour in the dark night to the hospital, where Tony Caro met us at the door and quietly told us David had died a few minutes before.

I never made another of the *Lyric Suite* series.

Notes

1. The exhibition opened at MoMA in the fall of 1965 and then traveled to other institutions throughout the following year.
2. The summer of 1941.

1970–1979

"On the Humanism of Abstraction" 6 February 1970

Motherwell's visit in early 1970 to St. Paul's School in Concord, New Hampshire, came about as the result of his being made a Conroy Fellow of the distinguished preparatory school and in conjunction with an exhibition of his work at the School's Art Center. Before an audience made up essentially of teenage students, he delivered a lecture on 6 February entitled "On the Humanism of Abstraction." His talk was soon published in *Robert Motherwell at St. Paul's School,* the postexhibition catalog issued by the school, and republished in 1974 for a somewhat wider audience in *Tracks: A Journal of Artists' Writings.* ■

In one sense it takes as much nerve to make a tiny picture with one line on it as it does to cover the cliffs of Australia with ten miles of canvas or plastic. The "nerve" is in not being afraid of what's really in your gut; and most people, unless they've had to face their gut, are terrified of it.

As the dictionary says, the purpose of abstraction in any field—art, science, mathematics—is, out of the incredible richness and complexity and detail of reality, "to separate," "to select from" the complexity of reality, *that which you want to emphasize,* or to deal with. For example, if one were to start to paint a picture of the Battle of Gettysburg, many people would want to have every soldier, every bullet, noise, sound, the blood, the feel of the weather that day, and so on. If one really succeeded in one's aim, what one would end up with would be an exact duplicate of reality. In this sense, it is not feasible to recreate the Battle of Gettysburg; yet, the ultimate aspiration of that naturalistic notion of what a work of art is, remains a reproduction of reality itself:

hence the popularity of the cinema in the twentieth century, as of the novel in the nineteenth.

What distinguishes, among other things, man from the beasts is this capacity for abstraction. All our forms of communication are abstractions from the whole context of reality. Moreover, one is able to choose on one's own part the degree of abstraction one wants to be involved in. I have often quoted Alfred North Whitehead in what I think is one of the crucial statements on abstraction, that "the higher the degree of abstraction, the lower the degree of complexity." In that sense, mathematical formulae are (ironically) by nature of a lower degree of complexity than a painted surface with three lines, even if it's an Einsteinian equation. Once one understands that every expression is a form of abstraction, then choices are made in relation to emphasis, i.e., to significance.

For example, it is customary for people when they meet to say, "How are you?" or more briefly, "Hi." Occasionally someone will reply in detail exactly how he is, often one doesn't want that degree of complexity in the reply, but would rather he reply as abstractly as you asked the question, as "Fine" or "Lousy" or merely nod. Abstraction is a kind of shorthand; it's quick, and has a certain kind of beauty . . .

Advanced mathematicians say that when there are two mathematical solutions to the same problem that are equally valid, mathematicians will often reject one of the two solutions as less beautiful than the other. Even in something seemingly as cool and remote as mathematics, there is an element of the aesthetic involved.

Once one can get over one's inherited primitive feeling that what a picture is is a picture *of* something in nature, and thinks instead that a picture is a deliberate choice of a certain degree of abstraction (which in the case of Andrew Wyeth or Norman Rockwell, for example, is a very low degree of abstraction and a relatively high degree of complexity, or, moving from them to, say, Mondrian, a high degree of abstraction and a low degree of complexity), then one begins to view painting in an entirely different way . . .

A difficulty for an artist speaking to you (in comparison with a composer or a mime) is that they can give you a performance, and the painter can't. If someone plays the piano for you as he is explaining what he's doing, you can literally hear it and you can see his skill in playing it. When Marcel Marceau comes here next month, you'll be enchanted; there is something magical in how he can change his face or make a gesture: mimes and musicians among civilized people are dealing with a universal language. Painting is also a language that is universal by nature, but one highly sophisticated and elite, in terms of the general run of people. If one is a very skillful abstract painter, it's difficult for many people to be aware of it. If I painted a picture for you right now, it could be the best I've ever painted, but most of you wouldn't know it was a good painting—or a painting even, maybe. In

that sense, there is nothing I can demonstrate. But I don't mean that painting is any more, though it's no less, mysterious than any other human enterprise. Certainly it can be *talked about,* in many ways . . .

Most people have a prejudice against abstraction in anything. They may say, "So-and-so is too abstract for me" or "I don't like that, it's too abstract. I like something concrete, something you can touch." And I must say that when I look at an advanced mathematical equation, it's meaningless to me. I can't read it, any more than I can read Chinese. *But I don't have resistance to it for its being abstract,* because I regard abstraction as a most powerful weapon. It is also true that abstraction can become so removed from one's experience—one's *sensed* experience—that it becomes remote from its origins. Most people's resistance toward abstraction is just that it is remote. It can also become "cold," when concrete things are inappropriately treated as abstractions.

Modern artists are "freer" than artists of the past because art, like everything else in past societies, was "tribal." It was an integral part of a context in a closely-knit society that agreed very much on basic ground rules: what God looks like, what's good, and so on. Modern artists have been in the position that other modern people, especially the young now, are increasingly reaching, where tribal mores are breaking down—I think probably in most ways for the better, in some ways for the worse—so that one *has* to become more of an individual, and make choices more on one's own. This becomes an unprecedentedly difficult task on most levels of experience.

We grow up in a tradition (that goes back to the eighteenth century in England and in France) of wanting to be less "social" animals in the sense that ants are "social," or that the Middle Ages ideally was a royal hierarchy, in which each person, from the Pope and the King to the lowest peasant, had his specific place and his specific function in society. We've had an aspiration to become an "individual," and what an individual is, I presume, is a person who deliberately chooses, in every aspect of his life, what he values and what he disvalues, rather than without contemplation accepting his society's overall view of the world and of his particular role in relationship to it. Moreover, with modern communications, with modern photography, with ease of travel, with incessant recovering of the past (uncovering monuments, finding varied pictures under whitewash that had waited generations dead until ours), there's a fantastic amount of art available throughout the world—from the caves of Lascaux to what was done last week in Tokyo—a whole vast thing that one must choose from. In this sense, "individualism" is a double-edged sword, as all of you are going to find out, in ways that have nothing to do necessarily with art . . .

The freer we all become and the richer our society becomes (which is to say, one will not be held in line by the necessity to earn a living if one doesn't want to), one will be faced with all the problems of

choice. What does one want to do at nine o'clock in the morning? Where does one want to be in August? Whom does one want to see? *How does one want to spend one's time?* This involves what a great Protestant theologian—a Dane named Søren Kierkegaard—called the "despair of the aesthetic." If one is given a thousand beautiful choices that are all equally beautiful, why would one choose one instead of another? If red and blue are equally beautiful, why choose blue instead of red? Or, if there are one thousand girls that are equally beautiful, why go out with Jane instead of Mary? Obviously there have to be some further criteria involved, and those criteria, in the end, have to be gut-rooted. In the end, they *must* reflect one's values: in this sense, all one's choices are expressive . . .

In relation to abstraction, I've always insisted on that gut choice to an absolute degree. Though a lot of my work is expressed by indirection, and is subtle—which is to say, I know enough (I don't mean this in an arrogant way; any professional painter knows much) to paint in a kind of shorthand, and arrive at that shorthand through what I want to emphasize. But it is traceable back to something perceived, what it originated in. For me, my work is *not remote,* because where it originated can be traced back, though not easily. Moreover, I value human warmth, and I've insisted for the most part that my form of abstraction, in terms of feeling, be relatively "warm." Now, if one is *not* sensitive to spatial placing, to the sensitivity of the texture of the surface, to the nuance of the brush (which is done by the pressure of one's hand, just as if feeling the skin of another person), then there is *no* way to demonstrate that visually. Still, such is my particular abstract position (one of my abstract positions; I have other positions) within my choices, in relation to the possibilities that abstraction affords. There are other artists who wish, as you people say, to have their art "cool"; indeed, some of them now have their work painted by other people in order not to have the personal touch of the brush on the canvas; they want it as impersonal as possible. For instance, in the case of Warhol, in his Campbell Soup cans, certainly part of the enterprise is to make the art both impersonal and at the same time a kind of social joke, which is part of his own attitude toward reality, his own value system.

It is perfectly possible in my work to see, say, windows, or to see a wave breaking in the sea, or to see a teddy bear, if you want, or the sky; but that's not the "real" subject matter. The real subject matter is an assumption that what painting is is the pressure of the brush with a colored liquid on a flat surface, that it involves placing what degree of spatial regression one wants; how much one wants to contract and shove in, or open up and expand, whether one wants to radiate a tender kind of feeling, or make an aggressive gesture, or whatever. These things absolutely correspond to human feelings, *with respect for a medium.* You don't have to paint a figure in order to express human feelings—there are many figure painters who strike me as to how much

they dislike the human figure, how much they dislike human beings
. . . The game is not what things "look like." The game is organizing, as accurately and with as deep discrimination as one can, states of feeling; and states of feeling, when generalized, become questions of light, color, weight, solidity, airiness, lyricism, sombreness, heaviness, strength, whatever—this is especially visible in artists of a wide range, such as J. M. W. Turner in the nineteenth century, or Pablo Picasso in the twentieth.

All of you are very aware of abstract differences in music. For example, everybody knows Mozart sounds very different from Wagner, and nobody doubts that both of them are "saying" something. In fact, most people don't feel impelled to say, "What does the Mozart clarinet quintet mean?" If you get it, you get it; if you don't, you don't. That is your own business. And in that sense, modern painting as all the arts, and the general tendency of modern civilized humanity, is to become (I say this as a metaphor) more and more "musical." Within the possibilities of the musical, all the media participate. Some like rock-'n'-roll, some like J. S. Bach, some people like folk music, and some people like African music, or whatever.

Most of your generation (and many slightly older) are beginning to abandon painting for happenings, events, or for technology—lights, sound, plexiglass, stainless steel! All kinds of things like that . . . Painting is (what we say in American) a "craftsman" thing. I like the European word better, *artisan,* because it relates to "artist"—but to a lesser degree of intensity of feeling. The artisans of Europe are usually from the peasant class, a class America does not have. Americans, from the very beginning—because of the size of this country and the lack of manpower and traditions that were largely northern (at a time when northern Europe was the most technologically advanced in the world)—Americans are mainly mechanics, not artisans. It seems to me natural that as Americans become more assured about what they want to do, they get involved in technology. Americans are also involved in spectacles. After all, though our movies are not necessarily the best, Hollywood has been one of the most spectacular things in the culture of the twentieth century, and now we have TV spectacles all over the place. So that both "happenings" and technology are very natural expressions to Americans, much more than hand carving, and other modes of artisanship.

This change is fine with me, by the way. In some ways I prefer it, because too many people got into the craft of painting. It was cluttered up with thousands of painters, most of whose work wasn't worth looking at. Now young people are finding their own media. But these new things are not substitutes for painting, but something different; they are different kinds of experiences in terms of a medium. It so happens that when I was three years old, I fell in love with the abstract medium of painting. Now I find myself, and perhaps my wife, who is

younger than I am, perhaps among the last "painters." There is such a shift from, say, thirty-five down, into a lack of interest in what we call painting and sculpture, that my show here at St. Paul's, for example, is paradoxical in that it is both avant-garde and also the relic of something that (at least temporarily) is dying out . . .

By "dying out," I mean "painting" in the traditional sense, of a brush applying colors to a flat surface. This is ceasing to interest the most talented young people. There are still plenty of people painting, but most of them are progressively less filled with faith and a sense of adventure.

When I started painting as an abstract artist in America, there were a few dozen maybe, so *there was plenty of room* for one more, certainly. But today, whatever you all may want to do, there are many hundreds of thousands. It's very difficult for you to find a place that is your "own thing" and yourself, and you're as sore as hell about it; rightly so. Something should have been done; on the other hand, the production of people is one social problem that is quite unmanageable!

Sheer size is one current way of pulling one's self out of the mass, in some ways a vulgar way, unless it's beautifully done; at this point, it is mind-jolting to see a sculpture 1200 feet long. But maybe twenty years from now it would seem small; no doubt sculptors will begin to design projects related to the stars and the moon. So in a way, I'm a very old-fashioned painter. I like things humanly scaled, i.e., in relation to the physical size of people.

A funny thing that one discovers: If you say, "I'm working"—you know, if you're invited somewhere and you say, "I'm sorry, I'm not going to come because I'm working," people resent it. But if you say, "I'm sorry, I'm not coming because I won't be in New York," that's accepted, though travelling is easier and less important than work. So, I've decided to move my studio out of New York City to an old stone carriage house in Connecticut.

I'd rather go to Venice and sit in the Gritti Palace and watch the boats sail by for two weeks, than go to the moon. But I can understand very well somebody else wanting to go to the moon. I also know artists who live in their studios and who never go out of them; or maybe they'll go out once a month to buy food. That has to do with temperament, neuroses, the lack of neuroses, fright, courage, habit. What is adventure to one person is routine or unimaginable to another.

It's very easy to make a good picture *if you're not trying to*. All of you. I could choose things from your rooms that would be much better than any of the pictures you're making *on purpose*. What would be very difficult would be to get one of you to sign and exhibit it; by doing that to say, "This is my identity." In that sense, there is as much risk staying at home drawing one line, as there is in getting into a space capsule and going to the moon. But the art risks are psychological and spiritual.

Most people innocently think that a painter or a musician or a poet has an experience, and then goes and writes it down, or paints it down. That's not at all what happens. What the poem or the painting or the piece of music is, is *an experienced person working with a medium,* and what turns out to be the poem or piece of music or the picture, as worked out in the medium, is not illustration or journalism or having a dream experience and then putting it down. You see, art is a triangle. Let's say, in the case of painting—most people think that the triangle is composed of yourself and the canvas and "nature," and that I, as a painter, look at nature and then stick over there on the canvas what I'm looking at. Actually, the triangle is composed of oneself, the medium, and human culture, not brute nature alone, which is but an aspect of culture; the sum total of one's human experience in relation to one's culture in painting. So in many ways, rather than looking at a tree, one is playing a game with other painters, with Picasso, let's say, in what is being transferred on to the canvas . . . What people confuse is the sense of nature and the painting sense; they're two entirely different things. Whereas you never confuse, for example, a professional baseball or football game with an idea of nature . . . It's very clear that a sports figure's specific thing is how he throws that ball or catches, or whatever. In painting or music or poetry, one is concerned with how a very specific medium functions, and paradoxically, in *how* it is functioning, the whole human soul is revealed, more than if one tried to paint a "picture" of the soul. It is one's soul that's being communicated, how one feels about the character of reality . . . which is much more interesting, say, than a series of photographs *of* reality, certainly in most cases. In the end, more hits your heart and your gut than can a photograph of two lovers embracing and so on, because abstract art—and music is *par excellence the* abstract art—can convey feeling in its "essence" (in the Platonic sense) in a way that "naturalism" cannot: it has far too many extraneous details, and loses its emphasis, its focus . . . In this sense, abstract art is active and decisive, not passive and undifferentiated, and only becomes remote, by definition, when it becomes too distant from its original discriminations among the complexities of concrete reality.

Letter to Irving Sandler 23 February 1970

Motherwell wrote to Irving Sandler at about the time the art historian was completing his book *The Triumph of American Painting: A History of Abstract Expressionism* in 1970.[1] But it was an article that Sandler had written two years earlier for *Artforum*[2] and that recently had been brought to the artist's attention that Motherwell addressed. His letter, dated 23 February, was intended to correct factual errors in Sandler's piece regarding Motherwell's relationship with

Wolfgang Paalen. The subject triggered memories of the early 1940s and prompted Motherwell's characterization of the period.

Through an introductory letter from André Breton, Motherwell and Roberto Matta had met Paalen while they were in Mexico in 1941. When Matta returned to the United States at the end of the summer, Motherwell left Taxco, the mountain village and artist colony where he and Matta had been staying since June, and spent several months near Paalen in Coyoacán, a suburb of Mexico City. Paalen, an Austrian-born exile, a surrealist artist, and an expert on American Indian art and culture, had ideologically separated from the surrealists, having joined the group while living in France in the 1930s. At the time he and Motherwell met, Paalen was compiling the initial issue of his periodical, *DYN,* for which Motherwell translated into English Paalen's essay "The New Image."[3]

Paalen continued to correspond with Motherwell for several years after Motherwell's return to the United States.[4] Late in 1944, he published Motherwell's lecture "The Modern Painter's World" in *DYN*.[5] The following year, Paalen's book, *Form and Sense,* became the first title in Problems of Contemporary Art, the second series published by Wittenborn and Schultz for which Motherwell served as editor and adviser.[6] ∎

Dear Irving,

Someone named Sylvia Fink,[7] writing about Paalen, quotes a paragraph from your article in *Artforum,* May, 1968, which includes the following sentence: "The influence of Paalen in part prompted Motherwell to modify his ideas. In an article of 1944, he changed the surrealist term . . ." etc. Phrased thus, there is a sequitur where in fact there is none. My substituting "plastic" for "psychic" was my own idea. To put it the other way around, Paalen had no "influence" on me. Our relationship was essentially his giving me a great deal of information about the origins and nature of surrealism, which was a topic that then fascinated me, and in return, I gave him equally factual information about contemporary philosophy in the English-speaking world, particularly the American pragmatic tradition of James, Pierce, and Dewey, and also of Russell and Whitehead. (My intellectual relationship with Matta at that time was parallel, but Paalen did not find Matta simpatico). I never particularly liked Paalen's painting, nor did he particularly like my painting, which was then literally in its first months of development, i.e., I began painting full time at precisely, but by coincidence, the same moment that I met Paalen. What we did do, as then isolated western intellectuals in Mexico, was to encourage each other in our various aspirations and with our various bits of knowledge and intuitions.

I realize that what I've said above is not of much consequence, but

it does remind me, for the thousandth time, how the past in being reconstructed by people who were not present, undergoes unwitting distortion, and each distortion, when it appears in print, spreads like the Hong Kong flu.

What Paalen, Matta, Onslow-Ford, and I shared—despite our profound characterological and national differences—was an intense enthusiasm about how much there was to explore in those years of the end of the Depression and the Second World War, when so many young artists were filled with apathy and frustration and bitterness. For objective social reasons I prefer to think that our joint enthusiasms were based on possibilities that surrealism suggested to us, which we transformed our various ways according to our talents and temperaments; but I am aware that a literal Marxist would point out that all of us were exempt from military service and of upper class backgrounds. But, at the time one is acting, one is often hardly aware of the various lines that converge to make the action possible, any more than one is aware of them in, say, making love. My point is that in those days we were all romantics.

I would like to see some day your manuscript and particularly the parts that pertain to me, in order to check the alleged facts; your judgments and opinions are, of course, your own right.

Notes

1. Irving Sandler, *The Triumph of American Painting: A History of Abstract Expressionism* (New York: Praeger, 1970).

2. Irving Sandler, "The Surrealist Emigrés in New York," *Artforum* 6, no. 9 (May 1968): 24–31.

3. Wolfgang Paalen, "The New Image," *DYN* 1, no. 1 (April–May 1942): 7–15. Paalen had written the essay in French. He had alienated himself from the surrealists by challenging certain of their ideas; and although Motherwell was never *officially* part of the group, his work on Paalen's essay nearly caused his *excommunication* from the surrealist contingent in New York (conversation with the artist, 30 August 1983).

4. Many of these letters were destroyed without Motherwell's permission in early 1970 by an overzealous secretary in the artist's employ, presumably honoring Paalen's expressed wishes (conversations with the artist, 1983–1986).

5. Robert Motherwell, "The Modern Painter's World," *DYN* 1, no. 6 (November 1944): 8–14.

6. Wolfgang Paalan, *Form and Sense,* Problems of Contemporary Art, no. 1 (New York: Wittenborn, Schultz, 1945).

7. Sylvia Fink, writing from Phoenix, Arizona, was writing her master's thesis.

Testimony Before the Select Subcommittee on Education 24 March 1970

■ His permanent move from Manhattan to Greenwich, Connecticut, in 1970 coincided with a notable change in certain of Motherwell's work habits, partly the result of a growing de-

mand on him for exhibits, articles, lectures, and various public appearances.[1] In the 1970s, he affiliated with Knoedler Contemporary Art in New York, his primary painting gallery in the United States until his death; was the subject of several documentary films; and executed a commissioned mural for the National Gallery of Art in Washington, D.C. His correspondence increased dramatically, much of it to do with his exhibits, particularly large retrospectives toward the end of the 1970s, and with responses to questions from art historians about the early years of abstract expressionism.[2] He continued his long-established habit of painting during the evening and night, but his days were now spent with a small staff who assisted him in various aspects of his increased activity. Having converted an old carriage house into living quarters and a number of studios, he installed etching and lithography presses and, in this further extension of his "cottage industry," began to work privately with his own printers. His literary work included several solicited articles and a revival of the documents series as the Documents of 20th-Century Art. Published by Viking Press, sixteen titles appeared in the new series from 1971 to 1980, after which the series was published by G. K. Hall.

Early in 1970, Representative John Brademas invited Motherwell and Helen Frankenthaler to appear before the Select Subcommittee on Education to comment on proposed legislation on the environment.[3] Frankenthaler declined, deferring to Motherwell. His testimony, given on the morning of 24 March, followed direct questioning by Brademas. It should be emphasized that Motherwell's plea to save the environment for future generations was made more than twenty years ago. Unfortunately, the bill did not pass. ■

[. . .] I am sure that scientists have or will testify to the relevant facts here and know them far better than I. I speak only as an artist. But to speak as an artist is no small thing. Most people ignorantly suppose that artists are the decorators of our human existence, the aesthetes to whom the cultivated may turn when the real business of the day is done. But actually what an artist is, is a person skilled in expressing human feeling. And if the "real" business of the day has led to a distortion or a petrification of human feeling on the part of the participants, as, for example, when a builder mows down the trees on a tract of land because it is easier and cheaper to build the house on empty ground, and the worker who drives the tractor that plows down the trees to do his job in order to race home for a beer and a TV western does so, oblivious to the hurt to the landscape and the hurt to the ultimate house buyer, who—if he has sensibility and limited means—will plant saplings that will take a generation, or two or three, to reach the stature of the trees mown down in a few minutes—then we are

dealing with a business of the day that makes the builder and the worker looking later at a masterpiece of landscape painting—say, a Constable or a Monet in a museum—a cultural transaction so grotesque and absurd that the most extreme plays of Ionesco and Samuel Beckett are less absurd than everyday life itself.

The first-mentioned playwright has said he has only felt "happy" when he was drunk, as millions of young people now seem only happy when drugged, which are indeed two ways of contending with the nausea that a person of sensibility must feel when he looks at the waste of modern civilization, covering the landscape like a slimy coating of vomit.

What kind of a race of men is it who can rape or vomit on the landscape, like drunken soldiers in a conquered village, or like destructive and greedy little boys let loose in an enormous toy-and-candy store, to break and gorge as they like; while other little boys, in other parts of this planet that we Americans are turning into a garbage dump, stand with a piece of string and an orange as their treasures?

As an artist, I am used to being regarded as a somewhat eccentric maker of refined, but rather unintelligible, objects of perception. Actually, those objects contain a murderous rage, in black and white forms, of what passes for the business of everyday life, a life so dehumanized, so atrophied in its responsibility that it cannot even recognize a statement as subtle and complicated as the human spirit it is meant to represent. I am as well, at other times, an expresser of adoration for the miracle of a world that has colors, meaningful shapes, and spaces that may exhibit the real expansion of the human spirit, as it moves and has its being.

But, as every artist knows, this is expressed in the middle of, and despite the vomit that surrounds us, a nauseous waste that makes the incessant and endless chewing down of trees by beavers, for instance, seem amateurish and almost benign, since they do not have the technology that we humans do to destroy on a huge scale. If we gave the beavers our tools, the forests of the world could disappear in one day. We are slightly more sensitive. It might take us a generation or two; or again, perhaps not.

We are certainly capable of destroying the forests of the world, of destroying everything that is not already covered with vomit, as well as everything that is, in one day.

I suppose that America began as a few people, on a vast tract of land, so vast that one could be as greedy and wasteful as one wanted, and there was still more. That time is gone. Now there are millions of people, and millions more in the offing; that vast land is becoming more the scale of a park, humanly speaking; but a park filled with waste: rusting cars, bottles, garbage, enormous signs seducing you to buy what you don't want or need, housing projects that don't show a

rudimentary sense of proportion in any shape or line or material, sub-urbs that are a parody of the barrenness of the Bronx, and of the gau-diness of Las Vegas.

Indeed, if God had said to a group of men: "Here is a vast park, of millions of square miles. Let's see how quickly you can cover it with everything that is an affront to the human spirit. And, above all, be certain that it is done on a grand scale of extravagance and waste, and of lack of regard for the sensibilities of the inhabitants of the other parks in the world."

Then we might by definition call that group of men that God so provoked "Americans."

No wonder our youth are up in arms! They are in order to preserve their sanity, in the midst of a vulgarity, a waste, a contamination with-out precedent in the annals of mankind. We talk about a "generation gap." I am more optimistic. I prefer to think of it as a "sanity gap," of a young generation saying (in the interest of their growing sensibil-ity that they certainly did not inherit from their parents) to their elders: "The way you go on covering our natural park with filth, waste, and vomit for the sake of monetary gain and monetary economy is in-sane."

If most of the members of Congress think that they are either lead-ing, or in touch with the young, I would remind them of the master-piece of Renaissance painting by Peter Breughel the Elder, called *The Blind Leading the Blind.* Congress may be leading or mirroring the so-called silent majority, but persons of sensibility are regarding the scene of vomit with the only possible sane response, one of "nausea." And no men, if they can cure it, will endure a state of nausea for long.

I do not know how you legislate the growth of human awareness, or how you make shameful insensitivity to landscape. But if the pre-sent bill can in any way do either or both, who could not favor it? Each of us lives a brief moment in what once was a primordially beau-tiful park that could only elicit a sense of ecstasy and the natural music proper to a virgin place. Does that moment for us now have to be spent surrounded by our own filth, so much of it that it is a problem even to cart it away? What kind of a human existence is that? A gift to our children?'

No, it is a dirty joke and a senseless one, and not God's, but our own.

That old cliché, the word "mess," is now taking on a vivid and literal meaning. The American landscape is visibly and literally a mess; the young know it. Let us give them all of our positive knowledge. It is little enough compared to the mess we have given them.

If you want to drive anyone insane, rear him in an environment without a sense of limits. And even our vast reality now is limited indeed.

One's mind reels at what men without an aesthetic sensibility have

been capable of. Far from being merely decorative, the artist's aware-ness, with his sense of proportion and harmony, is one of the few guardians of the inherent sanity and equilibrium of the human spirit that we have.

Keats's famous line, "Truth is beauty, beauty is truth," should be regarded as an obvious fact, not an enigma. What is enigmatic is that a whole society—and our modern technological one, which we cannot lose if we would, is the first such one in human history—that a whole society can think that it flourishes when, in fact, its mountains of waste matter reveal a paralyzed and psychopathic state, in the sense of having no feeling, no response to the wondrously complex and sensitive per-ceptions that are the human spirit itself.

What have we gained in conquering a virgin piece of nature if, in the process, we have destroyed the sensibility with which the human spirit perceives the world, that is, if we have destroyed our capacity to feel? Everyone knows that absence of feeling is the prime characteristic of death. A lot of what we observe among the young these days is their various reactions to moving about in an environment devoid of basic feeling, so as to better manipulate nature in the interest of greed. In short, from moving about in an environment that is deathlike. If they go to extremes in their efforts to revivify our environment, it can only be because of the mortal threat to their lives and state of being that our landscape represents.

The French surrealists like to think of themselves as "super-realists." In fact, they were sub-realists, in their realism, compared to the night-mare of aesthetic reality that we patriotic Americans have made for ourselves, without sensibility or principle.

It is interesting that the French have managed to engrain into a whole culture a sensibility as to what one eats. Each meal is a joy. I would that we could do the same in relation to the American landscape! How enhanced all of our individual lives would be!

Notes

1. Motherwell and Helen Frankenthaler had separated and would be divorced in 1971. In 1972, he married the German-born photographer Renate Ponsold.

2. Motherwell confided that when he anticipated the possibility of dying during critical surgery in 1974, his overriding sensation was one of relief at no longer having to answer his mail (conversations with the artist 1983–1986).

3. Representative John Brademas, a Democrat from Indiana, was chairman of the Committee on Education and Labor.

"The Universal Language of Children's Art, and Modernism" 29 April 1970

In the spring of 1970, Motherwell was invited to speak at the opening plenary session of a conference addressing interna-tional exchanges in the arts. Entitled "The Arts: An Interna-

tional Force" and sponsored by the Institute for International Education, the three-day meeting was held at the United Nations Plaza in New York. Motherwell's presentation, "The Universal Language of Children's Art, and Modernism," was delivered on 29 April and was published the following winter in the *American Scholar*.[1] ■

I am highly honored to have been selected to speak at the plenary session of such a talented and renowned group as the present participants in this Conference on International Exchanges in the Arts. And extremely intimidated. One would have thought the choice from this distinguished group would be a writer, perhaps a poet, or some other man of letters . . .

We live intellectually dominated by verbal discourse. Certainly one would not expect a painter—one of those slow, clumsy beasts who admittedly have a feeling for workmanship, for the character of certain physical materials, a certain unashamed sensuality and café gregariousness; a creature closest to the peasant in the hierarchy of high art—no, one would not expect a painter to be selected to speak. The French like to say, "*bête comme un peintre.*" Moreover, painters have a traditional distrust, even hostility, toward words, especially toward rhetoric. Every living painter, at one time or another, and more often than not, has been deeply wounded by the words of journalists and critics, in whose hands his immediate social fate so often lies, and before whom he cannot easily defend himself, since, in doing so, he must play *their* game of words. Although all the obvious issues are those of the eye, I think that at times every painter feels like Argus, *like a body covered with eyes* . . .

Moreover, the history of twentieth-century painting is in large part the history of the rise of abstraction into a position of international dominance, despite much opposition within the world of painting, and almost total opposition without. And what is modernism, among other things, but the effort to get rid of rhetoric in art?

Nevertheless, painters are not without a sort of existential ingenuity. Without it, none of us would have survived those difficult and solitary early years. So let me struggle to speak in this other language, that of everyday life, and hope that you will listen patiently, as we all do—except, perhaps, the French—to a foreigner with his inadequate grasp of our own use of words, with, moreover, a more monotonous grasp than his unfettered intelligence functioning at will in its own language. Certainly a price one pays for some mastery of one language is a terrible sense of inadequacy in any other. (Which reminds me of an international dinner in Switzerland last autumn for Martin Heidegger, who spoke only in German although he clearly understood other languages well, and when I inquired why, the opinion was that he did not feel *exact enough* in any language but his own. I was both startled and sym-

pathetic, for exactness of weights of feeling is everything in art.) For my part, I find that I write best on handmade drawing paper, absurd and expensive as that may seem! But, on the other hand, how could a painter cut off his interest in how lines look on a sensuous sheet of paper? As our late great American sculptor, David Smith, used to say, "Art is a luxury"—a luxury, he meant to say, that, among the various poor, artists themselves are the most likely to pay for. *That* is the beginning of our ingenuity in regard to everyday life! Every New York artist of a certain age, for instance, is a gourmet of Chinese food (although he may prefer Italian or French cuisine when he grows to understand wine), for in the old days it was in Chinatown that one's deep-rooted sensuality could be satisfied for a modest sum . . .

Still, at an international conference on international exchange in the arts, thrown back on my resources as a painter, (ironically) perhaps a painter is not such a comic choice after all. For, so far as I know, painting is the single language that is both universal and of some sophistication (by this latter qualification I wish to exclude a baby's sounds and gestures). Throughout the world, regardless of biological inheritance or cultural conditioning and environment, small children employ an identical repertoire of twenty or so painted signs at precisely the same ages in their growth, thus *creating an unqualifiedly universal language* (whether the child is French, African, Indian, Chinese, North American, or South Seas Islander) in order to express their vision of the world. Perhaps it is owing to my ignorance, but I know of no parallel universality of language among any persons in music or dance, or in the other arts, *above all, not in words.* Perhaps the painter's intuition, which is beginning to be widely shared by the present TV younger generation, that words represent the most artificial and easily manipulated language for empty ends is more than a class protest, more than an expression of resentment at being manipulated by another verbally more powerful group; it might even be a sturdy insight about our very nature, such as those close to the soil sometimes have about the natural world. But that is another topic, that has less to do with the universal than with power elites, who are only universal in a more degrading sense . . .

What a stupefying fact it is that, as modern anthropologists and psychologists seem to believe, all the small children of the world have a universal language, *painting,* with an identical iconography at the same ages of growth, a language that is taught to them *by no one,* that they need never have seen. A child reared in solitude uses a similar painting vocabulary as his more socialized contemporaries. In painting, the small children of the world have a language even more universal than sexuality (sexuality is culturally conditioned and the painting we are speaking of is not), a language of rudimentary but beautiful signs—a circular scribble, an oval, a circle, a square, a triangle, a cross, and so on, colored or not, according to the materials available—with which

they construct a completely adequate and beautiful, in its deeply felt drawing, picture of the universe, both of inside the dome of their own craniums, and of the visible limits of the dome of heaven, and of everything in between. Who would believe, let alone hope, that a universal language, so universal that not a single exception exists on the whole of our globe, not only exists, but has existed unchanged or untouched since the dim beginnings of mankind, of our human world. (One of the most baffling problems in art education is what we grownups do, or what children do to themselves, so that their universal language disappears at a later age even more rapidly than it begins and develops into a full-fledged expression.) One might suggest that small children need international exchange least of all, and, by the same token, perhaps the older one grows, the more one needs it. For instance, Matisse's voyages to North Africa in middle age modified the course of modern art, as did Kandinsky's emigration to Munich, Picasso's to Paris, and, more recently, Mondrian's and the European surrealists' to New York (during World War II). Another implication comes to mind: perhaps there is the unpleasant issue of quality; perhaps the most unique and creative individuals, rather than the undeveloped and the underprivileged or unendowed, should be sent abroad! The president of this Institute of International Education has said, "The artist's instant recognition of common denominators in human awareness makes him perhaps the most truly international individual." For my part, I would like to see him even more worldly. So far as I know, for example, of the greatest living European painters, only the Spaniard Miró has often visited New York, watched its painting's growth continually, and taken back from it what he pleased, as some of us in New York in turn had taken from him. But, having ventured this notion spontaneously, I am not sure that I wish to pursue it, but I cannot help emphasizing the painter's traditional interest in quality. For obviously part of what painting is universally, to the degree that it is art, is the condensing of quantity, so to speak, through exact amounts of quantity, into quality. Nothing else is precise enough to weigh this process of the human sensibility, so far more subtle is the accuracy of human feeling. Yesterday, for instance, I spent hours looking at a print of mine, deciding whether there were a few too many millimeters of white, and whether the white of an English Saunders paper or a French Arches was more exactly correspondent to my particular feeling for white. And when my children were small, they used to think that the act of painting on my part consisted of squinting with one eye, with the other closed, and they would shriek with laughter, "Oh daddy, you are painting again!" as I would squint at a picture on the wall. What I was doing, of course, by squinting, was blurring the particulars in the painting as much as I could in order to see more clearly the emphases. So the children were not mistaken. I suppose that is why Goya, if he did as reputed, put on the finishing strokes of his canvas by candlelight. The

great Englishman, Turner, used to "emphasize" in public before his colleagues on varnishing day, to their admiration (often grudging), and despair. (Because of him, perhaps, the English understood perfectly our own great abstract expressionist, Mark Rothko, whose recent tragic suicide we in America still mourn. But in Paris, as I understand it, his great colorful retrospective was shown below ground level in a certain museum and he was largely unnoticed, as Lorca was when he lived in New York, and Lenin during the dada days in Zurich.)

My emphasis here is that *quantitative* foreign exchange does not always work, certainly not automatically and easily (as anyone who has been a traveler knows). It is partly a question of what entrée one has or has not, and partly of the generosity, hostility, or indifference of one's hosts—less a question of oneself—because internationalized minds, like children's, are pretty much alike everywhere, while chauvinism and politics tend to be localized, by definition, sometimes violently. For example, Max Ernst and André Masson believe that, at a certain moment on the first Western front, it is probable, certainly possible, that they were shooting at each other. I remember Walter Gropius telling me that at the beginning of that war he was one of more than fifteen hundred Uhlans, going to war on horseback with lances; at the end, he was the only one left, a photographer in military aircraft. The print of mine that I referred to earlier is for an international album of prints for the benefit of the International Rescue Committee that got so many gifted artists and intellectuals, Jewish and gentile alike, out of Nazi Europe during World War II. (With such a gesture one feels fortunate to be both a painter and an internationalist, to the degree that both are vehicles of the humanity that is so universal that only with difficulty, even in our violent epoch, can the powers that be get committed men—that is, men from whom feeling has not drained—to destroy other people, vulnerable though we all are and clear as to where others are vulnerable: even to death, psychological or physical.)

Part of the enterprise of modern art is to strip away from painting the costumes, the masquerades, the status symbols of church and state and politics—hence, its so-called abstraction, which is actually a humanly felt universalism. This universalism is not unparallel to that of small children, as when the French fauves and the German expressionists began to paint more and more directly, colorfully, immediately, and expressively, or when Kandinsky in Munich began to understand the significance of the scribble (before he fell into logic in Paris), or Klee in Germany began turning his own scribbles into the fairyland of his magical art, as did Miró and the French surrealists in Paris, and as later the American abstract expressionists in New York used the scribble in the interests of a more sublime or tragic art than the intimacy of prewar Paris. Or, as Picasso quite consciously did in those great drawings during the Spanish Civil War after *Guernica,* drawings much greater than the painting itself. While in his picture he relied on cubism, which

is essentially a lyrical, and not a dramatic or tragic, mode of expression, in the drawings he relied some on Goya—natural enough for a Spanish painter during those terrible days of the rise of fascism—but, above all, on the directness of children's line drawings; for the world of the tragic is not alien, any more than the world of joy or anxiety or any other mode of feeling, to children's expressions. Still, in those Picassos, there is a maturity and a freedom of choice that is more exhilarating than children's art, which, after all, seems to be inherent in them, in an Aristotelian (or perhaps Jungian) sense, whereas Picasso's freedom is hard won, in that spirit-breaking struggle against everything that is provincial, parochial, ironclad conventional in the traditional classes and the nationalisms that surround every grown man, and which he may never conquer, but to which he dare not succumb without distorting the most valuable part of his inheritance, his universal humanity. (Which is not to say what is universal and what is particular. It is evident, for instance, that Catholic Latin Europe and South America find abstract painting more alien than do Northern Protestant Europe and America, perhaps because the one is surrounded by imagery from childhood, and the other is not. Who is more universal, Johann Sebastian Bach or Mozart? Or, more pointedly, in the instance of the great nineteenth-century Russian novel, is it the chauvinistic Slavophile Dostoevski or the Westernized Francophile Turgenev who is more universal? Perhaps total provincial concretion is as universal as abstract generalization . . .)

Who does not love the complexity of particulars in reality? At the same time, one *must* abstract—that is, select from—in order to manage reality at all. Meaning, after all, is a matter of emphasis, a selection; abstraction is the process of emphasis, no matter how relatively complex the work. To be a master of a language is to be a master of emphasis. What is emphasized is at once the form and the content. Renoir used to say, I am not a butcher, I do not paint flesh, but *skin*. That emphasis, the skin of the world, is the essence of his art, and the definition of the purely aesthetic.

[. . .]

Note

1. Motherwell's lecture was published under the general heading "The Scholar Cornered." At the time, Motherwell was a member of the editorial board of the periodical.

"Thoughts on Drawing" 1970

Motherwell's "Thoughts on Drawing" was written on 14 July 1970 in Provincetown, Massachusetts, for the catalog *Drawing Society National Exhibition—1970*. The publication accompanied an exhibition (with the same title) organized by the Drawing So-

ciety in New York that traveled to museums throughout the United States under the auspices of the American Federation of the Arts. ■

One day in the 1930s Picasso suddenly said to his long time retainer and buffer to the world, the writer Jaime Sabartés, "What is art? Did I ever ask you that before?" And before Sabartés could grope for an answer "as if he were questioning himself," Picasso said "And what is not?" In a parallel manner, the instant one tries to define drawing, one finds that no one has been able to, that one is led to the same question quite rapidly, "What is not?" Even the celebrated remark of Ingres, that haunted Matisse, "Drawing is the probity of art," doesn't necessarily mean that drawing is different from painting. On the contrary, Constable, and the English of the Romantic period in general, seemed not to have entered real discussion with their French contemporaries, so convinced were the latter that painting and drawing are "form," in the sense of clear contour and solid modelling. Certainly in present day America, if one looks at a group exhibition like the present one, or Una Johnson's two volumes on twentieth-century drawing, many of the works could equally well be represented in a painting show or a watercolor show. Nevertheless, one can't help but feel in one's eyeball that drawing is not identical with painting—that the Venetians left fewer drawings than the Florentines because they were more exclusively painters, that Rothko, for example, in twenty-five years of intimacy, never showed me a drawing, he was so sheerly a painter. From the opposite side, El Greco, who was trained in Venice, is reported to have said of Michelangelo that he is a great artist, but not a painter, meaning obviously that the painting was that of a draughtsman, sculptor, and (above all, to my mind) architect.

One could suggest two propositions: (a) drawing is that visual expression that painting is not, or alternately, (b) drawing is visual expression to which color is not essential.

But Helen Frankenthaler continually asserts, "You draw with color." (But this could be a definition of painting!) Cézanne certainly worked that way; Michelangelo equally certainly did not. And Matisse, a master of black and white drawing, clearly thinks of black and white as hues, as intense as English vermilion, or French ultramarine blue.

Baudelaire, who drew the best of all poets (save for Victor Hugo), has a profound observation: "The draughtsmanship of colorists is like that of nature: their figures are naturally bound by a *harmonious collision of masses.*" And Goya adds: "Where do they find lines in nature? As for me, I can distinguish only luminous and dark bodies; planes that approach and recede; reliefs and concavities. My eye never perceives lines and details . . . and my brush cannot see more or better than I." But the truth is that Goya's engravings are filled with lines.

Pragmatically, one sometimes thinks that drawing in essence could

be defined as that which burin engraving is limited to, i.e., what a certain kind of chisel can cut out of a metal plate, just as writing began with a sharp point drawing in a coat of black wax, where shadows, if they exist, can only be made with lines, in short, line drawing. From this point of view, the brush is the opposite of drawing. But then, without even allowing the Orient to complicate the question, what does one call that beautiful sepia wash by John Constable in the Victoria and Albert called *Trees and Water on the Stour*?

I happen to like the line drawings of very small children, better, in fact, than the work of anyone except masters. The closest thing to it, when children use pencils (colored or not), is the quill strokes of Rembrandt, the more spontaneous and less "spelled out" drawings by Picasso for *Guernica,* and a few stick drawings on paper by Pollock. If one assumes that a baby is born wholly integrated with its feelings and that separation from them is the result of intruding outside forces, then for an adult to reintegrate himself with an equivalent lack of division and alienation in his expressions is so rare that we call it, as well we might, "genius." Drawing is faster than painting, perhaps the only medium as fast as the mind itself. When I said "line drawing," I should have said "fine line drawing," for when small children use their imagery in what I imagine is a modern medium, finger painting, I find the imagery as felt as ever, but the medium repulsive, like drawing in a wide-mouthed jar of vaseline.

Given Oriental art, which is always done with a brush, one cannot define drawing as line, much as I like it, and different as I think its feel is in one's gut, compared with masses of color. But dropping the word "line" perhaps one can say—certainly I act on it—that drawing is the dividing of a plane surface (parallel to Denis's definition of painting as "essentially a plane surface covered with colors assembled in a certain order"). I personally like that dividing to be as decisive and fast as the cracking of an Argentinean's bullwhip, and generally make a drawing in seconds, whether geometric or calligraphic. (Most drawing is not the division of extension, but a blueprint of three-dimensional forms.)

I like the seventeenth-century collector of Rembrandt's drawings who called them Rembrandt's "pensées," his "thoughts." The quotation I previously made from Baudelaire, continues: "Pure draughtsmen are philosophers and dialecticians. *Colorists are epic poets.*"

If one leaves out the word "epic"—Baudelaire must have been thinking of Rubens and Delacroix—one can agree. Painting can overcome one with its sensuousness, like the soft warm skin of a woman, in a way that drawing cannot. But drawing can be as clear-cut as one's father's precepts. Drawing satisfies our sense of definition, even if we cannot define "drawing" itself. Drawing is a racing yacht, cutting through the ocean. Painting is the ocean itself.

Pancho Villa, Dead and Alive, 1943.
Collection Museum of Modern Art, New York. Purchase.
(Photo: Courtesy Museum of Modern Art)

Mallarmé's Swan, 1944.
Contemporary Collection of Cleveland Museum of Art.
(Photo: Courtesy Cleveland Museum of Art)

The Voyage, 1949.
Collection Museum of Modern Art, New York.
Gift of Mrs. John D. Rockefeller, 3d.
(Photo: Courtesy Museum of Modern Art)

Je T'aime No. 2, 1955.
Collection Mr. and Mrs. Gilbert W. Harrison, New York.
(Photo: Steven Sloman)

N.R.F. Collage No. 2, 1960.
Collection Whitney Museum of American Art, New York.
Purchase with funds from Friends of the Whitney Museum
of American Art.
(Photo: Victor's Photo, Piscataway, New Jersey)

Beside the Sea No. 5, 1962.
Private collection.
(Photo: Steven Sloman)

Yellow Wall, 1973.
Private collection.
(Photo: Steven Sloman)

The Hollow Men, 1983.
Private collection.
(Photo: Ken Cohen)

Spanish Picture with Window, 1941.
Private collection.

Elegy to the Spanish Republic No. 1, 1948.
Private collection.
(Photo: Peter A. Juley & Son)

Histoire d'un Peintre, 1956.
Private collection.
(Photo: Peter A. Juley & Son)

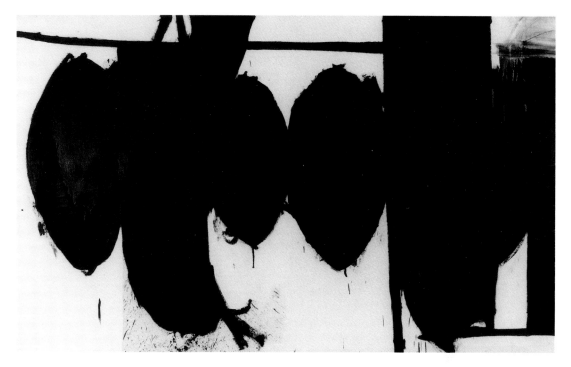

Elegy to the Spanish Republic No. 70, 1961.
Collection Metropolitan Museum of Art, New York.
(Photo: Courtesy Metropolitan Museum of Art)

(top)
From *Hollow Men Suite, No. 2*, 1985–1986.
(Photo: Ken Cohen)

(bottom)
From *Hollow Men Suite, No. 1*, 1985–1986.
(Photo: Ken Cohen)

Telemachia-Odyssey-Nostos (Frontispiece B),
from *Ulysses*, 1985–1988.
(Photo: Ken Cohen)

Untitled, from *Three Poems by Octavio Paz*,
ca. 1987–1988.
(Photo: Ken Cohen)

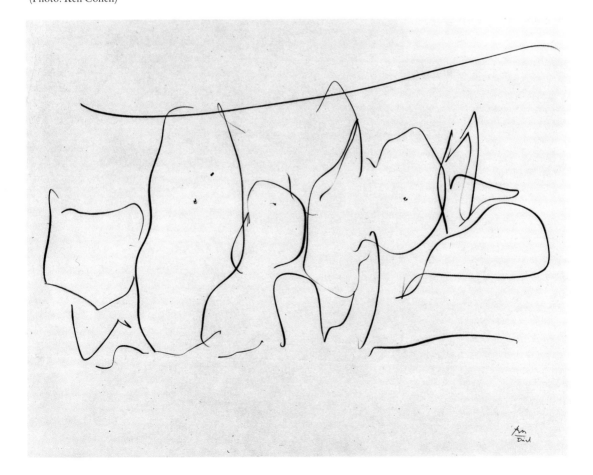

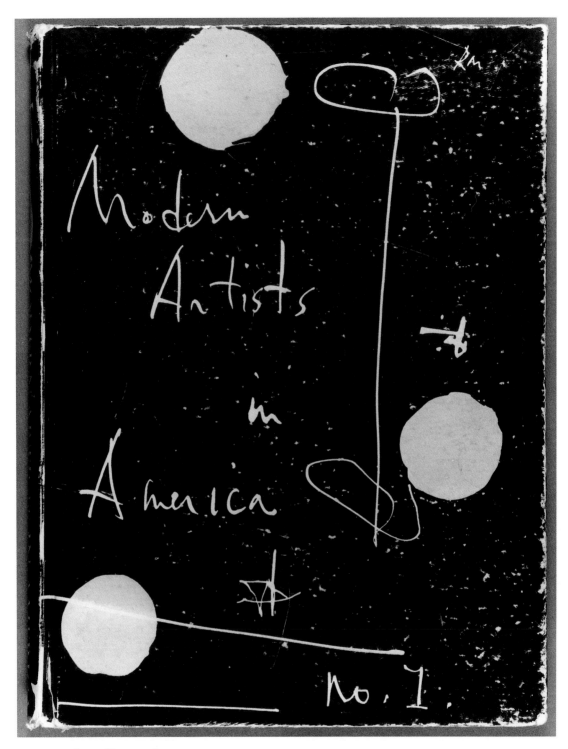

Motherwell's cover for
Modern Artists in America, [1951].
(Photo: Ken Cohen)

Motherwell *(right)* with roommates at Stanford University, 1934.

Motherwell in his studio, New York, 1943.
(Photo: Peter A. Juley & Son)

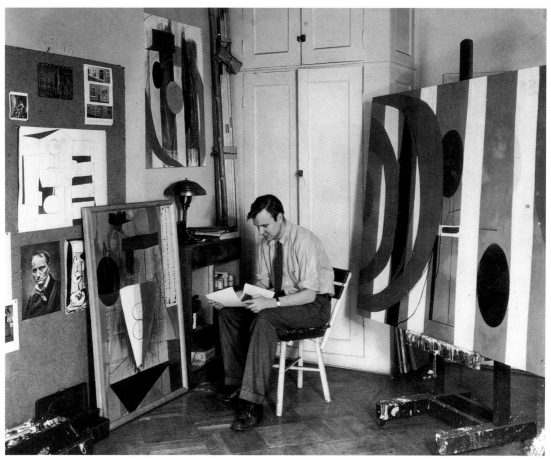

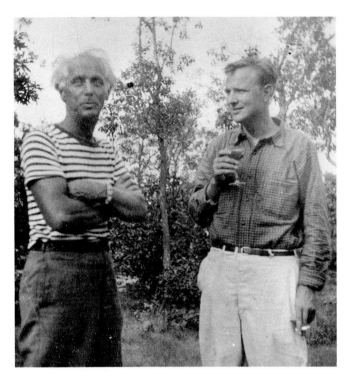

Max Ernst and Motherwell,
Long Island, 1944.

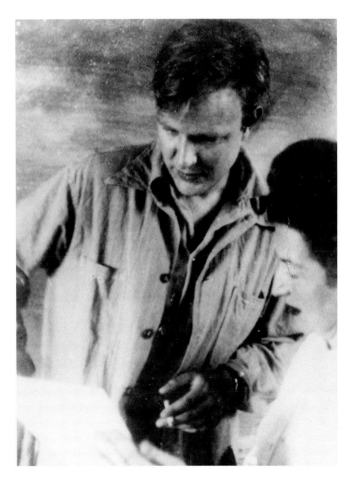

Motherwell teaching
at Black Mountain College,
Black Mountain,
North Carolina, 1951.

Motherwell in his Quonset hut studio
designed by Pierre Chareau, Long Island, 1950.
(Photo: Peter A. Juley & Son)

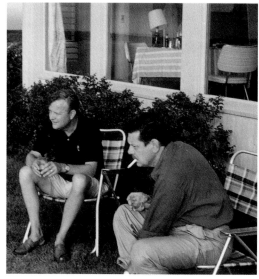

(above, left)
Motherwell and Mark Rothko,
Provincetown, Massachusetts, 1959.

(above)
Motherwell and David Smith,
Provincetown, Massachusetts, 1959.

(below)
Motherwell and Helen Frankenthaler,
Provincetown, Massachusetts, 1959.
(Photo: David Smith)

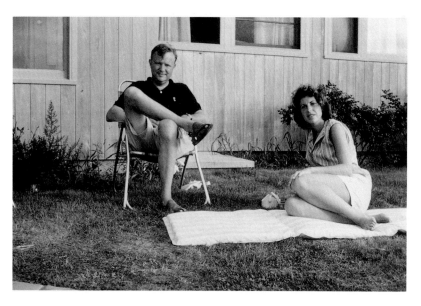

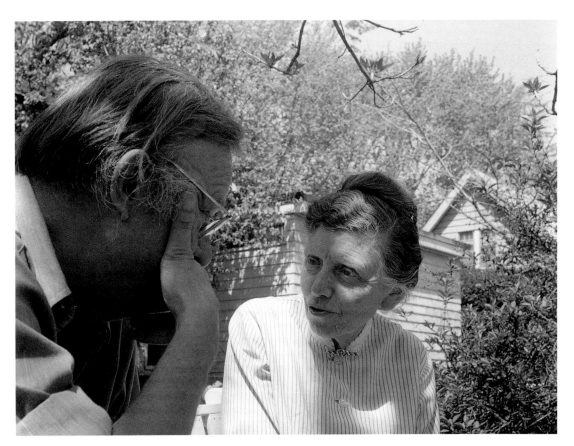

Motherwell and Tatyana Grosman,
West Islip, New York, 1972.
(Photo: © Renate Ponsold)

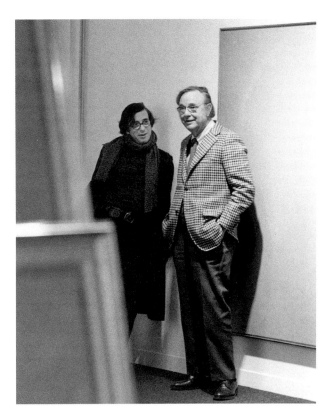

Motherwell and Arthur Cohen,
Knoedler Gallery, New York, 1974.

Motherwell and Renate Ponsold,
Greenwich, Connecticut, 1977.
(Photo: Terry Wehn Damisch)

Examples of miscellaneous
"Don't Forget" notations
that Motherwell frequently
tacked to his studio walls.
(Photo: Ken Cohen)

Motherwell *(far right)* and some fellow
artists from Long Point Gallery,
Provincetown, Massachusetts, 1978.
From left clockwise: Judith Rothschild,
Fritz Bultman, Nora Speyer, Varujan
Boghostan, Leo Manso, Sidney Simon,
Sideo Fromboluti, Rick Klauber (par-
tially occluded), Tony Vevers, Carmen
Cicero, and Budd Hopkins (Edward
Giobbi and Paul Resika are missing).
(Photo: © Renate Ponsold)

(facing, top)
Motherwell and Stephanie Terenzio
at installation of retrospective,
William Benton Museum of Art,
Storrs, Connecticut, 1979.
(Photo: Robert Neff)

(facing, bottom)
Motherwell and Rafael Alberti
in Ken Tyler's studio,
Bedford Village, New York, 1981.
(Photo: © Renate Ponsold)

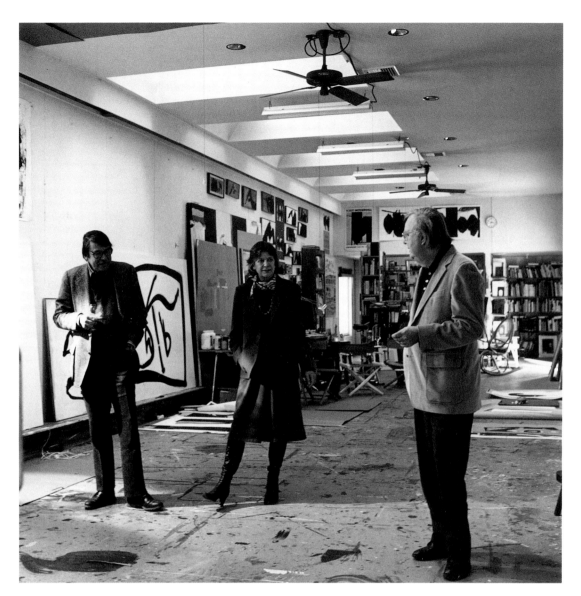

Motherwell and Richard and Phyllis Diebenkorn
in the artist's studio, Greenwich, Connecticut, 1982.
(Photo: © Renate Ponsold)

(facing, top)
Motherwell and Jack Flam,
Greenwich, Connecticut, 1982.
(Photo: © Renate Ponsold)

(facing, bottom)
Motherwell and Grace Glueck
in the artist's studio,
Greenwich, Connecticut, 1984.
(Photo: © Renate Ponsold)

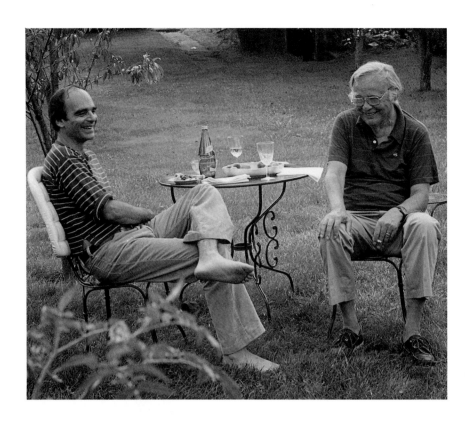

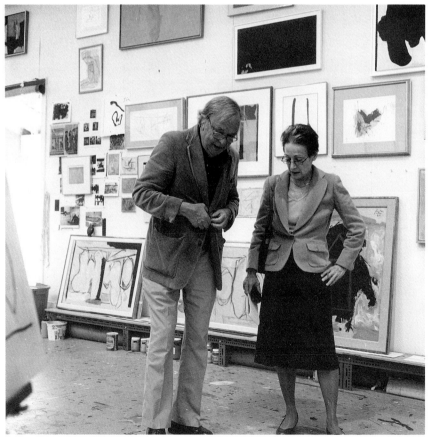

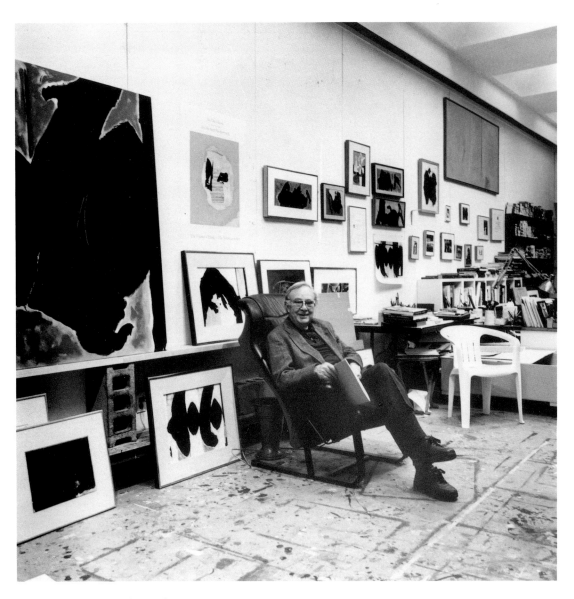

Motherwell in his studio,
Greenwich, Connecticut, 1991.
(Photo: © Renate Ponsold)

ON ROTHKO

■ The early 1970s, like the late 1940s, was a difficult and transitional period for Motherwell that began with the suicide of his friend Mark Rothko. Compounding his great personal loss, Rothko's death evoked the wanton tragedies of Arshile Gorky, Jackson Pollock, and David Smith, and the relatively premature deaths of Bradley Walker Tomlin, Franz Kline, William Baziotes, and Ad Reinhardt, soon to be followed by that of Barnett Newman. The youngest of the abstract expressionist group, Motherwell was now one of its few survivors. As a new generation of artists captured the art world's fancy, his role as the pioneering avant-gardist was evolving through time and circumstance into that of the elder statesman of art, reflected in the growing demand for his public counsel.

Motherwell had met Rothko in New York early in 1945 at Art of This Century. The following summer, Rothko rented a cottage near Motherwell's in East Hampton, and it was there on Long Island that their warm and *tempestuous* friendship materialized.[1] After Motherwell returned to New York City in the fall of 1948, he was introduced to Rothko's circle of friends—Herbert Ferber, Adolph Gottlieb, Newman, Tony Smith, and Tomlin—artists who constituted his next milieu, after that of Matta, other of the surrealists, and Baziotes.

In two unpublished recollections, unusual for their journal-entry tone—written on 10 March 1967 and 21 April 1969—Motherwell recorded visits with Rothko. In December 1970, he wrote a eulogy for the artist, which was read on 28 January 1971 before members of the National Institute of Arts and Letters in New York.[2] ■

10 March 1967

Friday morning, March 10th, 1967. I am to go to Irwin Hollander's lithography workshop on Tenth Street to look at a proof for a lithography edition that I am giving to the Committee for Spanish Refugees, Inc. Alexander Calder and Saul Steinberg are also contributing editions—the proceeds to go to the Spanish. I am nervous; my work is so much more austere, less immediately appealing. I want the Spaniards to make money.

I telephone Hollander to set the time, two p.m. (that will leave me 3:30–7:30 to paint). He reminds me that I have promised to try to bring Mark Rothko next time I appear. Hollander is anxious to add Rothko to his list of artists. This is unlikely. I telephone Rothko. We agree to meet at his East Sixty-ninth Street studio at one p.m., then go to lunch, and then to the workshop; he is glad that I have my car— he is in dread of subways (and elevators, and won't fly).

Rothko meets me at the entrance to his studio, a former carriage house, with very high ceilings, perhaps forty feet up to the skylights,

silent and grey-lit, like a warehouse. We shake hands warmly, though he always looks not at me, but the floor, when we meet. I peer toward the rear studio, not expecting to be invited in, knowing Rothko is just finishing enormous panels for a chapel yet to be built at the University of St. Thomas in Texas, for he is an extremely discreet man, whose secretiveness I always force myself to respect—or rather always do honor. He is twelve years older (born 1903) than I am, and we have been tempestuous friends for more than twenty years, Jew and Celt, acquisitive and extravagant, realistic and idealistic, beingness and literacy, in short, Leopold Bloom and Stephen, and now too old for it.

Held together by what? Unrestrained metaphysical anger, no matter how different the social style in which it is expressed? I do know that I am most "real" to him when I suffer most, which makes other meetings with him awkward, since it is my habit most of the time to hide despair with optimism and decorations. He detests both. The only important artist that I ever met wholly indifferent to objects. Which may not be unrelated to the nature of his art. His wife invariably refers to him by his surname, as though he were a myth, like Job, rather than a human being.

I think that part of his secretiveness (that is not neurasthenic) is because he is truthful. In situations where he does not want to say the truth, which are many, his only recourse is to say nothing. Extremely sensitive, he is wholly self-centered, in a way that only Europe has the ancient manners to contend with. From him I learned the enormous range of intonations that the Yiddish "oye!" can be given. He likes all the rituals to be observed, but is capable of barbaric brutality. I feel tense in his presence, yet he is not a stranger to me, different as we are; on the contrary, he is very real to me, like the people in nineteenth-century Russian literature. He quite literally spits at your face as he talks, either rye crumbs or whisky, and has managed his career more beautifully than any of us. He suffers from boredom, and is glad to see me.

To my surprise, he invites me back to his working space at the rear of the vast studio.

21 April 1969

Mark Rothko telephoned and asked if he would be welcome to come over and have a drink, to which I replied, of course. When he arrived, he seemed, though agitated, calmer than usual during this last couple of years. At a certain moment in the conversation, when I asked him about his present work, he told me that the UNESCO Headquarters in Paris were in touch with him about doing a room there which would also contain sculpture by Giacometti. When I asked him how big the room was, he said that it was not very large, maybe 28 × 20 feet, or something like that. Then he said that in any case, if he accepted the

commission, it would be unlikely that he would make a single picture to cover the whole wall. He said with irony that when you get involved in a painting of that size, there is nothing to do but "compose," that you get involved with all the problems of "composition," and that, as is well-known, he detests the idea of "composition." Then he mentioned, forgetting for the moment he had shown them to me in his studio, that he had started a new series of paintings, "a different world from myself," that were partially inspired by the notion of having his paintings in a room with work by Giacometti, whom he obviously respects. (But I remember about fifteen years ago when there was a run on those thin, gaunt figures of Giacometti in America, Rothko remarking about the insensitivity of a collector who could have such tragic sculptures in his living room.) It became evident to me that if he accepted the commission he would probably fill the walls with three or four individual paintings, rather than one large one. When I looked at the new paintings that he was speaking of, which are on paper about three or four feet by five or six feet high, I was struck that they were grayish and brownish combined, rather than the extraordinarily personal hues that he usually used, indeed not unlike the colors Giacometti himself uses in his own figure paintings. I knew exactly what he meant when he said he loathed "composition," but realized too that the ultimate meaning is that he has a different kind of composition, or methodology in making a picture if you like, from Renaissance composition, but which nevertheless is composition too. He emphasized his belief that every artist had to find his own way of making something that he finds "endurable," i.e., an adequate vehicle for the vision. He meant this as specifically as, let's say, a small child's vehement likes and dislikes in what it eats, or what it wants or wants not to do, at a given moment. In the past he has often talked of a group of his pictures as though they were an opera, i.e., as if each individual picture was a solo voice in an opera, so that such and such a picture from the ensemble is, so to speak, Don Giovanni, another picture, Elvira, and so on. I cannot exaggerate the intensity of his concern about specificity, and consequently in my opinion why his individual pictures do have a greater individuality than many artists who insist on a single imagery. A minor note: his inflection of sighs and of the word "oye" are multifarious and a counterpoint to what he is actually saying.

28 January 1971

When Mark Rothko took his life, alone in his studio during the exceptionally cold winter of 1970, this country and the world lost one of its great modern painters and, what is more rare, a profound one. For modern painting—I speak of it in the specific sense of *l'art moderne*—in general has been characterized by a certain éclat, the sun-drenched brilliance of open-air painting (whether the work was in fact done outside

or in a daylight studio) and by a section of the color wheel far more intense in hue-saturation than is the Renaissance tradition, with its several glazes of paint. It is believed that Goya, who died in 1828, purposely used to put the final emphasis on his paintings by candlelight. During Goya's lifetime, the English watercolorists, working outdoors from nature, began to lighten the painter's palette (and incidentally to begin the Romantic tradition, of which perhaps abstract expressionism is the last outburst in painting); later on, *chez* the French impressionists, sunlight began to permeate the mainstream of modern art. Mark Rothko, an original colorist, sometimes dipped in this stream, especially in those paintings with warm colors—vermilion, yellows, oranges; but even there it was evident that what was dominant in his cooler or darker pictures (those with blues and greens and purples and earth colors and black) was a color not that of bright daylight illuminating strongly colored objects—indeed, he hated objects, as he did so much else—but that instead of a luminescent glow from within. Not the light of the world. Technically speaking, Rothko was essentially a "night" painter, such as, perhaps, Odilon Redon, but on a sublime scale. He liked to paint, even in the daytime, with incandescent electric light, and publicly exhibited his pictures with an extraordinarily low degree of illumination. I remember a huge studio of his on the Bowery, a former storage space, I think, that had no windows at all, which gave one the sense of being behind the scenes on a darkened movie set; his last large carriage-studio on East Sixty-ninth Street also had no windows in the working part, and the skylight was dimmed by cloth. Even his previous studio on Third Avenue on the upper East Side, one that I know well, having sublet it from him for several years (when he took the carriage house) and which did have a wall of windows with strong daylight along the Avenue, he blacked-out as though it were wartime, and worked by artificial light.[3] Rothko was inspired by the Romantic tradition, and tormented by conflicts, by unrelieved anxiety. In his dim studios he used to have dozens of containers of powdered dry pigments, of every imaginable hue, which he mixed with his paint to intensify it—he loved Fra Angelico's bright tempera painting, and often had used egg as a medium—like a chemist of the sort that in Europe used to have a jar of green and of red liquids in the window. Rothko's mixtures resulted in a series of glowing color structures that have no exact parallel in modern art, that, in the profoundest sense of Baudelaire's invocation to modern artists, are *new*. So new that if Rothko had not existed, we would not even know of certain emotional possibilities in modern art. This is an accomplishment of magnitude. But Rothko's real genius was that out of color he had created a language of feeling.

Thus, with his death, a certain dimension left modern art, a certain contradiction that nevertheless glowed with an inner luminosity of color that is "poignant"—to employ one of his favored terms. The poi-

gnancy was dominant in his magnificent 1970 retrospective in Venice, and then in New York City after his death, just ten years after his previous one at the Museum of Modern Art here. Though he liked one to treat him as a genius—a visit to his studio was an audience, for he had an old-fashioned sense of the hierarchy of talent, despite his quasi-Marxist feelings of the WPA days of the 1930s—still in his heart of hearts he also had a deep-rooted ambivalence, a persistent doubt, questioning his intimates as to whether he was a painter at all, that went far beyond an artist's usual doubts at work—an ultimate doubt, so that his patrons, whom he sometimes terrorized or overnight made pay more, were to him possibly out of their minds and he a charlatan conjurer of color.

Crafty, Rothko had little sense of craft; secure by every external criterion, half-ironically, half-despairingly, he would ask me how does one live a life, as if I knew; widely acclaimed, by the artistic underground, by many collectors and critics, by various awards, by a doctorate from Yale, by this Institute, he would not exhibit, frightened by the specter of disinterest; a colorist, his life was grey; renowned as an abstract artist, he insisted that his work was pure subject matter, meaning the poignancy of which I have spoken, and perhaps, in the Oriental sense, the void—he loved the memory of Antonioni, the film director, telling him through an interpreter that they both had the same subject matter—"nothingness"; cheerless, he liked the good cheer of a ménage, and as a houseguest was at his best; vivid as a man, he was filled with a sense of impotence and a burning rage. He used to say that no one realized the amount of aggression in his paintings. ("Amount" was an important word to him: he knew the great artistic lesson, that amounts, or, as we say, quantities exactly weighed condense into quality in art. With Duncan Phillips, he used the word "measures.")

His sense of quality and subjective vision drew him apart artistically from those other Jewish immigrant painters from white Russia in New York City, with whom he otherwise had so much in common as a man, a world depicted in many East European novels, those that could have been illustrated by Burliuk.[4] He was as contemptuous of formalism in his own way—the School he and I founded with two other artists in the 1940s was called "The Subjects of the Artist"—as his social realist confreres were in their more obvious way. Rothko's artistic achievement is staggering because it breaks out of the riverbed of modern art through a shift in subject matter to the undreamed one in abstract art of poignancy before the unknown void. His work has an unmistakable resonance, peculiar to itself, its own characteristic tone. In essence his belief was, *I feel, therefore I am;* this is what his color expressed, even when it was ugly, as occasionally happened. The highest praise in his vocabulary was to call someone a "human being," that is, a person who feels. In the 1950s, he used the word "ecstasy," as though to describe his painting ideal; but his constant term was "to

endure." A work was fully realized if he could endure it, if it were not a lie.

In Rothko's last several years, after his aneurism (and other things) traumatized him, filled with therapeutic drugs and alcohol, his strained effort to control his rage was continually visible. He several times turned to me and said with the dazed look of an animal, "Mine is a bitter old age." Feeling was slowly being drained from him during those last two years of indescribable suffering and clumsy anaesthesia, as surely as his blood drained from his body in death. His suicide must have been complex; he himself was complex. His native intelligence was not fragile or passive, not that great innovative mind of the period. Rothko was fully capable of imagining with Antoine de Saint-Exupéry that "death is a thing of grandeur. It brings instantly into being a whole new network of relations between you and the ideas, the desires, the habits of the man now dead. It is a rearrangement of the world" *(Flight to Arras)*. And he did rearrange how we must view him with his final act. He became mythical, like Arshile Gorky, Jackson Pollock, and David Smith before him, a man whose capacity to integrate a work of art gave poignancy to his inability to integrate a viable existence. As Cocteau says, everything can be solved except being. Or, perhaps, it was not the artist but the everyday man who killed himself, in a single act of rage and despair and isolation and sickness. We can never know. Never be sure that he made a definite choice. But the liberating quality of his art, his true monument, is indeed authentic, because it does represent specific concrete choices, consciously and freely made, among whatever preconscious sources and technical discoveries—such as the intensification of manufactured pigments, the feathery edges made by the spring of the house painter's brush, the unusual depth of his stretchers (discovered in early efforts to economize), the white edges of his last dark pictures, which he originally masked but finally incorporated as part of the picture for their light; in short, those sources and means that became as one with his inner color-space expression, as befits a great painter who, rather than being compelled, chooses how to treat his subject, a subject nevertheless forced upon him by this agonized period. The past twenty-five years, the span of his artistic maturity, have seen a revolutionary change away from hope in human consciousness, of which Rothko was an accurate mirror. As Solzhenitsyn has said, "What if Tolstoy hadn't told the truth?"

Of a galaxy of brilliant Russian Jews in every field in our country, in my opinion Rothko was the greatest of all the painters. An equally brilliant friend of mine,[5] a Hebrew theologian among other things, recalls a single luncheon with Rothko who was defending being a painter as might a child appeal to his ancestors; and reminds me that at that last party Rothko gave in his huge studio, surrounded by his latest black and white works, the artist was as though surrounded by his own magic talismans, through which no evil could reach him, no devil

could possess him. Consequently, he was more than a great modern painter; he was a practitioner of sympathetic magic, and his magic retains its sacred character. Not to perceive the sacred magic is only to perceive originally colored sailcloth rectangles, i.e., one's own emptiness as a Philistine. He experienced what his forefathers disputed. He is dead, but his experience lives, poignant, clumsy, and on those occasions that he reached ecstasy, ravishing and unique.

Notes

1. The artists' friendship, evidenced by Rothko's warm letters to Motherwell over the years, continued until Rothko's death (Motherwell archives).
2. Motherwell made final revisions to this writing on 26 January 1971 (Motherwell archives).
3. Motherwell remembered it *roughly at Seventy-fifth Street, over a five-and-ten cent store* (conversations with the artist, 1983–1986).
4. David Burliuk (or Burljuk) (1882–1967), Russian-born artist who came to the United States in 1922.
5. Arthur Cohen (1928–1986), author, publisher, and rare-book dealer.

On David Smith 9 April 1971

Considering the intimate scale of New York City's art community in the 1940s, and that both artists later acknowledged they had long before admired each other's work, it is surprising that Motherwell and David Smith did not meet sooner than they did. Although Smith had moved to upstate New York just months before Motherwell arrived in New York City in 1940, he frequently visited the city from Bolton Landing. And before their meeting in 1950, the two artists had corresponded with each other regarding Smith's contribution to Motherwell's magazine, *possibilities*.

When Smith exhibited in New York in 1947, the Willard Gallery published three brief essays that he wrote for the accompanying catalog, two of which were later that year reprinted by Motherwell in *possibilities*.[1] At Smith's request, Marion Willard invited Motherwell to write a catalog statement for the sculptor's exhibit in 1950,[2] after which the two artists arranged to meet in Manhattan at a bar on Forty-second Street.

Motherwell's marriage in 1958 to Helen Frankenthaler, for whom Smith felt considerable admiration and fondness, deepened a relationship among all three artists that was to end abruptly with Smith's fatal truck accident in 1965. Just months before, Motherwell had written a tribute to Smith, that was published in *Vogue*.[3] Instead, it is Motherwell's moving account of his friendship with Smith, published in 1972 in John Gruen's *The Party's Over Now: Reminiscences of the Fifties—New York's Artists, Writers, Musicians, and their Friends* that is presented here.[4] ∎

I enjoyed David's companionship more completely than any artist I have ever known; he was a member of the family, with his own key to the house I have lived in on East Ninety-fourth Street for more than eighteen years (since the birth of my first daughter).[5] I can still hear the key in the lock of the front door turn without warning, and his cheerful deep voice booming through the house with greetings, and under his arms wine, cognac, French cheeses, and once (memorably) a side of young bear that he had shot on his farm at Bolton Landing, Lake George. If it was late, he could be drunk, always cheerfully and perhaps abashedly—he was profoundly sensual, mad about very young women, but with a stern Midwestern puritan guilt (about working, too). Helen Frankenthaler and he and I would all embrace, and in the mornings she would have a beautiful breakfast on a hot tray and a flower for when he awoke, and he would be moved with tenderness after the roughness of his bachelor's life in the mountains upstate. He was the only man I was willing to start drinking with at a late breakfast, because it was joy, not despair.

I have had many close friends among New York artists over the years, but David Smith's openness—he was never on guard, except that he would not say anything against a fellow artist, because by having that life commitment, he was beyond reproach—only David's openness was matched to my own instincts. Moreover, he loved Helen, who had been one of his first patrons when, a very young woman, she was going around with Clement Greenberg, and who never wavered in her belief in David, nor her open admiration for him ("open" is a very important word to me).[6] With him alone among my close circle of colleagues would I talk about certain male things—Mercedes-Benz (to which he converted me), shotguns, the wonders of Dunhill's tobacco shop, where the best dark bread and sweet butter was (Locke-Ober's in Boston), baroque music, Scotch tweeds, the pleasures and mysteries of Europe, the Plaza over the Chelsea Hotel (I converted him), the reminiscences of a Western American youth between two world wars, in short, his whole "Ernest Hemingway" side, so to speak, that was so adumbrated in New York City, and which, whether a fantasy or not, was a safety valve for both of us. Quite independently, we had come to roughly the same conclusions about aesthetic sources of our inspiration which, in ABC terms, might be put as any art before the fourth century B.C., cubism-*cum*-surrealism, James Joyce, Stravinsky, Picasso, the strength and sensuousness of materials themselves, and a certain "primitive" directness. There were of course minor blind spots on both sides: he liked to go to the Five Spot to hear Charlie Mingus or whoever might be there, while I've never been attracted to popular music, no matter how great; or once, when Helen and I spent a sleepless night at Bolton Landing, her anger at discovering our mattress was not on bed springs, but on boards. (When we visited him the weekend before his last weekend, he asked Helen what make of bed to

get for us; and then ten days later he was dead. Ken Noland called us to come to the hospital at Albany, and we drove north at ninety-five miles an hour through the night to get there, but Tony Caro came out with his kind face and said David had died from head injuries a few minutes before. For some months afterward, when I would occasionally come home with two items from a shopping tour—say, sea salt from England for boiled beef—I realized how deep my habit was to get one for him too. As always had he.)

David had many deep friendships, and I would guess with each that magic gift of making you feel you alone were the one. He'd been extremely handsome when young, and in his prime with his bear hugs and warm smile had the charisma of Clark Gable, or what a wonderful animal a man is, and how even more wonderful as a man.

On the occasion of his bringing the great hunk of bear meat, ghastly red (as much from the paprika marinade, I later realized, as from blood), it was the afternoon of a dinner party we were giving, and he would not have it that we did not serve the bear after the smoked Scotch salmon. Helen left us at the kitchen table (with a bottle of cognac before us) for a mysterious errand, and he and I ransacked a shelf of cookbooks for a recipe for bear. There was none, so we adapted one for roast venison, with salt, fresh pepper, bay leaf, burgundy, meat glaze, and at the end, ruby port and a tablespoon of red currant jelly for the sauce. (It was superb.) There were perhaps twelve of us at the table, high on Scotch and wine and animated conversation, and Helen brought in the bear on a large platter after clearing the first course, and sat down in the middle of an absorbing story by someone. Suddenly she said, "David, look at me!" and he burst into raucous laughter as we looked at her in an apron on a bear-suit costume that she had rented at a theatrical supply house that afternoon and, as the little bear of the three bears, began to eat roast bear, like a cannibal, but a most ladylike one . . .

I first met David in 1950. Marion Willard, his dealer, had sounded me out as to whether I would write a preface for his forthcoming show, to which I agreed, and it was arranged that he and I, who had never met, though I had admired his work for at least ten years before, after seeing an abstract steel *Head* of his in an outdoor show in Greenwich Village (he loved it that I remembered that head so well), would meet in a bar in Times Square around noon. After we met he said, "I'm drinking Irish whisky with Guinness stout as a chaser." "Fine," I said (after all, I am a Celt), and we proceeded to try to drink each other under the table. By midnight we had not succeeded, I don't remember where we ate (at Dorothy Dehner's?). I do remember driving my jeep station wagon back through the moonlit night to East Hampton, having a last beer to sustain me at Smithtown (or was it the name?), and wondering, before I fell into bed in a stupor, how I had made it, good a driver as I was in those days. But it was in 1958, when I mar-

ried Helen Frankenthaler, that we became a trio, a special dimension in all our lives.

His two daughters were almost the same age as mine, we both delighted in them, adored them in our clumsy way, and when he had his daughters on leave from their mother, I helped him "entertain" them. He loved during the summer to bring them down from Bolton Landing to visit us at the seashore in Provincetown, where I've mostly gone for the summers, and my daughters still remember their childish awe at him finding a wet, torn dollar bill in the outgoing tide. He and I both loved a ménage, with women, children, and friends and a bountiful table and endless drink, and we could do it unselfconsciously with each other, which is perhaps the deepest relief one peer can give another.

And we both knew damned well the black abyss in each of us that the sun and the daughters' skin and the bounty and the drink could alleviate but not begin to fill, a certain kind, I suppose, of puritanical bravado, of holding off the demons of guilt and depression that largely destroyed in one way or another the abstract expressionist generation, whose suffering and labor was to make it easier, but not realer, for the next generation. And if they liked it cool, we liked it warm, a warmth that is yet to reappear in the art of the young generations who have, as they should, their own life styles, whether chic or hippie or what. In any case, during the last year before he killed himself in his truck—his beautiful head was crushed against the cargo guardrail when he dove into a ditch, chasing Ken Noland in his English Lotus sports car to an opening at Bennington—David subtly changed, as though, about to be sixty, the old bravado was no longer self-sustaining. That optimism that we had shared through everything fluctuated ever so slightly, he made a will for the first time (naming me, without my knowing it, as one of his three trustees and executors, doubtless because of his daughters, his sole heirs); sometimes when very drunk he would begin to talk with a touch of paranoia about other artists or his domestic life, and sometimes despair would darken a moment. Then we would wordlessly pat each other on the shoulder, and have a final drink before bed. Rothko, in the fifties, before he himself began to drink a lot, used to say to me angrily, "Your solution to everything is another drink." Now I do not drink at all, they both are violently dead, Helen Frankenthaler and I are splitting, and I have invited David's daughters to visit with my daughters again this summer (1971) in Provincetown. I have felt deeply for various men during my life—masculinity is as beautiful in its own way as femininity is in its—but there will never be another David Smith.

Notes

1. David Smith, "I Have Never Looked at a Landscape," and "Sculpture Is," in *possibilities 1: An Occasional Review*, Problems of Contemporary Art, no. 4, ed. John Cage, Pierre Chareau, Robert Motherwell, and Harold Rosenberg (New York: Wittenborn, Schultz, 1947), 25.

2. Robert Motherwell, "For David Smith 1950," in *David Smith* (exhibition catalog) (New York: Willard Gallery, 1950).

3. Robert Motherwell, "A Major American Sculptor, David Smith," *Vogue*, February 1965, 135–39, 190–91.

4. According to Motherwell's datebook for 1971, the interview from which his comments were published took place on 9 April 1971 (Motherwell archives).

5. Jeannie Motherwell was born in 1953; Lise, in 1955.

6. Motherwell began his *Open* series of paintings in 1967.

Introduction to Pierre Cabanne,
Dialogues with Marcel Duchamp 1971

■ *Dialogues with Marcel Duchamp* by Pierre Cabanne appeared in 1971 as the first title Motherwell chose for the Documents for 20th-Century Art. The new series, an extension in purpose of the Documents of Modern Art, was published by Viking Press until 1980, with Motherwell serving as general editor, Arthur A. Cohen as managing editor, and Bernard Karpel as documentary editor.

The book was translated from Cabanne's *Entretiens avec Marcel Duchamp* (1968), although Motherwell did considerable work revising Ron Padgett's translation.[1] On completing his editorial work on the text in early 1969, Motherwell acknowledged that he had finished the task with great admiration for Duchamp.[2] He also wrote the introduction to the volume, which, of the sixteen titles published by Viking in this series, is the only one for which he produced any writing.

Duchamp had been artistically influential in the United States since his participation in the Armory Show of 1913 and had played an early and leading role in the dada movement, particularly in New York. In the United States again in 1942, as an exile with other Parisian surrealists, he became prominent in their publishing and exhibiting activities; and it was during Motherwell's association with the surrealists at the time that the two artists met. Later in the 1940s, while Motherwell was working on *The Dada Painters and Poets,* Duchamp made a number of suggestions for the text and reviewed the book's dummy in its various stages of production. ■

In the original French edition of this book, Pierre Cabanne wrote, shortly before Duchamp's death: "These interviews with Marcel Duchamp took place in his studio at Neuilly [near Paris], where he and his wife live during the six months they spend in France each year. It is the first time that the most fascinating and the most disconcerting inventor in

contemporary art has agreed to talk about and explain, so profoundly and at such length, his actions, his reactions, his feelings, and the choices he made." He adds that Duchamp gave these interviews with a "serenity from which he never departed, and which gave his theorems an undeniable grandeur; one divined a man not only detached, but 'preserved.' Through his creative acts, Marcel Duchamp did not want to impose a new revolutionary language, but to propose an attitude of mind; this is why these interviews constitute an astonishing moral lesson . . . He speaks in a calm, steady, level voice; his memory is prodigious, the words that he employs are not automatic or stale, as though one is replying for the nth time to an interviewer, but carefully considered; it must not be forgotten that he wrote 'Conditions of a Language: Research into *First Words.*' Only one question provoked in him a marked reaction: near the end, when I asked him whether he believed in God. Notice that he very frequently utilizes the word 'thing' to designate his own creations, and 'to make' to evoke his creative acts. The terms 'game,' or 'it is amusing,' or 'I wanted to amuse myself,' recur often; they are ironic evidence of his nonactivity.

"Marcel Duchamp always wore a pink shirt, with fine green stripes; he smoked Havana cigars incessantly (about ten a day); went out little; saw few friends; and went neither to exhibitions nor to museums . . ."

The present translation into English contains the entire text of the interviews, but differs in several respects from the French edition. The latter was not illustrated, and while Duchamp's work is not illustrated here (since there are several books containing illustrations of most of his work),* *he* is. When he was asked if he would like to write a preface to this English-language edition, he replied that he would not but would like his friend and summer neighbor in Cadaqués, Spain, Salvador Dali, to do so. Dali's preface appears here for the first time; so does a much more detailed chronology than in the French edition, and a more authoritative selected bibliography, by Bernard Karpel, librarian of the Museum of Modern Art, New York.

(Pierre Cabanne, who was born in 1921, has been for some years art critic of the Paris review *Arts-Loisirs.* He has written books on van Gogh, the cubist epoch, Degas, and Picasso, and he contributes to many French and foreign art magazines.)

Marcel Duchamp's own numerous writings (in the original French or in English) were published as *"Marchand du Sel: Écrits de Marcel Duchamp,"* in 1958.†

Duchamp died suddenly in his studio at Neuilly on October 1, 1968,

*Notably in Robert Lebel (1959; later edition without color); Calvin Tomkins (1966); and Arturo Schwarz (1969) [. . .]

†Edited by the great dada authority Michel Sanouillet; [. . .]

at the age of eighty-one, a year and a half after the original French publication of these conversations.

These conversations are more than mere interviews. They are Marcel Duchamp's "summing up," and constitute as vivid a self-portrait as we possess of a major twentieth-century artist, thanks to Duchamp's intelligence, scrupulousness, and disdain for the petty. Here, as throughout his life, he has rejected, as much as one can, that game of rivalry which makes so many modern artists uneasy and angry, or bitter, and sometimes false to themselves and to historical truth. In these pages, Duchamp's effort to be "objective" is sustained with an intellectual strength and modesty (though he had his own arrogance) of which few celebrated artists approaching their eighties are capable. We are also fortunate in Pierre Cabanne's intelligent choice of questions* and his sheer tenacity as Duchamp's questioner (he is obviously familiar with Duchamp's remark, "There is no solution because there is no problem"). Cabanne intuitively knows when not to press too hard, and when to come back discreetly again and again to a dropped question, finally to receive the "answer." On rereading these conversations, Duchamp said to Cabanne (in effect) that "this is from the horse's mouth." I, for one, shall always be grateful to Duchamp for his willingness to be so intensively recorded, just before he died.

I knew Duchamp casually, beginning in the early 1940s, in New York City, in the French surrealist milieu. Later in the decade, we used to meet when I was working on vexing questions that arose while I was editing my dada anthology.† We met once or twice at the dusty New York studio that he had for years (on West Fourteenth Street, I think), but more often at a little downstairs Italian restaurant, where he invariably ordered a small plate of plain spaghetti with a pat of butter and grated Parmesan cheese over it, a small glass of red wine, and espresso afterward. In those days his lunch must have cost seventy-five cents, or less‡ He could not have been more pleasant, more open, more generous, or more "objective," especially when I recall how few of my questions had to do with him.§ Most of my questions had to

*He obviously followed with care Robert Lebel's *Sur Marcel Duchamp* (Paris: Trianon Press, 1959), design and layout by Marcel Duchamp and Arnold Fawcus. The English translation by George Heard Hamilton was published under the title *Marcel Duchamp* (New York: Grove Press, 1959). The American edition also contains André Breton's beautiful and difficult tribute, Henri-Pierre Roche's impressions, and a brief lecture, "The Creative Act," that Duchamp gave before the American Federation of Arts, in Houston, Texas, in April, 1957. [. . .]

† *The Dada Painters and Poets* [. . .]

‡Lebel also remarks on the frugality of his eating habits.

§I also received his approval for a translation of his "Green Box" to appear in the Documents of Modern Art series, which it did, finally, more than a decade later: "The Bride Stripped Bare by Her Bachelors, Even," a typographic version by Richard Hamilton of Marcel Du-

do with the clarification of various dada mysteries (such as conflicting stories about the discovery of the name "dada") that had become clouded in legend so many years after the fact, often deliberately. Later, I enlisted his aid (which ultimately proved fruitless) in trying to reconcile Richard Huelsenbeck and Tristan Tzara to having their recent writings appear together between the same covers. They detested each other, rivals long after the dada period.

I had asked Duchamp to act as a mediator in regard to the book because of the *sense* one already had of him, seeing him among the Parisian surrealists gathered in New York City during the Second World War. The surrealists were the closest-knit group of artists, over the longest period of time, that I know of, with all the unavoidable frictions as well as the camaraderie implied by such intimacy. Often their various group projects produced violent disagreements. But their respect for Duchamp—who was not a surrealist, but as he himself said, "borrowed" from the world—and, above all, for his fairness as a mediator, was great.★ It seemed to me that he gave a certain emotional stability to that group in exile during those anxiety-ridden years after the defeat of France in 1940, when the Nazis gained everywhere, for a time.

I remember once at a surrealist gathering watching André Breton and Max Ernst standing mouth-to-mouth, in that curious French fashion, arguing with rage about something I do not remember—a personal matter, I think, but one which also raised the question of their professional indebtedness toward each other. At such moments as these, only Duchamp, with his detachment, his fairness (which, of course, is not the same thing), and his innate sensitivity, could try to bring calm.

It was with these same qualities that he tried to help me edit my Dada anthology, in the later 1940s.† Over the years, he himself was co-editor of a surprising number of projects, and heaven knows how many people he helped, or in how many ways. One should keep this in mind when Duchamp tells Cabanne he doesn't do much during the day, or when he so often gives his reason for having done something as that it "amused" him. It *is* true that he could not stand boredom. He rarely attended large gatherings, and when he did it was barely long enough to take off his hat.

champ's "Green Box," translated by George Heard Hamilton. [. . .] Both brief essays by the two Hamiltons in this volume are excellent, as are the layout and the translation, approved by Duchamp himself.

★On the poster of the 1938 Paris Surrealist Exhibition, Duchamp is listed among the organizers as "General Mediator."

†I also spoke to him a bit about his distaste for the technical procedures involved in becoming an American citizen. When I asked him why he preferred to live here, he repeated several times that being in France was like being in a net full of lobsters clawing each other. But his heart remained there, I think—though in the U.S.A. he was better known, and at the same time allowed privacy and noncommitment to anything that did not interest him (as he says in this book).

An artist must be unusually intelligent in order to grasp simultaneously many structured relations. In fact, intelligence can be considered as the *capacity* to grasp complex relations; in this sense, Leonardo's intelligence, for instance, is almost beyond belief. Duchamp's intelligence contributed many things, of course, but for me its greatest accomplishment was to take him beyond the merely "aesthetic"★ concerns that face every "modern" artist—whose role is neither religious nor communal, but instead secular and individual. This problem has been called "the despair of the aesthetic": if all colors or nudes are equally pleasing to the eye, why does the artist choose one color or figure rather than another? If he does not make a purely "aesthetic" choice, he must look for further criteria on which to base his value judgments. Kierkegaard held that artistic criteria were first the realm of the aesthetic, then the ethical, then the realm of the holy. Duchamp, as a nonbeliever, could not have accepted holiness as a criterion but, in setting up for himself complex technical problems or new ways of expressing erotic subject matter, for instance, he did find an ethic beyond the "aesthetic" for his ultimate choices.† And his most successful works, paradoxically, take on that indirect beauty achieved only by those artists who have been concerned with more than the merely sensuous. In this way, Duchamp's intelligence accomplished nearly everything possible within the reach of a modern artist, earning him the unlimited and fully justified respect of successive small groups of admirers throughout his life. But, as he often says in the following pages, it is posterity who will judge, and he, like Stendhal, had more faith in posterity than in his contemporaries. At the same time, one learns from his conversations of an extraordinary artistic adventure, filled with direction, discipline, and disdain for art as a trade and for the repetition of what has already been done.‡

There is one "deception" of Duchamp's here, however, in the form of a deliberate omission. He never mentions, even when questioned about his having given up art, that for twenty years (1946–1966) he had been constructing a major work: *Given: 1. the waterfall, 2. illuminating gas.*§ This last work of his is an environmental room, secretly "made," with some assistance from his wife, Teeny, in a studio on West Eleventh

★"Aesthetic" in this context refers to the perception of the world's surface through the senses, primarily sight; felt visual discrimination (what Duchamp called "retinal").

†"To get away from the physical aspect of painting . . . I was interested in ideas, not merely visual products. I wanted to put painting once again at the service of the mind" [1945]. "The final product [*Large Glass*] was to be a wedding of mental and visual relations" [1959].

‡Duchamp often said in conversation that no book should be more than fifty pages long, that a skilled writer could say everything he had to say in that space. Though he seemed not to be a great reader, I suspected that he had read Paul Valéry's discourse on the method of Leonardo da Vinci; but when I suggested this once, he displayed a certain ambivalence and evasiveness, not unlike Valéry's own towards dada—at least, this was my impression.

§*Étant Donnés: 1ᶜ la chute d'eau, 2ᶜ le gaz d'éclairage.*

Street in New York. It is now in the Philadelphia Museum in a gallery adjacent to the Arensberg Collection, as Duchamp had apparently intended.* When its existence became known after his death, it was realized how literal Duchamp had been in insisting that the artist should go "underground." In spite of all appearances, Duchamp had never ceased to work; moreover, he managed to keep his privacy inviolate in New York City—in a way that he thought would have been impossible for him in Paris. This extraordinary achievement, in addition to its place in Duchamp's *oeuvre* as a completely new work, exemplifies another aspect of the artist's character. I mean a theatricality and a brutality of effect wholly remote from the intellectualism and refinement of the earlier work. For, despite Duchamp's urbanity, from another standpoint, Duchamp was the great *saboteur,* the relentless enemy of painterly painting (read Picasso and Matisse), the asp in the basket of fruit. His disdain for sensual painting was as intense as was his interest in erotic machines. Not to see this is not to take his testament seriously. No wonder he smiled at "art history," while making sure his work ended up in museums. Picasso, in questioning himself about what art is, immediately thought, "What is not?" (1930s). Picasso, as a painter, wanted boundaries. Duchamp, as an anti-painter, did not. From the standpoint of each, the other was involved in a *game.* Taking one side or the other is the history of art since 1914, since the First World War.

Notes

1. Motherwell revised the translation in the first week of February 1969 while he and Helen Frankenthaler were aboard the ocean liner *Raffaello.*
2. Motherwell, letter to Emerson and Dina Woelffer, 12 February 1969.

"The Book's Beginnings" 1972

While working at Universal Limited Art Editions in West Islip, Long Island, in early 1968, Motherwell had produced the first etched plate in a bookmaking project that he completed four years later. In the late fall of 1972, the Metropolitan Museum of Art in New York mounted "Robert Motherwell's 'A la pintura,' The Genesis of a Book." The exhibition contained several proofs and the twenty-one etchings from the portfolio published by ULAE in 1972.[1] Motherwell's prints had been inspired by Rafael Alberti's cycle of poems on the nature of painting, *A la pintura,* found by the artist in the Spanish poet's *Selected Poems (1945–1952)* a year after the book was pub-

*There is a superb essay, illustrated, by Anne d'Harnoncourt and Walter Hopps on the new work in the *Bulletin* of the Philadelphia Museum (June 25, 1969). See also the July–August 1969 issue of *Art in America.*

lished in 1966. For the exhibition catalog, Motherwell discussed how his *livre* had come into being, dating his writing *22 September 1972*.

Motherwell had for many years resisted the entreaties of ULAE's determined director, Tatyana Grosman, that he illustrate a book in the tradition of the European *livre d'artiste,* preferably a book of his own writings. Although the deluxe books made by modern French artists held particular interest for him, he felt no desire to illustrate any text, let alone his own. He changed his mind only after he came upon Alberti's poems. For the project, Grosman installed an etching studio in what was essentially her lithography workshop and assigned a master printer, Donn Steward, to work almost exclusively with the artist.

Having experimented with the etching medium, Motherwell had found its demands unsatisfactory for the spontaneity and intense color he wished to convey. But with Steward's sensitivity and technical expertise, the rich saturated colors he was able to achieve through aquatint and the chalky line he obtained through the sugar-lift process released a tactile language that vividly captured his feelings toward the poet's words. ■

It must be more than fifteen years since Tatyana Grosman approached me to do prints for her Universal Art Editions. I have always been excited by the quality of various papers since childhood, but in the 1950s collage and drawing seemed sufficient to satisfy my needs for paper (as they had for years); I did relatively little for Mrs. Grosman—indeed, in the sixties we had a bit of a falling out, to my great regret (which, later on, we both realized was the result of a sheer misunderstanding, and I began to work with her again). From the beginning, she used to talk about a book—"the book," she would say—a *livre d'artiste,* to an accompanying text, preferably my own text. But I never wanted to illuminate my own writings: my writings had only come about in an effort to illuminate my paintings, or those of other modern artists. I have never written a word except when commissioned; conversely, hardly anything that I have painted has been commissioned. Presently, as Mrs. Grosman and I grew closer in collaboration, I would put her off with the remark that when I found "the right text," then I would do it. She said I must. But I then would put the project out of mind. There were always some at hand.

Meanwhile, my life was disorganized by my large—too large—retrospective exhibition late in 1965 at the Museum of Modern Art in New York, which then traveled to five museums in Europe. The disappointment of not being allowed to prune this exhibition, coupled with several personal difficulties, as well as the difficult transition from oil to acrylic painting (which I had to do because I was wont to use so much black, and oil black is technically tricky), the tearing down of

my huge ex-poolhall studio on East Eighty-sixth Street, increasing dissatisfaction with my dealer, the accidental deaths of David Smith (my best friend in the sixties) and of Frank O'Hara (who had done my MoMA show), the new anti-humanistic tone of the sixties, and who knows what else put me in a withdrawn frame of mind, which was often reflected in difficulties with my work. Or perhaps vice versa. Perhaps work problems exaggerated the importance of what was happening in everyday life. The life of the artist is an endurance test anyhow.

In the spring of 1967 in a subsequent, third, quiet studio (which I disliked)—but I had to leave the second because of the endless noise on Third Avenue—by chance I stumbled on what I had been half-consciously looking for during the past three years, a "field painting" that would not be overwhelmed by the force of "signs" (or images) on it. The "chance" was in having leaned the rear of a canvas against a larger one (that had been painted flat yellow ochre) and, in liking the relationships, spontaneously outlining the smaller canvas in charcoal on the larger one. That is, what came to be known as the *Open* series began as a charcoal "door," which presently I turned upside down into a "window." (In the summer of 1971, while having an exhibition of a few of the *Open* paintings in St. Gallen, Switzerland, a German art historian presented me with his long book on the history of "the window in art," covering the last two centuries!) But the *Open* series means more to me than the technical problem of a greater working harmony between the extension of the canvas and the "sign" or image, or than the various associations with the "window"; indeed, so mysterious in artistic possibilities is the conception that five years later I am still contemplating its mysteries in scores of later works . . . For the rest, some of my associations with the series are under "open," in the *Random House Unabridged Dictionary,* in a series of eighty-odd definitions that I find to be a prose poem, and would quote verbatim here, if there were space.[2]

One of my habits is browsing in bookshops. One day, perhaps in that same year 1967 that I have been speaking of, in E. S. Wilentz's Eighth Street Bookshop, I found Ben Belitt's translation, published by the University of California Press, of Rafael Alberti's *Selected Poems,* including small portions of his huge cycle of poems in homage to the great art of painting, *A la pintura.* I had found the text for a *livre d'artiste,* a text whose every line set into motion my innermost painterly feelings. And again and again between 1968 and 1972, working on the *livre,* sometimes discouraged, sometimes baffled, a line of Alberti's would start me again. This poetry is made for painters, and this *livre* was made for the poetry. I meant the two to be wedded, as in a medieval psalter, but with my own sense of the "modern."

The problem was iconography. A medieval book of hours on Biblical themes depicts them. A way for a modern artist to deal with references to the pantheon of great painters—Tintoretto, Veronese, Goya, Titian, Rembrandt, et al.—would be through montage (which, unbeknownst to me, Alberti later did himself for the Italian translation of *A la pintura*). But modern artists cannot otherwise use the Renaissance tradition, any more than medieval artists worked in the classical Greek tradition. I decided to cut the Gordian knot by sticking to my own iconography throughout, one that is meant to convey essences. My iconography can cope with, say, the bluenesses of blues, light and air and color, walls, perspective, and a general sense of the Mediterranean; with solitude, weight, intensities, placing, decisiveness, and ambiguities; it cannot deal with Venus—except as one aspect of the skin of the world, of which painting itself is also a skin, and in this sense my illuminations are both a higher degree of abstraction and a lower degree of complexity—but not of subtlety—than the poems.

The other problem was techniques. I wanted a more painterly quality than I had found for myself in lithography, and a more intense color (literally) than I had ever seen in engraving—after all, the poems were called "Blue," "Red," "The Palette," "The Paintbrush," "Black," and so on—and I was painting the *Open* series in intense color. It was when the master printer in the engraving workshop at Mrs. Grosman's, Donn Steward, introduced me to aquatint as a way of having both a subtle and an intense field, and to "sugar-lift" on aquatint as a felt equivalent to my charcoal lines that we were able to move—toward the ultimate realization of what I had in mind. Over four years, Steward's sensitivity, of technical response to my intentions, as well as suggestions and even anticipations (so closely did we work together) was sustained in a way that I would not have thought possible. In the midst of this technological era, one of my cherished experiences has been to work with a great and meticulous craftsman.

I do not know how much longer the collaboration between artist and artisan can exist in an increasingly electronic era without becoming a form of antiquarianism. To fight this latter was also a powerful impulse behind the modern aesthetic of the book.

Tatyana Grosman brought all together. Her integrity, tenacity, endless patience, extravagance with time and materials are as rare as is the ambience of her workshops, where it is simply assumed, as seldom elsewhere nowadays, that the world of the spirit exists as concretely as, say, lemon yellow or woman's hair, but transcends everyday life. At West Islip, this consciousness permeates every moment. Matisse said on his American journey that New York has the most beautiful light anywhere. I intended this book to have some of that light, as well

as the inner light of 5 Skidmore Place, West Islip, Long Island. Alberti's text has its own magical light, based on the latitude of the Mediterranean countries. New York, Barcelona, Long Island, and Rome (where Alberti now lives in exile from Franco Spain) are all approximately on the same latitude. Part of the artistic task is to find identity in differences, metaphors. Metaphors of painting and of poetry and of workshops and of women and of men that are in turn metaphors for reality itself. Indescribable as it is (whatever it is), directly.

Notes

1. Robert Motherwell, *A la pintura, 1968–1972* (West Islip, N.Y.: Universal Limited Art Editions, 1972). A *livre d'artiste* of twenty-four pages, containing twenty-one aquatints and selections from the original Spanish poem cycle by Rafael Alberti with English translations.

2. Motherwell detailed the origin of the *Opens* in this context because the majority of the plates in *A la pintura* are in that genre, which a reader unfamiliar with the *livre* would not know without the illustrated catalog in hand.

Interview with Richard Wagener 14 June 1974

"Robert Motherwell in California Collections," an exhibit conceived by the artist Emerson Woelffer, was hosted by the Otis Art Institute Gallery in Los Angeles late in 1974. Motherwell, seriously ill and anticipating radical surgery that fall, had consented to an earlier interview in conjunction with the exhibition. Conducted by Richard Wagener on 14 June, the interview was published the following fall in the exhibition catalog. An edited version is presented here.[1] ■

WAGENER I looked through Baudelaire since you mention him, and, from your writing and hearing you speak, I have picked five parallels between what Baudelaire has said and you have said. The first is an aversion to provincialism; art has to be universal.

MOTHERWELL I agree. The problem is, though, that the particular often takes on universal response.

WAGENER Secondly, Baudelaire, in his salon of 1846, quotes Stendhal as saying that art is essentially a construct in ethics. This seems very important to you—that art is an ethical, definite effort.

MOTHERWELL That I didn't know from Baudelaire, as I remember. The ethical concept as expressed by Kierkegaard hit me.

WAGENER Baudelaire, like you, speaks about feeling as the subject of art. When you were in Los Angeles in 1973 you insisted that feeling was the subject of art.[2] Was that something that grew out of Baudelaire, or did you arrive at it differently?

MOTHERWELL Independently. From philosophical and psychoanalytical studies. If I had been a philosopher, my original contribution to philosophy might have been a distinction between emotion and feeling. Commonly people ˙use the two words interchangeably, e.g., someone's full of feeling, or he feels too much, or he's too sensitive, or he's too emotional, or conversely, he's too cold. By the word feeling, I mean something very specific, which is difficult to say without being redundant. I mean just the way things feel. For example, the California sun on a clear day feels warm and radiant and makes your skin feel good, makes the air aromatic, etc. In one sense feeling is the objective response to what externally actually is.

For me emotion is something that originates in oneself. For example, if you have a certain neurosis—let's say a woman with white hair makes you sick at your stomach, but there's nothing intrinsic about having white hair and being female that makes you sick. Yet from your inner being, for some reason you react emotionally in a manner that is quite different from the way the woman actually is in herself.

In this context, one of my main problems in painting has been a swinging back and forth from expressionism, which I think is basically (as I've defined the word) an emotional thing, toward a modern classicism, like Miró or Matisse, which I think is a felt thing. I would say Kirchner or most surrealist work is emotional. I think Picasso, to some extent, swung between the horns of the same dilemma. I'm sure Hofmann did. There are certain works of Hofmann's that are really felt (and tend to be more geometric) and there are others that are wildly emotional. He swings from one to the other, and sometimes tries to incorporate both in the same picture. A problem for me is that artistically in general, I prefer works of feeling to works of emotion. Yet I love Goya!

But in the *Spanish Elegies* and several other things, I seem to have hit something which, though meant to arouse feeling, also arouses some deep emotion. In the Jungian sense of something archetypal. (I say this as a metaphor, because I don't know if Jung's theory is objectively "true" or not.) It's a useful concept that maybe there's something inside people that is more universal than one's immediate responses to the outside world, the society one lives in, the architecture, the climate, the temperature, the scene.

[. . .]

WAGENER The fourth point of correlation with Baudelaire is a denial of progress in art.

MOTHERWELL My basic feeling is that, in one sense, there is no such thing as art in general, but only the art of a particular place and time. Some artists, like Mondrian, regarded the art of their particular place and time as progress because it was different from past art.

It's difficult for me to believe, and I think Mondrian is a very great

artist, that he has progressed over Piero della Francesca. He's dealing with a different situation perhaps equally adequately, which is very high praise for me because I find Piero almost incomparable. But, in another sense, I think, the closest model to creativity is sexuality. And how can one talk about progress in sexuality? It's obvious that ancient Greek sexuality or Egyptian or Medieval sexuality must be biologically very similar.

From my standpoint, modern art is radical, but its radicalism consists essentially in trying to renew what's dead behind conventional expressions. So that great art is at once historical and eternal (or universal). (I wrote in detail about this seeming contradiction thirty years ago in an avant-garde journal called *DYN*.)

Here I break with the dadaists. I understand them, and I sympathize with them to the degree that they hate everything that is dead and cold and frozen and authoritarian. But their ultimate conviction that one can wipe the historical slate clean, I don't believe at all. I think humanity has a certain collective wisdom, as well as a collective stupidity. At any given moment, both are always fighting each other. I think particularly in modern times, where art is not a tribal but an individual thing, art tends more easily to go off into something stupid. But authentic creativity puts us again in connection with what's alive and real. From that standpoint, I don't have any a priori idea of style. I would prefer a Magritte (who's not at all my cup of tea but a genuine vision in his way) to a third grade abstractionist. You see, the whole problem is for one's experience to be authentic, not rhetorical, which implies, in a secular and individualistic society, an existential position. (I have a recent series of works called *Beckett's Space*.)

WAGENER Do you share Baudelaire's aversion to systems? As you said before, you begin without an a priori idea of how a picture should look.

MOTHERWELL At the same time, I do have some a priori ideas of how a picture of mine should *not* look. It shouldn't be involved in a world of illusion and representation.

This is the first thing you quoted from Baudelaire that I just couldn't just say "yes" to. But even Baudelaire had a theory of correspondences, a "system" of correspondences almost, which I find sympathetic. I think part of what art is consists of finding correspondences that are unexpected to the ordinary eye. But I distrust aesthetic systems, from Hegel to skyscrapers, say. Please also remember that Baudelaire is only one of a thousand creative minds who have interested me. I am *not* a Francophile, by the way.

WAGENER Did you at one time say you thought Delacroix was the first modern artist?

MOTHERWELL I might have, but I don't believe it. I think Rembrandt instead, if one wants to play this kind of game.

WAGENER Why Rembrandt? Most people say Manet.

MOTHERWELL Most? Well, in a narrow sense, perhaps Manet is accurate. Though, in a narrow sense, I could say Constable! One of the chief characteristics of modern art is secularism. It's the first great painting humanity has known that is only secular. Then you say, "How could you mention Rembrandt, who, among other things, was a religious painter?" But, the other great characteristic of modern art is individualism in the sense that it's not a tribal art. It seems to me. Rembrandt is the first artist who, after being a tribal artist, an Amsterdam artist, in his early middle age, forty or whenever, was really on his own alone following a vision that had nothing to do with prevailing orthodoxies. In that sense, he can be regarded as the first modern artist—the first complete individualist. Manet's modernism is in minimizing the subject in relation to his painterliness. Velásquez half did it with his detachment, and Constable wholly before Manet. The influence of the English on Impressionism is given lip service, but not felt enough.

WAGENER From what I understand, when Baudelaire talks about correspondences he means a direct thing, horizontally and vertically, and Mallarmé was more indirect, almost as if Baudelaire's was a one to one kind of a symbolic relationship, and then Mallarmé gives you a notion of something like one step beyond that . . .

MOTHERWELL Yes. Mallarmé in essence asserted that the correspondences were *indirect*. I always took that as "true" as a metaphor, as I did the collective unconscious. No, I shouldn't say took it as "true." I took it as a working idea. I think a lot of my work has to do with correspondences that are not at all literal. I mean that my orange picture is not merely pure orange (though the purest orange I could get). It also has to do with fruit, with the sun, with skin, lots of things. Some things I'm not even aware of, maybe a house I saw in Mexico once, forty years ago—who knows what? Ideally, all the reverberations orange could have.

WAGENER Do you think your paintings are related to the way Mallarmé used symbolism? Would you consider yourself an abstract symbolist; symbolism as it first started out, very object oriented?

MOTHERWELL No. An existentialist. But modern art in general is symbolic, in the French sense of indirection. (There's also another whole way of thinking about symbols, philosophically.) Mallarmé said somewhere, "You don't represent the object, you represent the *effect of the object.*" That's where the correspondence comes in. It's like dreams, where triple images or more work into one another. They make no mathematically logical sense, but obviously have some profound correspondence and profound sense—a psycho-logic.

[. . .]

WAGENER What about the symbolists who were painting at the time of Mallarmé? Are you interested in them?

MOTHERWELL Not at all—in fact, just as surrealism influenced me very much, most surrealist painters I have no sympathy with at all. I except of course Arp, Miró, Giacometti, Ernst's sculpture. The French symbolist painters do not compare with their poet confreres. Instead, it's Cézanne above all.

WAGENER Because of their literalness?

MOTHERWELL Because of their fantasy. I detest fantasy. You know, Mondrian, who'd called his aesthetic "neoplasticism," at the end of his life called it not the new plasticity, but the new *realism*. I understand exactly. He thought he had found true correspondences with reality. (Whether he did or not is another question.) While Dali, let's say, is fantastic like Arthur Rackham, or Walt Disney, though more ambitious. But the shock Dali fantasizes was given to us by Manson,[3] not Dali.

WAGENER There's something I've come upon which seems to apply to your work. I found it in the *Journal of Aesthetics and Art Criticism* (v. 26, n. 2, winter 1967). Speaking of Heidegger the article says: "Metaphysics is concerned with the recollection of the essence of being and with the accent on the essence of truth." Jaspers said: "The urge of man's metaphysical thinking is towards art. His mind opens up to that primary state when art was meant in earnest and was not mere decoration, play, sensuousness, but *chiffre* reading. Through all the formal analyses of its works, through all the narration of its happenings, in the history of the mind, through the biography of its creators, man seeks contact with that something which perhaps he, himself, is not, but which, as existence questioned, saw and shaped in the depth of being that which he too is seeking." That seems very close to the feelings you have.

MOTHERWELL Absolutely! I feel a shock of recognition.
<div align="center">[. . .]</div>
WAGENER When you wrote an article on Miró for *Art News,* you said that surrealism has some part in influencing the attitudes of modern existentialism in literature and art.

MOTHERWELL A lot of the surrealist experiments are essentially existentialist, to seek out the essence of the nature of existence, of being as opposed to all the rhetoric that existence is normally smothered in.

WAGENER Is your affinity for black and white relationships based upon the existential idea of being and nothingness? You have said that in these works white is life and black is death. [. . .]

MOTHERWELL Yes and no. You continually omit that I think as a painter. *In paint.* White is technically *all* colors together and black their absence. In certain drawings of Matisse's done with a relatively wide

brush the black and white drawing is as colorful as the paintings. When I was your age I read something by a brilliant, eccentric, relatively obscure English critic named Adrian Stokes, called *Color and Form*. Somewhere in that book he says that if you think about white, everyone really knows that it is all of the colors combined. But that isn't vivid enough. What you have to think of is a white farmer's field, and if you take a plow and plow the field, off the edges of the steel plow would come a rainbow of all the colors. White contains them all. That has stuck in my mind all my life, so that when I look at white, I look at it as all the colors. When I use black, I don't use it the way most people think of it, as the ultimate tone of darkness, but as much a color as white or vermilion, or lemon yellow or purple, despite the fact that black is no color, non-being, if you like. Then what more natural than a passionate interest in juxtaposing black and white, being and non-being, life and death?

[. . .]

WAGENER What color do you use as cool? Oh . . . you don't use cool colors . . .

MOTHERWELL No, and I can't stand "cool" paintings. I can't endure the painter Ingres, I can't endure Vermeer, or Velásquez, yet I know they're great artists. But all I have to do is look at an aquatint by Goya and it warms my whole body. It isn't in the colors, because there are none, but Goya had a warm mind. Rembrandt had a warm mind, the Venetians did, the Greeks did, and so did the folk artists of the Orient or of Mexico. In the old days, along the Mediterranean, with all those papier mâche purples and ultramarine blues and lemon yellows and plaster whites. God, I just dig that . . .

[. . .]

WAGENER In summarizing, could we say your aesthetic revolves around the following four points: 1. universality; 2. the ethical imperative; 3. a particular art being a response to a particular history; 4. feeling is the subject matter of art. Is that too cold a breakdown?

MOTHERWELL Yes, it is. And much too limited, four of perhaps several hundred notions. But my vocabulary isn't adequate. In one sense, my effort is to get to the absolute essence; to make the painting look like it happened totally spontaneously, at that magical moment when for one second your wrist, your arm, your shoulder, your heart, are totally at one with each other. This is not true of some of the works, especially some that are more complicated and ultimately less lyrical. But, in many of the paintings, the effort is almost to reach what an Oriental would call the moment of enlightenment. It happens and it doesn't happen in my work. I mean, I can have two pictures similar enough side by side and one will absolutely have all that and the other won't. But, if you tried to describe the difference technically . . . there's no way. That's why I called some of the pictures in the early days a

"throw of dice": you hit it or you didn't. But, in a way, that's too trivial a metaphor. Art is not a game. (It was also a way of indirectly paying a debt to Mallarmé.) But, there's more—that book *Zen and Archery*—that's much closer to what I'm concerned with in certain ways. But I'm also a Western materialist incorporating a lot of worldly things in some pictures, particularly the collages which wouldn't belong in a world of simply the essential ecstatic moment. I may have a complicated character with different aspects of it emerging on different occasions or with different preoccupations, or whatever. Most of what is written about me is essentially foolish, because most American writers won't deal with a person if he's more than one cliché. In the end, they want the idea of the essential artist—the ideal Rothko, the ideal Milton Avery, whatever it is, without thinking that it's possible to have a very wide range of interests and problems and preoccupations, as Virgil showed Dante.

WAGENER My impression before was that the symbolists heavily influenced you, but perhaps that's not the case.

MOTHERWELL Right. Forty years ago I was trying to find out about a certain kind of modernist vision and it so happens that, among other people, some symbolist poets came closest to expressing it. I was looking for what would help me understand modernist art. In the 1930s, it was almost impossible to find out in English, in America, modern art's deepest concerns, theoretically and culturally. I mean, you could see reproductions, and by the 1940s the Museum of Modern Art had the best collection in the world of modern art. You could go and look at it, but to find out what was in these guys' minds apart from the technical considerations, which were obvious, was almost impossible. It's as though you wanted to find out how Indians got to be the way they are, and you would have to read travelers' diaries, some of the literature, see the rituals. Slowly you begin to see, to comprehend, to grasp this whole cultural point of view which is so different from one's own. I think I grasped modern art so well that it ultimately became part of me.

[. . .]

Notes

1. Notes supplied for this interview by Melinda Wortz, who had organized the exhibit, have been omitted.
2. Motherwell presented this view in a lecture at the Los Angeles County Museum of Art.
3. Charles Manson and a cult of followers randomly massacred several people in California in the 1960s.

■ It had probably been in 1942 that Motherwell and Joseph Cornell first met and began a friendship that was to continue for more than a decade.[1] They had been introduced by Roberto Matta, most likely at Julien Levy's, the vanguard surrealist gallery that the otherwise reclusive Cornell frequented and where he exhibited. Cornell had been deeply impressed with collages by Max Ernst and had transformed the medium into his highly personal three-dimensional objects. It was Cornell's poetic sensibility, artistic authenticity, and intense imaginative identification with nineteenth-century Europe that Motherwell, accepting of an eccentricity he ordinarily would have rejected, for a time enjoyed. Both habitual browsers in second-hand bookstores, the two artists, at times together, foraged "Book Row" in Greenwich Village—Motherwell finding his rare and out-of-print books, and Cornell collecting old engravings, clippings, and souvenirs to assemble into his mythic objects. Periodically, cryptic communiqués from Cornell would arrive at Motherwell's studio, some honoring his wife, María, whose deportment suggested that of the ballerina, one among many classical figures that intrigued Cornell.

Early in 1949, at Motherwell's invitation, Cornell presented an evening of his unique collection of films at Subjects of the Artist, showing them again later that year at one of the Forum 49 sessions in Provincetown, Massachusetts. In 1953, Motherwell wrote a preface to a proposed catalog for an exhibit of Cornell's work at the Walker Art Center in Minneapolis; it eventually was published, in a slightly modified version, in another catalog in 1976, four years after Cornell's death.[2]

On 15 November 1977, Motherwell responded in a letter to a numbered questionnaire on Cornell, which had been sent to him by Lynda Hartigan, assistant curator of twentieth-century painting and sculpture at the National Collection of Fine Arts, Washington, D.C. ■

Dear Ms. Hartigan:

1) Cornell and I never discussed abstract expressionism, so that I was quite startled when I received his box.[3] If in fact he was splattering in 1941 and 1943, as you say, he was quicker on the draw than most of the abstract expressionists themselves. The colors were cheerful and "European."

2) I don't remember his ever talking about wanting to paint.

3) I met Cornell through Matta, who was a strong admirer of his work, but put off by his obvious "madness."* I became equally ad-

*[Handwritten as marginalia on p. 1]: The "madness" of genius; & of a depressing domestic situation, I would suppose. Those of us prone to madness are less fascinated by it than those not; the suffering is too awful. "Eccentric" is perhaps more accurate—his work is very sane,

miring and ultimately equally put off; but for some years, about 1942 to 1947, we were quite close. Among other connections, I was then married to a Mexican actress (see plate 312, H. H. Arnason, *Robert Motherwell*, Abrams, 1977), who was often mistaken in public for a classical ballerina. Cornell clearly enjoyed just watching her move about. He was a *voyeur par excellence,* entranced with the ballerina type. Most of our conversation was about nineteenth-century French culture, particularly ballet, Mallarmé, small hotels, Berlioz, and Erik Satie, "whiteness"—in short, things that I think few other American native artists at that moment could have shared with him. It was all the more curious because, so far as I know, he had never been out of New York state, and yet gave the impression of knowing Paris better than Baron Haussman, so to speak.

When he talked, he always stared at the floor, never at the person to whom he was speaking, and his monologues were like endless labyrinths, and one longed at times, after say, half an hour, to know the central subject of the conversation, and one almost never found the center. At the same time, he was acutely aware if one's attention lapsed, so that the tension was often almost unbearable. And he was very exacting. For example, he did not drink, but would be furious if the supply of hard candy sour balls ran out. Or, once a small, playful Welsh terrier that I had suddenly jumped into his lap; he shrieked in horror. In the American Heritage *History of the Civil War* there is a full page photograph of John Brown, with the same fanatical, burning, yet cool blue eyes. He was as gaunt as I imagine Captain Ahab . . . In those Depression days I remember[*] his contempt for anybody taking public money from the WPA, though he himself was just above the poverty line. He haunted Fourth Avenue and its second-hand bookstores; and there he collected his incredible collection of nineteenth-century and La Belle Epoque photographs, films (including the only known example of Loie Fuller's famous dance with draperies), books, memorabilia of every sort, including a rare translation published in Maine of de Nerval, and so on. He sent fabulous boxes to Lilly Tosch, who telephoned me whether this mad, distant suitor was for real or not . . .

Finally, that passage I have just sent you (with the image of a grandmother's attic),[4] I said to him once impatiently, and several times afterward (before I ever wrote it down) to my surprise, he would ask me to repeat it to him and would smile silently to himself. The request for me to formally write about him must also have originated with him,

if fantasy; as though he could not bear what was around him—scientists are often like this, as well as poets. What we most deeply had in common, besides the collage technique, was a belief in visual "poetry" rather than formalism; that is, Zen "essences" or Baudelaire's "correspondences."

[*At the top of p. 2, Motherwell encircled these hand-written notes]: What suffering! Unreachable suffering.

though of course the actual request came from the midwest museum involved. In his labyrinthine way he carefully controlled his image, as much as later on did Rothko and Newman—against extreme vulnerability, i.e., the human condition, distrusted . . .

[Hand-written addenda]: When I think of "eccentricity," Satie comes to mind; but Cornell, unlike Satie, was totally humorless. Yet we did have deep affinities. He told me about Primrose's recording of Berlioz's "Harold in Italy," and I was so taken with it, I made a whole exhibition, listening to it a 1000 times, I who like pre-Beethoven music, and XXth c. music, & not the romantics especially—about 1945.[5] His intensity may have matched Kafka's, but without the quickness & irony & acceptance. Very Yankee and repressed, the earthiness of Buñuel wholly wanting. Told me once he made the first surrealist purchase in America, a drawing by Dali for $75. Always had groupies, but gave little. Felt protective toward sister and crippled brother. Anguished but resilient man. Little self-knowledge, I suspect. Faultless taste in art, but not otherwise. Uninfluenceable by others. A loner, canny & rigid. — All this is impressions, not assertions of fact.

Notes

1. Cornell communicated by mail with Motherwell until the early 1950s (Motherwell archives).

2. Robert Motherwell, "Preface to a Joseph Cornell Exhibition," in *Joseph Cornell Portfolio—Catalogue* (New York and Los Angeles: Leo Castelli Gallery, Richard L. Feigen & Co., and James Corcoran Gallery, 1976).

3. Called *A Suivre* (for an inscription on the back that means "More is to follow"), the box was a gift to Motherwell from Cornell and represented Cornell's conception of or homage to abstract expressionism (Motherwell archives).

4. In a letter written to Jim Cohan and Arthur Greenberg on 26 July 1981, Motherwell said: *I remember once impatiently telling him, apropos a work that had not succeeded, that then the objects in the boxes had that morbid nostalgia of things that one finds in one's grandmother's attic, not knowing how he would react. To my surprise (because he was humorless), on the next several occasions in which we met, he would say with a strange smile, "Tell me about the attic again"* (Motherwell archives).

5. Probably for his first one-man exhibit at Kootz Gallery in New York in 1946.

"Provincetown and Days Lumberyard: A Memoir" 1978

Beginning in 1953, Motherwell spent most of the summer—from about mid-June to mid-September—in Provincetown, Massachusetts. It was there that he died on 16 July 1991. His first visit to Cape Cod had been in 1943, when Max Ernst, Roberto Matta, and other surrealist artists had discovered the particular quality of light and the relaxed social atmosphere exclusive to this village settled by Portuguese fishermen and harbored amid the dunes. These were the very attributes Motherwell would later measure against the pres-

sures he experienced after choosing instead to live during the remainder of the 1940s in the high-powered Hamptons of Long Island.

In the summers of 1961 and 1962, Motherwell and Helen Frankenthaler rented for their studios the main barn at Days Lumberyard in Provincetown. Among the works Motherwell produced in this prolific period was the *Elegy* (1961) now in the permanent collection of the Metropolitan Museum of Art in New York. It was also then that he began the series of oils on paper he called *Beside the Sea* (1962–1966). The evolving process in the making of the latter paintings and the artist's recollections of his years in Provincetown are described in the following essay, written at the Cape on 21 July 1978 and published in *Days Lumberyard Studios,* the catalog of an exhibition of works by artists who had worked at Days from 1914 to 1971. ■

I spent the summer of 1941 in Mexico with the Chilean surrealist painter Matta and his wife, where I formed (as one says nowadays) a relationship with a young Mexican actress, María Emilia Ferreira y Moyers, who sacrificed her screen test for the role of Maria in Hemingway's "For Whom the Bell Tolls" (ultimately played by Ingrid Bergman), to live with me. The summer of 1942 we spent in Provincetown; my dealer, Peggy Guggenheim, who had just married Max Ernst, was also here with him; the Mattas were in Wellfleet.

I still remember early that summer my parents from San Francisco bemusedly dining us all at the Colonial Inn (now Rosy), and my mother's distaste for María's being a Chicano; my father adored her. But after a lovely month or so, the FBI forcibly removed Max Ernst to the mainland as a German alien (though he was then a French citizen, I think, and certainly on the Nazi blacklist as a "decadent" modern artist). No enemy alien was allowed within fifteen miles of the seacoast by law.

Before Ernst was removed, I remember watching him in his studio, making automatic paintings on the floor, with a paint bucket wired six feet from the ceiling with a small hole in the bottom dropping black paint on to the canvas beneath, in splattered arcs, varying according to how widely and in what direction he swung the paint bucket hanging on its wire, a procedure far more limited mechanically in its rhythmic possibilities than Jackson Pollock's dance drips of the same period.

After the Ernsts left, María and I were rather isolated, carless, knowing no American painters here (I had begun painting seriously in New York among the Parisian painters in exile). Wartime blackouts at dusk gave Provincetown a somber silence, especially to strangers. Then the FBI visited us two, also. María had innocently written her mother in Mexico City about the sinking of the German submarine (off Long Point was it?). The FBI showed us her censored letter, cut up radically like square paper dolls, warned us discretion, and left. Then I received

in the mail an early number in the war draft. We married, friendless, in the beautiful old Universalist Church, so that María might become my legal heir.

In the hi-fi noise of Provincetown summers nowadays, the claustrophobic silent dark of those World War II nights here remains with me like a black stone. So does the Depression poverty of the town then—peeling paint, askew shutters, holes in roofs, primitive stoves, and occasional kerosene lamps—as well as my own poor means. I think we had six hundred dollars for the four-month summer. Going to the movies meant a tin of beans for supper. Most money went for rent and paint. But María happily sunbathed on the Bay while I struggled with painting inside.

After that summer I began to go to East Hampton, Long Island for the summer, where I had many colleagues—Jackson Pollock, Harold Rosenberg, the European surrealists (until the end of the war), Noguchi, Brooks, Matta, Rothko, and others—though by this time Provincetowners Hofmann and Adolph Gottlieb, as well as myself and two other artists, made up the core of the Kootz Gallery on Fifty-seventh Street in New York. In 1949 I drove de Kooning here from East Hampton, via the New London Ferry, both of us with devastating hangovers, he to meet his wife Elaine in Provincetown, I to give a lecture at Forum 49 at the Provincetown Art Association, on the New York avant-garde, I think, a lecture that Nat Halper remembers, but I do not, though it may exist somewhere. I do remember being struck by the simplicity and physical closeness of Provincetown compared to the status-consciousness and spread-outness of East Hampton; and in the mid-fifties, when I finally had a stable income from my professorship at the City University of New York, I began coming here regularly (with the exception of three scattered summers in Europe), always living within a stone's throw of Allerton Street, ideal for children.

Either one or two summers (I forget which), I had a studio at 4 Brewster Street, with the kindly Eulers as landlords. For the summers of 1961 and 1962, Helen Frankenthaler (to whom I was then married) and I rented the main barn in Days Lumberyard. In those years, the huge floors were undivided, and perfectly suited for the enormous formats of the paintings we both were accustomed to. The barn was beautiful to behold then, shingled, with arched barn doors on each floor (which I incorporated on the street side of my present studio-house at 631 Commercial Street); windows on all sides, with the radiant summer light of Provincetown that rivals the Greek Islands, because, I have always supposed, like them, Provincetown is on a narrow spit of land surrounded by the sea, which reflects light with a diffused brilliance that is subtly but crucially different from the dry, inland light of Tuscany, the Madrid plateau, of Arizona or the Sierra Madres in Mexico, where the glittering light is not suffused, but crystal clear, so that each color is wholly local in hue, as in the landscape

backgrounds of quattrocento Italian painting or in the late collages of Henri Matisse.

People tend to forget that Provincetown is (roughly) on the forty-two degree meridian, as is Barcelona and Opporto and Cannes and Rome (almost exactly) and Macedonia and Istanbul and Peking (more or less), a distinctly warm southern light compared to Northern Europe, a light as seductive to painters in the modernist tradition as geometry was to the ancient Greek philosophers and musicians, not to mention Mohammedan designers.

At any rate, the Days barn was filled with lovely light, and with clean, open, large, aged space. In 1962 I painted there one of my finest of the series of paintings called *Elegy to the Spanish Republic* (the one now in the Metropolitan Museum, New York); and also began a series of very free oils on paper, collectively called *Beside the Sea,* of which No. 22 is in the present exhibition about Days Lumberyard. Then I owned the old farmhouse on the Northeast corner of Allerton and Commercial Streets (No. 622). Catty-corner from it for sale was a c. 1900 tiny A-house summer cottage on the water, for which I was negotiating all that summer. The price was reasonable enough ($13,000 I think, i.e., $4,500 down payment), but it was owned by numerous heirs, each of whose share would not amount to much, so there was much hesitation and consultation. After painting at Days barn all day, in the late afternoon I would sometimes sit on the seaside steps of the unoccupied A-cottage, hypnotized by the ever changing tidal flats, hoping against hope that those beautiful thirty-three feet of bay side might end up mine, to convert into windswept studios for Helen and me, and into a beach house for my young daughters, Jeannie and Lise. The property (until 1976) had a massive concrete seawall, and, sitting dreaming on the steps, I used to be struck by the beauty, the force and the grace, at high tide with a strong Southwest wind of the sea spray spurting up, sometimes taller than a man, above the sea wall.

After a time, I began experimenting with *painting* the sea spray, at Days barn. I quickly discovered that I could not imitate the spray satisfactorily—as Arp says, "I like nature, but not its substitutes." It then occurred to me to use nature's own process: after all I was using liquid oil paint mixed in a bucket, not much more viscous than salt water. So, with dripping brush, I hit the drawing paper with all my force. There was indeed painted spray, but the physical force with which it was produced split the rag paper wide open. The next day, at Jim Forsberg's marvelous Studio Shop, I bought a package of five-ply (that is, paper sheets made of five sheets laminated together, tougher to tear than playing cards) Strathmore one hundred percent rag paper. I also made yard-long handles for my brushes. I hit the laminated paper with the full force of my one hundred eighty pounds, with the painting brush moving in a six foot arc—I remember the sensation as that of cracking a bull whip. An adequate equivalent of the pounding summer

sea spray appeared, in deep sky blue, on that lovely kid finish, creamy white laminated paper, *without* splitting or tearing, to my delight. I made thirty or so more . . . I write this now, sixteen years later, sitting exactly where I sat then, observing the savagery again of a sunlit summer sea driven hard at high tide by the prevailing Southwest wind against the massive bulkhead Bill Fittz built for me two years ago, following the structured principles laid down by the late Jimmy Thomas forty years ago.

My daughter Jeannie has her own studio next door, and if she lives to a normal age, she may be watching, beside the sea, the spray half a century from now. Summer people are never wholly accepted by natives, but that does not prevent us from absorbing the light and the sea air as deeply as any, almost into one's blood, certainly into one's eye and mind and painting wrist.

Excerpt from "A Conversation with Students" 6 April 1979

In the spring of 1979, the William Benton Museum of Art at the University of Connecticut in Storrs mounted "Robert Motherwell and Black," an exhibit composed of more than one hundred works in which the color black was important to their meaning and experience. In conjunction with the exhibition, Motherwell delivered a public lecture on 5 April, and on the following day he conducted "A Conversation with Students." Presented here is an excerpt from the conversation as it was published in the catalog documenting the exhibit. ■

Last night after the lecture, I was standing over there next to that huge black and white picture [*In Black and White No. 2*], and some middle-aged man came up to me and said, "exactly what does it mean" . . . or, "how do you go about doing it" . . . or, "what's the idea behind it." And, because we happened to be standing in front of it, which is really better than thinking inside my head, I looked at it and I realized that that picture has been painted over several times and radically changed in shape, in balances, in all kinds of things, in weight. At one time it was too black, at one time the rhythm of it was too regular, at one time there wasn't enough variation in the weights of the shapes . . . And suddenly I realized that each brush stroke is a decision, and it's a decision not only aesthetically:—will this look more beautiful?—it's a decision that has to do with one's gut: it's getting too heavy, or too light. It has to do with one's sense of sensuality: the surface is getting too coarse, or not fine enough. It has to do with one's sense of life: is it airy enough or is it leaden? It has to do with one's own inner sense of weights: I happen to be a heavy, clumsy, awkward man, and if

something gets too airy—probably though I admire it very much—it doesn't feel like my *self* to me. But in the end I realize that whatever meaning that picture has is the accumulated meaning of ten thousand brush strokes, each one being decided as it was painted. And in that sense to say, "what does it mean" is unanswerable except as the accumulation of all of these decisions [in] which, if it took two months to paint, my basic character has to be involved. I mean on a single day or in a few hours, I might be in a very peculiar state, or make something much lighter, much heavier, much smaller, much bigger than I normally would. But when you steadily work at something, your whole being comes out, in the same way that . . . what shall I say . . . if I were teaching students, I would like to teach them for two years and not just for a term . . . if I liked them! It really takes two years to get that close to what the essence is, if one ever does. It's the long haul that counts, and in that sense, all of these pictures to me—everybody talks about them as individuals, and they *are* in one sense—they're all sentences, or paragraphs, or slices from a continuum that has gone on my whole life, and will till the day I die.

TWO LETTERS ON SURREALISM

The following letters, the first written on 18 October 1978 and the second on 15 May 1979, were to Edward Henning, chief curator of modern art at the Cleveland Museum of Art in Ohio. Motherwell's esteem for Henning, as *one of the first museum people to "dig" abstract expressionism,*[1] inspired him to responses (letters from Henning obviously preceded) that were more considered than his usual matter-of-fact correspondence. Among other things, these *off the top of my head* thoughts nevertheless reflect the consistency with which Motherwell viewed the surrealist contribution to the development of modern art and the importance of the technique of psychic automatism to the genesis and development of abstract expressionism. ■

Letter to Edward Henning 18 October 1978

Dear Ed:

I want to tell you some things (off the top of my head) but would not like to be quoted.[2] (I think you know that I'm basically honest and even have some scholarly training and try to be as "objective" as possible, but at the same time as an actor in this particular drama, the other actors quite naturally resent one actor becoming the author as well.[3] Moreover, vested interests are always involved, since a place in history seems to be the prize of prizes and, since art history is so often written from the standpoint of influences and family trees, there is an almost irresistible impulse to falsify history by otherwise honorable

men.) What I'm going to say is also a résumé of something that is as complicated and subtle as Proust's novel and, to be truthful, ought to be written with as *many subordinate, qualifying clauses.* At any rate, here goes!

1) Surrealism's fundamental position was that art, like everything else in society, is an opiate for the public. The Americans, on the contrary, were united in a desire to make art. So there's a contradiction to begin with—parenthetically, Arp and Miró within the surrealists had parallel aspirations to the Americans. But *neither* was in America during the war.*

2) The surrealists were proselytizers, with a singular belief in the very young. (Many of their heroes—Rimbaud, Lautréamont, the early de Chirico, Seurat, etc.—made their main works at a very young age.)

3) Breton, who was the Mao of the movement, could not speak English, nor could Masson or Tanguy. Max Ernst, Duchamp, and Matta spoke English quite well, and therefore had much more connectedness with the American scene: all married Americans.

4) Matta was and is a hypnotic† proselytizer—he was still doing it at the Royal College of Art in London when I lectured there *last January*—and all to the good. I don't think he has ever influenced an artist artistically *as a presence,* except positively. For instance, it is my impression that in 1940 Noguchi was on the verge of becoming an art deco sculptor (like Paul Manship) when Matta turned him around. In the summer of 1940[4] I went to Mexico with him, and it was the turning point in my own development. It was his desire to make a "palace revolution" inside surrealism that made contacts between myself and Baziotes with Pollock, de Kooning, Kamrowski, Busa, and Hofmann. About 1943, he shifted Gorky from copying *Cahiers d'art* to a full blown development of his own (as well as running off with his wife).

5) Matta had a letter from someone—I presume Breton—to Paalen in Mexico City, 1940,[5] introducing us both. Paalen instinctively did not like Matta but did like me, so that after the summer I stayed on for several months near Paalen after Matta had gone back to New York. Paalen also wanted, on *other grounds,* to make a "palace revolution" within surrealism and was, in a year or so, excommunicated by Breton.

6) Matta's best work artistically then and perhaps always, were colored pencil drawings on Strathmore kid-finished drawing paper. They were as good in their way as Miró. His painting never compared with the drawings. (He used to say in Mexico that the difficulty with the

*I often read nowadays (in Kramer, e.g.) that Miró was.

†And charismatic.

Mexican movement was that they painted Indians instead of painting *like* Indians, meaning the bright colored popular art that in those days one saw everywhere.) The faded pink stripe of *Mallarmé's Swan* was a brilliant, intense magenta when the picture was made, incidentally.

7) The fundamental principle that he and I continually discussed, for his palace revolution, and for my search for an *original creative* principle (which seemed to me to be the thing lacking in American modernism), was what the surrealists called psychic automatism, what a Freudian would call free-association, in the specific form of doodling. (Just the other day I read a beautiful remark by Saul Steinberg: "Doodling is the brooding of the hand.") Psychic automatism has potent characteristics, a kind of Occam's Razor. A: it cuts through any a priori influences—*it is not a style;* B: it is entirely *personal;* C: it is by definition *original,* that is to say, that which originates in one's own being; D: it can be modified stylistically and in subject matter *at any point during the painting process:* for example, the *same original primitive doodle* in the hands of, say, Paul Klee, Tanguy, Miró, Baziotes, Masson, and Pollock, can end up as a Paul Klee, Tanguy, Miró, Baziotes, Masson, and Pollock, according to the aesthetic, ethic, and cultural values of each individual artist; E: in this sense I believe it is the most powerful creative principle—unless collage is*—consciously developed in twentieth-century art. The intelligent and honest use of it can only lead to the originality and to, of course, the limitations of one's own beingness. (One of the disasters of modernism for artists is equating originality with creativity.)

8) In this sense my own intuition is that the Masson–Pollock relationship is less an influence than a technical coincidence. Both were "peasant" types: vitalist, expressionist, eroticist, and lyricist by nature, and, in using psychic automatism, they were bound to overlap, though their differences show as clearly as their similarities. Actually I disliked the work Masson made in New York (1940–45) and continually exhibited, as being too thick and crowded with imagery, but, come to think of it, that is also characteristic of the Pollock of the early forties, whose principal influences (until he became aware of psychic automatism) were so far as I know Thomas Benton and the Mexican movement, both very crowded modes of expression, and both strongly and coarsely rhythmic, that is, expressionist. (In regard to expressionism, I prefer the clarity of fauvism, which is French expressionism and prior.)

Around 1943, Matta abandoned us, as is his wont. But by this time Peggy Guggenheim was aware of us, particularly Baziotes, Pollock, and myself; and I was carrying the insight to a new group of friends—Rothko, Newman, Gottlieb, and so on. Up at Bolton Landing, David Smith was drawing parallel conclusions on his own; that is, that the

*Which is also partly free-association.

painterly and sculptural qualities of the cubist period must not be abandoned, yet the surrealists were involved in a much more consequential and potent subject matter. His drawings are automatic, his sculptures collages, welded instead of glued.

I could go on and on, but history is not my primary function. However, I do think this scenario does account consistently for the artifacts themselves of the period (just as the presence of Mondrian, Léger, and Ozenfant in New York reinforced another tendency in abstract American painting).

I do think it has not been sufficiently emphasized that if modernism was a mainly French creation, North Americans (apart from Francophile Spaniards), have always been its strongest allies. For various historical reasons, I think modernism never was deeply rooted in the rest of continental Europe, or basically at all in Great Britain—I speak of art: poetry is another story abroad.

I have to dash off to the doctor now. I've a bum back. But I send warmest greetings to you all.

Rereading, would like to make every line above more specific and detailed, but haven't time—paragraph seven *was* worth the effort, the rest too simpleminded and general.

Letter to Edward Henning 15 May 1979

Dear Ed,

Apologies for not replying sooner to your letter of April 3rd. My whole family has had health problems all this winter; I have the most beautiful show of my life on at the Benton Museum at the University of Connecticut (ninety works filling the whole museum);[6] as well as two small shows that have just opened in galleries in New York, and half a dozen shows here and abroad coming up for the next academic year; and am overwhelmed. Not that it's not a lot my own fault!

One thing that strikes me about your letter is making aesthetic judgments after the fact [. . .] Of course, like you I prefer the mature Rothko and the mature David Smith, but neither I think would have matured with such depth without their early interest in surrealism. Or to put it more generally, it is a historical if not aesthetic error to apply painterly or sculptural standards to a position to which they were deliberately irrelevant. Since I wrote you, I've come across a book that is far superior to any previous book I know of in its comprehension of what surrealism is—I say this having lived daily within the surrealist milieu for several years. The book is by J. H. Matthews and is called *The Imagery of Surrealism* and was put out by Syracuse University Press in 1977. It is the only book on surrealism that I think really under-

stands it, including many of the French ones. What I'm trying to say is that if you read Matthews, I think you will overcome your aesthetic hesitations. To use a gross analogy, it would be as though someone rejected the concept of atheism because it is not a *beautiful* concept. I think one of the reasons Matthews's book is so good is that surrealism was primarily a spiritual and literary movement which, to exaggerate, the painters "illustrated," or did parallel works; but to approach surrealism through its visual works would be like trying to understand Marxism through *its* visual works, which is obviously the *least* effective way of understanding what Karl Marx actually thought. In my very first meetings with the surrealists, I used to ask Max Ernst to define surrealism a bit for me, and Max would point to André Breton and say point-blank, "Breton *is* surrealism," in the same way that one might point to Karl Marx and say he *is* Marxism. By the way, Matthews says in his preface: ". . . the surrealist poet Jean Schuster very rightly has stressed that the two best books on surrealist painting, André Breton's *Le Surréalisme et la peinture* and José Pierre's *Le Surréalisme,* 'complement one another in saying that surrealist painting is contained in surrealism and not the reverse.' "

I cannot tell you vehemently enough that the literature on surrealist painting has to be a gross distortion (as in fact practically all of it is) if it is approached from the standpoint of aestheticism in any way whatsoever. You know damned well that Breton's own definition includes the clause, "without a priori moral or aesthetic preconceptions." (I feel equally vehemently when, for example, I see voo-doo objects from Haiti or African spirit masks in a Mies van der Rohe or an Edwardian living room.) Even Picasso, who in my opinion is the greatest art critic of the century, during the surrealist period made his famous remark that art is not something made to hang over your mantel.

Therefore the Rothkos of the early 1940s are surrealist. As are aspects of David Smiths of the period. I think probably Noguchi wasn't. My impression is that Matta less converted Noguchi to surrealism than prevented him from becoming an art deco sculptor, since Noguchi has obviously always been a loner interested in architectural commissions (I hate all these oversimplifications of mine, but I can't write you a book). David Hare is more dubious. He had been an experimental photographer and I think became a sculptor very quickly: I remember him saying on numerous occasions in effect that the surrealists were right if only they would pay more attention to plastic values, an opinion which I myself instinctively shared, but knew to be an impossible contradiction, to the surrealists.

I think that Miró and Arp are the closest examples of everything I'm talking about. The work of both would be impossible without surrealism, but like the Americans, they also insisted on retaining "art." In this sense Max Ernst is *the* surrealist painter, a painter not particularly to my taste (though I love his sculpture), but who nevertheless over

fifty or sixty years has a consistency of quality and tone more even than any artist of the century; and I think this is not only because of his extraordinary courageous and intelligent character, but because he understood surrealism best, that is, surrealism when properly understood is inexhaustible, in a way that various kinds of formalism are not, witness any number of artists from Picasso to Kenneth Noland, and including Miró, who, in my opinion, was the most original artist in the world from 1924–1929, which is to say, at the height of his personally uncomfortable relations with the surrealists. Max Ernst used to tell me a story that the surrealists had actually begun to hang Miró for having gone to Mass with his devoted wife when one of them entered soberly—was it Giacometti?—and cut the noose before they could hang him. This event in itself shows how far the whole thrust of surrealism was from any kind of formalism or aestheticism . . .

My understanding of art history as scholarship is an effort to apply the scientific method to its subject matter. Any scholarship that does not subsume this art under surrealism and not vice versa is not only not scientific, but a lie, regardless of our own personal feelings. In a sense, surrealism was trying to make expressions that were identical with reality itself, as in more primitive times religious things must have so seemed to the communicants.

I learned the lesson myself when Breton would take the surrealist group into the junk shops and second-hand stores of Third Avenue of the early 1940s and force us to decide which objects were surrealist and which were not. I had always looked at such shops before aesthetically and I still remember vividly how one's mind felt twisted in the effort to overcome one's aesthetic conditioning—my mother's passion was antique-collecting, of which she was a master, and in accompanying her I had learned to look aesthetically or as a connoisseur. From a surrealist standpoint, that was to be a dilettante, a *castrato,* a blasphemy.

Notes

1. Conversation with the artist, June 1990.
2. Motherwell died before consenting to the publication of these letters. In the judgment of this editor and of Motherwell's Dedalus Foundation Literary Adviser, Jack D. Flam, they are of significant value and, in our estimation, contain no indiscretions.
3. Perhaps the most scathing criticism Motherwell received, other than the review by John Canaday (*New York Times,* 2 October 1965, p. 4) of his retrospective at the Museum of Modern Art in New York, was that from David Hare (*Art News* 66, no. 8 [December 1967]: 8, 10). In a wryly literary list of examples, Hare charged Motherwell with rewriting art history to his own benefit. The incident, totally unexpected and coming from a fellow artist, caused Motherwell considerable grief, as evidenced from his personal notes (Motherwell archives).
4. Motherwell meant 1941.
5. See note 4.

6. Motherwell was referring to the exhibition "Robert Motherwell and Black," which was held from March to June 1979.

"The International World of Modernist Art: 1945–1960"
May 1979

Motherwell wrote the following piece in May 1979 in response to a request from the editors of the *Art Journal,* a periodical published by the College Art Association. Presumably asked to formulate an "imaginary exhibition," the artist instead presented a *real* idea he had been considering for some time—an exhibition composed of postwar European and American art, to be viewed in juxtaposition. "The International World of Modernist Art: 1945–1960," as his essay was entitled, was published in the summer of 1980. ■

One immediately thinks of dozens of exhibitions, especially since they could be imaginary, that one would like to see. But I would rather stick to the idea of a real exhibition, one that, during the past ten or fifteen years, I have mentioned seemingly spontaneously on occasion, so that it must represent a deep desire on my part. As we all know, there is a more or less general assumption, particularly in New York but pretty widespread throughout this country and most sophisticated countries, that not only did American art blossom in an unprecedented manner during the 1940s and 1950s but, if one used the analogy of the Olympic games (inappropriate as it may be), that American art ever since is the undisputed world champion. Or, to put it the other way around, most of the generally admired artists in postwar Europe, such as Matisse, Picasso, Max Ernst, Miró, Giacometti, Henry Moore, Ben Nicholson, Marc Chagall, and so on, were already masters *before* 1939. The American assumption may be true. It certainly was the thesis of the late Harold Rosenberg, who even revived the phrase "Coonskins and Red Coats" in this context. But who knows?

The fact is that international art since 1940 is almost never seen together, nor in a detached way. At international exhibitions and biennials, the various countries are usually separated. In these same exhibitions the strongest representatives of these countries almost never happen to be chosen for the same year. Moreover, there is another division that is common in postwar international exhibitions, particularly in this country: to isolate Americans from *all of Europe.* This strikes me as strange, as if, say, Spain or France or Germany were isolated from the rest of Europe as well as from the United States in an international exhibition. I have the impression that the Metropolitan Museum in New York is planning a new wing, not of modern art, but of modern *American* art. In short, I cannot understand why there is not a show in which the artists who emerged after 1945, such as Dubuffet

and Soulages and Balthus in France, or Tapies in Spain, or Francis Bacon in England, are not shown side by side with whoever are their American correspondences (in Baudelaire's sense of the word).

Perhaps, as a painter, I should be ashamed to admit that I can only tell what I think in direct visual comparisons—in the presence of the actual physical works. I remember a couple of years ago mentioning the kind of show I am describing to the director of a major museum of contemporary art, saying that I would like to see, for example, lots of Franz Kline and Soulages side by side. He looked taken aback, protested, and said that such a comparison would be devastating. When I asked to whom, he replied Franz Kline! We all have our opinions, based on afterimages or photographs, but who has seen the two artists' work in depth side by side? I simply would like to see a huge show of, say, twenty-five painters from both sides of the Atlantic (and the Pacific for that matter) who emerged between 1945 and 1960—with at least a dozen works by each—in order to know that I think. All of us, in every country, cannot help being slightly brainwashed in favor of our own country, because most of what we read and view is stacked in favor of a host country. An example is the *Paris–New York* show at the Beaubourg in 1977. I also think it is possible to have a "fair" viewing. Certainly until 1970, when I moved to the country and my visits to museum exhibitions became rare, the Museum of Modern Art was international in its point of view, just as the Whitney by charter is devoted entirely to American art and just as the Guggenheim tends to favor foreign contemporary art (which is fine with me, since in this country, as in any country, native art in general gets more than a fair break). If one looks at the illustrations in any contemporary art magazine in any country or looks at the exhibition schedules of any country, one can easily guess what country it is by the preponderance of native artists.

In brief, though I usually do not consciously think in such terms and in fact regard all modern art as an art of individuals, I would nevertheless like to see if the mythical "triumph of American art" after 1945 is confirmed. This interest is obviously, in part, because I myself was fully engaged during those years; but I think that my interest transcends the personal. I would like to see with my own eyes, for better or worse, how the best artists emerging during the period in question look among their peers. As the world grows closer, I think many informed people have the same desire. Having had a dozen retrospectives abroad, consisting of essentially the same kind of work, I've been impressed by the extent to which my work is modified by the attitudes, light, architecture, and political and sociological situation of the country in which it is being shown. I am tired of hearing, of reading, and of segregation. I want to see collectively in depth the international world of modernist art, before it began to fragment in the late 1960s.

1980-1988

Letter to Yves-Alain Bois 13 October 1980

▪ In a letter of 13 October 1980 responding to questions about Mondrian posed by the art historian Yves-Alain Bois, Motherwell made reference to a large exhibit held in New York in the fall of 1942. "The First Papers of Surrealism" was among the first events in the United States sponsored by the surrealists in exile. It had been installed by André Breton with assistance from Marcel Duchamp, who had entwined the rooms of the Whitelaw-Reid mansion on Madison Avenue in sixteen miles of string. Prominently displayed in the exhibit were paintings by seven young American artists, William Baziotes, David Hare, and Motherwell among them. Motherwell's work (unidentified by title), possibly the first mature work he exhibited, appeared in a photograph of the exhibit installation.[1] Although the colors Motherwell used, lost to the black-and-white photograph, were not those of Mondrian's deliberately limited palette, the illustration of the work clearly reveals Motherwell's early debt to Mondrian.

Mondrian had come to New York City in the fall of 1940, coincidentally a little more than a month after Motherwell arrived to begin classes at Columbia University. Mondrian's first one-man exhibition in the United States took place in early 1942, and a few months later became the main subject of Motherwell's first published article.[2] Considering Motherwell's close association with the exiled Parisian surrealists, whose dogma was strongly opposed to abstract art, his instant conversion to Mondrian—to both his paintings and his theories—underscores his individual evolution as a painter. The subliminal influence was later strengthened when he edited Mondrian's *Plastic Art and Pure Plastic Art* for the Documents of Modern Art and came to discover ideas that supported his observation that Mondrian was not working in the constructivist tradition, as was commonly perceived. Instead,

Motherwell was to see Mondrian as a painter of the first rank and as passionate as van Gogh, an opinion he consistently maintained in his writings, lectures, teaching, and conversations. ■

Dear Monsieur Bois,

I have received your very interesting letter re Mondrian, and wish I had the time to write seriously and in detail on that fascinating subject, but I don't. —Then I thought, instead, of replying very briefly to the specific questions you ask me, but find even that not easy: for instance, your remarking that my attitude toward "the art of Mondrian might seem contradictory, as was, without hiding it, your beautiful article of *VVV* in 1942." —At that time I was moving mainly in the Parisian surrealist circle in New York City, whose own dogmatism was of course strongly antagonistic towards Mondrian's dogmatism, and for that matter against all abstract art. At the same time there was something about Mondrian's painting that penetrated my heart, so much so that in the famous huge surrealist show in NYC installed by Marcel Duchamp called "The First Papers of Surrealism," there is an installation photograph showing a very Mondrianesque painting in that show that has puzzled many art historians in later years, not realizing it was painted by me. (If the design is somewhat Mondrianesque, the colors are not at all.) Max Ernst's son Jimmy was present at that show and asked Mondrian what he thought of my painting. Mondrian replied to the effect that he thought it was a very good picture but "too tragic," which I was later to learn meant, in Mondrian's eccentric vocabulary, "too personal" or "too particular." —In short, Mondrian's painting affected me very much in 1942, but partly *against* my will or wish. But it was only later that I was to understand Mondrian's dogma, a point I will come to presently.

Seuphor[3] is correct that I was present at Mondrian's burial, an anonymous little grave in a huge anonymous cemetery on the outskirts of New York City, a graveyard very much like a military graveyard after a battle—row after row of the same size tombstones. I remember that the Dutch Consul-General to New York City gave an eulogy, as did Alfred H. Barr, Jr. —I vividly remember being shocked at the qualifications in Barr's eulogy, something to the effect—and perhaps I exaggerate—that though Mondrian may not have been a major figure, he was a sincere and devoted painter.[4]

Shortly after that, Mondrian's heir, Harry Holtzman,[5] proposed to publish Mondrian's writings that Mondrian had *written in English*—it was part of Mondrian's dogma to write only in the language of the country in which he happened to be living, which accounts for why some of the writings are in Dutch, then in French while he lived in Paris, and finally in English. —Holtzman proposed to publish the English writings in a series of small books by modernist artists that I was

beginning to edit for a German émigré bookshop in New York called Wittenborn—which I did. It was in editing these writings that I got to understand Mondrian's concepts for the first time. I enclose the brief, restrained preface I wrote in 1945 for that edition. My preface is more restrained and less personal than it would have been if it were not for the fact that Holtzman, as a disciple of Mondrian, was as dogmatically against the "personal" as Mondrian himself. (I should add, as a footnote, that *that* series of books ranges from Mondrian to Max Ernst, from Arp to Duchamp, from Kandinsky to Hugo Ball and Richard Hulsenbeck—in short, less my personal tastes than what I accepted to be authentic expressions within the modern tradition.)

During the fifties, I lectured each year on Mondrian, and, I think, was one of the few New York artists not in the constructivist tradition who always regarded Mondrian not only as an artist of the very first rank, but as a passionate one—as passionate as, say, van Gogh.

In the days after Mondrian's funeral I became aware, for the first time, of the phenomenon that I have seen repeated too often since, viz., that when a great artist dies, the living fight over his bones, so to speak: over "who knew him best," "who understood him best," and all the rest . . . I have never deviated in my belief these past forty years that Harry Holtzman had the most legitimate claim. (Mondrian himself must have thought so, in leaving his entire estate to Holtzman.)

To backtrack. I first met Mondrian in Peggy Guggenheim's gallery, where I had gone to see her about some affair of my own. (People forget now that her gallery was no different than present day contemporary galleries in that, apart from vernissage parties, there would rarely be more than several people present in the gallery at a given moment.) When I entered her gallery to talk to her, I was dimly aware that there was a man in a gray smock, such as a dentist might wear, working on a Mondrian painting. (New York City is always greatly overheated during the winter months, maybe twenty-five degrees centigrade, and Mondrian's thickly painted works often cracked under that very dry hot air that was universal in New York. And I presumed that the man in the gray smock was touching up some cracks in the Mondrian painting.) When Peggy introduced us, of course it was Mondrian himself, who seemed like a laboratory technician—scientific, immaculate, objective, reserved—who obviously wanted to continue his restoration, and visibly controlled his irritation at Peggy's 1920's American-heiress frivolity, in interrupting him to introduce a young nobody.

In those days, my closest friends—I speak now of, say, 1941 or 1942—among artists of my own age were Matta and William Baziotes (a now neglected early abstract expressionist). Baziotes and I both had very young, extremely beautiful wives. We discovered that Mondrian loved dancing (and loved Ginger Roger movies)—both of which did not seem to fit with his rather severe demeanor. Also, I think he preferred danc-

ing with someone else's wife, not with a friend of his own. —But as I remember, he danced very stiffly and awkwardly and seriously. Once one of us asked him, since he obviously liked pretty women, why he had never married. He replied that he never could afford to.

Apropos this last, at that time James Johnson Sweeney, the American art critic and museum official, was working on a book about Mondrian. So when I took on the task of editing Mondrian's English writings, I interviewed Sweeney and mentioned Mondrian's remark about not having enough money to marry. Sweeney told me that Mondrian said that in Paris he had lived on five dollars a month. I said, surely you mean a day or at least a week. Sweeney said no, Mondrian insisted it was five dollars a month. This still seems to me incredible, but Mondrian was certainly a very exact and truthful man.

In those days a small-sized Mondrian sold for about four hundred dollars. I tried to borrow the money to buy one, but could not. (I am not at all a collector. It was one of the few things I ever wanted.) You must remember that in those days a Vlaminck or a Raoul Dufy sold for thousands of dollars in New York.

I always felt that, though it was against his principles to create conflict or confrontation, *au fond* Mondrian deeply resented his relative lack of recognition; and have heard from someone who saw him in the hospital in his delirium, dying from pneumonia—in those days, during the War, penicillin was restricted to the army—that Mondrian openly cursed museum officials and critics of the greatest prominence, ones whose names I have promised not to reveal. There is no question in my mind that it is one of the few instances in New York in the twentieth century in which a major artist was treated as a minor one.

After Mondrian's death, I tried to persuade Alfred H. Barr, Jr. to, instead of buying a painting from Mondrian's estate, buy his small *studio itself,* with its red, blue, and yellow squares, and the thousands of pinholes in the white walls where Mondrian had obviously pinned the primary-colored squares again and again and again, in different configurations, and which, to a young artist, was a most moving and illuminating insight into his working procedures. As he himself used to say, he only painted pictures because he could not *afford* to do whole cities. The essential point is that what you call his dogma was not an aesthetic of painting, but in his mind an *exact representation of the ultimate nature of reality*.

Dear M. Bois, I wish I had some hours to write more completely and reflectively, but perhaps in just answering the few questions you have directly addressed to me, I have said enough . . .

Notes

1. William Rubin, *Dada, Surrealism, and Their Heritage* (exhibition catalog) (New York: Museum of Modern Art, 1968), p. 164. The work is probably the one that appears at the far right. The painting by Motherwell illustrated in the catalog *First*

Papers of Surrealism (New York: Coordinating Council of French Relief Societies, 1942) was *El Miedo de la Obscuridad* (1942), not the one illustrated in Rubin's book.

2. Robert Motherwell, "Notes on Mondrian and Chirico," *VVV* 1 (June 1942): 59–61.

3. Michel Seuphor, pseudonym of the Belgian-born Ferdinand Louis Berckelaers, twentieth-century art historian, who wrote on Mondrian and on modern art.

4. Harry Holtzman concurred with this opinion (interview with Holtzman, 1984).

5. Holtzman (1912–1987), who had been working in accord with Mondrian's neoplastic theories since the mid-1930s, had arranged for the Dutch artist's move to the United States and financially supported him for the remainder of his life here. Holtzman wrote the introduction to Mondrian's *Plastic Art and Pure Plastic Art* and, with Martin S. James, translated and edited *The New Art—The New Life: The Collected Writings of Piet Mondrian*, Documents of 20th-Century Art (Boston: Hall, 1986).

Letter to Guy Scarpetta 8 June 1981

In the spring of 1980, Motherwell privately previewed Picasso's retrospective exhibition, which filled the Museum of Modern Art in New York, and soon after was inspired to record his impressions. This extensive presentation of works by the artist who had strongly influenced Motherwell's development as a painter now brought him full circle to the early 1940s, when he had frequented MoMA to see *Guernica* (1937) and other fine examples of Picasso's work, especially *The Studio* (1927–1928).

On 7 April 1981, Motherwell wrote to Guy Scarpetta, author of the recently published book *Cosmopolitanism,* commenting: *by putting abstract expressionism in your larger context of cosmopolitanism, I think you have come closer to the essence of the aspiration of abstract expressionism than any writing I know. . . .* And Motherwell had added: *The reinforcement of nationalism, chauvinism, and patriotism is the crime of the modern epoch, and the relentless enemy of the modernist aesthetic, as well as of deeply humanistic values.*[1]

Scarpetta (who had interviewed Motherwell for the French periodical *Art Press* in 1977)[2] followed with a letter to Motherwell on 17 April, presenting the artist with five questions on Picasso, primarily to do with Picasso's influence on the abstract expressionists. On 8 June, Motherwell responded point by point to Scarpetta's questions.[3] Acknowledging that he could not speak for the others, he nevertheless summarized that, during the period in question, Picasso had been foremost in the minds of modern American artists. As a second response to Scarpetta's queries, he included the spontaneous and unedited notes he had made after viewing the Picasso retrospective. ■

Dear Guy Scarpetta:

I am sending you *two* different small responses to Picasso. One is a brief answer to your own five complicated questions, which are less

about Picasso as himself, than the reaction of my generation of American abstract expressionists to his work. (Obviously, I can only speak for myself to your questions; what I say about the other Americans are only my *impressions* of their responses.) —The second, even more brief piece, consists of some notes I made in November, 1980 and April of 1981, some months after I had a semi-private viewing of the enormous Picasso exhibition at the New York Museum of Modern Art, in the company of the art journalist, Robert Hughes, and (off-and-on that day) also with William Rubin, director of the Museum of Modern Art,[4] and director of the Picasso exhibition.

I

Now, in regard to your own questions to me:

1. I was living in Paris at the end of the 1930s when *Guernica* arrived in New York, and cannot therefore give an opinion on how the work was received by the future abstract expressionists. —I might however mention at this point, that European intellectuals seem generally unaware of how profoundly Marxist the intellectuals and artists of New York were during the 1930s—an epoch, to most Americans personally, as terrible psychologically as the years of World War II—and presumably *Guernica* would have been highly welcomed in that Marxist ambience, and perhaps its painterly virtues overwhelmed by its political importance, which, at that time, Picasso himself doubtless preferred as a public response.

2. During the 1940s and 1950s you ask about me, Pollock, Rothko, Newman, de Kooning, and certainly you should have added Gorky, in regard to discussions about Picasso. You mention the importance in those years of Matisse, and of surrealist "automatism," which I think is a mistaken impression. —A very important New York art dealer, of a caliber such as Maeght or Beyler, travelled all over America during the early 1940s looking at the work of thirty or forty artists who regarded themselves as influenced either by surrealist or abstract art. He (Sidney Janis) came to me last—maybe I was the youngest; I don't remember, and don't have the book that he wrote about his voyage of discovery—and when I asked him then (1942?)[5] who was the widest contemporary artist in influence, he said without hesitation, Paul Klee. But this may be owing partly to the fact that he was questioning both surrealists and abstractionists, and Paul Klee is certainly an artist whom *both* groups could admire. My own very strong conviction is that for modernists, Picasso *above all* was in the back of more painters' minds than anyone. The exceptions among the Americans that you name would be Rothko, a Matisse admirer, who used to say specifically that he thought cubism was a disaster; Newman who then was basically "a Sunday painter" in the minds of the rest of us; and myself, who was equally interested in *both* Picasso and Matisse. —I remember being on

a symposium at the Museum of Modern Art (1950?)[6] and Alfred H. Barr, Jr., then the director of MoMA, asking me from the audience whether I would choose first Picasso or Matisse, and my replying, perhaps too quickly, Picasso, because of his interest in death, as opposed to Matisse's interest only in life. —In my own opinion, in the case of Gorky, de Kooning, Pollock, and Matta (who was in our milieu in the very early 1940s), the interest in Picasso amounted to an obsession. Gorky was finally freed from Picasso by surrealist automatism; but de Kooning and Pollock to my mind remained *haunted* by Picasso, particularly Picasso's conception of the human figure. —The two Picasso paintings perhaps most admired by us *all* were highly formal: *The Studio* (1927–1928) in the collection of the Museum of Modern Art and *The Painter and His Model* (1928), at that time in the collection of Sidney Janis. —I might add that Americans were unknowingly somewhat misled about the *unvarying* greatness of twentieth-century European art because of the superb quality of the public collections in the New York area: the Museum of Modern Art, the Guggenheim Museum, the Katherine Dreier Collection, the Arensberg Collection, the A. E. Gallatin Collection, all on public view in 1940. (So many twentieth-century masterpieces could not have been seen on public display in all the museums of Europe in 1939.)

3. I imagine the main influence of Picasso on myself, unconsciously, was in the medium of papier collé. But I'm sure there are *many* other subtle ways that he influenced me, but almost always unconsciously, in the sense of an "afterimage."

4. [Scarpetta had asked what lessons could be drawn today from Picasso's work.] Technically speaking, on the level of feeling, the sheer *force* of the man; on the ethical level, Picasso's deliberate refusal to become totally abstract in the sense of Mondrian (the artist I would place next to Matisse and Picasso in twentieth-century Europe), and for which Picasso certainly had the capacity. (I am positive that this was a deliberate, knowing choice on Picasso's part.) Still, ethically speaking, that choice also led him to his greatest weakness, his romantic personality dominating the painting, as with Wagner, rather than the art dominating the biographical personality, as with J. S. Bach . . .

5. In relation to your last question, I have already published somewhere an observation on the phrase of Picasso that you quote, that if he runs out of blue he simply takes another color, criticizing it from the point of view of small children—(part of Matisse's greatness is his more profound connection with the art of children). If small children run out of blue, you cannot offer them another color as a substitute. They prefer on such an occasion to leave the painting unfinished, rather than use another color. But this is partly a semantic problem. By "color," children mean hue: blue, orange, green, etc. Picasso, as an adult, knows what most artists know—it was one of the principal objectives of mod-

ernism to destroy this position—that color is also tone, that is, various degrees of lightness or darkness, and that if the picture is primarily "working" in terms of tonality, then, yes, one can substitute for a given blue another color, *if it is of exactly the same tone* as the missing blue. —I am certain that Matisse would agree with the children, not Picasso.

So much for your questions, about which one could write a small book, if life were long enough!

II

I am giving you my notes on the enormous Picasso exhibition in New York, almost unaltered: the reader will have to complete them for himself.

1. His painting decline begins surprisingly early, 1940; but there are many exceptions, such as . . .

2. Sculpture remains of the highest quality throughout Picasso's life, ranking with Matisse and Degas sculptures—all three of whom I prefer to Rodin or Brancusi as sculptors. —The devastating surprise of the exhibition is that he invented collage *in sculpture.* The very first collage with chair-caning still works as a pure painting, but it is after making the metal sculpture of the "guitar," he discovers the real nature of collage—collage being the greatest invention of modernism—and then follows the incredibly beautiful series of papiers collés.

3. Leo Stein thought Picasso as compared to Matisse was an illustrator—partly true . . .

4. Overwhelming sense of the presence of *a man;* or, immediate contradiction, Colossus . . .

5. Changeability—styles, women, studios, friends, places . . .

6. *Guernica*—its full greatness can only be comprehended when it is surrounded (as it is at the Museum of Modern Art) by all the connected paintings, drawings, studies, etchings—

7. A book could be written on his attitudes toward women. (Since this note, one *has* been: *Picasso: Art as Autobiography* by Mary Mathews Gedo, The University of Chicago Press, Chicago and London.)

8. First painter as superstar in the universe of mass media—what problems! For him especially, also for us, his audience . . .

9. Nostalgia is the enemy of modernism. Picasso is filled with nostalgia, Greek legends, Roman pastorals, old lovers, acrobats, *saltimbanques,* historical costumes, the debris of Europe, academic Europe . . .

10. The dangers of an "artificial paradise"—The Côte d'Azur. Did anyone ever see Matisse or Renoir at the beach?

11. Drawing and graphics sustained to the end . . .

12. A primitive Spaniard living his life in sophisticated France. But

mainly keeps his ultimate existential truth to himself, trusting his instincts, like a clever animal, at the court of Louis XIV . . .

13. The clarity of his epistemology in regard to abstraction—*always* clear as to what degree of abstraction he desires in a given work.

14. His playfulness, sometimes touching, often ego-maniacal, if one thinks of Piero della Francesca or J. S. Bach . . .

Of the two responses, I have a slight preference for the second.

Notes

1. The letter is at the Motherwell archives.
2. "Les 9 ateliers de Robert Motherwell," *Art Press,* n.s., no. 9 (July 1977): 20–22. The interview was published at the time of the artist's retrospective exhibition at the Musée d'Art Moderne de la Ville de Paris.
3. Scarpetta translated the letter into French and published it as "Picasso par Robert Motherwell," *Art Press,* no. 50 (July–August 1981): 10–11.
4. William Rubin was director of painting and sculpture at MoMA.
5. Sidney Janis's *Abstract and Surrealist Art in America* was published in 1944; therefore, Motherwell's date could be correct.
6. Motherwell was referring to either "A Personal Expression" (19 March 1949) or "What Abstract Art Means to Me" (5 February 1951), both lectures presented at MoMA.

"In Memoriam: Anthony Smith" 19 October 1981

"In Memoriam: Anthony Smith" was written by Motherwell on 19 October 1981 and presented that day at a memorial service held for the sculptor in the Medieval Sculpture Hall at the Metropolitan Museum of Art in New York.[1] Motherwell had met Smith through Mark Rothko in the mid-1940s. ∎

Gargantuan desires, on every level. Greying warm brown grizzly bear, trained by civilization. Irish eyes often popping with drink, rolling with delicacy, of spirit and breeding. The Irish Curse. Temptations of St. Anthony. Well-named. —During the late sixties, at his birthday party, much drink. Mark Rothko sweating with abstinence, drink and tobacco forbidden. Because of his heart. Tony drinks more. Mark silent. Two of the deepest minds of the abstract expressionist generation, each in his private torture. As usual. I think now of James Joyce: *Beingless beings. Stop! Throb always without you and throb always within. Your heart you sing of. I between them. Between warring worlds where they swirl, I. Shatter them, one and both. But I stun myself too in the blow.* Will Tony start reciting Joyce? Don't remember. Often did. —Earlier, during the 1950s, lurching together on a train on the Connecticut shore somewhere. Tony had built a modern house there for an industrialist. Tony wanted a wall painting commissioned for me. Faint hope! Why me? "You are artistically the least naturalistic of us." (He had also wanted

to do a Roman Catholic chapel in East Hampton with Pollock's drip painted but figurative glass windows.) —Earlier, during the 1940s, Tony startles me, saying "The Museum of Modern Art is the greatest single disaster for American art." Then I remember. He had studied with Frank Lloyd Wright. Very conscious of America's possibilities. Big accomplishments. Tony was of an old New Jersey industrial family. The Victorian family house Tony kept all his life, though his beloved brother soon lost the family fortune. —His reading was universal, his appreciation too. And there is the incomparable good fortune of being born an American, in the twentieth, this tragic century. His "American" sculpture is universal, like ancient Egypt. Of all the great sculptors of the twentieth century he, and he alone in his works, could make surrounding buildings of whatever order seem like Hollywood stage sets. —When in Texas iron workers mistakenly and tediously cut up one of his monumental sculptures weighing many tons and threw the huge steel fragments into the river, he would roar with ironic laughter as he told of it. "In New York, at least they would have sold the pieces to a junk dealer," he observed. —Franz Kafka had gagged with laughter in Prague when he read his stories aloud to comrades. Tony Smith's sculpture is as intense as Kafka. As pointed. To speak of Tony as a "minimalist" is soft-eyed. The monumental "simplicity" of his sculpture is the reduction to essences of a complex mind and a primordially vital one. Shem the Penman! Tony the Scaler and Shaper! Careening through life, guarded by his wife Jane, as noble and patient as his vision was deep and persistent. God rest him at last, though at the last he fought. —One of the honors and inspirations of my life, knowing him. Nothing left except elegiac feelings. —The work will live its own life. Endurance built in. Time now to realize full-scale the remaining models. Time the river runs on.

Note

1. Among other speakers were Henry Geldzahler and William Lieberman.

Letter to Virginia Dorazio 26 January 1982

More than a year after Peggy Guggenheim returned to the United States from war-torn Europe in the summer of 1941, the American heiress opened Art of This Century, the unorthodox museum/gallery that she directed with advice from a coterie of artists and museum personnel. She began by exhibiting modern European art from her private collection and the work of exiled surrealist artists, many of whom used the gallery, located on Fifty-seventh Street in New York, as a central meeting place.

Apart from the importance it had to Motherwell and other American painters as one of the few galleries where they could see avant-

garde art at the time, over the next several years Art of This Century pioneered in giving William Baziotes, Adolph Gottlieb, David Hare, Jackson Pollock, Mark Rothko, Clyfford Still, and Motherwell their first one-man exhibitions. These exhibits were to mark the earliest consistent public introduction of work by artists later referred to as "abstract expressionists." In 1943, Motherwell showed collages at Art of This Century in an international exhibit of works in that medium, the first in the United States, and was included in the gallery's Spring Salon, which introduced several other young Americans. His one-man show was held there in November 1944. The gallery closed at the end of the war, when Guggenheim returned to Europe.

In the early 1970s, when queries about the 1940s began to arrive in his mail with some frequency, Motherwell received a letter from Virginia Dorazio asking about Art of This Century.[1] More than ten years later, he was returned his comments for review and, on 26 January 1982, amended his initial response. ■

Dear Virginia,

[. . .] The gallery was indeed shaped like an upside-down "U," and when you entered you were facing the left (looking south from Fifty-seventh Street) or east leg of the U, which was devoted to masterpieces of European abstract art—cubism, constructivist works, Mondrian, a magnificent white Picasso, and so on. Then the center part of the "U," facing south with windows, was the shortest gallery and where the temporary exhibitions were held. It was there that I, along with several other of the abstract expressionists, had our first one-man shows. The right hand, west leg of the gallery was designed by Kiesler[2] with a curved ceiling, like a Quonset hut, rather dimly lit, and filled with her superb collection of dada and surrealist art. Therefore, any artist having the current show in the south gallery was flanked on each side by the permanent collections of great abstract and surrealist art of the first third of the twentieth century. Obviously, any artist would be both delighted and honored to show in such a situation. (I hope this description is more clear than my 1971 version.)

The second point that I was trying to make was the informality of the gallery. Many of the abstract paintings were hung on poles, attached to the poles by a universal joint; and you not only could but were encouraged to actually take hold of the picture and move it for close examination or into a more desirable light.

I believe it was the first gallery where pictures (in the abstract section at least) were hung without frames. In short, it seemed to me that part of the intention of the gallery was to de-sanctify art, and treat it more like, say, books in the reading room of a library. —On the second page of the 1971 statement, what I was trying to say was that the audience for modern art was tiny compared to nowadays; and that

Peggy's gallery was deliberately *unlike* the first-rate galleries showing modern art such as Curt Valentin's Bucholz Gallery, Julien Levy's, Pierre Matisse's and Valentine Dudensing's, all of which were very professional. Hers, on the contrary, was more a mixture of a small private permanent collection that also did occasionally a bit of business in relation to whatever the small current show was.

When I say that I thought Mondrian was "a professional restorer" the first time I saw him, I meant that I entered the otherwise empty gallery while he was restoring one of his own pictures dressed in a long gray smock, and for some reason it never occurred to me that it was the artist himself. —In regard to him and Léger, I was trying to emphasize how much more regular and professional in their working habits they were in comparison with the erratic and more bohemian young American artists who I knew at the time.

The third point I am trying to make on that page is that part of the surrealists' ideology was a belief in youthful talent, such as Seurat or Rimbaud or Lautréamont or the early Chirico, and since Peggy was very close to the surrealist circle, she was as a result more interested in finding young talent than the other more market-oriented galleries were. —On the third and final page of the 1971 statement, one of the points I was trying to make was that she always made very clear to us American painters that she showed that she preferred Europe and European art, and that as soon as the war was over and it was possible to go back to Europe to live, she would, and in fact did.

The rest of what I say in the 1971 statement I would rather have omitted. All I really meant to say was that Peggy, as a modest heiress, was independent, and the gallery was her passion rather than her business. As a result the gallery had both an aristocratic and an unbourgeois tone, in a much more modest way something like the Phillips Collection in D.C. She was also intelligent enough to listen to the enthusiasms of the remarkable men who surrounded her, such as Marcel Duchamp, Max Ernst, Alfred Barr, and so on. (I say this in the context of being constantly astonished at how little art dealers tend to listen to the opinion of artists and their intimates, who seem to me to have more discernment. I think Vollard and Kahnweiler for example did listen to certain artists and created the remarkable galleries they did.)

Notes

1. Among other of her literary works, Dorazio was the author of *Giacomo Balla: An Album of His Life and Work* (New York: Wittenborn, 1969).

2. Frederick Kiesler (1896–1965) was associated with the surrealists in the 1930s and 1940s.

Motherwell's extensive exhibition activity of the late 1970s continued into the following decade. Along with numerous exhibits in Europe and his annual shows at Knoedler Contemporary Art in New York were a retrospective of his prints, which opened at the Museum of Modern Art in New York and traveled throughout the United States, and a comprehensive retrospective of his work, which opened at the Albright-Knox Art Gallery in Buffalo, New York, in 1983 and completed its tour of the United States at the Guggenheim Museum in New York. These years also brought him numerous honors and awards, in many cases requiring of him some form of acceptance speech.[1] During the 1980s, his writing greatly increased, much of it as correspondence responding to questions on the abstract expressionist milieu and artists who may have had some influence on it. One such letter, dated 4 February 1982, answered questions about Matisse.

Motherwell had first seen paintings by Henri Matisse at the Palo Alto home of Michael Stein in 1933, while he was a student at Stanford University. Deeply affected by the experience, he soon began to collect and read everything in print he could find on the French painter, including European periodicals, a rare Russian publication, and the monograph by Albert Barnes, an early collector of paintings by Matisse. He may not have seen another original Matisse work until he arrived in New York in the fall of 1940, but the impression had been indelibly set. All aspects of Matisse's work, particularly his use of unqualified color, especially black, were to influence Motherwell's own painting—ultimately to a degree greater than that of any other twentieth-century artist.

Motherwell's letter was written in response to a request from Bruce Grenville, a Canadian graduate student,[2] for information on his "interest in Matisse." Beleaguered by myriad such letters on various subjects, he procrastinated in answering an initial complicated letter from the student, but responded to a later more succinct questionnaire. ■

Dear Mr. Grenville,

Now that abstract expressionism begins to fade in the mists of time, I am besieged by scholars, so please excuse my brevity.

1. I took my undergraduate degree at Stanford University in Palo Alto, California. I first saw Matisse's paintings, aged about eighteen, at the Michael Stein house in Palo Alto, ca. 1933. After that, I very rarely saw an original until I moved to New York in 1940, though I must have seen at least a few during more than a year in France.

2. I read and reread an Albert Barnes long Matisse book. In fact, it was encrusted in oil paint when I finally gave it away. I also had the

Matisse number of *Cahiers d'art,* as well as a complete run of *Verve.* I also remember a small paperback printed in Moscow, attacking Matisse as a bourgeois. Also I think an issue of *Le Point,* also marvelous color reproductions in one of a series of books issued by the Braun Gallery in Paris. In short, everything I could find.

3. This question is the most difficult to answer and certainly the most important. [Grenville had asked Motherwell if Matisse was for him a "source of technical interest or theoretical interest, or both."] All I can say is, at the time, that is in 1933, I knew nothing of modernism except Cézanne, and with both of them [Cézanne and Matisse] I felt "a shock of recognition" or "an elective affinity" or however one would describe (to put it naively) love and identification at first sight. Everything I have said or written about those two experiences are rationalizations after the fact. In both cases, I did not have the slightest hesitation in my reaction or judgment—the Cézanne experience happened when I was about fourteen. That is, both experiences happened before I myself was a painter, and before I knew there was such a thing as modernism. I knew no artists. The only visual education I had had, apart from endless copying in pencil or charcoal of Baroque artists, was that my mother was a fanatical collector of eighteenth-century French Provincial furniture, and that for many years in San Francisco, at this time, we lived in a house whose ground floor had only French doors rather than windows. Finally, what confused me, since Cézanne and Matisse were both French, was that for some years I thought it was something particularly French that was attracting me rather than, as I now realize it was, the aesthetic of modernism. And yet, there may be something "French." The director of the Museum of Modern Art in the city of Paris, where I had an enormous retrospective in 1977, was here recently and told me that I had no idea of the continuing affect that show is having on very young French painters now. So maybe they felt a "shock of recognition" in reverse. But my own impression is that it is in Mexico and especially Spain that my work is understood in its own terms at first sight without intervention of any kind.

Going back to your second point, I think Greenberg exaggerates.[3] I still have a copy of Jerome Eddy's book on modern art which I think was published around 1915. In my opinion, at least off the top of my head, the three artists most deeply affected by Matisse in this country in my time were Mark Rothko, Richard Diebenkorn, and myself. It is interesting that all three of us grew up on the Pacific Coast.

I hope this is of some help to you, though I think my reaction is as irretrievable as it was decisive in turning me to painting as the love of my life. I am about to exhibit in several weeks my most recent paintings,[4] which are still partly indebted to Matisse, though this probably will not be noticed because they are mainly in black and white.

P.S. I should emphasize that I do not analyze other artists. I simply have a direct response or not, and any "influence" would be invariably via an "afterimage" rather than from technical or any other kind of critical analysis.

Notes

1. Of note are the Grande Medaille de Vermeil de la Ville de Paris; the Gold Medal of Honor from the National Arts Club, New York; the Medal of Honor from the MacDowell Colony, Peterborough, New Hampshire; the Medallo d'Oro de Bellas Artes from Madrid, Spain; the Centennial Medal from the Graduate School of Arts and Sciences, Harvard University; and the National Medal for the Arts.

2. Bruce Grenville had written from the art department at Queen's College, Kingston, Ontario, on 20 January 1982 (Motherwell archives).

3. Motherwell was referring to Grenville's quotation from a letter from Clement Greenberg in which the critic, responding to the student on the same question ("the type of literature you read concerning Matisse's painting and theory . . ."), stated: "There were no *texts* on Matisse that were of any real consequence to anybody during the formative years of abstract expressionism. . . ."

4. Most likely, Motherwell was referring to his exhibition at Knoedler.

Letter to Ann Louise Coffin McLaughlin *29 September 1982*

A few years after William C. Seitz died in 1974, Harvard University Press in Cambridge, Massachusetts, decided to publish "Abstract Expressionist Painting in America," the dissertation that the aspiring art historian had submitted in 1955 for his doctorate in philosophy. In the nearly twenty-eight years since it had appeared as a typewritten text until it was published in 1983, the work maintained an underground reputation as a rare firsthand account of the artistic movement. Seitz, himself a painter (and later a critic, teacher, and museum official), had concentrated his study on six painters, Motherwell among them, using interviews with several of the artists to explore his thesis.

Motherwell had been asked to write a foreword for Seitz's book in 1979; he completed and signed it on 29 October of that year. Nearly three years later, he received a letter from Ann Louise Coffin McLaughlin, senior editor at Harvard University Press, proposing certain changes in what he had submitted. Surprised that the project was still alive, the artist responded on 29 September 1982 in a letter of many purposes. Primarily to expedite a task he felt he had long before completed, he agreed with most of the editor's suggestions, but could not refrain from defending his stylistic preferences against the standard editing process, which, he felt, often obscured artistic meaning in its insistence on proper language. ■

Dear Mrs. McLaughlin,

Thank you very much for your letter of September 20th in regard to Seitz. I had begun to think that I had imagined the whole enterprise, especially since at the time of writing my little foreword, I was given a very brief deadline. From my standpoint two and a half years later, nothing had advanced. I am glad the project is still alive.

I think you have done a beautiful job of editing, and I agree with all three of your editorial suggestions in the third paragraph of your letter. But as you say in the same paragraph, I "don't feel like looking at the enclosed manuscript ever again." I prefer, if you are willing, that you cut down the overused words, omit italics, as you see fit, and change the punctuation as well as omitting the first epigraph. Even though the first epigraph is one of my main themes.[1]

I know that I am not a good narrative writer. I am more a collage maker, such as in my introduction to the *Dada Painters and Poets.* I have no sense of transitions. Moreover, my foreword is not only about the pioneering value of Seitz's work, but is also a general argument that art scholars see works from one perspective, and painters from another, and that Seitz saw from both. For instance, one of the best books I have ever read on modern art from Constable and Turner through the impressionists down to Bonnard is by an English painter who is a Royal Academician and who talks only about the technical methods employed.

A few explanations: It is difficult for me to edit my own writing because so many memories and images arise in my mind I cannot focus on my language. That is why a superb editor such as yourself could do the job better. A second point. I picked up the habit of the three dots from Paul Valéry, indicating in his case that much more could be said; and from Céline who uses the three dots to indicate the rhythm, the hesitation, the free association, the disconnectedness of normal human speech: very few Americans speak the Queen's English [. . .], as everyone who has been tape-recorded realizes to his dismay. In my case, either I have to completely rewrite a tape recording into literate prose; or if I use the three dots by the handful, as Céline does, the horrible transcripts lose most of their awful character. In short, the three dots are used as intervals as in musical notation but such a method is doubtless inappropriate in introducing a scholarly work, and can degenerate into mannerism. I use punctuation eccentrically because I am so visual. My writing greatly improves if I write on fine drawing paper and pin the pages on the studio wall as though they were a series of drawings. But cold print is a different kettle of fish. I could not agree more with your implication in your various notes, that emphasis is everything. But if what I am trying to say in the foreword is clear enough about where the emphases should be, I would be delighted if someone else did it.

The basic problem in most publishing is standardizing—typography, punctuation, grammar, paragraphing, house styles, and so on. My creative life has been spent doing the opposite. It is for that reason that editing (though I have done a lot of it, maybe thirty books) is so difficult for me. From this standpoint perhaps I should not be the writer of the foreword, except that I also happen to be the living witness. If I were publishing the book I would make my foreword typographically quite different from the rest and perhaps not call it a foreword, but an appreciation or homage or something of that sort. But let me emphasize that I am perfectly content to give you carte blanche editorially. I have the deepest respect for everything you have suggested.

Note

1. This was a quotation from Martine de Courcel's *Malraux: Life and Work* (1976): "Basically he is disliked by *anyone who is a professional of any sort;* he is considered as a cheat and a marginal man. He is a bit like those young Spaniards called *'espontaneos'* who jump unauthorized into the bullring, but Malraux kills the matador's bull and the matador is left looking a trifle ridiculous" (Motherwell archives).

Foreword to William C. Seitz,
Abstract Expressionist Painting in America 1983

William C. Seitz's analysis of the fundamental premises by which abstract expressionist painting developed had been written in the early 1950s, when the art produced by the American avant-garde artists he had chosen to study—Willem de Kooning, Arshile Gorky, Hans Hofmann, Mark Rothko, Mark Tobey, and Motherwell—still met with public controversy. By concentrating on "technical, aesthetic, philosophical, or ethical" aspects of the work of the six artists, Seitz avoided historical generalizations. Through attention to specific artists and ideas, he hoped to find "the nature of their milieu." For Seitz, the period between 1944 and 1954 marked "a fundamental transformation in American painting . . . when it joined the mainstream of western culture." Further, this art no longer followed a temporal succession, since, unlike that of previous art, its subject matter utilized the entire history of civilization and included the objects of all cultures. Modern art was international (and here, as in numerous instances, Seitz quoted Motherwell) *in the sense that it is a natural consequence of dealing with reality on a certain level.* Assisted by interviews with some of the six artists (Motherwell and his writings were ubiquitous), Seitz provided an empathic and inimitable account of the decade well before the dust had settled on it.

Abstract Expressionist Painting in America was published in 1983. Dore Ashton wrote the introduction. Motherwell had written the foreword on *29 October 1979,* shortly before the book was initially scheduled

for publication. It is presented here (with editorial revisions made in 1982) as it appeared in the volume. ■

1980–1988

> The supreme temptation for the philosopher of art, said Paul Valéry, is to discover the laws that will make it possible to know with *absolute certainty* (and it was he who underlined the words) which paintings and sculptures will be admired in a hundred years time. To which Picasso replied that art philosophers had the souls of picture dealers. In a civilization that regards posterity as hazardous, Valéry's "absolute certainty," the fight against chance, becomes as absurd and as invincible as the desire to escape from death.
> Which of us does not dream of catching posterity red-handed? André Malraux, *Anti-critique* (1976)

Until now William Seitz's book has existed for some twenty-eight years only in a few, poorly microfilmed copies of the typewritten original, a dissertation submitted in 1955 to the art history faculty of Princeton University for a doctorate of philosophy. As one of the book's protagonists, and as one of the originators (in various ways) of that "movement" in painting that is Seitz's central subject—abstract expressionism—I reread now his volume with mixed and intense emotions, with a strange sensation that is more than that of an old artist reading about the deeds and attitudes and colleagues of his youth. Is it a Proustian sensation? No, not at all. Proust was remembering the past. Here is not the past recaptured, but the *past as present*. And in all its problematic immediacy . . . *something that can never happen again!* For though present and future art critics may be "Prousts" in scholarly reconstruction of this earlier period, they will undoubtedly transform it, as Proust himself did with reflection.

Artists, while this book was being written during the early 1950s, were themselves asking what voyage we had been embarked on for the past ten years, one that had become known as abstract expressionism, an adventure that was, as Alfred H. Barr, Jr. told me several times, the movement most hated and feared by other artists and by the art public in American art history, even though its works were beginning to be respected and becoming influential among artists abroad. But self-consciousness, that enemy of creation, and epigones were already appearing by 1955—indeed, at this moment it seemed that half the jokes at the old Cedar Bar were in a pseudo-Dutch accent, homage to the growing de Kooning personality cult, as well as a reflection of the withdrawal to the East Hampton countryside of the deeply depressed Jackson Pollock, shortly to die in his automobile in 1956. (If Pollock had been accessible to Seitz, he would have been, I presume, one of this book's key figures—perhaps in place of Mark Tobey, who alone of the six was not a member of the new New York scene.) With hind-

sight of course anyone can question the choice of Seitz's particular six "key figures." But it is easy to forget that it was only after 1950 or so that the mature Kline, the Newman, the abstract Guston so familiar to us now, made their appearance, as does a whole second wave of artists. I presume that Seitz was sticking to artists with a longer abstract expressionist history, going back to the very early 1940s. Or perhaps certain artists, say, Clyfford Still or Adolph Gottlieb, refused to see him. Who knows? Or perhaps Seitz had a six-pointed schema of extremes, which each of his chosen artists fitted characteristically. Part of his fairness was not to violate each artist's individuality, despite the general phrase, "abstract expressionism." Or perhaps these six *were* indeed his choice, with the unfortunate exception of Pollock. In my own case Seitz was hesitant about a brief "nude" series of 1953, and just before he finished this thesis, I abandoned it, destroyed most of the paintings, and began—all in 1955—the *Je t'aime* series, the note on which, if either of us had known, my representation here should have ended.

Subsequent art history makes most original artists seem more sure than they were at the time. In the early fifties a certain initial confusion, compounded by the growing number of followers at second hand, yielded the verbal confusions which were then becoming ubiquitous. This situation partly motivated Seitz's desire to go directly to the paintings. Thus, his study became a stunning effort to clarify the actual nature of abstract expressionism, a thorough but broad critical analysis of not only what we artists were saying, but more importantly, were *painting,* the central issue. In this respect Seitz's book remains unsurpassed. For he was not only a skilled scholar inspired by such superb predecessors at Princeton University as George Rowley and Alfred H. Barr, Jr.; Seitz was a talented, practicing painter. This extraordinary circumstance cannot be emphasized enough. It is the sine qua non of the several other elements that, taken together, make his book a classic—not only in the literature of abstract expressionism, but also sui generis in the scholarship of modernism.

It should not be forgotten that often the main emphases in graduate departments of art history are on iconography, cultural symbols, attribution, and historical artistic borrowings and influences, all highly relevant to the art of the past, but less so in the case of twentieth-century artists; a century that has seen, generally speaking, iconographic subjects assume less and less importance with the rise of abstraction in regard to its leading artists, a century which does not employ a tribal iconography for the most part (being an art of individuals, whose principal conquest, perhaps, has been the realm of subjective feeling), showing on a stage where the principal influences on any contemporary artist are more or less obvious, and where nearly every work can be authenticated. One might argue that traditional art history training in certain respects gets in the way of scholars of modern art, that the

method implies as natural taking-off places ones that are not only inadequate, but even misleading.

I remember, ten years or so ago, speaking at the request of the advanced students at the famous New York Institute of Fine Arts, a citadel of impeccable art historical methodology, one block from New York City's Madison Avenue with all its art galleries, and discovering to my astonishment that no one could remember when, or even if, another artist had spoken within those academic premises. Here were scores of art scholars who had never heard an artist talk, let alone had frequented an artist's studio. Yet I would suspect that the structural methods and tools of most painters and their studio routines have changed less during the past five centuries than those of any of the arts. I do not mean here to malign art scholarship, I mean only to emphasize that his intimate studio knowledge as a practicing painter equipped William Seitz uniquely to deal with a contemporary art movement whose very character resisted and, in the end, *could not yield its essential nature*—or natures, the more individualized the matter was treated—to traditional art scholarship, a method better suited to more peripheral discoveries, for example, the reason for a given title.

The core of Seitz's book, Chapters 2 through 6, is a detailed examination of what happens in each of his painters' work in those painterly means that painters themselves think in, consciously or not. By painterly means I mean something more than sheer technique (on which Seitz is masterly), but in no way divorced from it. I open Seitz's manuscript at random, encountering: "the spirit in which the extreme abstract expressionist painting is begun can be summarized thus: shapes, colors, and lines are placed on the canvas with the least possible premeditation, their initial form and juxtaposition dictated by various levels of the sub-, un-, or semi-consciousness—by unplanned inspirations, by sheer fortuity, or by the inherent nature of the medium. Here is a disorganized but vital complex of raw formal data—an uncoordinated 'unknown,' a Heraclitean flux which the painter during subsequent phases of the process relates, alters, and organizes on the basis of a mediating set of attitudes and principles which runs through his works, and even through all of his life. In direct contrast with the purist point of view, predetermination of goal is regarded not as an essential discipline, but as a danger. 'The question of what will emerge is left open. One functions in an attitude of expectancy.' Motherwell and Harold Rosenberg quote Juan Gris's statement: 'You are lost the instant you know what the result will be.' "[1] This passage jerks back from time the freshness, the anxiety, the devotion, and the risks each artist in those days carried in his own way and also implies memories of the very look of each artist's studio then, scattered with the debris, like autumn leaves, of work in progress, of human nature working on a "disorganized but vital complex of raw formal data—an uncoordinated 'unknown.' "

With *known* criteria, the work of the artist is difficult enough; with no known criteria, with criteria instead in the process of becoming, the creative situation generates an anxiety close to madness; but also a strangely exhilarating and sane sense too, one of being free—free from dogma, from history, from the terrible load of the past; and above all a sense of nowness, of each moment focused and real, outside the reach of the past and the future, an immersion in nowness that I think non-creative persons most commonly parallel in making passionate love under certain circumstances—or perhaps in their dreams, where one knows there are meanings, but meanings so charged and so ambiguous, so transformed and cryptic that one is astounded by one's own imaginativeness and richness of connections, and frightened too.

On a more limited, technical level, note the precision with which Seitz uses the scientist Katz's 1911 treatise on color to arrive at an accurate description of each artist's individual attitudes toward color. From the concrete directness of some of the artists' color to the *mysteriousness of* Rothko's color effects, all is made plain: I know of no "poetic" or "religious" evocation of Rothko's "film" color so accurate empirically and, at the same time, so eloquently evocative of the actual appearance of Rothko's unique masterworks in color. Or the lucidity of Seitz's discussion of "Area, Shape, and Plane" where, beginning quite matter-of-factly with a discussion about what can happen on a picture plane, by the third, short paragraph he has arrived at this summary: "If the case is equivocal . . . is unstable and one cannot clearly separate image and ground—the effect gains the *ambiguity* [Motherwell's emphasis] so important to the modern aesthetic." Only someone used to *making painting* can move so clearly and fluidly from practical possibilities to ultimate aesthetic "effects" (in Poe's and Mallarmé's sense) and the moral vision implied, a vision in the case of abstract expressionists that is perhaps an ambivalent humanism, strongly against entrenched dogmas, aesthetic, moral, religious, or political, but strongly for *presences* and possibilities—possibilities of truth to experience that a real man, a whole man might feel less ambivalent about than our sickeningly rich inheritance of clichés, politics (right or left), God or not, art or anti-art, and all the rest.

Seitz does have difficulty in finding an essential abstract expressionist manifesto, but the very nature of a manifesto is to affirm forcefully and unambiguously, and not to express the existential doubt and the anxiety that we all felt. Certain kinds of paintings are easier to describe and to evoke (and perhaps to make) than others: van Gogh more easily than Cézanne, Picasso more easily than Matisse, surrealism more easily than abstract expressionism (one that is certainly very difficult). For more than thirty years contemporary art criticism has been strewn with failures to interpret abstract expressionism adequately and accurately not only because of faulty methodology, but often deliberately (in New York City) because of personalities and art politics.

But very early on William Seitz succeeded. He modestly noted at the beginning of his preface that "whatever unique qualities this book may have . . . arise in part from the fact that it combines the viewpoint of a painter with that of an art historian. If such a blend can constitute a method, it lies in an attempt to reconcile empathy with fact." He did just that, with the factuality of a fine scholar and the generosity of spirit of a creative mind, whose true satisfaction comes not from recognition of self but of the work. To have accomplished this so soon, without historical distance from his subject, is creatively nothing short of the category of the marvelous. But then we are confronting a man whom Leonardo himself would have understood across the centuries when Seitz wrote to his own art dealer, Marian Willard, also the dealer of Tobey and David Smith, during the period he was writing this book and no doubt thinking of himself: "the fact that the artist paints in what seems to be an automatic manner does not in the least imply that his theories, his ethics, his ideals, and his cynicisms, are not involved. The more he can both broaden and intensify his knowledge, empathy, and cognizance of the world and himself, the richer is the raw material which gives meaning to his paintings. I cannot believe that the humanist scholar and the artist must, by definition, be separate. The barrier which has arisen between their twin approaches toward the truths of existence is one of the sad phenomena of modern life. Intellect, emotion, and sense need not be separated."

With his completeness of view, perhaps Seitz has indeed caught posterity red-handed.

Note

1. Robert Motherwell and Harold Rosenberg, Editorial Preface, in *possibilities 1: An Occasional Review,* Problems of Contemporary Art, no. 4, ed. John Cage, Pierre Chareau, Robert Motherwell, and Harold Rosenberg (New York: Wittenborn, Schultz, 1947), 1.

"Remarks" 30 October 1982

On 30 October 1982, Motherwell participated in celebrations in New Haven, Connecticut, marking the 150th anniversary of the founding of the Yale University Art Gallery, the oldest college art museum in the United States. For the occasion, he delivered a brief talk, along with Alan Shestack, the director of the gallery; Henry J. Heinz II, the chairman of the gallery's governing board; and A. Bartlett Giamatti, the president of Yale. Motherwell's remarks and those of the other participants were soon published by the gallery in a booklet.

Motherwell, who later described his Yale talk as *indirectly on the transition from WASPism to modernism,*[1] began his presentation by acknowledging his transcendence of a cultural inheritance much like that of his

"preppy" audience to membership in a society of universal scope—that of modernism. Taking obvious pleasure in thus disconcerting his audience, he later used the same approach in lectures at two other venerable institutions.[2] ■

One of my compulsions is to leap before reflecting. This characteristic sometimes works well enough in the studio: probably some of my best painting originates from the painful process of digging myself out of some abyss in the surface of a canvas into which I had jumped without due premeditation. As Degas more wisely says, a painting actually should be planned as carefully as a risky crime. Having impulsively accepted speaking here tonight six months ago, I find myself extremely uncomfortable this evening. It is not that I am not like (presumably) many of you, a "preppie," an Ivy-Leaguer, and an Episcopalian, by birth and education; and now a citizen of Connecticut: in short, a member of a certain social tribe. My point is rather that I have spent half a century trying to transcend this inherited parochial background—without disclaiming it. At my age I have seen, as Marcel Proust did in the last volume of *Remembrance of Things Past,* how empty so much of that world that I grew up with is, how naive I was to take it at its own self-evaluation! I had to leave it behind, when I came of age, in the interests of a more international and universal tribe of intellectuals and artists whose most serious works of art (with few exceptions—usually of a popular order) fall under the umbrella of the aesthetic called modernism. It is about this last that I should like to speak for my allotted twenty minutes, despite my ambivalences. After all, I do like my studio-home, and Connecticut, adjacent to New York City, is a fine place for it.

Modernism, which represents for most persons the most difficult art movement to get a handle on, even though it is our own historical creation, began, in large part, as a critical act, as a rebellion against that academic nineteenth- and twentieth-century art so beloved of not only the leisure class, but as it turns out, also the working class, an art of storytelling, sentimentality, religion, portraiture of eminent individuals, animals, domestic or romantic landscapes, historical subjects, flowers, and above all, especially in the nineteenth century, an art of what might be called "moral uplift," of which, by the way, Colonel John Trumbull[3] was a practitioner. The modernist critical act, accomplished by the most serious and intelligent painters and sculptors of our own twentieth century, as well as poets, novelists, and musicians, involved not only getting rid of the worn-out baggage of officially and institutionally acceptable current art; but also, conversely and more positively, became a new investigation into what constitutes art as art—how it differs from more or less competent conventional art, whose

main virtue and pathetic flaw is its kitsch: sentimentalized subject matter. As Alberto Giacometti remarked, Cézanne set off a bomb when he painted a head as though it were like any other object . . .

To greatly oversimplify, Matisse was one of the first in the twentieth century in the modernist investigation, with his concept of intense colors as independent forces (in regard to what was being represented); Picasso and Braque, in stumbling on cubism and, above all, on the collage, reaffirmed that painting is after all a flat surface, on which components of everyday life—in their case, studio life—need not be imitated in order to show off technical virtuosity, but could be instead incorporated literally onto the picture's surface, thus recovering an effect of "purity" and directness of feeling that we hadn't seen since the early Renaissance; and Constantin Brancusi, in opposing the virtuoso aspects of Rodin and others in marble, was one of several artists to set in motion a pervasive *atavism* for prehistoric or primitive art, which runs like a leitmotif through most of the serious art of the twentieth century. Primitivism cannot lie in its innocence, cruel as it often is, whereas kitsch is a lie, a self-deception—this last being the true subject-matter of psychoanalysis . . .

One of the consequences of this almost "scientific" modern investigation by modern artists (even though its ultimate criteria are feelings, not repeatable verification) has been an increasing attraction toward abstraction in modern art, as you all know. If I had the time, I could give you a small digression on what abstraction is, its nature and function. But there isn't time enough now. Let me instead add a sociological remark that, for instance, with nothing in their social, cultural or historical situation to support it, how striking it is that artists of a certain caliber behind the Iron Curtain are irresistibly drawn to abstract art, even via, say, inferior reproductions. Love at first sight! I felt it myself at age fourteen, when I saw my first late Cézanne, also in reproduction.

The accomplishment of what naively could be called "total abstraction"—actually there is no such thing, nor the possibility of it, by definition—in my opinion (though again I know of no one who has dealt with this notion), is conceivably moving toward a new pictorial language, drawing on a strange mixture of modern abstraction in getting rid of the baggage of the past, Oriental calligraphy, the art of so-called "primitive" societies, and on our own century's increasing interest in the role of symbols and signs, all expressions that may be closer to the categories of the human mind as it perceives reality—"Categories" in the German philosopher Immanuel Kant's meaning—rather than "naturalistic" conventions for representation. I do deem it likely that music, when it gave up words, whether in a chorus or a mass or lyrics, already had made a parallel leap, on occasions. No one knows how to describe adequately in words the content of a late Beethoven quartet, a Bach fugue, or Bartok's "Concerto for Two Pianos and Drums,"

whose world premiere I heard in Paris (with a tiny audience) in 1938. But no one questions that all this music is charged with content of the highest order. Wittgenstein spent a large part of his time at Cambridge in England demonstrating that, at the point where things become most "interesting," logical description fails us. With Shakespeare, in such "interesting" situations, his characters resort to poetry. Kierkegaard maintained (not without a certain irony) that Mozart's opera *Don Giovanni* is the perfect work of art, because the only thing imaginable that could enable Don Juan to be irresistible to 1,001 women has to be Mozart's musical voice, Mozart's music, that most ravishing of human expressions . . .

But in speaking of Mozart or Shakespeare or Far Eastern calligraphy or "primitive" sculpture, we are referring to rather closely knit, traditional societies, or, as I prefer to say, for the sake of vividness, tribes. Tribes with generally accepted mores, religions, class structures, symbols, signs, common perceptions and blindnesses; but also, in short, with a more or less general consensus in regard to their values. Set in the Spain of the Holy Inquisition, we are not in the least surprised that Don Juan is dragged down to hell in the stony grasp of the Commander. We must expect it. But we don't expect any such thing nowadays with a rock-and-roll star, or with Hollywood. All of us are increasingly conscious of the ever developing dissolution of our Western tribal mores into, on the one side, "a herd of individuals,"[4] and, on the other side, a small group of solitarily independent and creative individuals. This latter creative individuality, carried near the breaking point, is the cutting edge of modernism, whether it be in James Joyce or Franz Kafka or Igor Stravinsky or Jackson Pollock. The only possible audience for such individual creators are those relatively few others who experience with such works a shock of recognition . . . And yet, paradoxically, it is our individual creators who, far from being nihilists, as the traditional tribe often thinks, especially when it is authoritarian, are making the most sustained, intelligent, and radical effort to find adequate expressions for the perceptions, insights, and enormously broadened background of the modern mind. This task could take centuries. It took thirteen centuries before Dante in the *Divine Comedy* or the early Gothic cathedral builders were able to integrate expressively the world-view of Christianity. Seven centuries later, we know that the unconscious has no religion, no classes, no politics, not even an awareness of death, let alone redemption. We now also suspect that the essence of our physical being is to transmit each in our turn the germ plasm that has been transmitted to us by our forefathers; and along with the physical, hopefully, those social and historical values that we possess that are still viable. The question is, in relation to the small elite tribe here seated, which of our values are actually viable to the modern mind. Especially in this horrifying and ever-greedy century of ours. Over such questions, we might all feel uncomfortable

. . . Our present cultural baggage is simply not adequate to our deepest perceptions: our twentieth-century knowledge of physics, genetics, psychoanalysis, class-structures, political power, new technologies, artificial geographical boundaries, ecological and population dangers, instant communications, and all the rest are forcing a world-view on us that every day make past dogmas and world-views less and less adequate. Modernism is a desperate and gallant attempt at a more adequate and accurate view of things now. The past cannot be recaptured, except in memory.

Yet we must rejoice that the Yale Art Gallery, which, with the highest degree of professionalism, does its best to show the past recaptured; and moreover, beautifully conserved, with devotion. Each historical moment, each link in the chain of civilization, has its own unique beauty, without awareness of which life is impoverished—so much so that I, for one, would not choose to survive nuclear devastation, even if it were possible. I am not talking about mere aesthetics. I am talking about shaped meaning, without which no life is worth living . . .

When contemporary artists talk among themselves about other artists, first they weed out what is meaningless in terms of repetition and conventional clichés; then they reject what may show more talent, but is essentially false, without inner integrity, whatever the mode of expression. Much of what passes for art is not different from the rest of society, a series of lies, for exterior reasons, or occasionally from self-delusion, or most often from inherited prejudices and a priori conceptions. True originality is that which originates in one's own being. Nothing else is worth consideration or preservation in this gallery that is one of the ornaments, as well as one of the repositories of meaning of Yale University.

Notes

1. Motherwell, letter to Jack Beatty, 6 October 1983.
2. The National Arts Club, New York, 26 January 1983; and the Pennsylvania Academy of the Fine Arts, Philadelphia, 17 February 1983.
3. John Trumbull (1756–1843), at one time aide-de-camp to George Washington, was a painter of historical subjects and a noted chronicler of events of the American Revolution. In offering his paintings to Yale, he "provided the impetus to the founding of the Gallery" in the early 1830s.
4. One of Harold Rosenberg's characterizations that Motherwell has frequently quoted.

"Kafka's Visual Recoil: A Note" 19 March 1983

"Kafka Unorthodox," a homage to Franz Kafka in commemoration of the Austrian writer's hundredth birthday, was sponsored by the Department of Humanities and the School of Art at the Cooper Union in New York. The two-day event, held in March 1983, was organized by the art historian and author Dore Ashton, who

invited many prominent novelists, poets, painters, sculptors, filmmakers, architects, and composers to participate. Motherwell delivered "Kafka's Visual Recoil: A Note" on 19 March, dedicating his presentation to Ashton. It appears here as it was published in *Partisan Review* in 1984.

For Motherwell, the poignant intensity of Kafka's writing was a demonstration of the extreme in a particular direction to which the individual imagination could venture and its product still be experienced as a structured work of art. Kafka's painful fidelity to the truth, particularly in *The Metamorphosis,* a novel imbedded in Motherwell's mind since his student days (aptly *like a thrown apple that had hit its mark*), had shunned artfulness; in this stance rested the author's authority as well as his possible limitation. Kafka had risked a degree of subjectivity that had inverted into an objective reality, a process Motherwell likened to that of his own generation of painters. To make the main point of his lecture, and in an essential comparison with abstract expressionist painting, Motherwell detailed the events that had led Kafka to his violent objection to illustration of *The Metamorphosis*—a result of his fear that a literal translation of the work would destroy its ambiguity. ■

A general reader cannot help but be aware of the numerous authorities on the life and works of Franz Kafka, let alone the horde of major novelists, poets, playwrights, critics, psychologists, and intellectuals who have commented on him, briefly or at length, from broad generalities to detailed and sometimes arcane analyses. As a mere painter, I will not venture where angels fear to tread. What I can contribute to this occasion—or any other, for that matter—is personal experience, for whatever it is worth, as one human being to others, each with our own uniqueness that in some way overlaps, or we could not speak to each other at all . . . Besides, painters sometimes see things that word-purveyors do not.

I first encountered the work of Kafka while a student, aged twenty-two, at the Graduate School of Philosophy at Harvard University during the academic year of 1937–38. I liked my brilliant professors (more brilliant then than now) and my school work, but found myself depressingly lonely—it was my first year on the Atlantic Coast after being on the Pacific Coast, where I grew up. My chief avocation became browsing in the secondhand bookstores around Harvard Square. In those days before paperbacks, scholarly and other esoteric books were rarely reprinted. It was a modest little triumph to find a longed-for, out-of-print book, say, the two volumes of the nineteenth-century Wilhelm Windelband's *History of Philosophy* in translation. Just off the Square was a rather small, highly selective bookstore whose name I forget, which dealt in new and often elitist books. It was there, as a

recognized browser, that I was persuaded to buy *The Metamorphosis,* that shatteringly poignant story. If I remember correctly, the book was printed unusually nicely and, of all places, in Dublin. I used to wonder how and why . . . At any rate, after moving on to Paris, and at the onset of the Second World War, to New York, I had my first show at Peggy Guggenheim's, in which one of the watercolors was entitled *Kafka's Room.* I did not have such an idea in mind. The picture simply demanded that title when it was finished, though I did worry a bit about its being taken too literally, rather than as an analogous visual metaphor. But obviously Kafka was deeply imbedded in my preconscious, like a thrown apple that had hit its mark.

It so happens that I was born on January 24, 1915, which means that I was conceived some weeks after my parents' marriage in March 1914; and somewhat more significantly, all of peaceful Europe at my conception was at war at the time of my birth. (I spent my kindergarten years for the most part drawing and painting war planes.) It recently occurred to me to look up in Allen Blunden's excellent chronology of Kafka's life what *he* was doing in 1915. On January 23 and 24, Kafka and Felice are meeting at Bodenbach on the Czech–German border and find that "their aims remain incompatible: he wants a life shaped around his writing, while she has conventional middle-class aspirations." The next month Kafka leaves his suffocating home for his first rented room. Restless, the next month he takes another room, noisy, but "with a fine view of the Old Town of Prague." He then travels to Vienna and Budapest but returns, writing of himself, "incapable of living with people, talking to people. Totally absorbed in myself, thinking about myself. Dull, mindless, fearful." He tries to enlist in the army but is turned down (like my own father, very close to Kafka in age) two years later, when America also enters the First World War.

In October of 1915, two important things happen to Kafka. Carl Sternheim, who has won the Fontane Prize for literature, passes the prize on to Kafka. And *The Metamorphosis* is published in a literary review, and then in book form a month later by the famed and estimable publisher, Kurt Wolff. Then something trivial on the surface, but profoundly interesting to a painter of my abstract expressionist generation, happens. Wolff throughout his career cared not only about fine writing, but also about a fine physical appearance to his books. Wolff informs Kafka that he has commissioned an artist to do a frontispiece for *The Metamorphosis.* Kafka is horrified and writes to Wolff: "It occurred to me . . . that [the artist] might want to draw the insect itself. Please, not that—anything, but that! The insect itself cannot be drawn. It cannot even be shown in the distance!" Blunden comments astutely that "Kafka knows that the ambiguities of his fiction can only be accommodated in the mind, in the imagination: to *draw* his images is to resolve their ambiguity, 'take them literally'—and hence destroy them." Dare I assert here that this recoil of Franz Kafka's to the benign inten-

tion of Kurt Wolff to illustrate his insect is identical in its reasons to the principal, and certainly principled, major preoccupation of my generation of abstract expressionist painters thirty years later in the mid-1940s—Gorky, Kline, de Kooning, Pollock, Rothko, David Smith, and the others. The subject matter was at once too "real" as felt and too ultimate in its existential concerns not to be betrayed by the domesticized beauty of the School of Paris, or by the graphic design tradition of constructivism, or by the obviousness and pathos of the socially varied forms of realism, or by the fantasies and black humor of the surrealists. No, in the 1940s, with the Second World War, the atomic bomb, and the beginnings of the electronic era now exploding, only a monumental ambiguity would do . . . When we were sardonically asked in those days, "What does *that* represent," we learned to reply, "What do *you* represent?"

Part of Kafka's tragedy was that he dared not ask that question—not even of his father, especially not of his father, nor of his fatherland. His genius is not artfulness, but truth. He could not lie. In this he was matched in modern Germany—to my limited knowledge—in a relentless and unflinching fidelity to his truth only by another Jew in the Hapsburg Empire writing at the same time, Sigmund Freud. Supreme artfulness belonged instead to self-chosen and cunning exiles during the first third of our century, to James Joyce, to Pablo Picasso, to Igor Stravinsky. In this sense, Kafka cannot instruct us as artists; he instead moves us to the depths of our being by his own doom, which was to be unable to lie. He had no conception of art in Picasso's sense that "art is a lie that makes us see the truth." Kafka lived his truth. He dared not share the living of it. The old-fashioned women of Kafka's day, with their highly developed sense that their survival depended on their man—in German there is no word for husband, simply "my man"—must have sensed this about Kafka, that so much truth could not be lived with in harmony or, probably, at all.

And if his friend Max Brod had not gone against Kafka's posthumous wishes, neither could we, the general public, share his lived truth. His writings were to be destroyed. True, *we* have the advantage of sharing them from a psychic distance, like Dante led by Virgil through Hell, so that Kafka's images become less personally hurtful. They are subjects for meditation and awe, but lack the awesomeness of Dante, for whom the punishments of hell are justified by his conception of the universe. Kafka's ultimate leitmotif is that there is no justification or, if there is, asks *what* that justification is.

As André Breton put it beautifully in his anthology of black humor, Kafka raises "the question of all time: where are we going, to what do we owe allegiance, what is the law?" For my own part, from lived experience, an eternal optimist emotionally if not intellectually, and tonal in contrast to such starkness, it seems that emotional pleasure from the world as sensed, plus emotional empathy and social respect

for the beingness of other human beings, counterbalances the empty space left by not knowing "the law." Any painter knows that empty space is his most powerful artistic weapon, *if* he can adequately animate it. The void need not be terrifying. It can indeed vivify, when contrasted as an image with the fragility of human life—as centuries of Oriental painting and calligraphic poetry, not to mention our own century's essays in modernism, reveal. Think of *Guernica.*

Kafka's sense of emptiness is mainly but not only personal. His middle Europe was an empty shell. He himself described Vienna as "an enormous village dying on its feet." When I was there several years ago, my museum-official hosts described it as a capital city without a country. My point in relation to Kafka here is that, in some curious way, the more subjective and the more faithful to one's own truth that one becomes, the more objective one becomes as a witness to historical truth. Here I think Kafka has been underestimated. But no one can forget him. To read him is to be marked for life—as he was—marked by the reality of inwardness, that most sacred of modern domains of which he is a vivid witness.

"A Collage for Nathan Halper in Nine Parts" 12 August 1983

In the early 1950s, Samuel Kootz (at the time still Motherwell's dealer) had opened an extension of his New York gallery in Provincetown, Massachusetts, on property owned by Nathan Halper, a summer resident from New York and the author of several works on James Joyce. Soon recognizing the venture as unprofitable, Kootz backed out and left the operation to Halper and John Cuddihy, another Joyce enthusiast. (Both, too, held Motherwell's work in high esteem.) Halper and Cuddihy named their new enterprise the HCE Gallery after themselves and the hero of Joyce's novel *Finnegan's Wake.*

Motherwell had begun to spend the summer in Provincetown in the early to mid-1950s, over the years occupying various houses and studios in the vicinity of Allerton Street at the east end of Commercial Street. By the late 1960s, he had finished converting an existing structure, also at the east end of the town's main thoroughfare, into the home and studio to which he returned almost annually until his death. Chief among his summer friendships was that with Halper, a fellow poker player and a frequent casual visitor to 631 Commercial Street, where discussions between the two men often centered on their favorite modern writer. James Joyce had also been the subject of seminars that Halper had organized in Provincetown in mid-June 1982 and 1983, in which experts on the Irish-born writer participated. On 12 August 1983, Motherwell presented a eulogy at Halper's memorial service at the Provincetown Art Association. ■

1

The most interesting people to my mind are those who are deeply involved in something, the more complex the better. Nat was always interesting, as few are.

2

He could say more in fewer words than almost anyone I have ever read. I myself have tried to do the same thing in painting, to express rich feelings with the sparest of means. There was one of our deepest affinities, a hatred of unnecessary rhetoric. Silence and empty space are more beautiful.

3

This past spring, I gave a concise lecture, along with many other intellectuals, at Cooper Union in New York on Franz Kafka, apropos of his centenary. Afterwards Nat complimented me, as much with a smiling look expressing something like "that's my boy," as with whatever he actually said, perhaps partly because I had pointed out that Kafka, in my opinion, in remaining within the Austro-Hungarian Empire, was ultimately more limited than the cunning exiles, Pablo Picasso, Igor Stravinsky, and of course James Joyce. But perhaps more importantly, his attitude was as Leopold Bloom, that Irish Jew in Catholic Dublin, might have looked at Stephen Dedalus, who was to exile himself from Dublin, as did my maternal Irish ancestors during the great famine of 1847. Nat knew nothing is more fierce than feelings. One of the fiercest of all is that of delimiting surroundings. New York and Provincetown, in a way that no outsider can understand, freed us both in our different manners. In both places there is the personnel and options that make it possible to be oneself without isolation or the sense of a vacuum.

4

On that same occasion, Nat proudly showed me a university press brochure announcing its forthcoming books. The page he showed me was about his own new book of writings on Joyce. I could not help noticing the bibliographic details, the price (which I forget) and the number of pages, ninety-nine. "Of course," I thought, "Nat writes with the concision and precision of a poet."

5

Earlier this spring, Nat and Mervin Jules made what in the last few years had become an annual trek to my studios in Greenwich. They would arrive at noon, and around one-thirty we would repair to a

French Provencal restaurant down the road, like three old men in a tub, munching frog's legs and sipping white wine. Both drank moderately, which is hardly true of me. So, having drunk enough, I remarked that though I was born and bred a WASP—my Irish grandfather married into one of the oldest families in America, leaving the Church—nevertheless my world view is Darwinian, Freudian, and empirical, not religious; but sometimes, with my Jewish friends, I was induced to feel a WASP; and that I thought the categorical projection was from them, not from me. Both their faces lit up with animation and deeper interest and agreement, and time dissolved. I marvelled that it had taken thirty years to speak of this, though we had met once a week to play poker during the summers of all those years . . .

6

An important aside, and apropos of what I have just said, I have rarely, during so long a period of time, heard a man speak of his wife with such respect, tenderness, and empathy as consistently as Nat did of his New England bride, Marjorie Windust Halper.

7

Quick-witted and a master of games, he would become irritable and impatient with members of the game who were slow to make up their minds, or make unlikely and sometimes impossible moves. He would become almost a fishwife. Sometimes I would say, "Nat, it is only a game." But of course it isn't. Poker is structured, and its structure "real" in itself, not only as a system of internal relations like mathematics, but as a revelation of personality as well. Generally, when Nat raised the ante, he had you cold. He bluffed when tactically necessary, as we all do to survive, but he wasn't a bluffer at heart, either in the game or real life. He preferred having the edge through thorough preparation, and thorough he was . . .

8

His lack of bravado was evident in a minor thing, but the one that I remember most poignantly, his difficulty, when he dropped by my place here once or twice a week and unannounced—the only person who ever did so—was his difficulty with the formalities of greetings and good-byes, entrances and exits. On those two occasions alone he would become awkward, shy, almost childlike, to the point of being led in and out. But in between, while he was discussing whatever he had come to discuss, a new understanding of a word in Joyce, a lovely continuing poem for children that he was writing, a question of picture prices, the politics of the Art Association, village news—he brought the same structural mind to bear on each aspect of reality, so that he

was equally interesting about all. Sometimes he reminded me of Edmund Wilson. But Nat was clearer in mind, less self-indulgent, sharp as Occam's razor.

9

Year after year we had a close but strictly compartmentalized relationship. There were numerous areas and occasions in the other's life that neither of us knew about or wanted to. Not unlike a secret love affair. I loved the man more because it all revolved around the concepts of modernism in culture, that supreme expression of an individualistic, untribal, international world, of which James Joyce was the prophet in English, and Nat his apostle. After all, in the beginning was the word. Though it is better in French with "in the beginning was the verb," and still better in Greek with "in the beginning was the logos." If Nat were here, he would now explain with joy that the Hebrew word, which I do not know, is best of all. Who could not love a man like that?
Peace.

Letter to Glen MacLeod 21 September 1983

In the fall of 1983, Motherwell received a letter asking him about possible associations between the poetry of Wallace Stevens and abstract expressionist painting. His response, dated 21 September, offered a couple of observations, acknowledgedly less to do with any such affinity than with recollections that the subject of Stevens had evoked. For one, after reading a compelling prose piece by Stevens on a painting by an artist who, in the end, disappointingly turned out to be a lesser figure than he had anticipated, Motherwell concluded that good writing does not necessarily guarantee the author a qualitative vision for painting. For another, in recalling a Greenwich Village literary party in the mid-1940s honoring Stevens, whose demeanor was not that of the bohemian stereotype but that of what he was, a prominent insurance executive, Motherwell identified his own painful alienation from that milieu with the poet's similar discomfort there.

Stevens is one of few American poets to whom Motherwell made reference throughout his writings. ■

Dear Glen MacLeod,

I am afraid that what little I remember in regard to Wallace Stevens is mainly trivia. I myself liked his poetry very much but do not recall another abstract expressionist speaking of him. The most likely candi-

date would have been Philip Guston, who was a great reader of poetry.

One thing that I do remember distinctly was receiving a brochure from a gallery—I would think in the late 1940s—with a preface to the artist by Wallace Stevens. As you read the piece (which I have not seen since), he was beautifully evoking (without mentioning a name) [a] French still life, which I suspected was that of Georges Braque. On turning the page where the brief essay continued, to my stupefaction, Stevens was instead talking about a fashionable and kitschy Parisian painter [. . .]. And I remember thinking that the quality of verbal images is no guarantee that the writer has any sense of visual quality in the specific sense of painting.

I also remember, sometime around that period when I used to be on the fringes of the *Partisan Review* crowd, that there was arranged by them, a dinner in honor of Stevens, with considerable uneasiness and trepidation, and that apparently Stevens felt the same way—at least it was rumored that he simply slowly and quietly got drunk, and said almost nothing. I think the fact that he was a businessman, a connoisseur of wines and teas and food, a patrician, probably greatly prejudiced the bohemian milieu of Greenwich Village in those days in a way that is difficult to exaggerate. I am not a businessman, but have suffered enough myself from the other a priori clichés to know how hurtful and unfair it is.

I think the problem is that the most energetic, passionate, and black-and-white minds are among persons in their twenties who want to be inspired—inspired not only by the work, but by the lifestyle. From this standpoint, I would guess that Stevens's support has always been stronger in English departments. Someone like Hart Crane fits the alternative bill better. On the other hand, T. S. Eliot was not exactly a bohemian, and I think had the deepest influence of any poet in English in the twentieth century.

However, Stevens's influence persists. I happen to belong to a coop artists' gallery in Provincetown comprising Varujan Boghosian, Fritz Bultman, Carmen Cicero, Sideo Fromboluti, Edward Giobbi, Budd Hopkins, Rick Klauber, Leo Manso, Paul Resika, Judith Rothschild, Sidney Simon, Nora Speyer, and Tony Vevers, and just this past summer we had a group show entitled "Thirteen Ways of Looking at a Blackbird." Years ago, maybe thirty years ago, I called one of my paintings (or collages) *The Blue Guitar*.

But certainly Stevens was not a common subject among the abstract expressionists.* [. . .]

*I suddenly remember that William Baziotes was deeply interested in Stevens, partly because both were born in Reading, Pa.

Letter to Jack Beatty 6 October 1983

Jack Beatty, senior editor at the *Atlantic Monthly,* wrote to Motherwell in the fall of 1983 requesting that he contribute an essay, in particular a "Letter to a Young Artist or some such personal form," to the magazine. Motherwell's response, dated 6 October, described the pressure and ambivalence that the deadline of such a commission aroused in him. Instead of consenting to a new writing, he suggested to Beatty the possibility of using existing material—for example, a selection from his previous writings that might be edited in collage form *(the twentieth century's greatest creative innovation)* by one of his several collaborators. In essence a refusal of the editor's *kind proposal,* Motherwell's letter contains the most unequivocal expression of his attitude toward the act of writing, what it meant in his life, and its relative position in his creative hierarchy. ■

Dear Mr. Beatty,

Thank you for your clear and sensitive letter of September 28th. As about so many things, your proposal arouses ambivalent feelings. I would much rather paint than write, and am something of a perfectionist—in the sense of wanting a work exactly on target—and have learned long since that it is better for me to be satisfied with a work and then present it, rather than accepting a commission, which can become a freezing obligation. Some of my worst work is from trying too hard! My seemingly most effortless work is usually the most artful, the result of constant revisions and deletions and occasionally unexpected additions. I never contemplate the Eliot–Pound collaboration or the final form of *The Wasteland* without total sympathy.

On the other hand, certainly one of my chief gifts is for the collage. Regardless of the medium, whether it is in Eliot or Picasso or a TV thirty-second advertisement, I think collage is the twentieth century's greatest creative innovation.

I have written hundreds of thousands of words during my life, though I loathe the act of writing, its lack of physicality and sensuality; I think what you are asking for could be *collaged* if there were world enough and time.

It so happens that I have a huge retrospective which opened last week at a marvelous museum in Buffalo[1] and will travel for the next year and a half, ending up filling the Guggenheim Museum in New York in December–January, 1984–85. —Apropos the opening, I was sent an interview I made a year or so ago with the Canadian Broadcasting Corporation, which is superbly edited, both in its after-the-fact questions, and in making concise and to the point my replies.[2] The same thing occurs in one of the two essays in the catalog[3] accompanying the exhibition which I just mentioned, as it does in, from my

standpoint, a random selection of quotes in a bilingual catalog published by a German museum several years ago.[4] In short, it can be done. But it requires a collaborator, my Ezra Pound, of whom there are several, and the time and energy at my age is considerable.

Last season I wrote three things: a lecture for the Yale Museum, indirectly on the transition from WASPism to modernism; the question of ambiguity in Franz Kafka for Cooper Union; and an eulogy for a suddenly dead friend, an expert on James Joyce. Those sixteen or twenty typewritten pages altogether took more out of me than painting a mural, and gave me considerably less satisfaction!

If you don't mind, let me contemplate and also discuss your kind proposal, for which I thank you.

Notes

1. "Robert Motherwell," the Albright-Knox Art Gallery, Buffalo, New York.
2. Interview with Robert Enright on "Stereo Morning," Canadian Broadcasting Corporation, 1982.
3. Jack D. Flam, "With Robert Motherwell," and Dore Ashton, "On Motherwell," in *Robert Motherwell* (exhibition catalog) (New York: Abbeville Press, for Albright-Knox Art Gallery, 1983), pp. 9–27, 29–47.
4. "Robert Motherwell: Selected Writings," in *Robert Motherwell* (exhibition catalog) (Düsseldorf: Städtische Kunsthalle, 1976), pp. 5–19.

Letter to Christian Leprette 5 August 1984

In the summer of 1944, at a dinner party in the East Hampton home of the author Jane Bowles, Motherwell met Pierre Chareau and his wife, Dollie, recent exiles from France. Chareau, who had begun his career as an interior designer, had exhibited an ingenious pivoting desk at the Paris Exposition in 1925. He later took up architecture and, in the early 1930s, gained considerable acclaim in France for the "glass house" he had designed for a wealthy Parisian doctor.[1] With what Motherwell characterized as Chareau's *originality, poetry, good humor, skilled mimicry, and general knowledge,* the sixty-year-old Frenchman had enchanted him, and he soon developed a strong compassion and fondness for him.[2] During their developing friendship, the displaced architect extolled the wonders of the Quonset, a hut that recently had been invented by the U.S. Army, explaining to Motherwell the advantages of its ribbed construction in freeing interior space. When the war ended, Chareau and Motherwell set about building a Quonset studio and house in East Hampton, where the artist and his wife moved in the spring of 1947. In exchange for his design commission, Chareau built himself a summer house of concrete and terra cotta blocks on Motherwell's property, where he died in 1950.

Motherwell's poignant tribute to Chareau was dated 5 August 1984. He was again responding to a specific request, in this case from Christian Leprette in Paris, who was working on a monograph on Chareau.

He returned to Leprette an inspired portrait of the man and a vivid remembrance of times past. ■

Dear Christian Leprette,

I regret very much that the year 1984 is the busiest and the most complicated of my life so that I cannot write about Pierre Chareau with the care, emotion, and substance I would desire. All I can do for you is give you a few spontaneous memories and a few facts about him that only I could know. (If this latter were not true I would not at this moment accept your invitation to speak about Chareau, much as I admired and loved him.)

Chareau was born about the same time as my father—he was about thirty-two years older than myself. I first met him in East Hampton—as you know, the most elegant summer resort for New Yorkers—where I was living, early in the summer of either 1941, or 1943[3] when Chareau would have been sixty and I twenty-eight. I met him at a small dinner party given by Jane Bowles, the novelist, whom I had known in Mexico. I remember that she served roast duck in the American style, very crisp and well-done, but did not know how to carve the whole ducks and demanded that a guest do the carving. No one responded, to a point where it became embarrassing—I do not remember why I did not respond—and at that moment Chareau, who was a small man, volunteered, and with a comic routine (as though he were Charlie Chaplin), made a hilarious parody out of carving the roasted birds. I think that moment was when my admiration for him began, because I realized not only did he not speak English and was in exile in a strange land, but that he was basically a shy and introverted soul, whose deep sense of civilization forced him to arise to the occasion. Francis Jourdain[4] is absolutely correct in describing Chareau as a man who "combined delicacy and distinction," was authentic and original, and, though a designer and an architect, really a "poet." In the sense of the word "poet," the drama of our relationship was of two "poets," one of whom did not speak English, and the other who spoke baby-French, trying to build not one, but *three* buildings, with local and parochial constructors, on what in the beginning was the comically low budget of $7,000 (which I had just inherited on the death of my father).

When I say three buildings, I mean we built the army surplus Quonset hut house for myself and my wife, and on the same piece of ground, a second Quonset hut which was a separate studio for me. Instead of Chareau taking a commission for his designs, we built a third little summer house on the same property for him, of an entirely different construction: concrete blocks, alternating with terra cotta blocks, separated by "French doors," essentially one single room, with a cluster of pipes in the center leading to a kitchenette, a bathroom, and a fire-

place. It looks to me as though the last diagram in the Rene Herbst piece could be Chareau's own house on my property in East Hampton. He died in his little house there, of a stroke, in the summer of 1950.

Having been divorced in 1948 [1949], I spent the winter of 1948–49 [1949–1950] as a *pensionnaire chez* Chareau and his wife, in their apartment on New York's East Fifty-seventh Street. Chareau had some trivial cultural job at the French Consulate in New York City, and I had the impression that economically they were largely sustained by his wife Dollie (originally English-born, and early in Pierre's life, his nanny) giving French lessons to sophisticated New Yorkers—sophisticated in the sense that they were interested in modern art, and she built the French lessons around her passionate devotion to modern art. They also had a few beautiful works of art: a superb cubist Juan Gris in his beautiful deep blue; a Modigliani statue caryatid in limestone. (I remember a crisis arising when the Chareaus were offered $4,500 for the Modigliani and whether to accept it or not.) But apart from the people who came to the apartment on Fifty-seventh Street that year, I knew very little about his private life.

I do not have the impression that he was in the center of the list of artists in exile that you mention in your letter of June 6. Certainly Jacques Lipchitz was a friend, but I am not sure that any of the surrealists or Léger or Mondrian were. (Mondrian was already dead in 1944.)

I had the impression that Chareau was unhappy at the French Consulate. He was certainly not an institutional man! I know that he had some conflicts with José Luis Sert and Paul Weiner who, he felt, pushed him out of some enterprise. I do not remember the details. Chareau was quite discreet in speaking of other people. The only designer-architectural activities of his that I was aware of were his modestly decorating a storefront that acted as the Free French canteen in New York, and his building the small house for Mesdames Germaine Monteil and Nancy Laughlin, which I have never seen. I do remember his telling me that he was building it with the traditional American construction method of wood shingles. He felt that Americans were not masons . . .

To revert to the building of the compound in East Hampton, for me there were many moments of real anguish. I knew that what we were doing together was beautiful, but way beyond my means. In those days I had an income of $2,400 a year. In fact, it would have been an unfinished economic disaster if, at the last moment, my mother (who was not sympathetic to the project) had not arranged to have the local bank pay the bills until the enterprise was completed. I think its cost totalled about $27,000.* I realized after it was too late that Chareau should have had a client like Dr. D'Alsace, and not a poor young artist. During the blackest hour of my anxiety, I reproached Pierre

*for 3 buildings!

involuntarily, expressing regret that I had gotten us both into such an impossible economic situation. (The design of the buildings was so radical that no bank would offer even a tiny mortgage.) With tears in his eyes, the old man said to me vehemently, "Regret nothing! You alone have given me life in America." We never mentioned the subject again. We encountered not only economic problems, but language difficulties as well. Pierre knew scarcely any English and my French was that of a small child. Moreover, some of the technical building terms I did not even know in English, so that communication with the builders (who thought we were both mad) was extremely difficult. The buildings were built on sand in a small pine grove, and Pierre and I often made drawings in the sand with sticks to explain to the builders what we were trying to do, when all attempts at verbal communication had failed . . .

The house had some extraordinary features. The floor was about a meter below the earth level (below the freezing line) and [the house] was faced directly south at the winter solstice. The south side was made almost entirely of small panes of glass *overlapped* like shingles. Chareau had seen this method of construction in a local greenhouse and loved the effect. With all that glass facing south, the central heating bills were almost zero—as I remember, something like twelve dollars per month. The floor foundation was concrete, which was not pleasant during the winter, but we could not afford wooden plank or tile floors. In order to build the house, some pine trees had been cut down and their trunks were still lying on the ground next to the house. One day it occurred to me that if the pine trunks were cut horizontally, a few centimeters thick into discs and embedded in some sort of mastic, it would make an interesting pattern and a pleasant surface to walk on. That is what we did! The studio floor was left concrete *without seams* because I paint on the floor, and a seam under the canvas makes the charcoal or paint brush jump.

To our astonishment, shortly after the construction was completed, an American magazine called *Harper's Bazaar* came and photographed the place and it became quite well-known. —Recently, the architectural editor of the *New York Times* mentioned in passing that it was the first modern house built in the Hamptons. But as I have said earlier, out of respect for the prevailing shingle summer style of the Hamptons, we carefully concealed the buildings behind pine trees so that they were not visible from the road. —The two technical difficulties involved getting the local workers to curve doors and windows— the workers were not at all artisans. The other difficulty involved painting the corrugated metal roof, which was galvanized with zinc. The paint would not adhere properly to the galvanized steel. We even spent a few days rubbing the metal roof with vinegar, in an attempt to get the paint to bond to the steel, but still it did not work. The last time I saw the house, more than ten years ago, the semi-circular roofs

had been shingled and looked quite awkward. Also, a tennis court and I think a swimming pool had been added. What originally had been a pure and simple working concept with something of the feel of Alexander Calder's aesthetic, had been turned into a rather bizarre compromise . . .[5]

In short, I have never doubted Chareau's genius, his poetic sense, his total integrity, and a sweetness of character and *gentilesse* that are not describable. But perhaps he was a Frenchman born out of time. He should have had great patrons, who both wanted and could afford constructions of sheer and original "poetry."

One last complicating fact. In America one must be licensed as an architect in order to practice architecture. Pierre was not so licensed. Therefore, as I remember, on the official documents he does not appear as the architect. Instead, my name appears, because the *owner* of a house *can* build what he likes by himself, so long as it does not violate certain laws. I think it is because Pierre was not technically an architect that he may have had very little connection with American architects. I never heard him speak of one. (But in my experience, architects as a class are the least generous toward each other of any artistic group that I know.) Pierre, by nature, was totally generous, and I suspect not at all appreciated in the measure that he deserved. In his mind, his triumphs were the Paris Exhibition of 1925 and of course Dr. D'Alsace's glass house. —I only regret that being so young I did not fully comprehend at the time that Pierre Chareau was the kind of man, in his uniqueness, that one encounters very few times in a lifetime. But I did what I could in our limited circumstances.

Notes

1. The concept, wholly innovative at the time, left visible the metallic skeleton of the house and exposed all the utility cables. The glass brick employed for the façade (because the site was the interior courtyard of an existing structure) allowed sunlight in, while exterior spotlights illuminated the interior at night.

2. Conversations with the artist, 1983–1986.

3. Motherwell spent the summer and fall of 1941 in Mexico. He traveled there again in the summer of 1943 and stayed until news of his father's impending death called him to California. He did in fact spend the rest of that summer on Long Island, but it is more likely that he met Chareau during the summer of 1944.

4. Francis Jourdain was a French designer of modern furniture admired by Chareau.

5. Attempts by persons interested in historically preserving the property were unsuccessful, and the house was razed for development in the late 1980s.

"Animating Rhythm" October 1984

Motherwell had met Jackson Pollock through William Baziotes in the fall of 1942 when the three artists spent a couple of sessions together discussing the advantages of the surrealist theory of psychic automatism. On several occasions during the follow-

ing winter, Motherwell, María, Pollock, Lee Krasner, and William and Ethel Baziotes experimented in writing automatic poetry. In the spring of 1943, Motherwell and Pollock made their first collages together in Pollock's studio at the instigation of Peggy Guggenheim, who exhibited them in her international collage exhibition at Art of This Century. Motherwell's personal relationship with Pollock and Krasner continued for a time after the couple's move to Long Island in 1945 and thereafter deteriorated. His positive appraisal of Pollock's work, however, remained consistent from when he first championed it in 1944[1] throughout the rest of his life.

For the October 1984 issue of *Art and Antiques,* Motherwell, "with an assortment of people in and out of the art world" (including William Barrett, Robert Hughes, John Updike, and Andy Warhol), was asked, "Was Jackson Pollock any Good?" Motherwell's response was written on 10 August. ■

Jackson Pollock had the odd advantage of all American artists in the 1940s. The art scene was parochial. No one thought that we could ever produce truly great modern painting; only Europeans could. So we had nothing to lose by risking all. A time of innocence in American painting; a now lost innocence that cannot be recovered.

Pollock had the deep intuition that if you *are* yourself, such beingness willy-nilly is expressive. And another deep intuition of his about painting is that its given format is animated by rhythm. Pollock went further than anybody: his rhythm came literally out of "dancing."

A small grandchild staying with me is trying to talk but can't yet. She can now only express herself through bodily movement—probably the earliest form of human expression. Pollock was closer to this primary form of expression than other painters. His authenticity is indubitable.

People were likely to mix up his character with his painting. An explosive character, it's true; a land mine, seemingly like Marlon Brando in *A Streetcar Named Desire;* and that sullen, socially inarticulate character was projected by others onto his paintings. But in the studio Pollock was wholly articulate—with his body, arm, wrist, and eye dancing over the canvas on the floor. What might have seemed at the time brutal, a war dance, now seems to me sheer lyricism.

His painting dance is highly ordered, naturally so. When a human being does something with great intensity, he instinctively orders it. In modern physics the firm, Newtonian sense of order has not held sway for a long time, and more recently scientists have been searching for patterns that can be found in seeming chaos. Pollock has, no doubt unknowingly, a sense of order much more in line with modern physics. His work is organic, without artifice, shattering all that is solid.

If you've ever seen a young goat—a kid three or six months old—as

I've seen in the hills, then you know that they gambol. They spring up on their hind legs and move about with a kind of balanced exuberance and exact focus. That's what Pollock was doing in those drip paintings. This does not imply that his work is childlike; it has the intensity of a possessed man. A kind of ecstasy in paint. But an ecstasy that has dropped all preconceptions of what painting is or ought to be. This is truly his great accomplishment. I see his truth even more now than I did then.

Note

1. Robert Motherwell, "Painters' Objects," *Partisan Review* 11, no. 1 (Winter 1944): 93–97; Motherwell, letter to Samuel Kootz, 21 January 1947.

"On Not Becoming an Academic" 4 September 1986

■ Nearly fifty years after Motherwell left Harvard University, where he had spent the 1937–1938 academic year in graduate studies, he returned to Cambridge, Massachusetts, for the university's 350th Anniversary Celebration. On 4 September 1986, he participated in a panel discussion, "Tradition and Innovation: The Realms of Scholarship," and delivered a brief lecture, "On Not Becoming an Academic."[1]

The year at Harvard had been important to Motherwell—to both his intellectual development and the expansion of his humanistic vision. Lasting influences, to which he referred in his lecture and frequently throughout his writings, had come from Arthur O. Lovejoy's seminar, where the focus had been on the history of ideas in international culture; from C. I. Lewis's seminar in twentieth-century epistemology; and from David W. Prall, his adviser and mentor, with whom he had studied aesthetics and the philosophy of Spinoza. Certain of Prall's ideas and the writings of Alfred North Whitehead (which Motherwell had read independently) had supported his predilection toward abstraction when he began to paint three years after leaving Harvard. ■

My lifelong desire to be a painter may have begun in kindergarten. The curse of my life has been that I am both tone-deaf and a monotone. Consequently, singing and dancing and everything musical in kindergarten was torture to me. A sensitive teacher noticed this, and also that I loved the painting and coloring-book part of the day, and very kindly excused me from the singing and dancing in order to paint. Several years later, in the first grade, in another city, my disability was so marked that the teacher put adhesive tape over my lips, assuming that I was singing deliberately off key! At age twelve, I won a painting scholarship in California,[2] where I mainly grew up, but my father and

mother made it so difficult for me to get to the Art Institute (which was many miles from where we lived) that I was unable to take much advantage of the honor.

Apart from this passion for painting, I lived a normal American, upper-class youth in California, filled with sports and being valedictorian of my class in prep school,[3] and then graduating from Stanford University (majoring in philosophy) half-a-century ago.

The major professional crisis of my life occurred after my graduation, when my banker-father asked me whether I was going into business administration or law or whatever profession. I replied that I wanted to be a painter, and I will never forget his look of dismay. You must remember that 1936 was the depth of the Great Depression. My solitary dilemma was compounded by the fact that I was already hooked on modernism in painting—Cézanne, Matisse, and Picasso—and I knew no artists in such a direction, or of anyone so teaching. The ultimate compromise with my father was that, if I got a doctorate so that I could teach (for which I have something of a knack) to support myself, the rest would be up to me. To my astonishment (because of my disability, foreign languages were a nightmare, and in those days, were a sine qua non for a doctorate), the Harvard Graduate School of Philosophy accepted me for the academic year 1937–38.

My mentor in the philosophy department was D. W. Prall, with whom I took a seminar in Spinoza. Likewise a seminar in twentieth-century epistemology from C. I. Lewis, the mathematical logician, who made us students each identify with and defend a twentieth-century philosopher, in my case, Henri Bergson, and in the case of my roommate at Stanford (who went on to become a professor of philosophy at Harvard),[4] Bertrand Russell. I also began a seminar with C. I. Lewis on Kant. I think I dropped out, though I now regard Kant most highly. But the important year-long seminar for me was given by a visiting professor at Harvard from Johns Hopkins University called Arthur O. Lovejoy, whose obsession was with the history of major ideas throughout international culture. This particular year, the idea to be examined was that of Romanticism. I remember someone took the Schlegel Brothers, someone else Coleridge, someone else perhaps the young Karl Marx, and on learning of my interest in painting, Lovejoy assigned to me *The Journal of Eugène Delacroix,* the great French Romantic painter . . .

Though Alfred North Whitehead had retired the academic year before, his presence and ideas permeated the philosophy department at Harvard, and through tracking down, in his scattered writings, a paragraph here or there, I came to understand the philosophical nature of abstraction, which was a crucial idea for an aspiring young modernist painter in the 1930s to apprehend, saving me those years of doubt and confusion that most painters of the period had to go through in slowly breaking away from the representational modes in which they had been

trained. My own doubts were about other questions . . . To put it in simple form, the verb "to abstract," taken from the Latin, means to "select from," "to choose from," "to pick out" from the concrete matrix of reality that which one wants to deal with, excluding the rest. As Whitehead put it somewhere, the function of abstraction is *emphasis,* and, somewhere else, "the higher the degree of abstraction, the lower the degree of complexity." The clarity of these insights on Whitehead's part, allowed me within six months of when I began painting full time (for the rest of my life) in 1941, to paint a now celebrated small work called *The Little Spanish Prison* (collection, Museum of Modern Art, New York). Who could have guessed that in the Graduate School of Philosophy at Harvard, I should come across perceptions by a professional philosopher and mathematician that would play a crucial, though far from the only role, in my development as a painter?

For the rest, the following year I spent in Paris, working on Delacroix and painting on the side.[5] With the imminence of World War II, I returned to America and transferred to the Graduate School of Art History at Columbia University, where there was a great modern art historian, Professor Meyer Schapiro, who, in his wisdom, introduced me to several important European artists in exile, and through them came to know, casually or well, the other score or so major European artists in New York, from Marcel Duchamp and Max Ernst to young Roberto Matta (who was in my age group). Matta in turn introduced me to a young American, William Baziotes, who in turn introduced me to young Jackson Pollock, Willem de Kooning, and the older Hans Hofmann. Such artists became my real graduate education. One not to be found in a University. Nor is the vitality of New York City.

Notes

1. Other participants were Roger Rosenblatt (who made the introductions), Renate Adler, Edward M. Bernstein, Marilyn French, Paul H. Nitze, Arthur M. Schlesinger, Jr., and Roger S. Swain. In a five- to seven-minute presentation, panelists were to address their "original plans, challenges, unexpected twists in their professional progress, and the value of the graduate education."

2. From the Otis Art Institute, Los Angeles.

3. Moran Preparatory School, Atascadero, California.

4. Henry David Aiken, who had been Motherwell's roommate at Stanford, entered Harvard with him.

5. Motherwell's manuscript on Delacroix no longer exists. He exhibited twelve paintings at the Raymond Duncan Gallery in Paris in 1939.

"Introduction for Octavio Paz" 4 October 1987

 His love of the materials of his art, especially paper, eventually brought Motherwell to printmaking. One of his early accomplishments in the medium incorporated his next most passion-

ate preoccupation after modern painting—modern literature. The *livre de luxe,* a book in which high qualitative standards are maintained in all phases of production, and particularly the *livre d'artiste,* a book for which only established artists are chosen to illustrate the text, were a tradition going back in twentieth-century France to the dealer-publisher Ambroise Vollard, who had produced models long fixed in Motherwell's imagination. His own first illustrated book came only after he had discovered an unusually appropriate text—poetry that focused on the physical properties of painting. As already noted, *A la pintura,* a twenty-four-page book illuminating Rafael Alberti's poems, had been published in 1972.

More than ten years later, Motherwell again addressed a text by Alberti, "El Negro Motherwell," a poem written for the artist, and a *livre de peinture,* a portfolio of lithographs entitled *El Negro,* was published in 1983.[1] Next came a book of lithographs made for three poems by Octavio Paz (one written for Motherwell) and published in 1988,[2] followed that year by a *livre d'artiste,* a hand-set and hand-bound edition of James Joyce's *Ulysses,* illustrated with etchings.[3]

When Paz came to the Poetry Center at the Ninety-second Street YMHA in New York to read from his work in 1987, Motherwell introduced the Mexican poet and essayist. The artist's welcoming comments were written in September and delivered on the evening of 4 October. ∎

The French have a saying, *"Bête comme un peintre,"* that is, "Dumb as a painter." I do indeed feel dumb in speaking of such an incomparable poet, intellectual, critic, historian, man of affairs and of social conscience, an internationalist haunted by the complicated fate of being Mexican, but being much more, in short, of Octavio Paz.

There are some cross-connections. I first found myself as a painter in Mexico in 1941, and also married a Mexican. My closest comrades in Mexico then were Roberto Matta, the Chilean surrealist, and Wolfgang Paalen, the late Austrian painter and surrealist. (I believe that surrealism has been rarely deeply understood in the United States, its sustained effort for decades in devising various modes of what they called "psychic automatism"—and which psychoanalysts call free-association—in order to free the creative spirit, to shatter those conventional thoughts and mores that suffocate us all.) I believe that Octavio Paz's poetry, in its richness, humanism, explosiveness, and liberation, owes something to the surrealists' effort to reach the preconscious and the unconscious, where most of our being lives. Paz moved in Parisian surrealist circles in the later 1940s, as I did slightly earlier when the surrealists were in exile in New York. Through their psychic automatism, I (as an abstract painter) have spent my artistic

life trying to reach beyond the merely formal, essential as it is to art. In this aspiration Paz has already succeeded.

Paz and I were born within some months of each other, which means that at precisely the same historical points in time we were faced with the same problems—political, social, aesthetic—fascism and Stalinism, the Great Depression, World War II, the aesthetics of late modernism, the emergence of his Northern neighbor as a superpower, and in the future, the possibility of the ultimate holocaust. —I slightly know Octavio Paz personally, but for more than a year I have been working on illustrating three poems of his in a very limited edition deluxe—what the French call a painter's book. My mind is filled with his images and insights, and, had I had the chance, would have chosen him above all others as my savant through our horrifying shared period of time. What more all-encompassing guide or guiding light?

Notes

1. *El Negro* (Bedford Village, N.Y.: Tyler Graphics, 1983). A *livre d'artiste* of nineteen lithographs.
2. *Three Poems by Octavio Paz* (New York: Limited Editions Club, 1988). A *livre d'artiste* of twenty-seven lithographs, including the poem "Skin Sound of the World," which was written for Motherwell on 16 May 1971.
3. James Joyce, *Ulysses* (San Francisco: Arion Press, 1988). A *livre d'artiste* of forty etchings.

Interview with David Hayman 12 and 13 July 1988

The prospect of illustrating James Joyce's novel *Ulysses* loomed as a Herculean task for Motherwell. He esteemed Joyce above all other writers—ancient or contemporary—but, for him, the Irish-born writer also represented the epitome of the modern spirit. He had first read *Ulysses* while he was in Europe and at the threshold of adulthood. The book had moved him profoundly and became his bible for the next half-century. But it was also the imaginative and technical aspects of making pictures for this novel that froze him, and from the time the project was initiated by Andrew Hoyem, director of the Arion Press in San Francisco, in 1985 until it was completed three years later, Motherwell vacillated in his commitment, even temporarily abandoning the work in mid-course.

Motherwell feared that the task might consume him: an obsession with Joyce had nearly destroyed an artist friend. He wrote to Hoyem in 1985 that his life was too full with creative, practical, and physical complications to take on what would be a staggering task. Nevertheless, he toyed with the idea. He considered using existing works or making a few full-page engravings that could serve the entire book. He began to explore media and techniques, favoring lithography so that he could potentially use his whole repertoire of colors, washes,

1980–1988

282

and lines: *But this still leaves the problem of finding a visual equivalent for* Ulysses. *I collected an Irish library, photos of Ireland of about the period when* Ulysses *takes place, Bloomsday 1904, histories of Irish art, color books of Ireland. But on a much deeper level, the subject matter of* Ulysses *is not Ireland any more than the subject matter of the* Odyssey *is oceanography of the Mediterranean.*[1]

In another letter to Hoyem, written in 1987, where it appears he had quit the project, Motherwell compared the difficulty of the work on *Ulysses* with the ease and success he experienced in illustrating *Three Poems of Octavio Paz* (a contemporaneous project), and added:

I realized two things that I should have known consciously from the other two livres d'artiste *that I have done, the Alberti* A la pintura *with Tatyana Grosman and the Alberti* El Negro *with Ken Tyler, to wit, my vocabulary works only with poetry, that is to say with* non-narrative writing *to which my visual metaphors can be matched with verbal metaphors springing from the same kind of source, so to speak, that is, not illustration, but a series of explosions or fireworks or oppositely, a kind of restrained silence. The second discovery, or rediscovery, was that I really do like full collaboration, especially in my own studio or in a studio a few minutes away. This is simply the nature of the beast.*[2]

The medium and the collaboration Motherwell found was with his own studio etcher, Catherine Mousley, and together they produced hundreds of images from which forty were published in the volume, which was designed and produced under Hoyem's direction.

The following interview took place in Provincetown, Massachusetts, and was published in 1988,[3] the same year in which the *livre d'artiste Ulysses* was published. ∎

DH Do you recall your first contact with the works of Joyce?

RM It was when I was twenty in 1935. My father had in the back of his mind for years that we should do the gentlemanly thing and make the Grand Tour. Neither of us had ever been to Europe. We finally did go, crossing the American continent from San Francisco by train, then taking a steamship to Le Havre.

When we arrived in Paris, he was tired. My younger sister was also along, and they were unsettled—while I was filled with excitement. It must have been nine o'clock in the evening, so I got my father's permission to walk out on the boulevards. A man accosted me and made some fantasy proposals. I innocently followed him. Soon I realized I was in a whorehouse and became upset and frightened. Not speaking the language, I just took out of my pocket a handful of bank notes, handed them to him, and left.

All this had taken about thirty-five minutes. I still wanted to smell Paris, so I walked down the boulevard again. There was a large book-

store with stalls out on the street like the ones along the Seine, so I browsed. One of my favorite pastimes, both for fun and for cutting off, is second-hand book browsing. I came across a small edition of *Ulysses,* printed in Germany on Bible paper. I had heard about *Ulysses* vaguely, and, since it was printed on thin paper and fit in my pocket, I thought I could read it on the long train rides. Then, somehow, I was satisfied with the evening.

We traveled all the way down to Amalfi, back up through Italy and Switzerland and Germany and Holland and finally to England and to Scotland (to see the town of Motherwell). My father, who was very observant, would comment on the various methods of farming along the way, which didn't interest me. Instead, I'd be reading this novel, and one day he said, "What's that damned book you're reading?" I replied, "It's by an Irishman. But I have a feeling it's a masterpiece."

I'm a visual person. I don't think any other book could have absorbed me so thoroughly when we were going through the landscape of Europe for the first time. That was the beginning of my interest.

DH So it was the landscape versus the book.

RM Yes, and the landscape took second place. So did architecture while we were actually en route. Whenever we were waiting during the trip, I'd pull out the book and read it—really read it, word for word. I've never read it through since. Now I dip into *Ulysses* the way one might look through the Bible.

DH We are going back fifty-three years.

RM In those days that novel was still little known, very elitist. I believe in my unconscious there was something important about the experience of buying the book in this foreign place while slightly traumatized. It was my personal discovery and restored my equilibrium. I didn't talk about it to anybody.

DH It sounds as though you had a strong personal experience a long time ago, one that obviously lasted—yet you weren't driven to reread the book?

RM Well, I have about ten copies in all the places I normally am: near my bed, or in the studio, in the living room. In the back room there are *Finnegan's Wake* and *Ulysses* and the *Portrait*.

From time to time I'll just pick one up, read a dozen pages or so and feel perfectly happy. Half the time I may not know exactly what is going on, but from another point of view the reading is very real—so plastic—I can almost smell it.

For example: the other day, while looking over the Arion Press announcement, I was reading and rereading the sample page of the opening of the first episode and noticed how many colors Joyce mentions in those first few lines.

DH All shades of yellow, solar colors appropriate to the morning hours.

RM There is something very visual about Joyce—not in the usual way of writing realistic descriptions—but as though he were a modernist painter. His skin is modernist, not scientific and hardly "realistic."

DH You spoke of Joyce's language as being plastic.

RM I should say that in painter's argot, mistakenly, the word plastic means painterly or materiality—where the image emerges out of the brush covered with colored mud, so to speak—which is something very different from a careful drawing, delicately modelled. In that sense Joyce seems to be forging the thing out of heaps of words, and the human experience directs the heaps of words he is involved in. But that is what makes him a writer *sui generis,* compared to . . . Jane Austen?

DH Heaps of words, mud, Joyce would like that. For him, the language we speak today has its past built into it. When we use a word we are digging straight through the muck of time to its origins. That is why he was so fascinated by etymology.

RM Whereas the Bible begins, "In the beginning was the word," a painter might say, "In the beginning was the brush."

DH Or the painterly gesture?

RM No, but you could say the paint or the pot of color. If we begin with that conception, then, the more the paint is investigated and mastered, the further it gets away from the word. And that is the difficulty everyone has with modern art—actually, with great art. They go to Michelangelo because they've been told to, and there is enough they can make out so that they have an experience. There are lots of things I admire, but they give me no impulse to go home and become energetic and do my feeble whatever. A writer like Joyce can make me just want to paint. The magic of painting is there. It gives you almost a chill what words can do. Everybody has to use words just to get things done, but not necessarily with any feeling. You can't paint your way through the world in that practical sense. I think this is why they cut children off in full bloom, castrate them visually, because, what use is there, practically, in being able to paint? [. . .]

I found *Ulysses* at a time when I was searching for the key to a vaguely perceived modernist aesthetic that I knew I had to make my own. Joyce served my purposes then and now. If you have taken on the adventure of modernism as I have—and the history of it—there have to be a few prophets to help you when you get discouraged. You go back to them for reinforcement.

DH In November you will be publishing two very different works. The first is a reproduction of a series of drawings called *The Dedalus Sketchbooks,* published by Abrams. The second, and more ambitious, is a series of forty etchings for *Ulysses,* to be published by Arion Press.

Both relate to Joyce. Obviously you like to work in different formats, and you have different modes and moods. When you undertook this project, were you illustrating Joyce or taking encouragement from a prophet of modernism? You must have seen *Ulysses* more as an aspect of your creative and intellectual life than as an object to be illustrated or explicated.

RM In a certain way I did not regard it as a separate project but as part of what I would be doing anyway. And the images I made, if we couldn't adapt to the books, I would have used them for something else, with other associations in terms of title. Yet Joyce is permanently on my mind. For over forty years I have on occasion dedicated a picture to him or taken a title from him. [. . .]

DH Now, in later life, you are seriously looking at this cherished text and expressing yourself in relation to it, performing a kind of active translation, or better, an active recreation, something Ezra Pound used to do with poems he loved but didn't want to betray.

RM Or, I would say, an act of free association. Joyce's books, on one level, are all about his own experiences. I can't live them, but I've lived my own. I mentally asked him: Is it OK for me to do this, if I'm trying to be in tune with the way you worked? I never had any feeling of violating this trust. Certain words move Joyce, a phrase he heard somewhere and can elaborate on. With me it may be a certain angle, or whiteness in relation to greyness, that provokes an inner response.

I suppose I have the arrogance to make my *own* "Dublin" for *Ulysses* the way he had his. I think the book is so great and so profound that there is no possibility of matching it. You have to do your own thing in an equivalent state of mind, of freedom and concreteness and so on. Dublin was the subject or matrix for Joyce. No matter how personal or nightmarish or irrational, in some way Dublin was always present, even if the subject was someone screwing.

DH Joyce manages to impose Dublin without really describing it. He gives us a sense of place by constantly hinting at placeness and through frequently oblique allusion to the culture of Dublin.

RM In Proust, Paris isn't always present exactly that way. You feel his Frenchness, but you don't feel the city or the various layers of the city. Probably more in Balzac.

DH Balzac appears to give us everything even though his exposition is full of irony. In Joyce exposition is part of the drama, perception part of the action. If Dublin is omni-present for Joyce, what is the presence in your etchings?

RM I think the only reply I could make would be a remark of John Dewey's that sticks in my mind: We tend to think that we end with our skins, but actually we are always interpenetrating with reality. I suppose that this is basically self-referential, but a person of continual

broad interests and exceptional eye will pick significance out of a heap of experience. [. . .]

DH Your images, like Joyce's prose, leave a lot to the imagination.

RM Painting, like music, has an inner dialectic that has nothing to do with anything else, what one might call decorum. That is where so many biographers fail. They think if the subject is miserable that accounts for their miserable expression. It can be the exact opposite. In a depressed state an artist may produce the most radiant things because the dialectic is established, as you would say, by the first words. When a person follows his nose, something takes over that has nothing to do with the personal situation. Nearly everybody thinks that everything created is a transcript of what is happening to the artist, and it's not. [. . .]

DH To go back to the concrete, you've had *Ulysses* on your mind for over fifty years now, and we are reacting to work you did in response to that interest. Tell how you approached the task.

RM These etchings were chosen from maybe 450 sketches. This is a small and somewhat arbitrary sampling. Almost by chance my printer would pick up plates, and we would consider proofs of them. Yet I think all of the etchings are roughly equal in merit.

I was "off again, on again, Finnegan." I would work on the images for a while, then write to Andrew Hoyem, the publisher, that it was impossible. Other well-known artists have worked for years on *Ulysses* in very different styles from mine, but this is the first illustrated edition to be realized since Matisse.

DH You said that you did a great many sketches for this project.

RM I normally work at night, from after dinner to one or two in the morning. An awful lot of painting is just sitting and thinking. Very often, when I'm resting during a session, I'll pick up a pad, begin to draw on it—only half looking—and sometimes do this very rapidly, maybe make ten sketches in a half an hour.

One of the things I did learn from the surrealists, which was a doctrine for them and is not for me, is that part of the creative process (as they envisaged it) was never to edit, to let it stand. I tried that a few times when I was on the fringes of the movement and at other times in my life, but I couldn't accept it absolutely. On the whole I have done better by not editing at the time than if I consciously tried for completion. Looking at my oeuvre, I find that the works I'm least proud of are the ones I revised too much. It's true that some of the prime works were either spontaneously made or, conversely, were struggled over for several years. I'm always making many things at once, so I have been able to salvage by becoming spontaneous again and realizing the substructure during revision. That can enrich the finished piece. A painter once remarked to me that contemporary work

should look as though it were made all at once. Or, in other words, that it should have its intensity sustained by immediacy.

When you've done something a lot, it gets built into your arm and wrist and just comes out—in the way you might use a certain phrase habitually, though in wholly different contexts.

DH These are formulas for your artistic existence. But you constantly manipulate them so that your hallmarks express more—say it better.

RM To say it better and also to understand it better. Some viewers might think, "Oh, he's doing another *Spanish Elegy*. But to this day, I really don't know how that vocabulary functions, and my judgement is often faulty immediately after a visual statement. After a passage of time I do know which images do and which don't succeed. It's as though my focus dissolves. To put it very simply, I don't know how to paint on purpose. So, after days or weeks of suffering, finally I just pick up a tool and make marks, then the internal dialectic takes over, and I can truthfully say that quite often I'm more astonished than anybody else could be at what comes out. Yet, if it's any good, I recognize myself.

DH [. . .] The books of yours I've seen, including *A la pintura* and the Octavio Paz volume you showed me yesterday, are big splendid productions with marvelously varied material in them. And now there is the *Ulysses* project where you are aware of your personal sense of Joyce's novel but also of the page. How does that awareness figure in your calculations?

RM For me the margins are the proper wall or the proper space for the image to be in. That has a lot to do with how the page comes to be the way it is. I make the etchings self-matting: there are margins that are right for a given image. In the case of *Ulysses,* the illuminations are etchings, and etching is printed when the paper is damp, really quite wet, so a certain fiber quality in the paper is required if it isn't to split during printing or ripple when it dries. There is a limitation on the possibilities of papers imposed by the medium. Whereas, since lithography is printed dry, you can even use a very thin oriental rice paper. [. . .]

To me the most important thing, which has nothing to do with my etchings, is that there be a readable volume of Joyce. The typeface is faultless, done by an English sculptor, Eric Gill, a contemporary of Joyce. It has a carved feeling like ancient Roman lettering. And it is a large type on a large page. To ponder over Joyce you need a larger type! You need to be able to pause over each word instead of worrying over a web of little dots. After all, who would want to read Joyce in the fine print of *The New York Times?* It would become a physical ordeal.

I have a sense of how the prints will look opposite the beautiful

typeface. I would have liked to go on endlessly. At seventy-three, one has to make choices. I am not in particularly good health, and there are so many things I want to do. I have to limit myself. I'm not nearly as creative as Joyce, but, after all, he wrote the book until it was finished.

I've always regarded what I have done in the book as being modest illuminations, as many English books had in the early nineteenth century. This is not at all comparable to my two Rafael Alberti books or the recent Octavio Paz. Those are almost portfolios. They go beyond bookness—and I happen to like books. I have probably spent more time reading than doing anything else, and I'm always delighted when the book I'm reading is also an agreeable physical object. Given the character of the publisher, whose thing is book-books, and with his genius for typography, I wanted to accommodate myself both to Hoyem and to making a beautiful book *that can be read*. I also wanted to be—as I should be—very modest in proximity to maybe the greatest text in English since Shakespeare.

Notes

1. Motherwell, letter to Andrew Hoyem, 19 September 1985 (Motherwell archives).
2. Motherwell, letter to Andrew Hoyem, 30 March 1987 (Motherwell archives).
3. "The Artist Interviewed by David Hayman in Provincetown, Massachusetts, July 12 and 13, 1988," in *The "Ulysses" Etchings of Robert Motherwell* (San Francisco: Arion Press, 1988).

Letter to Ted Lindberg 19 October 1988

Gordon Onslow-Ford, a British-born artist who had joined the surrealist group in France during the 1930s, was part of their exodus to New York City at the beginning of the Second World War. In February and March 1941, he delivered four lectures on surrealism at the New School for Social Research in New York, where he also organized five exhibitions of surrealist art.[1] It was at one of these lectures that Motherwell met Roberto Matta, the artist who, as an actual artistic presence in his life, was to exert the most direct influence on him during his formative years as a painter. The energetic and optimistic Matta soon became his close friend, his mentor, and his tipster, graphically mapping out for him the terrain of modern art and, during their summer together in Mexico in 1941, revealing to him the process of psychic automatism. Motherwell's commitment to painting and, by extension, to writing can be dated to this fortuitous summer.

In a letter dated 19 October 1988, Motherwell responded to a questionnaire about his relationship with Onslow-Ford, focusing more pertinently on his friendship with Matta. ■

Dear Mr. Lindberg,

Yes I did attend one lecture by Onslow-Ford at the New School for Social Research. It has never been my habit to attend a lecture by anyone, but a young woman named Jacqueline Johnson [. . .] invited me to the Onslow-Ford lecture because she was sure it would interest me.[2] [. . .] When she telephoned me to invite me to the lecture, we decided to meet there. I was slightly late and crept to the seat next to her. At a certain moment, during a brief lapse in the lecture, she pointed to the young man sitting next to her, and, to my astonishment, said he was a genius. After the lecture we spoke at some length. The man was Roberto Matta, who became one of my closest friends in those days. (Jacqueline Johnson became Mrs. Gordon Onslow-Ford some time later.)

As I remember, the lecture was a very good one, intelligent, clear, and filled with an enthusiasm that bordered on Onslow-Ford's sense of an ultimate revelation. He did demonstrate automatism on the blackboard, in a most unexpected way. The usual forms of automatism, as were practiced by Masson or Tanguy (in his preliminary drawing) and above all Miró, possess an absolute autonomy. Onslow-Ford began with lines seemingly at random and very rapidly drawn. At a certain critical moment, with the addition of several more lines, to my stupefaction, there appeared a typical classical de Chirico before one's eyes.* —It never would have occurred to me that de Chiricos were made automatically, and to this day I am inclined to doubt it. — I got to know Matta and then inevitably Onslow-Ford, who was fanatically devoted to and influenced by Matta. Matta was indeed an electrifying personality. In those grim, leftover days of the Depression, and with World War II going on, Matta carried an optimism, a sense of infinite possibilities of everything still to be done, that was a breath of fresh air in the bleakness of Greenwich Village. (We all lived on or around Eighth Street.)[3] Matta was also extremely generous and impartial in his artistic counsel. That is, if he was looking at an inexperienced artist's work of varying imagery and quality, he would invariably pick out the best expression by the artist and vehemently encourage him to move in that direction.[4] Onslow-Ford followed him around like a St. Bernard, but with a fanaticism that was totally different from Matta's empirical realism. In those days, Matta was probably at his best as an artist. His drawings in colored pencil made one suspect that he would be the heir to Miró. Conversely, his painting always struck me as glossy and almost academically overdone despite the richness of imagery, which was unadulterated in the drawings. I must have had many conversations with the two of them (once every month or two). —I do not remember a face to face conversation with Onslow-Ford alone. His fanaticism about surrealism representing human redemption, in the midst of that impoverished and desperate scene, would have turned me off.

*Onslow-Ford owned some early de Chiricos.

Until your letter I was unaware that there was more than one lecture at the New School. —Matta later, say in 1943,[5] wanted to have a palace revolution within surrealism and asked me and Baziotes to contact various American painters including de Kooning, Pollock, Hans Hofmann, Peter Busa, and Gerome Kamrowski. But there was very little response on their side and, as I remember, perhaps incorrectly, Matta began to move in uptown circles and lost his focus on the project. (The genesis of this project may have had something to do with the development of abstract expressionism, though the artist that Matta most directly influenced was Arshile Gorky, who still strikes me as a surrealist rather than an abstract expressionist.) With Matta's abandonment of Greenwich Village and his wife and twins, I largely lost contact with him, and Onslow-Ford must have moved to Marin County with Jacqueline about then.[6]

Notes

1. According to Jimmy Ernst in *A Not So-Still Life* (New York: St. Martin's Press, 1984, p. 196), Motherwell's work was included in one of these exhibits, a possibility the artist was unable to confirm.

2. Motherwell had met Jacqueline Johnson while he was a student at Stanford University.

3. At the time of Onslow-Ford's lectures, Motherwell was living on West Eleventh Street. After his return from Mexico at the end of 1941, he took an apartment on Perry Street, also in Greenwich Village. Later (probably in the fall of 1942, when he returned from Cape Cod), he and his wife, María, moved to an apartment on Eighth Street between Fifth and Sixth Avenues.

4. When Motherwell made his first collages in Jackson Pollock's studio in early 1943, he showed them to Matta, who suggested that he make them much larger. Motherwell explored the larger scale, an idea that had not occurred to him, and during the next four months, he produced three important collages: *Pancho Villa, Dead and Alive; The Joy of Living;* and *Surprise and Inspiration.*

5. Actually, the fall of 1942.

6. Matta left the United States for Rome in 1948. Shortly after his lectures at the New School, Onslow-Ford left for Mexico with Jacqueline; they remained there until 1948, when they moved to California.

APPENDIX A
Prospectus
for the Documents
of Modern Art

The series called "The Documents of Modern Art" is aimed mainly at young artists and students who need their material in English: their needs have primarily determined the selection, treatment, and presentation of the series; e.g., notes and prefaces are provided, and the format has been kept as inexpensive as possible.

By documents is meant first-hand material; the texts are restricted to writing by artists themselves, or by their friends and associates. By modern is meant our international art, which expresses the insights and aspirations of cultivated men everywhere, and which, by virtue of its assimilation of the ideas and morphology of the twentieth century, is our most advanced expression.

The effort of the series is to show that modern art is the expression of feelings and ideas which are complex, but not arbitrary in origin.

The series is limited to the great established artists and movements of the period from the turn of the century to the present; its director is Robert Motherwell, a young modern painter.

Another series, called "Problems of Contemporary Art," exists for current discussions.

APPENDIX B
Catalog (1948–49)
for the Subjects
of the Artist

Artists: William Baziotes, David Hare, Robert Motherwell, Mark Rothko

Theory of the School: The artists who have formed this school believe that receiving instruction in regularly scheduled courses from a single teacher is not necessarily the best spirit in which to advance creative work. Those who are in a learning stage benefit most by associating with working artists and developing with them variations on the artistic process (through actually drawing, painting, and sculpting). If the "student" so prefers, he can choose one artist on the faculty and work exclusively with him. But it is the school's belief that more is to be gained by exposure to the different subjects of all four artists—to what modern artists paint about, as well as how they paint. It will be possible to work with a single artist only in evening sessions, since the afternoon sessions are the responsibility of the faculty as a whole.

Curriculum: There are no formal courses. Each afternoon and evening session will be conducted by one of the four artists as a spontaneous investigation into the subject of the modern artist—what his subjects are, how they are arrived at, methods of inspiration and transformation, moral attitudes, possibilities for further explorations, what is being done now and what might be done, and so on. The afternoon sessions are from 1:30 to 4:30, and the evening sessions from 7:30 to 10:30. There is no instruction on Fridays, when the school will be at the disposal of the students for independent work. The school is closed on Saturdays, Sundays, and certain holidays.

Students: Those attending the classes will not be treated as "students" in the conventional manner, but as collaborators with the artists in the investigation of the artistic process, its modern conditions, possibilities, and extreme nature, through discussions and practice.

Requirements: There are no technical requirements; beginners and those who paint for themselves are welcome; the school is for anyone who wishes to reach beyond conventional modes of expression.

Regulations: Smoking will be regulated according to the fire laws; anyone who does not fit in the school will be asked to withdraw (with refund of unused tuition).

Terms: (each of ten weeks)
11 October–17 December, 1948
3 January–11 March, 1949
21 March–27 May, 1949

Fees: (payable in advance by term or year)
One evening a week: term $45; year $125
Two evenings a week: term $80; year $225
Four evenings a week: term $150; year $400
Five afternoons a week: term $150; year $400

APPENDIX C

Prospectus
for *Modern Artists
in America*

Modern Artists in America is the first biennial to document modern art in the United States. Since it is not concerned with all contemporary art, but only with what is specifically modern, this means an anthology which is both critical and selective. In as compact and objective a manner as the situation permits, illustrations and text are designed to convey *the sense of modern art as it happened.*

The First Series is devoted to the events of the previous two seasons. Vanguard painters and sculptors, youthful and mature, report in their own words in "Artists' Sessions at Studio 35." To accompany this intimate conference from New York is a transcript from San Francisco of "The Western Round Table on Modern Art," in which a representative cross-section of our cultural elite dissect contemporary issues. "Exhibitions of Artists in New York Galleries 1949–50" is a detailed list supplemented by an extensive pictorial selection of the more significant paintings and sculpture, including some works shown outside of New York proper.

In "New York–Paris 1951," a French critic, Michel Seuphor, compares the artistic climate of the two major art centers, not without deference to a renascent America. Photographs of the pioneer Arensberg collection in its home setting, records of modern works acquired by American museums, excerpts from magazines, catalogs, and pamphlets compressed into a calendar which illustrates the social attitudes affecting the position of the practicing artist today, and, finally, an international inventory of art publications for 1949–50 complete the documentary portion of the biennial. In all, there are 200 pages and almost 160 illustrations.

Modern Artists in America: First Series is edited jointly by Robert Motherwell, painter and the editor of "The Documents of Modern Art," by

Ad Reinhardt, painter and Professor of Art, Brooklyn College, and by Bernard Karpel, Librarian, The Museum of Modern Art, New York. Frontispiece and installation photos are by Aaron Siskind, photographer and Instructor at the Institute of Design, Chicago.[1]

Note

1. The prospectus was written in longhand (neither the writing style nor the script appear to be Motherwell's) and was reproduced as end papers in the book.

APPENDIX D
Motherwell's Course
Syllabus, Hunter College
Fall 1955

Part I: The Public's Problem with Modern Art, consisting of five lectures on the "dehumanization" of modern art (ref: José Ortega, Span. phil.); one lecture on the Armory Show in NYC, 1913 (ref: Meyer Schapiro); and one lecture on three law suits (the indictment of Apollinaire, the indictment of Le Douanier Rousseau, and the Brancusi U.S. Customs case [ref: trial transcripts]).

Part II: The Structure of Modern Society, consisting of five lectures on the nature of man under capitalist society (ref: Section 5, Erich Fromm, *The Sane Society);* one lecture on the theory of the leisure class and the conspicuous display of wealth (ref: Thorstein Veblen); and one lecture on the modern artist's definition of the "bourgeois-Philistine" (ref: Baudelaire, Matthew Arnold, Delacroix, et al.).

Part III: The Modern Artist, consisting of one lecture on a distinction between "moral" (social) and "ethical" (individual) (ref: Sophocles's *Antigone;* Hegel's philosophy of fine art); the nature of the tragic.

Part IV: Modern Art and Religion, consisting of two lectures on the Church at Assy, France; the Matisse Chapel at Vence, France; Braque and Léger stained glass; Le Corbusier's new church; modern American synagogues; Tillich's view of Reinhardt; Father Couturier's position; and Catholic, Protestant, and Jewish tendencies.

Part V: Modern Art and the Problem of Public Commissions, consisting of five lectures on Picasso's *Guernica;* one on Braque's ceiling in the Louvre; and two lectures on the statue of the unknown political prisoner (ref: Butler, Calder, Pevsner, Lippold, et al.). Winston Churchill's opinion.

Part VI: The Artist as an Ethical Individual, consisting of five lectures on Picasso's *The Human Comedy* (a suite of 180 drawings of the artist and model: all on slides).

Part VII: Résumé and Conclusion

Part VIII: Appendices and Supplementary Material[1]

Note

1. The course syllabus is at the Motherwell archives.

BIBLIOGRAPHY

Previous bibliographies, beginning with that prepared by Bernard Karpel for Motherwell's retrospective exhibition catalog (New York: Museum of Modern Art, 1965) and Susan Bradford's updated work for the second edition of H. H. Arnason, *Robert Motherwell* (New York: Abrams, 1982), were starting points for these additions and amendments. Except for those lectures introduced in this volume, unpublished lectures are not listed, although typescripts for some exist in the Motherwell archives, Dedalus Foundation, Bedford Hills, New York; the Archives of American Art, Smithsonian Institution, Washington, D.C.; and the Museum of Modern Art, New York. Many of Motherwell's published writings, lectures, and interviews have been excerpted or reprinted in their entirety in various publications since their original appearance in print and, when known, have been cited here. In many instances, the date of the actual writing or lecture rather than the date of publication has determined the chronology. Entries preceded with an [★] indicate those included in this volume. Writings *about* Motherwell are not given here.

WRITINGS

1941

Translation [Fall 1941] (from French) of Wolfgang Paalen. "The New Image." *DYN* (Mexico City) 1, no. 1 (April–May 1942): 7–15.

REPRINTED

In Wolfgang Paalen. *Form and Sense*. Problems of Contemporary Art, no. 1. New York: Wittenborn, Schultz, 1945, pp. 31–41.

1942

[★] "Notes on Mondrian and Chirico." *VVV* (New York) 1 (June 1942): 59–61.

1944

[★] "Painters' Objects." *Partisan Review* 11, no. 1 (Winter 1944): 93–97.

REPRINTED

Portion in *New York School. The First Generation: Paintings of the 1940s and 1950s* (exhibition catalog). Los Angeles: Los Angeles County Museum of Art, 1965, p. 21.

Portion in *Robert Motherwell: With Selections from the Artist's Writings* (exhibition catalog). New York: Museum of Modern Art, 1965, pp. 35–36.

Excerpt in *Motherwell* (exhibition catalog). Turin: Galleria Civica D'Arte Moderna, 1966, pp. 33–35. [In Italian]

Portion in *New York School. The First Generation: Paintings of the 1940s and 1950s.* Rev. ed. (Greenwich, Conn.: New York Graphic Society, 1970, pp. 99–100.

Preface, paragraph headings, and editor's notes, in Guillaume Apollinaire. *The Cubist Painters: Aesthetic Meditations 1913.* Documents of Modern Art, no. 1. New York: Wittenborn, 1944, pp. 5–6, 34–35. 2d rev. ed. [see 1949].

[★] "The Modern Painter's World." *DYN* (Mexico City) 1, no. 6 (November 1944): 9–14.

[From "The Place of the Spiritual in a World of Property." Lecture presented at Mount Holyoke College, South Hadley, Mass., 10 August 1944. (Session moderated by André Masson, with Robert Goldwater, Stanley William Hayter, Jean Hélion, Motherwell, José Luis Sert, and Ossip Zadkine participating)]

REPRINTED

Excerpt in Barbara Rose. *American Art Since 1900, a Critical History.* New York: Praeger, 1967, pp. 155, 179.

In Barbara Rose, ed. *Readings in American Art Since 1900, a Documentary Survey.* New York: Praeger, 1968, pp. 130–35.

In *The Artist as Adversary* (exhibition catalog). New York: Museum of Modern Art, 1971, pp. 19–21.

Excerpt in *The Collages of Robert Motherwell: A Retrospective Exhibition* (exhibition catalog). Houston: Museum of Fine Arts, 1972, p. 91.

Excerpt in Barbara Rose, ed. *Readings in American Art 1900–1975.* New York: Praeger, 1975, pp. 104–7.

Excerpt in *Robert Motherwell: Choix de peintures et de collages 1941–1977* (exhibition catalog). Paris: Musée d'Art Moderne de la Ville de Paris, 1977, [pp. 6–8]. [In French]

"Calder's 'Three Young Rats.' " *New Republic* 3, no. 26 (25 December 1944): 874, 876.

Plate caption, in Sidney Janis. *Abstract and Surrealist Art in America.* New York: Reynal and Hitchcock, 1944, p. 65.

1945

Preface to Piet Mondrian. *Plastic Art and Pure Plastic Art, 1937, and Other Essays, 1941–1943.* Documents of Modern Art, no. 2. New York: Wittenborn, Schultz, 1945, pp. 5–6. Updated 2d ed., 1947. 3d ed., 1951.

"Personal Statement" [ca. February 1945] in *A Painting Prophecy—1950* (exhibition catalog). Washington, D.C.: David Porter Gallery, 1945.

[Among other artists included in this exhibition were William Baziotes, Stuart Davis, Jimmy Ernst, Adolph Gottlieb, Karl Knaths, Jackson Pollock, Richard Pousette-Dart, and Mark Rothko; all artists were asked to write for the catalog, but not all responded]

"Henry Moore." *New Republic* 113, no. 17 (22 October 1945): 538.

1946

[★] "Beyond the Aesthetic." *Design* (Columbus) 47, no. 8 (April 1946): 14–15.

REPRINTED

Excerpts in *Contemporary American Painting* (exhibition catalog). Urbana: University of Illinois Press, 1951, p. 201.

Excerpt in William C. Seitz. *The Art of Assemblage* (exhibition catalog). New York: Museum of Modern Art, 1961.

Portion in *Robert Motherwell: With Selections from the Artist's Writings* (exhibition catalog). New York: Museum of Modern Art, 1965, pp. 37–39.

Excerpt in *Motherwell* (exhibition catalog). Turin: Galleria Civica D'Arte Moderna, 1966, pp. 35–37. [In Italian]

As deluxe edition of thirty numbered copies designed and printed by James B. Nutter at Kresge Art Center, Michigan State University, East Lansing, 1967.

Excerpt in *The Collages of Robert Motherwell: A Retrospective Exhibition* (exhibition catalog). Houston: Museum of Fine Arts, 1972, p. 91.

Excerpts in *Robert Motherwell* (bilingual exhibition catalog). Düsseldorf: Städtische Kunsthalle, 1976, pp. 5, 6–7, 14, 18.

Excerpts in "Robert Motherwell." *Flash Art* (Milan), no. 70/71 (January–February 1977): 48.

In Clifford Ross, ed. *Abstract Expressionism: Creators and Critics: An Anthology.* New York: Abrams, 1990, pp. 103–6.

[★] Statement [ca. September 1946] in *Fourteen Americans* (exhibition catalog). New York: Museum of Modern Art, 1946, pp. 34–36.

REPRINTED

Excerpt in *Robert Motherwell: With Selections from the Artist's Writings* (exhibition catalog). New York: Museum of Modern Art, 1965, p. 36.

1947

[★] Statement [ca. April 1947] in *Motherwell* (exhibition catalog). New York: Samuel Kootz Gallery, 1947, [pp. 2–3].

[★] Editorial Preface, with Harold Rosenberg [September 1947], to *possibilities 1: An Occasional Review*. Problems of Contemporary Art, no. 4. Edited by John Cage, Pierre Chareau, Robert Motherwell, and Harold Rosenberg. New York: Wittenborn, Schultz, 1947/1948, p. 1.

REPRINTED

In Herschel B. Chipp. *Theories of Modern Art: A Source Book by Artists and Critics.* Berkeley: University of California Press, 1968, pp. 489–90.

In Barbara Rose, ed. *Readings in American Art Since 1900, a Documentary Survey.* New York: Praeger, 1968, pp. 129–30.

In Barbara Rose, ed. *Readings in American Art 1900–1975.* New York: Praeger, 1975, pp. 103–4.

1948

[★] Prefatory Note [June 1948] to *Max Ernst: Beyond Painting and Other Writings by the Artist and His Friends*. Documents of Modern Art, no. 7. New York: Wittenborn, Schultz, 1948, pp. v–vi.

[★] Prefatory Note [24 August 1948] to Jean (Hans) Arp. *On My Way: Poetry and Essays 1912–1947*. Documents of Modern Art, no. 6. New York: Wittenborn, Schultz, 1948, p. 6.

REPRINTED

Excerpt in *Robert Motherwell: With Selections from the Artist's Writings* (exhibition catalog). New York: Museum of Modern Art, 1965, p. 42.

[★] "A Tour of the Sublime," in "The Ides of Art—Six Opinions on What Is Sublime in Art." *Tiger's Eye* (Westport, Conn.) 1, no. 6 (15 December 1948): 46–48.
[Includes opinions by Barnett Newman and Kurt Seligmann, among others]
REPRINTED
In *Robert Motherwell: With Selections from the Artist's Writings* (exhibition catalog). New York: Museum of Modern Art, 1965, pp. 40–41.
Excerpt in *Motherwell* (exhibition catalog). Turin: Galleria Civica D'Arte Moderna, 1966, pp. 37–39. [In Italian]

1949

[★] Preliminary Notice [22 February 1949] to Daniel-Henry Kahnweiler. *The Rise of Cubism*. Documents of Modern Art, no. 9. New York: Wittenborn, Schultz, 1949, pp. vi–viii. 2d rev. ed., n.d.
REPRINTED
Excerpt in *Robert Motherwell: With Selections from the Artist's Writings* (exhibition catalog). New York: Museum of Modern Art, 1965, p. 42.
Excerpt in *Motherwell* (exhibition catalog). Turin: Galleria Civica D'Arte Moderna, 1966, pp. 39–40. [In Italian]
Excerpt in *The Collages of Robert Motherwell: A Retrospective Exhibition* (exhibition catalog). Houston: Museum of Fine Arts, 1972, p. 92.

[★] "A Personal Expression." Lecture presented in session "The Artist's Point of View" at the Seventh Annual Conference of the Committee on Art Education (sponsored by the Museum of Modern Art), New York, 19 March 1949. Transcript in Motherwell archives.
[Session moderated by Ruth Reeves, with Balcomb Greene, Motherwell, and Ben Shahn participating]

[★] Preliminary Notice [29 March 1949] to Guillaume Apollinaire. *The Cubist Painters: Aesthetic Meditations 1913*. Documents of Modern Art, no. 1. 2d rev. ed. New York: Wittenborn, Schultz, 1949, pp. iv–v. 1st ed. [see 1944].

[★] "Reflections on Painting Now." Lecture presented at symposium "French Art vrs. U.S. Art Today" at Forum 49, Provincetown, Mass., 11 August 1949. Transcript in Motherwell archives.
[The event for this day in the week's sessions was organized by Adolph Gottlieb, with Karl Knaths, Paul Mocsanyi, Motherwell, Stuart Preston, and Frederick Wight participating]
PUBLISHED
Paragraph excerpt in *Robert Motherwell Collages 1943–1949* (exhibition catalog). New York: Samuel Kootz Gallery, 1949.

[★] Preliminary Notice [16–21 October 1949] to Marcel Raymond. *From Baudelaire to Surrealism*. Documents of Modern Art, no. 10. New York: Wittenborn, Schultz, 1949, pp. vii–viii.
REPRINTED
Excerpt in *Robert Motherwell: With Selections from the Artist's Writings* (exhibition catalog). New York: Museum of Modern Art, 1965, p. 42.

1950

[★] "Black or White" [10 February 1950], in *Black or White: Paintings by European and American Artists* (exhibition catalog). New York: Samuel Kootz Gallery, 1950, [pp. 2–3].
REPRINTED
In "Robert Motherwell." *Appia Antica* (Rome) 1 (1959): 12.

In *Black and White* (exhibition catalog). New York: Jewish Museum, 1963, p. 9.

Portion in *Robert Motherwell: With Selections from the Artist's Writings* (exhibition catalog). New York: Museum of Modern Art, 1965, p. 43.

In "Mr. Motherwell's Acceptance." *MacDowell Colony News* (Peterborough, N.H.) 15, no. 1 (Fall 1985): 3–4.

In Marcelin Pleynet. *Robert Motherwell*. Paris: Edition Daniel Papierski, 1989, p. 62. [In French, English, and German]

In *Poesía y poética* (Santa Fe, Argentina) (Winter 1990). [In Spanish]

"For David Smith 1950" [April 1950], in *David Smith* (exhibition catalog). New York: Willard Gallery, 1950.

REPRINTED

Portion in *Robert Motherwell: With Selections from the Artist's Writings* (exhibition catalog). New York: Museum of Modern Art, 1965, p. 43.

Open letter to Roland L. Redmond, president of the Metropolitan Museum of Art, in "18 Painters Boycott Metropolitan; Charge 'Hostility to Advanced Art.' " *New York Times,* 22 May 1950, pp. 1, 15.

[Protest, signed by eighteen artists (subsequently referred to as "The Irascibles"), against the museum's discriminatory policy toward American avant-garde painting]

[★] Preface [14 July 1950] to Georges Duthuit. *The Fauvist Painters*. Documents of Modern Art, no. 11. New York: Wittenborn, Schultz, 1950, pp. ix–x.

[★] "The New York School" [revised by the artist, 10 December 1950]. Lecture presented in panel "Appraisals of Contemporary Art" at the Mid-Western Conference of College Art Association, Louisville, Ky., 27 October 1950. Transcript in Motherwell archives.

Comments on three themes [ca. November 1950] in *Motherwell: First Exhibition of Paintings in Three Years* (exhibition catalog). New York: Samuel Kootz Gallery, 1950, [pp. 2–3].

REPRINTED

Excerpt in *Guggenheim International Award 1964* (exhibition catalog). New York: Solomon R. Guggenheim Museum, 1964, p. 96.

1951

[★] Preface ["The School of New York"] [1 January 1951] to *Seventeen Modern American Painters* (exhibition catalog). Beverly Hills: Frank Perls Gallery, 1951, [pp. 2–5].

REPRINTED

In *The School of New York* (exhibition catalog). Santa Barbara, Calif.: Santa Barbara Museum of Art, 1951.

Portion in *New York School. The First Generation: Paintings of the 1940s and 1950s* (exhibition catalog). Los Angeles: Los Angeles County Museum of Art, 1965, p. 41.

Excerpt in *Robert Motherwell* (bilingual exhibition catalog). Düsseldorf: Städtische Kunsthalle, 1976, p. 6.

Explanation [early 1951] of preface to *Seventeen Modern American Painters*. Transcript in Motherwell archives.

[Motherwell's defense of the preface after it was attacked by some of his peers]

PUBLISHED

Portion in *Robert Motherwell* (bilingual exhibition catalog). Düsseldorf: Städtische Kunsthalle, 1976, p. 15.

[★] "What Abstract Art Means to Me." *Museum of Modern Art Bulletin* 18, no. 3 (Spring 1951): 12–13.
[Lecture presented at symposium (organized by the Museum of Modern Art's Junior Council) in conjunction with the exhibition "Abstract Painting and Sculpture in America," New York, 5 February 1951. (George L. K. Morris, Willem de Kooning, Alexander Calder, Fritz Glarner, Motherwell, and Stuart Davis participated)]

REPRINTED

Edited version in *Art Digest* 25, no. 10 (15 February 1951): 12, 27–28.
In "La peinture abstraite aux U.S.A." *Art d'aujourd'hui* 2, no. 4 (June 1951): 16–23.
Portion in *Robert Motherwell: With Selections from the Artist's Writings* (exhibition catalog). New York: Museum of Modern Art, 1965, p. 45.
Excerpt in *Motherwell* (exhibition catalog). Turin: Galleria Civica D'Arte Moderna, 1966, pp. 39–40. [In Italian]
Excerpts in Herschel B. Chipp. *Theories of Modern Art: A Source Book by Artists and Critics.* Berkeley: University of California Press, 1968, pp. 562–64.
In *Robert Motherwell* (bilingual exhibition catalog). Düsseldorf: Städtische Kunsthalle, 1976, pp. 16–18.
Excerpt in *Robert Motherwell: Choix de peintures et de collages 1941–1977* (exhibition catalog). Paris: Musée d'Art Moderne de la Ville de Paris, 1977, [p. 9]. [In French]

"The Public and the Modern Artist." *Catholic Art Quarterly* (Buffalo, N.Y.) 14, no. 2 (Spring 1951): 80–81.

[★] "The Rise and Continuity of Abstract Art." *Arts and Architecture* (Los Angeles) 68, no. 9 (September 1951): 20–21, 41.
[From lecture presented at the Fogg Art Museum, Harvard University, Cambridge, Mass., 12 April 1951. (Session organized by John Coolidge, with Oliver W. Larkin, Motherwell, and Ben Shahn participating)]

REPRINTED

Brief excerpt in *40 American Painters, 1940–1950* (exhibition catalog). Minneapolis: University of Minnesota, Department of Art, 1951.
Portion in *Contemporary American Painting* (exhibition catalog). Urbana: University of Illinois Press, 1952, p. 217.
Excerpt in *The Collages of Robert Motherwell: A Retrospective Exhibition* (exhibition catalog). Houston: Museum of Fine Arts, 1972, pp. 92–93.

[★] Introduction [Winter 1951] and Preface [14 June 1951] to Robert Motherwell, ed. *The Dada Painters and Poets: An Anthology.* Documents of Modern Art, no. 8. New York: Wittenborn, Schultz, 1951, pp. xv–xxxviii. Reprint, 1967. 2d ed., 1981 [see Documents of 20th-Century Art].

[★] Statement, with Bernard Karpel and Ad Reinhardt; Introduction to the Illustrations, with Ad Reinhardt [Fall 1951]; and Statements from "Artists' Sessions at Studio 35" [Spring 1950], in Robert Motherwell, Ad Reinhardt, and Bernard Karpel, eds. *Modern Artists in America: First Series.* New York: Wittenborn, Schultz, [1951], pp. 6–7, 40, 8–24.

REPRINTED

Portions (from "Artists' Sessions") in *New York School. The First Generation: Paintings of the 1940s and 1950s* (exhibition catalog). Los Angeles: Los Angeles County Museum of Art, 1965, pp. 33–41.
Excerpt (from "Artists' Sessions") in Barbara Rose, ed. *Readings in American Art 1900–1975.* New York: Praeger, 1975, pp. 143–45.
Excerpt in *Robert Motherwell* (bilingual exhibition catalog). Düsseldorf: Städtische Kunsthalle, 1976, p. 6.

"The Mural," in *Symbols and Inscriptions in the Synagogue.* Millburn, N.J.: Congregation B'nai Israel, [ca. 1951].

Quoted in Thomas Hess. *Abstract Painting: Background and American Phase.* New York: Viking Press, 1951, p. 132.

Notes [October] in *Cy Twombly* (exhibition catalog). Chicago: Seven Stairs Gallery, 1951.

REPRINTED

In *Cy Twombly: Paintings and Sculpture 1951 and 1953* (exhibition catalog). New York: Sperone Westwater, 1989.

In *144th Anniversary Awards Dinner.* New York: Skowhegan School of Painting and Sculpture, 1990. [Dinner held at Plaza Hotel, New York]

1952

Quotations from The Documents of Modern Art series. *Bulletin of the Allen Memorial Art Museum* (Oberlin) 9, no. 3 (Spring 1952): 110–12.
[Motherwell conducted a seminar at Oberlin College, 15–24 April 1952]

1953

"Joseph Cornell." Preface [26 June 1953] to aborted exhibition catalog, Walker Art Center, Minneapolis. Published as "Preface to a Joseph Cornell Exhibition," in *Joseph Cornell Portfolio—Catalogue* (exhibition catalog). New York and Los Angeles: Leo Castelli Gallery, Richard L. Feigen and Co., and James Corcoran Gallery, 1976.

REPRINTED

Excerpt in *Robert Motherwell* (bilingual exhibition catalog). Düsseldorf: Städtische Kunsthalle, 1976, pp. 15–16.

"Is the French Avant-Garde Overrated?" *Art Digest* 27, no. 20 (September 1953): 13, 27.
[Written symposium with Ralston Crawford, Clement Greenberg, Motherwell, and Jack Tworkov contributing]

1954

Statement in *Four Americans from the Real to the Abstract* (exhibition catalog). Houston: Contemporary Arts Museum, 1954.

[*] "Symbolism." Lecture presented at Hunter College, New York, 24 February 1954. Transcript in Motherwell archives.

PUBLISHED

Excerpt in *Robert Motherwell* (bilingual exhibition catalog). Düsseldorf: Städtische Kunsthalle, 1976, p. 5.

[*] "The Painter and the Audience," in "Symposium: The Creative Artist and His Audience." *Perspectives USA* (Brooklyn) 9 (Autumn 1954): 107–12.
[Saul Bellow, Robinson Jeffers, Motherwell, and Roger Sessions contributed]

REPRINTED

In French, Italian, and German, with comments by Jean Paulhan, "L'Artiste moderne et son public." *Profils* 9 (1954): 192–98; Felice Casorati, "I Pittori." *Prospetti* 9 (1954): 118–20; and Karl Hofer, "Die Krise des Publikums." *Prospekte* 9 (1954): 167–69.

Portion in *The New American Painting: As Shown in Eight European Countries 1958–1959* (exhibition catalog). New York: Museum of Modern Art, 1959, p. 56.

Portion in *Robert Motherwell: With Selections from the Artist's Writings* (exhibition catalog). New York: Museum of Modern Art, 1965, p. 47.

Excerpt in *Motherwell* (exhibition catalog). Turin: Galleria Civica D'Arte Moderna, 1966, pp. 41–42. [In Italian]

Excerpt in *Robert Motherwell: Choix de peintures et de collages 1941–1977* (exhibition catalog). Paris: Musée d'Art Moderne de la Ville de Paris, 1977, [p. 10]. [In French]

In 1,000 copies (50 numbered and signed by Motherwell) as *Peintre et public*. Translated by Jean Paulhan. Caen: L'Echoppe, 1989.

In Clifford Ross, ed. *Abstract Expressionism: Creators and Critics: An Anthology*. New York: Abrams 1990, pp. 106–10.

1955

[★] "A Painting Must Make Human Contact," in *The New Decade: 35 American Painters and Sculptors*. New York: Whitney Museum of American Art, 1955, p. 59.

REPRINTED

In Eric Protter, ed. *Painters on Painting*. New York: Grosset and Dunlap, 1963, p. 250.

Portion in *Robert Motherwell: With Selections from the Artist's Writings* (exhibition catalog). New York: Museum of Modern Art, 1965, p. 50.

Excerpt in *Robert Motherwell: Choix de peintures et de collages 1941–1977* (exhibition catalog). Paris: Musée d'Art Moderne de la Ville de Paris, 1977, [p. 11]. [In French]

Letter to the editor. *Arts* 30, no. 7 (April 1956): 8.

[Correction of the magazine's upside-down publication of a photograph of his painting *Granada* in the previous issue]

1957

[★] Notes, in John I. H. Baur. *Bradley Walker Tomlin* (exhibition catalog). New York: Macmillan for the Whitney Museum of American Art, 1957, pp. 11–12.

1959

Statement. *It Is* (New York), no. 3 (Winter–Spring 1959): 10.

Statements, in *The New American Painting: As Shown in Eight European Countries 1958–1959* (exhibition catalog). New York: Museum of Modern Art, 1959.

[Includes excerpt from "The Painter and the Audience" (1954)]

REPRINTED

In *Robert Motherwell: With Selections from the Artist's Writings* (exhibition catalog). New York: Museum of Modern Art, 1965, p. 53.

In David Shapiro and Cecile Shapiro, eds. *Abstract Expressionism, a Critical Record*. Cambridge: Cambridge University Press, 1990, pp. 95–96.

[★] "The Significance of Miró." *Art News* 58, no. 4 (May 1959): 32–33, 65–67.

REPRINTED

Edited portion in *Robert Motherwell: With Selections from the Artist's Writings* (exhibition catalog). New York: Museum of Modern Art, 1965, pp. 50–53.

In Barbaralee Diamonstein, ed. *The Art World: A Seventy-five Year Treasury of ARTnews*. New York: Artnews Books, 1977, pp. 298–301.

As "La importancia de Miró" [with note by Motherwell (1985)], in *Joan Miró*. Barcelona: Fundación Joan Miró, 1986, pp. 27–30.

Letter to the editor. *Arts* 33, no. 8 (May 1959): 8.

[★] Lecture (with Charles R. Hulbeck [Richard Huelsenbeck]) on "Modern Art and Human Development, a Psychoanalytic Comment," presented at a meeting of the Association for the Advancement of Psychoanalysis, New York Academy of Medicine, New York, October 1959. Transcript in Motherwell archives.

[★] Occasional pieces: [1] "Of Form and Content," [2] "Abstract Art and the Real," and [3] "Expressionism," ca. 1950s. Transcript of [2] in Motherwell archives.

PUBLISHED

[1] In Robert C. Hobbs. "Motherwell's Concern with Death in Painting: An Investigation of His Elegies to the Spanish Republic, Including an Examination of His Philosophical and Methodological Considerations." Ph.D. diss., University of North Carolina, 1975, p. 33.

[1] In E. A. Carmean, Jr. "Robert Motherwell: The Elegies to the Spanish Republic," in *American Art at Mid-Century: The Subjects of the Artist* (exhibition catalog). Washington, D.C.: National Gallery of Art, 1979, p. 104.

[3] In *Robert Motherwell* (bilingual exhibition catalog). Düsseldorf: Städtische Kunsthalle, 1976, pp. 8–10.

1960

Statements, in "The Philadelphia Panel on the Concept of the New." *It Is* (New York), no. 5 (Spring 1960): 34–38.
[From "Conversations with Artists," panel on painting organized at the Philadelphia Museum School of Art, 28 March 1960]

REPRINTED

Portion in *Robert Motherwell: With Selections from the Artist's Writings* (exhibition catalog). New York: Museum of Modern Art, 1965, p. 53.

1961

"In Support of the French Intellectuals." *Partisan Review* 28, no. 1 (January–February 1961): 144–45.
[Petition on Algerian war, signed by Motherwell and many others, including Willem de Kooning, Herbert Ferber, Franz Kline, Stanley Kunitz, Norman Mailer, Harold Rosenberg, and Mark Rothko]

Letter to the editor. *New York Times,* 26 February 1961.
[A protest against the *New York Times* art critic John Canaday, signed by Motherwell and others, including Willem de Kooning, Adolph Gottlieb, Thomas Hess, Hans Hofmann, Sam Hunter, Barnett Newman, Harold Rosenberg, Irving Sandler, Meyer Schapiro, and David Smith]

REPRINTED

Portion in John Canaday. *The Embattled Critic.* New York: Farrar, Straus, and Cudahy, 1962, pp. 219–23.

[*] "What Should a Museum Be?" *Art in America* 49, no. 2 (March–April 1961): 32–33.

REPRINTED

In *Robert Motherwell: A Retrospective Exhibition* (exhibition catalog). Pasadena, Calif.: Pasadena Art Museum, 1962.

Statement, in "Something for All." *Newsweek,* 31 July 1961, pp. 80–81.
[On Provincetown, Mass.]

Statement, in Gay Talese. "Yankee Stadium: Night of Idolatry." *New York Times,* 2 September 1961, p. 10.

1962

Statements, in Florence Berkman, "Motherwell Opens Art Lecture Series." *Hartford Times,* 24 March 1962, p. 26.
[On the artist's lecture at Burns School, Hartford, Conn.]

[*] "Homage to Franz Kline" [17 August 1962], in *Kline: The Color Abstractions* (exhibition catalog). Washington, D.C.: Phillips Collection, 1979, p. 43.
[Written at the request of Washington (D.C.) Gallery of Modern Art for a Kline retrospective in 1962, but not published]

Interview with David Sylvester: "Painting as Existence." *Metro* (Milan), no. 7 (1962): 94–97.
[Minor revisions of "Painting as Self-Discovery" interview for BBC, London, conducted in 1960]

REPRINTED
Excerpts in Clifford Ross, ed. *Abstract Expressionism: Creators and Critics: An Anthology.* New York: Abrams 1990, p. 112.

[★] "Robert Motherwell: A Conversation at Lunch" [November 1962], in *An Exhibition of the Work of Robert Motherwell* (exhibition catalog). Northampton, Mass.: Smith College Musum of Art, 1963, [pp. 10–19].

REPRINTED
Excerpt in *Guggenheim International Award 1964* (exhibition catalog). New York: Solomon R. Guggenheim Museum, 1964.
Excerpts in *Robert Motherwell: With Selections from the Artist's Writings* (exhibition catalog). New York: Museum of Modern Art, 1965, p. 54.
Excerpt in *The Collages of Robert Motherwell: A Retrospective Exhibition* (exhibition catalog). Houston: Museum of Fine Arts, 1972, p. 93.
Excerpts in *Robert Motherwell* (bilingual exhibition catalog). Düsseldorf: Städtische Kunsthalle, 1976, pp. 7, 8, 13–14.
Excerpt in "Robert Motherwell." *Flash Art* (Milan), no. 70/71 (January–February 1977): 48.
Excerpts in *Robert Motherwell: Choix de peintures et de collages 1941–1977* (exhibition catalog). Paris: Musée d'Art Moderne de la Ville de Paris, 1977, [p. 12]. [In French]
Excerpt in Clifford Ross ed. *Abstract Expressionism: Creators and Critics: An Anthology.* New York: Abrams, 1990, p. 112.

Statements, in "The Deepest Identity." *Newsweek,* 10 December 1962, p. 94.

1963

[★] "Robert Motherwell: A Conversation at Lunch" [see 1962].

Letter to the editor. *Art News* 62, no. 1 (March 1963): 6.
[In reply to a letter to the editor from Esteban Vicente on Motherwell and the Spanish Civil War]

[★] "A Process of Painting," in Jules Barron and Renee Nell, eds. *The Creative Use of the Unconscious by the Artist and by the Psychotherapist.* Monograph no. 8 of *Annals of Psychotherapy: Journal of the American Academy of Psychotherapists* (Westwood, N.J.) 5. no. 1 (1964): 47–49.
[Lecture presented at symposium at the Eighth Annual Conference of the American Academy of Psychotherapists, New York, 5 October 1963]

REPRINTED
In *Robert Motherwell* (bilingual exhibition catalog). Düsseldorf: Städtische Kunsthalle, 1976, pp. 10–13.
Excerpt in *Robert Motherwell: Choix de peintures et de collages 1941–1977* (exhibition catalog). Paris: Musée d'Art Moderne de la Ville de Paris, 1977, [p. 13]. [In French]

1964

"The Motherwell Collection." *Vogue,* January 1964, pp. 88–91, 118.

[★] "A Process of Painting" [see 1963].

Statement, in Robert Ostermann. "Men Who Lead an American Revolution." *National Observer* (London), 17 February 1964, p. 18.

Statement, in "Sharks Go Home." *Newsweek,* 24 August 1964, p. 78.
[On Provincetown, Mass.]

"The Motherwell Proposal," in Howard Conant, ed. *Seminar on Elementary and Secondary School Education in the Arts*. New York: New York University, 1965, pp. 205–9.
[From conference (sponsored by the Institute for the Study of Art and Education, New York University, and the U.S. Office of Education), New York, 8–9 October 1964]

1965

[★] Interview with Bryan Robertson, Addenda. Transcript in Motherwell archives.

PUBLISHED

Excerpt in *Robert Motherwell* (bilingual exhibition catalog). Düsseldorf: Städtische Kunsthalle, 1976, pp. 14–15.

"A Major American Sculptor, David Smith." *Vogue,* February 1965, pp. 135–39, 190–91.

REPRINTED

Excerpt in *Robert Motherwell: With Selections from the Artist's Writings* (exhibition catalog). New York: Museum of Modern Art, 1965.
In *Studio International* (London) 172 (August 1966): 65–68.
In Allene Talmey, ed. *People and Things in "Vogue"* (Englewood Cliffs, N.J.: Prentice-Hall, [1970], pp. 201–6.

Interview with Max Kozloff: "An Interview with Robert Motherwell." *Artforum* 4, no. 1 (September 1965): 33–37.
[The interview was conducted in March 1965]

REPRINTED

Excerpt in *Robert Motherwell: With Selections from the Artist's Writings* (exhibition catalog). New York: Museum of Modern Art, 1965, p. 54.

[★] "Letter from Robert Motherwell to Frank O'Hara, Dated August 18, 1965," in *Robert Motherwell: With Selections from the Artist's Writings* (exhibition catalog). New York: Museum of Modern Art, 1965, pp. 58–59, 67–68, 70.

REPRINTED

Excerpts in *Robert Motherwell: Choix de peintures et de collages 1941–1977* (exhibition catalog). Paris: Musée d'Art Moderne de la Ville de Paris, 1977, [p. 14]. [In French]

"Selections from the Writings of Robert Motherwell," ed. William Berkson, in *Robert Motherwell: With Selections from the Artist's Writings* (exhibition catalog). New York: Museum of Modern Art, 1965, pp. 35–56.
[Includes excerpts from "Painters' Objects" (1944); "Beyond the Aesthetic" (1946); Statement in *Fourteen Americans* (1946); Prefatory Note to Jean (Hans) Arp, *On My Way: Poetry and Essays 1912–1947* (1948); "A Tour of the Sublime" (1948); Preliminary Notice to Daniel-Henry Kahnweiler, *The Rise of Cubism* (1949); Preliminary Notice to Marcel Raymond, *From Baudelaire to Surrealism* (1949); "Black or White" (1950); "For David Smith" (1950); "What Abstract Means to Me" (1951); "The Painter and the Audience" (1954); "A Painting Must Make Human Contact" (1955); Statement, in *The New American Painting* (1959); "The Significance of Miró" (1959); Statements, in "The Philadelphia Panel on the Concept of the New" (1960); "Robert Motherwell: A Conversation at Lunch" (1962); "A Major American Sculptor, David Smith" (1965); and interview with Max Kozloff (1965)]

REPRINTED

Excerpts in *Robert Motherwell* (exhibition catalog), Turin: Galleria Civica d'Arte Moderna, 1966, pp. 33–43. [In Italian]

Statements, in *New York School. The First Generation: Paintings of the 1940s and 1950s* (exhibition catalog). Los Angeles: Los Angeles County Museum of Art, 1965.
[Includes excerpts from "Painter's Objects" (1944); Preface ["The School of New York"] to *Seventeen Modern American Painters* (1951); and "Artists' Sessions at Studio 35," in *Modern Artists in America* (1951)]

"The Motherwell Proposal" [see 1964].

Letter to the editor [13 October 1965], in "Editor's Letters." *Art News* 64, no. 8 (December 1965): 6.
[Correction of biographical errors in October issue]

Statement on title page of *The Madrid Suite*. New York: Irwin Hollander, 1965.
[Ten original black-and-white lithographs by the artist, edition of 100, numbered and signed by the artist]

1966

Statements, in *Robert Motherwell* (exhibition catalog). Amsterdam: Stedelijk Museum, 1966.

Excerpts, in *Robert Motherwell* (exhibition catalog). Turin: Galleria Civica d'Arte Moderna), 1966. [In Italian]
[Includes "Painters' Objects" (1944); "Beyond the Aesthetic" (1946); "A Tour of the Sublime" (1948); Preliminary Notice to Daniel-Henry Kahnweiler, *The Rise of Cubism* (1949); "What Abstract Art Means to Me" (1951); and "The Painter and the Audience" (1954), all from *Robert Motherwell: With Selections from the Artist's Writings* (exhibition catalog). New York: Museum of Modern Art, 1965]

1967

[★] Interview with Sidney Simon: "Concerning the Beginnings of the New York School: 1939–1943." *Art International* (Lugano) 11, no. 6 (Summer 1967): 20–23.
[The interview was conducted in January 1967]
REPRINTED
In David Shapiro and Cecile Shapiro, eds. *Abstract Expressionism, a Critical Record.* Cambridge: Cambridge University Press, 1990, pp. 33–45.

Statement, in Barbara Rose and Irving Sandler. "Sensibility of the Sixties." *Art in America* 55, no. 1 (January 1967): 47.
[Response to questionnaire sent to thirty-four artists]

"Jackson Pollock: An Artists' Symposium, Part 1." *Art News* 66, no. 2 (April 1967): 29–30, 64–67.
REPRINTED
In "Festival l'automne à Paris: Jackson Pollock." *Art Press,* no. 32 (October 1979): 8–10.

Eulogy [8 October 1967], in *"A Tribute" to René d'Harnoncourt.* New York: Museum of Modern Art, 1967.
[Other participants in the service were Arthur Drexler, William S. Paley, David Rockefeller, and the Vienna Concentus Musicus]

Letter to the editor. *Art International* (Lugano) 11, no. 8 (20 October 1967): 38.
[Rebuttal of letter from Barnett Newman in previous issue; answered by

Newman in the November issue; and followed by Motherwell's regret for the exchange in January issue (12, no. 1 [1968]: 41)]

1969

Statement. *Art Now: New York* 1, no. 5 (May 1969).

[★] "Addenda to The Museum of Modern Art *Lyric Suite* Questionnaire— from Memory . . . with Possible Chronological Slips" [8 August 1969]. *Museum of Modern Art Members' Newsletter* (Fall 1969): [9–10].

1970

[★] "On The Humanism of Abstraction," in *Robert Motherwell* (exhibition catalog). Concord, N.H.: St. Paul's School, 1970, pp. 5–14.
[From "The Artist Speaks." Lecture presented at St. Paul's School, Concord, N.H., 6 February 1970]

REPRINTED

In *Tracks: A Journal of Artists' Writings* (New York) 1, no. 1 (November 1974): 10–16.
In 1,000 copies (50 signed by Motherwell) as *L'Humanisme de l'abstraction*. Translated by Joel Dupont. Caen: L'Echoppe, 1991.

[★] Testimony Before the Select Subcommittee on Education, 24 March 1970.

PUBLISHED

As "Statements of Robert Motherwell and Helen Frankenthaler," in U.S. Congress. House. Committee on Education and Labor. Select Subcommittee on Education. *Environmental Quality Education Act of 1970.* H.R. 14753. Washington, D.C.: Government Printing Office, 1970, pp. 24–32. [Frankenthaler did not testify]

[★] "The Universal Language of Children's Art, and Modernism." *American Scholar* 40, no. 1 (Winter 1970): 24–27.
[From lecture presented at Conference on International Exchange in the Arts, "The Arts: An International Force" (sponsored by the Institute for International Education), New York, 29 April 1970]

REPRINTED

In Clifford Ross, ed. *Abstract Expressionism: Creators and Critics: An Anthology.* New York: Abrams, 1990, p. 112.

[★] "Thoughts on Drawing" [14 July 1970] in *Drawing Society National Exhibition—1970* (exhibition catalog). New York: American Federation of Arts for the Drawing Society, 1970.

1971

[★] "On Rothko" [December 1970]. Eulogy delivered at the National Institute of Arts and Letters, New York, 28 January 1971. Transcript in Motherwell archives.
[Portions of this eulogy and other of Motherwell's remembrances of Rothko were presented by the artist in "A Dialogue with Robert Motherwell Concerning the Spirit of Painting" at Rothko Symposium, "The Language of Presence," Yale University Art Gallery, New Haven, Conn., 1–3 December 1989]

[★] On David Smith, in John Gruen. *The Party's over Now: Reminiscences of the Fifties—New York's Artists, Writers, Musicians, and Their Friends.* New York: Viking Press, 1972, pp. 191–96.
[The conversation was conducted on 9 April 1971]

"David Smith—Erinnerungen," *Robert Motherwell: Bilder und Collagen 1967–*

1970 (exhibition catalog). Saint Gall: Galerie im Erker, 1971.
[From On David Smith]

Interview with Irmeline Lebeer: "Robert Motherwell (entretien avec l'artiste)." *Chroniques de l'art vivant,* no. 22 (July–August 1971): 10–12.
[The interview was conducted on 8 June 1971]
REPRINTED
Abridged version in *Robert Motherwell: Recent Paintings* (exhibition catalog). Minneapolis: Walker Art Center, 1972, [pp. 2–3].
Abridged version in *Robert Motherwell: Recent Work* (exhibition catalog). Princeton, N.J.: Princeton University Art Museum, 1973, pp. 13–18.
Excerpts in *Robert Motherwell: Choix de peintures et de collages 1941–1977* (exhibition catalog). Paris: Musée d'Art Moderne de la Ville de Paris, 1977, [p. 15]. [In French]
Excerpt in Clifford Ross, ed. *Abstract Expressionism: Creators and Critics: An Anthology.* New York: Abrams, 1990, p. 112.

[★] Introduction to Pierre Cabanne. *Dialogues with Marcel Duchamp.* Documents of 20th-Century Art. New York: Viking Press, 1971, pp. 7–12.
REPRINTED
In Pierre Cabanne. *Dialogues with Marcel Duchamp.* New York: Da Capo Press, 1987.

"Introduction to the Compass Edition" [November 1971], in Eugène Delacroix. *The Journal of Eugène Delacroix.* New York: Viking Press, 1972, pp. 7–8.

1972

[★] On David Smith [see 1971].

[★] "The Book's Beginnings" [22 September 1972], in *Robert Motherwell's "A la pintura": The Genesis of a Book* (exhibition catalog). Introduction by John J. McKendry. Texts by Diane Kelder and Motherwell. New York: Metropolitan Museum of Art, 1972, [pp. 10, 12–13].

"Introduction to the Compass Edition" [see 1971].

1973

"Selected Writings by Robert Motherwell on Collage and on Cubism," in *The Collages of Robert Motherwell: A Retrospective Exhibition* (exhibition catalog). Houston: Museum of Fine Arts, 1973, pp. 91–93.
[Includes excerpts from "The Modern Painter's World" (1944); "Beyond the Aesthetic" (1946); Preliminary Notice to Daniel-Henry Kahnweiler, *The Rise of Cubism* (1949); "The Rise and Continuity of Abstract Art" (1951); and "Robert Motherwell: A Conversation at Lunch" (1962)]

1974

Interview with Heidi Colsman-Freyberger: "Robert Motherwell: Words and Images." *Print Collector's Newsletter* 4, no. 6 (January–February 1974): 125–29.
REPRINTED
In *Art Journal* 34, no. 1 (Fall 1974): 19–24.

Interview with Vivien Raynor: "A Talk with Robert Motherwell." *Art News* 73, no. 4 (April 1974): 50–52.
[The interview was conducted in February 1974]

Statement, in Barbaralee Diamonstein. "Caro, de Kooning, Indiana, Lichtenstein, Motherwell, and Nevelson on Picasso's Influence." *Art News* 73, no. 4 (April 1974): 46.

[★] Interview with Richard Wagener: "Interview of Robert Motherwell, June 14, 1974," in *Robert Motherwell in California Collections* (exhibition catalog). Los Angeles: Otis Art Institute, 1974.

1975

Interview with Janet Baker-Carr: "A Conversation with Robert Motherwell, Painter." *Harvard Magazine* 78, no. 2 (October 1975): 34–41.
[The interview was conducted in March 1975]
REPRINTED
As "Robert Motherwell, Artist," in Douglas Schwalbe and Janet Baker-Carr. *Conflict in the Arts: The Relocation of Authority, the Museum*. Cambridge, Mass.: Arts Administration Research Institute, Harvard University, 1976, pp. 3–7.

Quoted in Robert C. Hobbs. "Motherwell's Concern with Death in Painting: An Investigation of His Elegies to the Spanish Republic, Including an Examination of His Philosophical and Methodological Considerations." Ph.D. diss., University of North Carolina, 1975.
[Includes numerous quotations from published writings, from unpublished writings and lectures, and from interviews with the author]

Interview with Christopher Crosman: "Speaking of Tomlin" [see 1979].

Interview with Roberto Polo: "Robert Motherwell Talks About Fashion as Fantasy." *Andy Warhol's Interview* 6, no. 1 (December 1975): 19.

1976

"Joseph Cornell" [see 1953].

"Correspondence." *Art Press*, no. 22 (January–February 1976): 2.
[Letter to Marcelin Pleynet]

"Robert Motherwell on Art and Artists." *New York Times*, 3 February 1976, p. 33.

"Robert Motherwell: Selected Writings," in *Robert Motherwell* (bilingual exhibition catalog). Düsseldorf: Städtische Kunsthalle, 1976, pp. 5–19.
[Includes excerpts from "Beyond the Aesthetic" (1946); Preface ["The School of New York"] to *Seventeen Modern American Painters* (1951); explanation of the preface [as "The New York School (and Symbolism)"] (1951); "What Abstract Art Means to Me" (complete text) (1951); *Modern Artists in America* (1951); "Joseph Cornell" (1953); "Symbolism" (1954); "Robert Motherwell: A Conversation at Lunch" (1962); "A Process of Painting" (complete text) (1964); interview with Bryan Robertson, Addenda (1965); and undated, unpublished notes]

Interview with Barbara Catoir: "Überwinnung der weissen Fläche: ein Gesprach mit Robert Motherwell" (Conquering the White Surface: A Conversation with Robert Motherwell). *Kunstwerk* (Stuttgart) 29, no. 6 (November 1976): 7–8, 43.
[The interview was conducted in September 1976]
REPRINTED
As "The Artist as a 'Walking Eye': Fragen an Robert Motherwell." *Pantheon* (Munich) 38, no. 3 (July–September 1980): 281–89, 304.

1977

"Robert Motherwell." *Flash Art* (Milan), no. 70/71 (January–February 1977): 48–49.
[Excerpts, in English and Italian, from published writings including "Beyond

the Aesthetic" (1946) and "Robert Motherwell: A Conversation at Lunch" (1962)]

Statements. *Quest* (Bombay), March–April 1977, p. 72.
[Based on an interview with Margaret Staats and Lucas Matthiessen on topic "The Genetics of Art"]

Interview [by letter May 1977] with Guy Scarpetta: "Les 9 ateliers de Robert Motherwell." *Art Press*, n.s., no. 9 (July 1977): 20–22.

REPRINTED
Revised excerpt in Stephanie Terenzio. *Robert Motherwell and Black* (exhibition tabloid). Storrs: William Benton Museum of Art, University of Connecticut, 1979, p. 6.

Interview with Eugenia Wolfowicz: "Un Entretien avec Robert Motherwell." *Les Nouvelles Littéraires* (Paris), 23 June 1977.

Interview with Yvonne Baby: "Un Entretien avec le peintre Robert Motherwell: Un ordre visuel arraché au chaos." *Le Monde*, 29 June 1977.

REPRINTED
As "Robert Motherwell: Order Out of Chaos." *The Guardian* (*Le Monde* section), 31 July 1977, p. 14.

Selections from the writings of Robert Motherwell, in *Robert Motherwell: Choix de peintures et de collages 1941–1977* (exhibition catalog). Paris: Musée d'Art Moderne de la Ville de Paris, 1977. [In French]
[Includes excerpts from "The Modern Painter's World" (1944); "What Abstract Art Means to Me" (1951); "The Painter and the Audience" (1954); "A Painting Must Make Human Contact" (1955); "Robert Motherwell: A Conversation at Lunch" (1962); "A Process of Painting" (1963); "A Letter from Robert Motherwell to Frank O'Hara, Dated August 18, 1965" (1965); and interview with Irmeline Lebeer (1971)]

Notes to plates in H. H. Arnason, *Robert Motherwell*. New York: Abrams, 1977, pp. 95–228.

REPRINTED
Revised in H. H. Arnason. *Robert Motherwell*. 2d rev. ed. New York: Abrams, 1982, pp. 103–215.

"Artistes parisiens en exile: New York 1939–45" (Parisian Artists in Exile: 1939–45), in *Paris–New York* (exhibition catalog). Paris: Musée National d'Art Moderne, 1977, pp. 106–14.

Statement, in Gene Baro. *Twelve Americans: Masters of Collage* (exhibition catalog). New York: Andrew Crispo Gallery, 1977.

1978

Interview with Nicole Genetet-Moral, Thierry Delaroière, and Alain Pomarède: "Entretien avec: Robert Motherwell." *Art Présent* (Paris), no. 6/7 (1978).

Interview with D. MacMillan: "Robert Motherwell." *Art Monthly* (London), no. 14 (February 1978): 4–6.

Introduction to *Emerson Woelffer: Paintings and Collages* (exhibition catalog). New York: Gruenebaum Gallery, 1978.

REPRINTED
As "Emerson Woelffer: A Born Painter." *Art News* 77, no. 2 (February 1978): 80–81.

Interview with Terence Maloon: "Robert Motherwell: An Interview." *Artscribe* (London) (April 1978): 17–21.

"Words of the Painter." Review of *Matisse on Art,* by Jack D. Flam, and *Henri Matisse Paper Cut-Outs,* by Jack Cowart, Jack D. Flam, Dominique Fourcade, and John Hallmark Neff. *New York Times Book Review,* 4 June 1978, pp. 12, 42–43.

[★] "Provincetown and Days Lumberyard: A Memoir," in *Days Lumberyard Studios: Provincetown 1914–1971* (exhibition catalog). Provincetown, Mass.: Provincetown Art Association and Museum, 1978, pp. 14–18.

REPRINTED
In *Separata* (Seville), no. 5/6 (Spring 1981): 6–7. [In Spanish]

1979

[★] "Homage to Franz Kline" [see 1962].

Interview with Barbaralee Diamonstein: "Inside New York's Art World: An Interview with Robert Motherwell." *Partisan Review/3* 46, no. 3 (1979): 376–90.
[Abridged and revised version of an interview conducted before an audience at the New School for Social Research, New York, 1977]

REPRINTED
In *Inside New York's Art World.* New York: Rizzoli, 1979, pp. 239–53.
In *Robert Motherwell* (exhibition catalog). Madrid: Fundación Juan March, 1980.
 [In Spanish]
In *Robert Motherwell* (exhibition catalog). Barcelona: Centre cultural de la Caixa de Pensions, 1980. [In Catalan]
Abridged and revised in H. H. Arnason. *Robert Motherwell.* 2d rev. ed. New York: Abrams, 1982, pp. 227–31.

Brief remarks, in *Helmut M. Federle: Paintings 1977–78* (exhibition catalog). Basle: Kunsthalle, 1979.

Presentation of award [19 March 1979] by *Dance Magazine* to Erick Hawkins. *Dance Magazine* 53, no. 6 (June 1979): 56–57.

Quoted in Stephanie Terenzio. *Robert Motherwell and Black* (exhibition tabloid). Storrs: William Benton Museum of Art, University of Connecticut 1979, pp. 1, 4, 6, 8–10.
[Includes brief excerpts from published writings]

Foreword and footnotes [Easter Day] in *Robert Motherwell: Prints 1977–1979* (exhibition catalog). New York: Brooke Alexander Gallery, 1979.

[★] "The International World of Modernist Art: 1945–1960" [May 1979]. *Art Journal* 39, no. 4 (Summer 1980): 270–71.

Interview with Christopher Crosman: "Speaking of Tomlin." *Art Journal* 39, no. 2 (Winter 1979/1980): 110–11.
[The interview was conducted on 3 September 1975]

1980

[★] "The International World of Modernist Art: 1945–1960" [see 1979].

Statement, in *Face of the Artist: Photographs by Norma Holt* (exhibition catalog). Provincetown, Mass.: Provincetown Art Association and Museum, 1980.

Robert Motherwell: Reconciliation Elegy. Presented by E. A. Carmean, Jr., with Motherwell, Robert Bigelow, and John E. Scofield. Geneva: Editions d'Art Albert Skira; New York: Rizzoli, 1980.
[Photographic and verbal journal of the creation of the mural *Reconciliation*

Elegy (1977–1978) for the National Gallery of Art, Washington, D.C., by Motherwell and his studio assistants]

[★] Quoted in Stephanie Terenzio. *Robert Motherwell and Black* (exhibition catalog). Storrs: William Benton Museum of Art, University of Connecticut, 1980.
[Includes correspondence, excerpts from published writings, excerpts from a public lecture (5 April 1980) and conversation with students (6 April 1980), and statements]

REPRINTED
In Stephanie Terenzio. *Robert Motherwell and Black*. 2d ed. London and New York: Petersburg Press, 1981.
Excerpt in Jack D. Flam. "With Robert Motherwell," in *Motherwell* (exhibition catalog). New York: Abbeville Press for Albright-Knox Art Gallery, 1983, p. 12.
Excerpt in Jack D. Flam. *Motherwell*. Oxford: Phaidon, 1991, p. 8.

Quoted in *The Painter and the Printer: Robert Motherwell's Graphics 1943–1980*. New York: American Federation of Arts, 1980.
[Includes numerous quotations from published writings on printmaking by Motherwell and excerpts from an interview on the subject with Stephanie Terenzio, 28 December 1979, pp. 24–149]

REPRINTED
In *The Prints of Robert Motherwell: A Catalogue Raisonné 1943–1984*. 2nd rev. ed. New York: Hudson Hills Press in association with the American Federation of Arts, 1984, pp. 24–149. 3rd rev. ed., 1991, pp. 24–149.

"A Note by the Artist," in *The Painter and the Printer: Robert Motherwell's Graphics 1943–1980*. New York: American Federation of Arts, 1980, p. 9.

REPRINTED
As "A Note by the Artist on Collaboration," in *The Prints of Robert Motherwell: A Catalogue Raisonné 1943–1984*. 2d rev. ed. New York: Hudson Hills Press in association with the American Federation of Arts, 1984, p. 9. 3d rev. ed., 1991, p. 9.

1981

[★] Letter to Guy Scarpetta, 8 June 1981. Transcript in Motherwell archives.
PUBLISHED
As "Picasso par Robert Motherwell," trans. Guy Scarpetta. *Art Press,* no. 50 (July–August 1981): 10–11.

[★] "In Memoriam: Anthony Smith." Eulogy delivered at the Metropolitan Museum of Art, New York, 19 October 1981. Transcript in Motherwell archives.
PUBLISHED
In *Art Press,* no. 57 (March 1982): 50.

1982

"A Note by the Artist on the Second Edition," in H. H. Arnason. *Robert Motherwell*. 2d rev. ed. New York: Abrams, 1982, p. 7.

"How It All Happened: Motherwell Remembers." *Art/World* (New York), 22 February–22 March 1982.

"What We Wanted to Do: Motherwell Remembers." *Art/World* (New York), 22 March–22 April 1982.

[★] Foreword [29 October 1979, 1982] to William C. Seitz, *Abstract Expressionist Painting in America*. Cambridge, Mass.: Harvard University Press, for the National Gallery of Art, 1983), pp. xi–xiv.

[*] "Remarks," in *On the Occasion of the 150th Anniversary of the Yale University Art Gallery*. New Haven, Conn.: Yale University, 1982, pp. 17–24.
[From presentation given at Yale University, New Haven, Conn., 30 October 1982 (with Alan Shestack, Henry J. Heinz II, and A. Bartlett Giamatti participating)]

1983

[*] Foreword to William C. Seitz, *Abstract Expressionist Painting in America* [see 1982].

Quoted in William C. Seitz. *Abstract Expressionist Painting in America*. Cambridge, Mass.: Harvard University Press, for the National Gallery of Art, 1983.
[Includes extensive quotations throughout from published writings and conversations with the author]

"Gedanken über abstrakte Kunst" (Thoughts on Abstract Art). *Kunst und das Schöne Heim* (Munich) 95, no. 6 (June 1983): 388–92, 441.
[From lecture presented at the University of Munich, 18 November 1982]

[*] "Kafka's Visual Recoil: A Note." *Partisan Review* 4 51, no. 4/52, no. 1 (1984–1985): 751–54.
[From lecture presented at "Kafka Unorthodox," commemorating Kafka's 100th birthday (organized by Dore Ashton and sponsored by the Department of Humanities and the School of Art of The Cooper Union), New York, 19 March 1983]

Statements, in Jack D. Flam. "With Robert Motherwell," in *Motherwell* (exhibition catalog). New York: Abbeville Press for Albright-Knox Art Gallery, 1983, pp. 13–26.
[Primarily from interviews with the author in 1982]

"Robert Motherwell: In His Own Words" (exhibition flyer). Buffalo, N.Y.: Albright-Knox Art Gallery, 1983.
[Includes numerous excerpts from published writings to accompany the retrospective exhibition "Robert Motherwell"]

1984

[*] "Kafka's Visual Recoil: A Note" [see 1983].

Introductory Note [27 March 1984] to Robert Osborn. *Osborn on Conflict*. Cambridge, Mass.: Carpenter Center for the Visual Arts, Harvard University, 1984), pp. 2–3.

[*] "Animating Rhythm" [10 August 1984], in "Was Jackson Pollock Any Good?" *Art and Antiques*, October 1984, p. 87.

1985

"Mr. Motherwell's Acceptance." *MacDowell Colony News* (Peterborough, N.H.) 15, no. 1 (Fall 1985): 3–4.
[In accepting the MacDowell Colony Award, Motherwell quoted "Black or White" (1950)]

Response, in Paul Gardner. "When Is a Painting Finished?" *Art News* 84, no. 9 (November 1985): 94.
[Fourteen artists responded]

"Research Conversation with Robert Motherwell" (with Jack D. Flam), conducted by Sigmund Koch at the artist's studio in Greenwich, Conn., 14–15 May 1986. Transcript of filmed conversation in Motherwell archives.

[★] "On Not Becoming an Academic." Lecture presented in panel "Tradition and Innovation: The Realms of Scholarship" at Harvard University, Cambridge, Mass., 4 September 1986. Transcript in Motherwell archives.

Quoted in Robert Saltonstall Mattison. *Robert Motherwell: The Formative Years*. Ann Arbor, Mich.: Research Press, 1986.
[Includes numerous quotations from published writings, from unpublished writings, lectures, and interviews, and from interviews with the author]

1987

Interview with Monique Brunet-Weinmann: "Robert Motherwell à Provincetown." *Vie des Arts* (Montreal) 32, no. 128 (September 1987): 40–41.

[★] "Introduction for Octavio Paz." Introduction delivered at Poetry Center, Ninety-second Street YMHA, New York, 4 October 1987. Transcript in Motherwell archives.

Recollection of the artist, in *David Smith: Sculpture and Drawings* (exhibition catalog). Düsseldorf: Kunstsammlund Nordrhein-Westfalen, 1986.
[Includes excerpts from published writings]

1988

Afterword [May 1988] to *Eye to Eye: The Camera Remembers: Portrait Photographs by Renate Ponsold*. New York: Hudson Hills Press, 1988, p. 115.

[★] Interview with David Hayman: "The Artist Interviewed by David Hayman in Provincetown, Massachusetts, July 12 and 13, 1988," in *The "Ulysses" Etchings of Robert Motherwell*. San Francisco: Arion Press, 1988.

Quoted in Constance Glenn and Jack Glenn eds. *Robert Motherwell, The Dedalus Sketchbooks*. New York: Abrams, 1988.

Quoted in Ellen C. Oppler, ed. *Picasso's Guernica* New York: Norton, 1988, pp. 344–45.
[Includes excerpts from published writings]

1989

"An Artist's Odyssey." *Art and Antiques* 6, no. 11 (February 1989): 72–77.

"American Odyssey." *Cape Cod Arts and Antiques* (1989).

Statements on illustrations, in Marcelin Pleynet. *Robert Motherwell*. Paris: Edition Daniel Papierski, 1989, pp. 66–212.

" 'Ulysses' and Motherwell: Illustrating an Affinity." *James Joyce Quarterly* (Tulsa) 26, no. 1 (Summer 1989): 583.

Interview with Robert Enright: "The Monumental Diarist: An Interview with Robert Motherwell." *Border Crossings* (Winnipeg) 8, no. 4 (Fall 1989): 7–17.

1990

In Clifford Ross, ed. *Abstract Expressionism: Creators and Critics: An Anthology*. New York: Abrams, 1990, pp. 103–12.
[Includes reprints and excerpts from "Beyond the Aesthetic" (1946); "The

Painter and the Audience" (1954); interview with David Sylvester (1960); "Robert Motherwell: A Conversation at Lunch" (1962); "The Universal Language of Children's Art, and Modernism" (1970); and interview with Irmeline Lebeer (1971)]

1991

"Leo Manso" [March], in *Leo Manso, Collage and Assemblage, Selected Works 1981–1991* (exhibition catalog). New York: Stuart Levy Gallery, 1991.

Statements, in Jack Flam. *Motherwell.* Oxford: Phaidon, 1991, pp. 10–25. [Primarily from conversations and interviews with the author, 1982–1989]

"Dear Friend: Letter to Philippe Sollers." *Infini* (Paris), no. 35 (1991): 127–28.

EDITED WORKS

The Documents of Modern Art

As director of this series, Motherwell also served as editor of many of the volumes. In most cases, he selected the text and translator; served as adviser; read, approved, and introduced the text; and, with certain volumes, performed all these functions. The series was published by Wittenborn, Schultz (New York) or, when noted, by Wittenborn alone. For the majority of the books, covers and typography were by Paul Rand, and the format was referred to as a "large 8 vo." Documents of Modern Art numbers are chronological, except numbers 8–11, as *The Dada Painters and Poets,* delayed in publication, threw off the sequence.

[*] Guillaume Apollinaire. *The Cubist Painters: Aesthetic Meditations 1913.* Documents of Modern Art, no. 1. Translated from French by Lionel Abel. Preface by Motherwell. New York: Wittenborn, 1944. 2d rev. ed., 1949; Preliminary Notice by Motherwell.

Piet Mondrian. *Plastic Art and Pure Plastic Art, 1937, and Other Essays, 1941–1943.* Documents of Modern Art, no. 2. 1945. Preface by Motherwell. Introduction by Harry Holtzman. 2d printing (text augmented), 1947; updated preface by Motherwell.
[The 1945 edition, including all of Mondrian's writings in English to that date, coincided with the artist's memorial exhibit at the Museum of Modern Art]

László Moholy-Nagy. *The New Vision.* Documents of Modern Art, no. 3. Revised translation of 1928 translation from German by Daphne M. Hoffman. Introduction and Obituary by Walter Gropius. New York: Wittenborn, 1946. 4th rev. ed., 1949.

Louis H. Sullivan. *Kindergarten Chats and Other Writings.* Documents of Modern Art, no. 4. 1947. Edited by Isabella Athey.
[Although he was director of the series, Motherwell did not work on this volume]

Wassily Kandinsky. *Concerning the Spiritual in Art and Painting in Particular.* Documents of Modern Art, no. 5. 1947. Translated from German by Sir Michael Sadleir, with revisions by F. Golffing, M. Harrison, and R. Ostertag. Kandinsky's prose poems translated by Ralph Manheim. Prefaces by Mme. Kandinsky and Julia and Lyonel Feininger. Contributions by Stanley William Hayter. New footnotes and additions by Kandinsky.

[★] Jean (Hans) Arp. *On My Way: Poetry and Essays 1912–1947.* Documents of Modern Art, no. 6. 1948. Translated from French and German by Ralph Manheim. Prefatory Note by Motherwell. Bibliography by Bernard Karpel. [With two color woodcuts by Arp especially for this publication]

[★] Max Ernst. *Max Ernst: Beyond Painting and Other Writings by the Artist and His Friends.* Documents of Modern Art, no. 7. 1948. Translated by Dorothea Tanning and Ralph Manheim. Prefatory Note by Motherwell. Texts by André Breton, Nicholas Calas, Paul Eluard, Georges Ribemont-Dessaignes, Tristan Tzara, and others. Bibliography and Biography by Bernard Karpel.

[★] Daniel-Henry Kahnweiler. *The Rise of Cubism.* Documents of Modern Art, no. 9. 1949. Compiled by Bernard Karpel. Translated from German by Henry Aronson. Preliminary Notice by Motherwell.
[First translation into any language of original German text written in 1915 and published in 1920]

[★] Marcel Raymond. *From Baudelaire to Surrealism.* Documents of Modern Art, no. 10. 1949 [may have appeared in 1950]. Translated by "G.M." from 1947 rev. ed. of 1933 French text. Preliminary Notice by Motherwell. Introduction by Harold Rosenberg. Bibliography by Bernard Karpel. Appendix, "Mallarmé and Painting," by Daniel-Henry Kahnweiler.
[First English translation]

[★] Georges Duthuit. *The Fauvist Painters.* Documents of Modern Art, no. 11. 1950. Translated from French by Ralph Manheim. Preface by Motherwell. Bibliography by Bernard Karpel.
[First English translation of 1949 text, some of which had appeared approximately twenty years earlier in *Cahiers d'art,* and first book devoted to the subject published in English]

[★] Robert Motherwell, ed. *The Dada Painters and Poets: An Anthology.* Documents of Modern Art, no. 8. 1951. 2d ed., 1981 [see Documents of 20th-Century Art]. Translated by Ralph Manheim and others. Preface and Introduction by Motherwell. Bibliography by Bernard Karpel. Texts by Jean (Hans) Arp, Hugo Ball, André Breton, Gabrielle Buffer-Picabia, Arthur Craven, Paul Eluard, Georges Hugnet, Richard Hulsenbeck, Georges Ribemont-Dessaignes, Hans Richter, Kurt Schwitters, Tristan Tzara, and others.
[First publication in English of most of the material]

Although Motherwell's severance with Wittenborn and Schultz occurred before the publication of *The Dada Painters and Poets,* he was still listed as director in the two subsequent volumes of the series. Beginning with number 12, George Wittenborn (New York) was listed as the sole publisher (Heinz Schultz died before the volume appeared).

Carola Giedion-Welcker. *Contemporary Sculpture: An Evolution in Volume and Space,* Documents of Modern Art, no. 12. 1955. Bibliography by Bernard Karpel.
[Motherwell did not work on this volume, originally scheduled for publication in 1951.]

Marcel Duchamp. *The Bride Stripped Bare by Her Bachelors, Even,* Documents of Modern Art, no. 13. 1960. Typographic version by Richard Hamilton of Duchamp's *Green Box.* Translated by George Heard Hamilton.

Problems of Contemporary Art

A second series published by Wittenborn, Schultz, unlike the more permanent Documents of Modern Art series, was designed *for current discussions.*

Motherwell's directorial, editorial, and advisory work was essentially that described for The Documents of Modern Art. According to correspondence (Motherwell archives, Dedalus Foundation) Motherwell did considerable work on numbers 1, 4, and 5.

Wolfgang Paalen. *Form and Sense.* Problems of Contemporary Art, no. 1. 1945.

Herbert Read. *The Grass Roots of Art.* Problems of Contemporary Art, no. 2. 1947.

Albert Dorner. *The Way Beyond Art: The Work of Herbert Bayer.* Problems of Contemporary Art, no. 3. 1947. Introduction by John Dewey.

[★] *possibilities 1: An Occasional Review.* Problems of Contemporary Art, no. 4. 1947/1948. Edited by John Cage (music), Pierre Chareau (architecture), Robert Motherwell (art), and Harold Rosenberg (writing). Contents: Lionel Abel, "The Bow and the Gun." Jean (Hans) Arp, "A Sweet Voice Sings in the Hump of Glass." William Baziotes, "I Cannot Evolve Any Concrete Theory." Andrea Caffi, "On Mythology." Lino Novás Calvo, "Long Island." Paul Goodman, "The Emperor of China." Alexei Haieff, Answers to Robert Palmer, Adolph Weiss, Henry Cowell, Milton Babbitt, Harold Shapero, Kurt List, Jacques de Menasce, John Cage; list of works; biographical note; list of recordings. Stanley William Hayter, "Of the Means." Chalres R. Hulbeck (Richard Huelsenbeck), "En Avant Dada." Joan Miró, Interview by Francis Lee. Robert Motherwell (with Harold Rosenberg), Editorial Preface. Oscar Niemeyer, "A New Church in Brazil." Jackson Pollock, "My Painting." Edgar Allan Poe, "Marginalia, LXI, Expression." Harold Rosenberg (with Robert Motherwell), Editorial Preface; "The Shapes on a Baziotes Canvas," "The Stages," "Introduction to Six American Artists." Mark Rothko, "The Romantics Were Prompted." David Smith, "I Have Never Looked at a Landscape," "Sculpture Is." Virgil Thomson, Answers to Stefan Wolpe, Wallingford Riegger, Paul Bowles, Elliott Carter, Carter Harman, Arthur Berger, Lou Harrison, Merton Brown; list of works; biographical note; list of recordings. Paul Valéry (a text chosen by William Baziotes). Edgard Varèse, Answers to Robert Palmer, Adolph Weiss, Milton Babbitt, Henry Cowell, Harold Shapero, Kurt List, Jacques de Menasce, John Cage; list of works; biographical note; list of recordings. Ben Weber, Answers to Merton Brown, Wallingford Riegger, Arthur Berger, Stefan Wolpe, Elliott Carter, Paul Bowles, Carter Harman, Lou Harrison; list of works; biographical note; list of recordings.

Georges Vantongerloo. *Paintings, Sculptures, Reflections.* Problems of Contemporary Art, no. 5. 1948. Preface by Max Bill.

Untitled Series

Published by Wittenborn, Schultz (New York).

[★] *Modern Artists in America: First Series.* [1951]. Edited by Robert Motherwell and Ad Reinhardt, with Bernard Karpel as documentary editor. Cover design by Motherwell. Bibliography by Karpel. Photography by Aaron Siskind. Contents: A statement by the editors. "Artists' Sessions at Studio 35" (1950), edited by Robert Goodnough. The Western Round Table of Modern Art, edited by Douglas MacAgy. Motherwell and Reinhardt, Introduction to the Illustrations. Sequence of paintings and sculpture, 1949–1950. Exhibitions in New York galleries, 1949–1950. Michel Seuphor, Paris–New York 1951. The Louise and Walter Arensberg Collection. Museum acquisitions: Modern

Works Added to American Public Collections. Painters and poets in Barcelona: *Dau Al Set*. Art Publications, 1949–1950: An International Selection, with a Preface by Bernard Karpel.

[This book was a documentation of events and exhibitions of modern art, principally in New York City, from September 1949 to July 1950. A second series, planned for the spring of 1953, was not completed]

The Documents of 20th-Century Art

For this series, published by Viking Press (New York), Motherwell was general editor; Arthur A. Cohen, managing editor; and Bernard Karpel, documentary editor.

[★] Pierre Cabanne. *Dialogues with Marcel Duchamp.* 1971. Tranlsated by Ron Padgett. Introduction by Motherwell. Preface by Salvador Dali. Appreciation by Jasper Johns. Selected Bibliography by Bernard Karpel.
[Motherwell did considerable work revising the translation]

Daniel-Henry Kahnweiler, with Francis Cremieux. *My Galleries and Painters.* 1971. Translated by Helen Weaver. Introduction by John Russell. Chronology and Selected Bibliography by Bernard Karpel.

Guillaume Apollinaire. *Apollinaire on Art: Essays and Reviews 1902–1918.* Edited by LeRoy C. Breunig. 1971.

Henry Moore. *Henry Moore on Sculpture.* Edited by Philip James. 1971.

Jean Arp. *Arp on Arp: Poems, Essays, Memories.* Edited by Marcel Jean. 1972.

Pablo Picasso. *Picasso on Art: A Selection of Views.* Edited by Dore Ashton. 1972.

Jacques Lipchitz, with H. Harvard Arnason. *My Life in Sculpture.* 1972.

Fernand Léger. *Functions of Painting.* Edited by Edward F. Fry. 1973.

Umbro Apollonio, ed. *Futurist Manifestos.* 1973.

Wassily Kandinsky and Franz Marc, eds. *The Blaue Reiter Almanac.* 1974. Documentary editor, Klaus Lankheit.

Stephen Bann, ed. *The Tradition of Constructivism.* 1974.

Hugo Ball. *Flight out of Time: A Dada Diary.* Edited by John Elderfield. 1974.

Richard Huelsenbeck. *Memoirs of a Dada Drummer.* Edited by Hans J. Kleinschmidt. 1974.

Ad Reinhardt. *Art as Art: The Selected Writings of Ad Reinhardt.* Edited by Barbara Rose. 1975.

John C. Bowlt, ed. *Russian Art of the Avant-Garde: Theory and Criticism 1902–1934.* 1976.

Marcel Jean, ed. *The Autobiography of Surrealism.* 1980.

In 1980, production of The Documents of 20th-Century Art was transferred to G. K. Hall (Boston). With Motherwell and Jack D. Flam as general editors, four titles were published before Motherwell's death in 1991.

[★] Robert Motherwell, ed. *The Dada Painters and Poets: An Anthology.* 2nd ed. 1981. Preface and Introduction by Motherwell. Foreword by Jack D. Flam. 1st ed. [see Edited Writings].

REPRINTED

The Dada Painters and Poets: An Anthology. Cambridge, Mass.: Belknap Press of Harvard University Press, 1989. [Paperback]

Wassily Kandinsky. *Kandinsky: Complete Writings on Art, Vols. I and II.* Edited by Kenneth C. Lindsay and Peter Vergo. 1982.

Piet Mondrian. *The New Art–The New Life: The Collected Writings of Piet Mondrian.* Edited and translated by Harry Holtzman and Martin S. James. 1986.

Joan Miró. *Joan Miró: Selected Writings and Interviews.* Edited by Margit Rowell. 1986.

INDEX

Abel, Lincoln: 27, 35n.4, 63, 64n.3
Abstract art; also abstraction: 66, 178;
"Abstract Art and the Real," 126-27;
addressed in M. lecture, 84-87; Braque,
Miró, and Picasso attacking a wholly, 23;
Janis and, 242, 245n.5; Kandinsky and,
24; Mondrian and, 126-27, 243; M.
developing theory of, 10-11; M.
insistence on, 178-79; oddity of, 23;
original meaning of, 124; result of
development in structure, 29; as revolt,
124
Abstract expressionism; also, abstract
expressionists: 125, 247; alternative names
for 69n.4; ambition of, 3; art critics and,
257; artists as transmission agents of, 113;
artists included in "The New Decade"
exhibit, 108; characteristic artists of, 76;
Coates and, 147; in context of
cosmopolitanism, 241; definition of, 147;
gaining prominence in U.S., 109; Kafka's
subjectivity and fear of literal translation
and, 263, 265; Kandinsky and, 165; Miró
and, 115, 119; M. as spokesman for, 11;
Noguchi and, 113; psychic automatism
and, 15; Seitz and, 11, 253-58; Still's
influence on, 167. *See also* The New York
School
Abstraction: 192; as emphasis, 86; modern
art and, 29; M. and nature of, 12, 23; not
as an end in itself, 10-11; painters with
low degree of, 176; "scientific"
investigation and, 260. *See also* Whitehead
Alberti, Rafael: *A la pintura* by, 210-13;
Belitt and, 212; "El Negro Motherwell"
by, 281, 282n.1; M. illustration of text
by, 283; photo with M., 194 insert
Apollinaire, Guillaume: 60-61, 169, 298;
books by artists and, 59; *The Cubist
Painters* by, 9, 35n.4, 63-65; as a "cubist"
poet, 107-108, 122; cubists listening to,
55; desire to be modern, 56; "modernistic"
art and, 77. *See also* Documents of
Modern Art

Architects and architecture: 28; Chapel of
the Rosary, Vence, 110, 112n.3, 298;
Church at Assy, 298; Corbusier 109, 110,
112n.2, 298; Goodman, 96; Gropius, 96;
Kiesler, 247, 248.2; least generous artistic
group, 276; Michelangelo, 110;
Ronchamp, 110; 112n.2; Saint-Pierre and
Cocteau, 111; Sert, 116, 140, 274; Stone,
132n.2; Sullivan, 59, 131; van der Rohe,
66, 91, 140, 141n, 232; Weiner, 274;
Wright, 246. *See also* Chareau
Arp, Jean (Hans): 33, 59, 82, 169, 229, 239;
dada movement and, 47; *The Dada
Painters and Poets* and, 47, 50, 91; Friday
evening talks and, 62; humanity of
formalism, 34; M. first encounter with
work of, 49; 51n.3; M. Prefatory Note to
book by, 49-51, 69; *possibilities* and, 45;
quotation from, 72; Subjects of the Artist
and, 49, 62; surrealism and work of, 119,
218, 232, 247. *See also* Documents of
Modern Art; Documents of 20th-Century
Art
Art of This Century: American artists and,
7, 22, 165-66, 247; Baziotes and, 3, 166,
247; description for Dorazio, 246-48; first
exhibition quarters of movement in, 113;
first U.S. collage exhibition at, 22, 247;
Kiesler and, 247, 248n.2; M. exhibitions
at, 36, 52, 247, 264; M. meeting
Mondrian in, 239; opening of, 164, 246;
Pollock at, 27, 121n.2; Spring Salon at,
247. *See also* Guggenheim
Artists, passing reference to: Alberts, 36;
Audubon, 131; Avery, 220; Bacon, 235;
Balthus, 235; Benton, 230; Bonnard, 117,
137, 252; Boudin, 131; Brady, 131;
Brancusi, 50-51, 110, 118, 244, 260, 298;
Breughel, 186; Brooks, 225; Burliuk, 199,
201n.4; Busa, 155, 156, 160, 161, 229,
291; Caro, 173, 203; Chagall, 234; Corot,
56; Courbet, 56; da Vinci, 209n, 258;
Degas, 131, 244, 259; della Francesca, 89,
216, 245; Delvaux, 82; Denis, 194;

York, 19; "entering the world," 10, 25;
frugality of, 240; funeral of, 238-39;
Gallatin Collection and, 19; influence on
M., 146, 237, 238; "Masters of Abstract
Art" and, 19; M. essay on, 19-22; M.
first meeting with, 239; M. intended
book and, 9; M. letter on, 237-41; M.
"Notes" on, 19-22; M. painting hierarchy
and, 10, 20, 243; M. review of exhibit
by, 21, 93; M. theory of art and, 9, 10;
nonobjective painters and, 77; original
ideas of, 8; *Plastic Art and Pure Plastic Art*
and, 8, 19, 36, 41, 237; "Pure Plastic Art"
and, 19; quotations from, 92, 141; refusal
and, 52-53; Ginger Rogers and, 239;
Seuphor and, 238, 241n.3; structural basis
of paintings, 59; students "read" work
by, 88; Sweeney and, 240; symbolizing
the ethical, 102; theory of neo-plasticism
and, 10; total abstraction and, 243; the
tragic and, 30, 238; the "universal" and,
31, 33, 67. *See also* Documents of
Modern Art

Motherwell, Robert, correspondence of:
Letters to: Jack Beatty (1983), 271-72;
Yves-Alain Bois (1980), 237-41; Virginia
Dorazio (1982), 246-48; Bruce Grenville
(1982), 249-51; Lynda Hartigan (1977),
221-23; Edward Henning (1978, 1979),
228-34; John (1956), 109-12; Samuel
Kootz, (1947), 40-42, 278n; Christian
Laprette, (1984), 272-76; Ted Lindberg
(1988), 289-91; Glen MacLeod (1983),
269-70; Ann Louise Coffin McLaughlin
(1982), 251-53; Irving Sandler (1970),
181-83; Guy Scarpetta (1981), 241-45; on
Surrealism (1978, 1979), 228-34; William
Carlos Williams (1941), 15-19; Emerson
Woelffer (1968, 1969), 168-70; Unknown
Party (early 1952), 96-97; Christian
Zervos (1947), 43-44; *See also* O'Hara

Motherwell, Robert, editorial work of: see
Documents of Modern Art; see
Documents of 20th-Century Art; see
Modern Artists in America; see *possibilities
1;* see Problems of Contemporary
Art

Motherwell, Robert, education of:
Stanford University: Winters at, 16; M.
with roommates, photo 194 insert; M. as
undergraduate student at, 4. Harvard
University: Aiken and M. at, 279,
280n.4; Delacroix assigned to M. at, 156;
C. I. Lewis seminar in Spinoza at, 278,
279; Lovejoy and Prall as professors at,
16, 156, 278, 279; M. encountering work
of Kafka, 263; M. loss of interest in, 17;
M. return to lecture at, 87-88, 134;
M. student at, 4, 16, 156, 278-80;
Pierce and Whitehead as M. "companions"
at, 59; Prall at, 279. Columbia Uni-
versity: M. gives up studies at, 15;
Schapiro at, 157; studies at, 4, 237, 280

Motherwell, Robert, essays of: for
periodicals: "Addenda to The Museum of
Modern Art, *Lyric Suite* Questionnaire—
From memory with Possible
Chronological Slips" (1969), 170-173;
"Animating Rhythm" (1984), 276-78;

"Beyond the Aesthetic" (1946), 11, 35-39;
"Homage to Franz Kline" (1962), 132-34;
"The International World of Modernist
Art: 1945-1960" (1979), 234-35; "The
Modern Painter's World" (see
Motherwell, lectures of); "Notes on
Mondrian and Chirico" (1942), 9, 19-22,
23, 238; "On Rothko" (1967, 1969,
1971), 195-201; "The Painter and the
Audience" (1954), 11, 104-108; "Painters'
Objects" (1944), 9, 10, 22-27, 278n; "The
Significance of Miró" (1959), 114-21; "A
Tour of the Sublime" (1948), 51-54;
"What Should a Museum Be?" (1961),
129-32.
For exhibition catalogs: "Black or White"
(1951), 71-72; "The Book's Beginnings"
(1972), 210-14; "Letter from Robert
Motherwell to Frank O'Hara, Dated
August 18, 1965," 147-55; Notes in John
I. H. Baur, *Bradley Walker Tomlin* (1957),
112-14; "A Painting Must Make Human
Contact" (1955), 108-09; Preface to
Seventeen Modern American Painters (1951),
82-84; "Provincetown and Days
Lumberyard: A Memoir" (1978); 223-27;
"Robert Motherwell: A Conversation at
Lunch" (1962), 134-38; Statement in
Fourteen Americans (1946), 39-40;
Statement in *Motherwell* (1947), 42-43;
"Thoughts on Drawing" (1970); 192-94.
Other: Occasional Pieces and other
writings by, 125; "Abstract Art and the
Real," 126-27; "Expressionism," 127;
"Of Form and Content," 126

Motherwell, Robert, honors and awards of:
249, 251n.1

Motherwell Robert, Interviews with: David
Hayman (1988), 282-89; Bryan Robertson
(1965), 141-47; 171; Sidney Simon,
"Concerning the Beginnings of the New
York School, 1939-43" (1967), 155-68;
Richard Wagener (1974), 214-20

Motherwell, Robert, lectures and public
presentations of: "A Collage for Nathan
Halper in Nine Parts" (1983), 266-69;
Excerpt from "A Conversation with
Students" (1979), 227-28; Lecture with
Charles R. Hulbeck (1959), 121-25;
"Kafka's Visual Recoil: A Note" (1983),
262-66; "In Memoriam: Anthony Smith"
(1981), 245-46; "The Modern Painter's
World," (1944), 10, 27-35, 36; "The New
York School" (1950), 76-81; "On Not
Becoming Academic" (1986), 278-80;
"On The Humanism of Abstraction"
(1970), 175-81; "A Personal Expression"
(1949), 56-63; "A Process of Painting"
(1963), 138-41; "Reflections on Painting
Now," (1949), 65-69; "Remarks [at Yale
University]" (1982), 258-62; "The Rise
and Continuity of Abstract Art" (1951),
87-89; "Symbolism" (1954), 98-104;
Testimony Before the Select
Subcommittee on Education (1970), 183-
87; "The Universal Language of
Children's Art" (1970), 187-92; "What
Abstract Art Means to Me" (1951), 84-
87. *See also* Rothko

Onslow-Ford, Gordon: 183; arrival in U.S., 167n.5; Johnson and, 290, 291n.2, 291n.6; lecture by, 167n.6; Matta and, 159, 290; M. letter on, 289-91, 291n.3, 291n.6; psychic automatism and 290; *VVV* and, 16

Paalen, Wolfgang: correspondence with M., 182, 183n.4; *DYN* and, 182, 183n.3; *Form and Sense* and, 182, 183n.6; letter regarding, 182-83; M. meeting with, 159, 229; M. in Mexico with, 281
Painting, process and definition of: 180; automatism and, 146; chemistry of pigments, 72; configuration of M. hierarchy of, 10, 20; definition of, 31-32; ideal medium 37; mind actualizing itself in, 32; Miró and, 118-19; M. description of his methods in, 135-36; 138-41; "painter's painting," 103; planned as carefully as Degas, 259; sensitivity to medium, 124
Papier collé: see Collage
Paz, Octavio: 288; M. "Introduction for Octavio Paz," 280-82; M. and three poems by, 281, 282n.2
Periodicals: *American Scholar*, 188, 192n; *Art and Antiques*, 277; *Art in America*, 129; *Art International*, 155; 168n.18; *Art Journal*, 234; *Art News*, 114; *Art Press*, 241, 245n.2; *Artforum*, 182, 183n.2; *Atlantic Monthly*, 271; *Cahiers d'art*, 44, 229, 250; *Commentary*, 44; *Design*, 36; *Harper's Bazaar*, 275; *Kenyon Review*, 18; *Kultur*, 148; *Le Point*, 250; *Life*, 78; *Minotaure*, 15; *New Republic*, 11, 35, 38n.1-39n.1; *Partisan Review*, 11, 18, 23, 27n.1, 35, 270, 278n; *Perspectives USA*, 102, 104; *Southern Review*, 18; *Tiger's Eye*, 52; *Time*, 78; *Tracks*, 175; *Transition*, 43, 51; *Verve*, 43; *Vogue*, 148. *See also DYN; VVV*
Philosophy and philosophers; also mathematicians, psychologists, theoreticians: American pragmatic tradition of, 182; Aquinas, 101; Bergson, 279; Bosanquet, 21, 28; Croce, 21n; Descartes, 65; Dewey, 182; Freud, 32, 265; Fromm, 298; Greek and early Christian etc., 59; Hegel (also Hegelian), 18, 29, 135, 216, 298; Heidegger, 188, 218; Hume, 65; James, 182, Jaspers, 218; Jung, 5; Kant, 260, 279; Lenin, 149, 191; Lewis, 278, 279; Locke, 65; Longinus, 52; Lovejoy, 16, 278, 279; Lucretius, 67; Marx (also Marxian, Marxist), 18, 23, 29, 78, 122, 183, 232, 242, 279; Nietzsche, 45; Ortega, 298; Pierce, 59, 182; Plato, 28, 40; Prall, 16, 17, 279; Russell, 182, 279; Socrates, 124; Veblen, 298; Windelband's *History of Philosophy*, 263; Wittgenstein, 261. *See also* Kierkegaard; Spinoza; Whitehead
Picasso, Pablo: 23, 72n, 131, 148, 162, 164, 170n.3, 179, 181, 190, 191, 202, 210, 232, 234, 245, 247, 257, 260, 271, 279; architecture and, 110; Arp and, 50; Cézanne and, 69, 103; children's art and, 137, 243-44; as an exile, 265, 267; Gilot's *Life With Picasso* and, 153; *Girl with Cock* and, 30; *Guernica*, 30, 102, 105, 116, 191, 194, 241, 242, 266, 298; *The Human Comedy*, 298; humanity of, 34; as investment, 106; Kootz and, 40, 41; Manolo and, 55, 56n; Michelangelo and, 99; modern art and, 92; MoMA retrospective of, 241-245; M. letter on, 241-44; M. painting hierarchy and, 10, 20, 243; M. spontaneous notes on, 244-45; *The Painter and His Model*, 243; *Picasso: Art as Autobiography* and, 244; *possibilities* and, 46n.2; questioning what art is, 193; quotations from, 36, 107; *The Rise of Cubism* and, 54-56, 66; Sabartés and, 193; Scarpetta questions on, 241-45; sculpture compared to Matisse, Degas, Rodin, and Brancusi, 244; sensitivity to materials, 116; social values, 31; Spanish Civil War and, 102; statement of 1935, 106; *The Studio*, 241, 243; surrealism and, 233; total abstraction and, 23, 243; work swinging between expressionism and classicism, 215; what art is not and, 232. *See also* Cubism
Poety and poets: automatic poems by M. et al, 162; Coleridge, 279; Crane, 270; Cummings, 77; Donne, 111; French modern poetry, 59, 110; Hopkins, 155; Jeffers, 102, 104; Keats, 187; Lautréamont, 229, 248; Lorca, 7, 77, 191: Moore, 68; The New York School of poets, 89, 147-48; Novalis, 66; Poe, 155, 257; Pound, 272; Rilke, 7, 38, 77; Schlegel, 279; Schuster, 232; Whitman 68, 155; Yeats, 77. *See also* individual entries for poets
Pollock, Jackson: 144, 147, 200, 230, 261, 265, 277, 291, 291n.14; ambition of, 164; Art of This Century and, 27, 121n.2; 247; Benton and, 230; compared to Brando, 277; death of, 195; discussion of surrealist automatism with, 119; drawing by doodling and, 120; Ernst's drip painting and, 224; Krasner and, 42n.6; 162; Matta's *coup d'état* and, 160-62; M. champions the work of, 23, 26-27, 41, 42; M. first collages with, 277; M. introduction to, 156, 276, 280; M. writing on, 27, 276-78, 278n; Picasso and, 242, 243; plastic version of automatism in, 120; *possibilities* and, 45, 46n.2; "The School of New York" and, 76; Seitz book and, 254; studio, 168n.13
Pop Art; also pop artists: 137-38; 147-48
possibilities 1: An Occasional Review, 41, 42n.2, 43, 44-47, 258; Abel and, 44; Caffi, Cage, and Calvo in, 43, 44, 45; Editorial Preface to, 44-46; Goodman and, 44; Hayter and, 45; Lee and, 45; Miró and, 45, 114; models for, 43; Seitz quotation from, 256; second issue of, 71; suggested other titles for, 44; Zervos and, 43-44. *See also* Arp, Baziotes, Chareau; Pollock; Problems of Contemporary Art; Rosenberg; Rothko; David Smith
Primitive art: Brancusi and, 260; as leitmotif in twentieth-century art, 260, 261